THE
ETRUSCAN
LANGUAGE

AN INTRODUCTION

MANCHESTER
UNIVERSITY PRESS

FOR VITTORIA

THE
ETRUSCAN
LANGUAGE

AN INTRODUCTION

Second edition

GIULIANO BONFANTE
and
LARISSA BONFANTE

Manchester University Press
Manchester and New York
distributed exclusively in the USA by Palgrave

First edition published 1983 by Manchester University Press
First USA edition published 1983 by New York University Press

This edition published 2002 by
Manchester University Press
Oxford Road, Manchester M13 9NR, UK
and Room 400, 175 Fifth Avenue, New York, NY 10010, USA
www.manchesteruniversitypress.co.uk

Distributed exclusively in the USA by
Palgrave, 175 Fifth Avenue, New York,
NY 10010, USA

Distributed exclusively in Canada by
UBC Press, University of British Columbia, 2029 West Mall,
Vancouver, BC, Canada, V6T 1Z2

British Library Cataloguing-in-Publication Data
A catalogue record for this book is available from the British Library

Library of Congress Cataloging-in-Publication Data applied for

ISBN 0 7190 5539 3 *hardback*
 0 7190 5540 7 *paperback*

This edition first published 2002

10 09 08 07 06 05 04 03 02 19 9 8 7 6 5 4 3 2 1

Typeset by
Carnegie Publishing Ltd, Lancaster
Printed in Great Britain by
Biddles Ltd, Guildford and Kings Lynn

CONTENTS

LIST OF ILLUSTRATIONS

PREFACE TO THE
FIRST EDITION

The last twenty years have changed our view of the Etruscans. Excavations, discoveries, and new approaches have shown the history of this people in a way not before possible. Scholarly publications – catalogues, excavation reports, collections, and monographs, beautifully illustrated and fully documented – are making available a wealth of material never previously usable for study. At the same time, the results of these new discoveries and research reach the interested public with remarkably little delay. The English translation of Massimo Pallottino's handbook, *The Etruscans*, edited by David Ridgway (1975), undid the barrier of language that often separates our students and a wider English-speaking audience from scholarly study of Etruscan history and culture. With Otto Brendel's *Etruscan Art* (1978), Pallottino's book opened a new period in Etruscan studies in English, a hundred years after the first publication of George Dennis's first-hand, still-classic account, *The Cities and Cemeteries of Etruria*. Historians, for instance in English, Michael Grant, are now for the first time writing the history of the Etruscans independently of Rome.

The chapters on language in Pallottino's *Etruscans* set forth the evidence and warn of the hazards in the study of the Etruscan language. Pallottino's patiently repeated injunction that sterile discussions on the origin of the Etruscans and the genetic connections of Etruscan with other languages should give way to a consideration of the historical development of the culture and the language of these people has finally won the day.

We attempt here to present the first concise but reasonably complete account of the Etruscan language in English. We hope to enable our readers to consult the works that collect and explain the material for

the study of the Etruscan language: the *Corpus of Etruscan Inscriptions*, the *Thesaurus of the Etruscan Language*, Carlo de Simone's study of Greek borrowing in Etruscan, Ambros Pfiffig's full-scale grammar, and the collections of artistic monuments on which inscriptions appear, for example the various fascicles of the *Corpus of Etruscan Mirrors*. The book as a whole is a joint project. The author of the grammar has concentrated on the language. I have written the archaeological introduction and suggested the additions of monuments and inscriptions, chosen the illustrations, and prepared the Study Aids, which I hope will be useful to colleagues and students. We are grateful for Nancy de Grummond's generous and expert collaboration in this and other areas.

Because we have no Etruscan literature, we must turn to what they *have* left behind, in order to understand something of the historical Etruscans. In a way we are in the position of one of their ancient neighbours, who might have gone to an Etruscan city, visited the sites, and seen the people without speaking the language. An ancient Greek or a Phoenician recognized an Etruscan by his dress and his armour – and by the words he spoke. After dress and armour, recently studied in English, language now has its turn. The translations are partial and tentative, mistakes are unavoidable. We would be happy to know that a traveller, after reading this book, could identify the figures represented on an Etruscan mirror or could make out the epitaph on the door of a tomb in the beautiful cemetery of Orvieto, *eca suthi*, 'this is the tomb', and remember the Etruscan buried there long ago.

L. B.

Scholars, frequently sceptical about what is happening in Etruscan studies, will find here a concise and – we hope – clear review of the status of the question in the 1980s. The truth is difficult to reach; but we can try to dispel mistakes.

Almost nothing is absolutely sure. Had every doubtful form or statement been so marked, the book would have been unreadable. The absence of a cautionary question mark after a form or a 'probably' before a statement merely means that the author of the grammar feels the form or statement can be reasonably defended.

Attempts to connect the Etruscan language with Albanian, Armenian, Aztec, and a long series of other languages are based on the so-called 'etymological' method now in disgrace among serious scholars. In contrast, the method we follow in this book, which might be called

'cultural-historical', is based on the ideas of Karl Olzscha and Massimo Pallottino, both great masters of Etruscan studies, who assert that the Etruscan language can be understood only in a historical context, through Etruscan culture: religion, art, 'parallel texts', and so on.

Indeed, the second purpose of this study is to present such a method as an example to other linguists. For although there are now several books on the Etruscan language, this is the first (barring the doubtful example of Trombetti) written by a linguist who is not a specialist of Etruscan. Etruscan has been studied mainly by archaeologists and by Etruscan specialists. It is a tribute to their work that a linguist who is not an Etruscan specialist can write an Etruscan grammar and try to make their findings available to a wider public, one not necessarily acquainted with Etruscan archaeology and its problems.

As an Indo-Europeanist, I have tried to write an introductory text which will be of use to scholars of other disciplines as well as to students and laymen interested in language. It is, as far as possible, a clear, straightforward account.

Without Ambros Pfiffig's *Etruskische Sprache* (1969), this book could not have been written. While I have not always agreed with him, my debts are more than could possibly be individually acknowledged in the text. I want to acknowledge them here, and to thank him.

We are particularly grateful to Massimo Pallottino, who welcomed us as members of the Istituto di Studi Etruschi and invited us to the various congresses. We owe this book to his kindness.

<div align="right">G.B.</div>

Generous publication grants from the Dr M. A. Aylwin Cotton Foundation and from the Ellaina Macnamara Memorial Scholarship helped towards the publication of this book.

PREFACE TO THE
SECOND EDITION

This revised edition preserves the format of the original 1983 version. Changes have been introduced in the text and the sources; the section on mythological figures has been rewritten, and new sections have been added, including the glosses. Bibliography and footnotes have been updated to include major works of the succeeding two decades, and to reflect changes that have occurred in the field.

The book is, as the title indicates, an introduction. The reviews and the comments of colleagues have indicated that such a basic text was welcome, and that we had in general succeeded in our intention to present as clear and concise an account of the Etruscan language as the evidence allows. In revising the text we have taken into account reviewers' remarks and criticisms,[1] as well as changes and additions introduced into the two translations that have appeared, in Italian (1985) and Romanian (1995). We have also taken into account the ongoing discussion of particular problems and monuments that has taken place in the 1980s and 1990s, though it has not always been possible to do justice to the important studies that have appeared, by Agostiniani and others. Most important for recent research is Helmut Rix's collection of Etruscan inscriptions. We have added several sources, a feature of the book our readers particularly appreciated: these indicate the inscriptions' archaeological contexts, and make it possible to read some of them in the original script as well as in transcription. We have given translations of many of the most significant epigraphic texts, as well as shorter ones with interesting features. Though scholars are still divided about the interpretation of the Cortona Tablet, and of specific passages in the boundary stone of Perugia and the funeral inscription of Laris Pulenas, for example, we believe readers will be glad to have

at least partial, tentative translations of the Etruscan texts even if many details are still doubtful.

New focuses have surfaced since the appearance of the first edition. A turning point in Etruscan studies was the Second International Congress in Florence in 1985, organized by Massimo Pallottino as President of the Istituto di Studi Etruschi ed Italici – as a young man he had attended the First, in 1927–8. The proceedings, published in 1989, remain an important base for further study. 1985, the Year of the Etruscans, was the first year of the Progetto Etrusco, with its many exhibits and catalogues. Since then, Etruscan language and epigraphic studies have registered new trends and participated in areas of current scholarly interest. The following is a partial list.

1. The subject of literacy in antiquity attracted attention, discussion, and controversy with the appearance of William Harris's *Literacy in the Ancient World* (1989). Books and writing were clearly a very important aspect of Etruscan civilization. The exhibit in Perugia, *Scrivere Etrusco*, organized by Francesco Roncalli in 1985 as part of the Progetto Etrusco, brought together in a single exhibit in Italy three of the longest, most important Etruscan texts: (a) the newly restored linen wrappings from the Egyptian mummy in the museum in Zagreb, (b) the stone cippus from Perugia, and (c) the terracotta Capua Tile from the Berlin Museum. The material in this exhibit inspired Massimo Pallottino to call the Etruscans the 'People of the Book'.[2] Indeed, though the books of the *Etrusca disciplina* are lost to us, Etruscan art frequently illustrates books, tablets and scrolls being written, examined, and displayed. Books were clearly an extremely important aspect of Etruscan civilization. So were other inscribed objects, such as engraved bronze mirrors and votive gifts.

2. The focus of literacy intersects with two other areas of research, religion – of which more below – and gender studies or women's studies. The latter, a relatively recent focus, is particularly relevant for an understanding of Etruscan civilization. The three thousand or so bronze mirrors which have come down to us, many of which are engraved with figured representations and often inscribed, were an Etruscan specialty, produced in workshops between *c.* 500 and 200 BC. They testify to the literacy and culture of the women for whom they were made, who used them in their lifetime and took them to their graves after their death – women whose names showed them to have a different legal and social status from the women of Rome. The important role of women in writing, related to wool-working and to

the metaphor of weaving for the development of writing, has been much discussed. There is much evidence in its favour: most of the earliest inscriptions come from women's graves, and many inscriptions or sigla ('graffiti') are found on implements for wool-working, spools, or loomweights.[3]

3. Closely related to the importance of writing is Etruscan religion, which has been the subject of congresses, workshops, books, and articles.[4] Writing defined and fixed the established channels of communication between gods and mortals: the signs of the gods were a kind of writing meant to be read by humans, as noted in Seneca's famous quotation about their religion: 'The difference between us and the Etruscans ... is the following: while we believe that lightning is released as the result of the collision of clouds, they believe that clouds collide so as to cause lightning. For since they attribute everything to the gods' will, they believe, not that things have a meaning in so far as they occur, but rather that they happen because they must have a meaning' (*Quaestiones Naturales* 32.2).

Etruscan inscriptions and their contexts account for much of our present knowledge about Etruscan religion, and there is still much to learn from these texts – ritual and funerary, votive, legal, and mythological. Recent publications have added to our understanding of the names of gods and their contexts, whether they be mythological figures from Greek or Etruscan traditions, or gods worshipped in local sanctuaries: sometimes, as in the case of Hercle (= Herakles), they are clearly both. Scholars have also derived important information from the names of donors, ritual formulas, the material and forms of votive gifts, and funerary dedications. A new section of the present volume, 'The Written Word', focuses on the significance of the act of writing and of the written word, while the section on 'Mythological Figures' has been completely rewritten to reflect new research in this area.

4. The swing of the pendulum has once more made the subject of early Roman history central in historical studies. There is no doubt that the Greek alphabet and the habit of writing were among the innovations the Etruscans brought to Rome, to Italy, and to Europe. But scholars are divided about the kind and extent of Etruscan influence on Rome, and controversy abounds in books, articles, reviews, *incontri*, and conversations.[5]

5. Enthusiasm for the European Union resulted in a focus on its forerunners, presumed or otherwise, with exhibits on the Gauls (Venice 1991), and on the Etruscans as the first Europeans (*Les Etrusques et*

l'Europe, Paris 1992, Berlin 1993). Hellenocentric and Romanocentric views are being revised, encouraging a wider view of the ancient world. The authors have dealt with aspects of Etruscan influence in Europe in an earlier book, *Out of Etruria* (1981).[6] Certainly without the Etruscans, who brought writing to Europe, making it possible for us to recognize the languages of some of its peoples, we would not even know much about Europe's early history.

6. Most immediately important for the book are recent studies of basic monuments and texts: the Zagreb mummy wrappings, the Piacenza Liver, the Capua Tile, the Lemnos Stele, the François Tomb, the newly discovered Tabula Cortonensis. The collaboration of archaeologists and linguists has stimulated conferences, exhibits, and workshops, the publication of their proceedings and catalogues, and the preparation of various international corpora which have been appearing at a steady pace: the Corpus of Etruscan Mirrors (*CSE*), the *Lexicon Iconographicum Mythologiae Classicae*, new volumes of the *Corpus Inscriptionum Etruscarum*, and journals old and new.[7] Scholars can more easily take into account the archaeological context of Etruscan inscriptions, speculate on their religious, political and social implications, and take a closer look at categories of epigraphic material long ignored or underestimated: alphabets, bilingual inscriptions, coin legends, simple epitaphs, graffiti.[8] In general it is now accepted, as David Ridgway has noted, that language is an indispensable component of Etruscan studies.[9]

7. New publications are of course also stimulated by new finds. Chief among these is the Tabula Cortonensis, a bronze tablet of Hellenistic date with long lists of names, perhaps a contract, which came to light in 1992. Presented to the public in June 1999, it caused a flurry of excitement on Italian television and in newspapers around the world. Published by Luciano Agostiniani and Francesco Nicosia (2000), it takes its place, at some two hundred words, as one of the longest Etruscan inscriptions to have come down to us.

8. Recent dictionaries, encylopaedias, and surveys include useful summaries of Etruscan writing, language, and religion and of related aspects of Etruscan civilization.[10] Still recommended for useful, reliable information are the books by Pallottino and Brendel; readers should consult these even when no specific reference is made in the notes.

9. The year 2000 brought two large Etruscan exhibitions prominently featuring the aspects of writing and language. *Gli Etruschi*, at the Palazzo Grassi in Venice, was organized by Mario Torelli. Its handsome cata-

logue includes essays on early Etruscan inscriptions and their significance
(Giovanna Bagnasco Gianni), on the Etruscan language (Luciano Agos-
tiniani), and on the related language of the Lemnos stele (Carlo de
Simone). Focusing directly on the Orientalizing period, the exhibition
in Bologna's Museo Civico under the dynamic direction of Cristiana
Morigi Govi, *Principi Etruschi tra il Mediterraneo e Europa*, included
important Etruscan inscribed monuments, illustrated in the catalogue
along with an essay by Giovanni Sassatelli. The wealth of the aristocratic
elite of this early period of Etruscan history, for whom writing was a
sign of status, was the subject of two other remarkable recent exhibi-
tions: *Carri da Guerra e Principi Etruschi*, organized by Adriana
Emiliozzi (Viterbo, Rome, Ancona, 1998–99), and *Principi Guerrieri. La
Necropoli Etrusca Orientalizzante di Casale Marittimo* (Cecina, 1999).

 10. The influence of the Etruscans in later times has been investigated
in some detail, in particular the 'Etruscan Revival' which took place
in Renaissance Tuscany. It is no coincidence that the Renaissance began
in Tuscany, and scholars have traced Etruscan inspiration on the most
famous artists of the Renaissance, and even a connection between the
ancient Etruscan pronunciation and a peculiar feature of the dialect
spoken in the area in modern times, the 'gorgia toscana'.[11]

 We have also added material resulting from our own recent interests,
for example 'The Written Word' (LB), and on the Etruscan influence
on the letter *f* (GB).

 A note about proper names: we have used the Greek or Latin forms
according to custom and context, while trying to respect the Etruscan
forms as much as possible in translations and discussions.

 As before, we thank all those who have helped with suggestions,
criticism, publications, and permissions. We are grateful to Tom Ras-
mussen, Nancy de Grummond, Michael Dumbra, Rex Wallace, our
reviewers, colleagues, and friends for their generous help with advice
and permissions. Alessandro Morandi allowed us to illustrate revised
drawings of the Pyrgi tablets, the Laris Pulenas inscription, and the
Piacenza Liver. Massimo Morandi's assistance with recent bibliography
and variant readings was invaluable. Nicole Diamente scanned the
original, transcribed and organized the revised version, and made useful
suggestions throughout, working with the authors in both America and
Europe. Finally, we are grateful to our editor, Clive Tolley, whose
knowledgeable queries and suggestions improved the book in many
ways; and to Luciano Agostiniani, whose book on the Cortona Tablet
and masterful synthesis in Mario Torelli's *The Etruscans* (2000) allowed

us to profit from the latest information and research in the fast-moving study of the Etruscan language.

It is with a personal sense of loss that we record the deaths of Massimo Pallottino, Jacques Heurgon (1995), Mary Moser (1996), Raymond Bloch, Mauro Cristofani, Sabatino Moscati (1997), Ambros Josef Pfiffig (1998), Clelia Laviosa, and Emeline Richardson (1999).

NOTES TO PREFACE

1 Reviews of *The Etruscan Language: An Introduction* (Manchester and New York, 1983): D. Ridgway, *Times Literary Supplement* (24 Feb. 1984) 196; N. T. de Grummond, *Archaeology* 37 (1984) 74; P. Defosse, *Latomus* 44 (1985) 899–900; R. A. Fowkes, *Word* 35 (1984) 189–193; H. M. Hoenigswald, *Classical Review* 34 (1984) 340–341; A. J. Pfiffig, *Gnomon* 56 (1984) 770–771; T. Rasmussen, *Antiquity* 58 (1984) 144–145; V. Slunecko, *Listy filologické* 114 (1991) 34–37; J. P. Small, *Classical World* 79 (1985) 49; L. D. Stephens, *AJP* 106 (1985) 133–135; N. Vincent, *Language* 61 (1984) 688–691. Reviews of *Lingua e cultura degli Etruschi* (Rome, 1985): F. R. Adrados, *Emerita* 56 (1988) 136–138; G. B. Pellegrini, *AGI* 70 (1985) 147–151; A. J. Pfiffig, *Anzeiger für die Altertumswissenschaft herausgegeben von der Österreichischen humanistischen Gesellschaft (Innsbruck)* 40 (1987) 62–63; D. Slusanschi, *Studii S'i cercetari linguistice* 38 (1987) 252–253.

2 Massimo Pallottino was writing a book on the Etruscan language when he died, in February 1995. The Table of Contents and what would have been the first chapter, with a brief Introduction by Mauro Cristofani, were published in *Studi Etruschi* 61 (1997).

3 W. V. Harris, *Ancient Literacy* (Cambridge, MA, and London, 1989). The discussion that followed included an informative, valuable volume, *Literacy in the Roman World*, *JRA* Supplementary Series 3 (1991), with essays by M. Beard, A. K. Bowman, M. Corbier, and a survey of the situation in the Etruscan cities and early Rome by Tim Cornell, 'Archaic Italy and the Roman Republic', 149–151. On Etruscan women, woolwork, and literacy see M. Torelli, 'Un nuovo alfabetario etrusco da Vulci', *ArchClass* 17 (1965) 126 ff., and T. Hodos, 'The asp's poison: women and literacy in Iron Age Italy', in R. Whitehouse (ed.), *Gender and Italian Archaeology: Challenging the Stereotypes.* Accordia Research Institute (University of London, 1998) 197–208. E. Peruzzi, 'Appunti su *pecto, plecto, flecto, necto*', *Rivista di Filologia e d'Istruzione Classica* 40 (1962) 394–408, on Latin words related to weaving, and Etruscan influence on weaving techniques among the Latins. G. Bagnasco Gianni, in *Scritture mediterranee tra il IX e il VII secolo a.C.* (Milan, 1999) 85–106, with discussion, 145–153. G. Colonna, 'Ceramisti e donne padrone di bottega nell'Etruria arcaica', in *Indogermanica et Italica. Festschrift H. Rix* (Innsbruck, 1993) 65–88. On the metaphor of weaving, see J. Scheid, J. Svembro, *Le Métier de Zeus. Mythe du tissage et du tissu dans le monde gréco-romain* (Paris, 1994). See below, Part I, note 8. For inscriptions on Etruscan mirrors see *TLE*, de Grummond, *Guide, ES*, fascicles of *CSE*, C. de Simone, *Die*

Griechischen Entlehnungen im Etruskischen (Wiesbaden, 1968–70), and van der Meer, *Interpretatio Etrusca: Greek Myths on Etruscan Mirrors* (Amsterdam, 1995), with van der Meer's note that gems, in contrast to mirrors, almost exclusively bear the names of male figures. For the names and status of Etruscan women, see M. Nielsen, 'La donna e la famiglia nella tarda società etrusca', in A. Rallo (ed.), *Le donne in Etruria* (Rome, 1989) 121–145; and 'Common Tombs for Women in Etruria: Buried Matriarchies?' in *Female Networks and the Public Sphere in Roman Societies*. Acta Inst. Rom. Finlandiae 22 (Rome, 1999) 65–136.

4 M. Torelli, 'La religione', in *Rasenna* (Milan, 1986) 159–237. J. Linderski, *Roman Questions. Selected Papers* (Stuttgart, 1995). F. Gaultier, and D. Briquel, *Les Étrusques, les plus religieux des hommes* (Paris, 1997). J.-R. Jannot, *Devins, dieux et démons. Regards sur la religion de l'Étrurie antique* (Paris, 1998). N. T. de Grummond (ed.), *The Religion of the Etruscans*. Conference, Tallahassee, Florida, February 1999 (forthcoming). N. T. de Grummond, 'Mirrors and manteia: Themes of prophecy in Etruscan and Praenestine mirrors', in A. Rallo (ed.), *Aspetti e problemi della produzione degli specchi etruschi figurati*. Atti dell'incontro internazionale di studio. Università degli Studi di Roma 'Tor Vergata', Roma 1997 (Rome, 2000) 27–67.

5 *La grande Roma dei Tarquinii*. Catalogue of Exhibit (Rome, 1990). A. Carandini, *La nascita di Roma: dèi, lari, eroi e uomini all'alba di una civiltà* (Turin, 1997). Tim Cornell, *The Beginnings of Rome: Italy and Rome from the Bronze Age to the Punic Wars (c. 1000–264 B.C.)* (London, New York, 1995). E. Fentress, A. Guidi, 'Myth, memory and archaeology as historical sources.' Review of Carandini (1997) *Antiquity* 73 (1999) 463–467. See also M. Pallottino, *Origini e storia primitiva di Roma* (Milan, 1993); J. Hall (ed.), *Etruscan Italy* (Provo, Utah, 1996); L. Aigner-Foresti, *Die Integration der Etrusker und das Weiterwirken etruskischen Kulturgutes im republikanischen und kaiserzeitlichen Rom* (Rome, 1998).

6 A. J. Pfiffig, *Einführung in die Etruskologie* (Darmstadt, 1972) 85–87. L. Bonfante, *Out of Etruria. Etruscan Influence North and South*. BAR International Series 103 (Oxford, 1981), with a chapter on languages by G. Bonfante (124–134); reprinted as 'The spread of the alphabet in Europe: Arezzo, Erz, and runes', in R. Gendre (ed.), *Scritti Scelti di Giuliano Bonfante* IV (Alessandria, 1994) 109–118. L. Aigner Foresti (ed.), *Etrusker nördlich von Etrurien* (Vienna, 1992).

7 New journals include *Journal of Roman Archaeology, Ostraka, Scienze dell' Antichità, Etruscan Studies*.

8 For graffiti, see also Part I, note 83.

9 D. Ridgway and F. R. Serra Ridgway, 'New aspects of Tarquinia, Veii, and Caere', *JRA* 12 (1999) 450.

10 H. Rix, in *Der kleine Pauly*, s.v. L. Bonfante, *Reading the Past. Etruscan* (London, Berkeley, and Los Angeles, 1990). See also, in P. T. Daniels, W. Bright (eds), *The World's Writing Systems* (New York, Oxford, 1996): L. Bonfante, 'Etruscan', 297–301; R. W. V. Elliot, 'The runic script', 333–338. H. Rix, 'Etruscan language', in S. Hornblower and A. Spawforth (eds), *The Oxford Classical Dictionary*, 3rd edn (Oxford, 1996) 559–560.

11 Nancy de Grummond, 'Rediscovery', in L. Bonfante (ed.), *Etruscan Life and Afterlife* (Detroit, 1986) 18–46. On the connection between the Etruscan aspirates (*kh, th, ph*), and the 'gorgia toscana', the pronunciation of these sounds in the

dialect of Tuscany (*la hasa* = *la casa*), see *Fonologia etrusca, fonetica toscana: il problema del sostrato*, ed. L. Agostiniani, L. Giannelli (1983), C. Battisti, 'Aspirazione etrusca e gorgia toscana', *StEtr* 4 (1931) 249–254; D. Geissendörfer, *Der Ursprung der Gorgia Toscana* (1964), and G. Bonfante, 'La gorgia toscana e l'etrusco' (forthcoming).

ABBREVIATIONS

AGI	*Archivio glottologico italiano*
AJA	*American Journal of Archaeology*
AJAH	*Americal Journal of Ancient History*
AnnFaina	*Annali della Fondazione per il museo 'Claudio Faina' (Orvieto)*
AnnPisa	*Annali della Scuola normale superiore di Pisa, Sezione di lettere*
ArchClass	*Archeologica Classica*
BABesch	*Bulletin van de vereeniging tot bevordering der kennis van de antieke beschaving*
BICS	*Bulletin of the Institute of Classical Studies*
BSL	*Bulletin de la Société de linguistique de Paris*
CIE	*Corpus Inscriptionum Etruscorum*
CII	*Corpus Inscriptionum Italicarum*, ed. A. Fabretti (1867)
CP	*Classical Philology*
CRAI	*Comptes Rendus de l'Académie des inscriptions et belles lettres*
CSE	*Corpus Speculorum Etruscorum*
CUE	Corpus delle urne etrusche di età ellenistica. Urne volterrane, 1. I complessi tombali, ed. M. Cristofani (Florence, 1975)
DdA	*Dialoghi Di archeologia*
ES	E. Gerhard, *Etruskische Spiegel*, I–IV (Berlin, 1840–67); A. Klugmann and G. Körte, *Etruskische Spiegel*, V (Berlin, 1897)
ET	H. Rix, *Etruskische Texte*, I–II, Editio Minor (Tübingen, 1991)

EtrStud	*Etruscan Studies*
GöttGelAnz	*Göttingische Gelehrte Anzeigen*
IBR	*Italy before the Romans*, ed. D. Ridgway and F.R.S. Ridgway (London, New York, and San Francisco, 1979)
JAOS	*Journal of the American Oriental Society*
JdL	*Jahrbuch des Deutschen archäologischen Instituts*
JHS	*Journal of Hellenic Studies*
JRA	*Journal of Roman Archaeology*
JRS	*Journal of Roman Studies*
LIMC	*Lexicon Iconographicum Mythologiae Classicae*
MEFRA	*Mélanges d'archéologie et d'histoire de l'École française de Rome. Antiquité*
Ostraka	*Ostraka. Rivista di antichità*
ParPass	*Parola del passato*
Pauly–Wissowa	A.F. Pauly and G. Wissowa, *Real-Encyclopädie der klassischen Altertumswissenschaft* (Stuttgart, 1894–)
Popoli e civiltà	*Popoli e civiltà dell'Italia antica* 1–7 (Rome, 1974–78)
QuadUrb	*Quaderni urbinati di cultura classica*
RdA	*Rivista di Archeologia*
REE	*Rivista di epigrafia etrusca*, continuing survey of inscriptions, new or revised, published in *Studi etruschi*
REL	*Revue des études latines*
RendLinc	*Rendiconti dell'Accademia nazionale dei lincei*
RivStAnt	*Rivista storica dell'antichità*
RömMitt	*Mitteilungen des Deutschen archäologischen Instituts, Römische Abteilung*
ScAnt	*Science dell'antichità. Storia Acheologia Antropologia*. Università degli Studi di Roma 'La Sapienza'. Rome.
StEtr	*Studi etruschi*
ThLE	*Thesaurus Linguae Etruscae* I. Indice Lessicale. Rome, 1978.
TLE	M. Pallottino, *Testimonia Linguae Etruscae*, 2nd edn (Florence, 1968)

CHRONOLOGICAL PERIODS

Iron Age, Villanovan period	10th–9th centuries BC
Orientalizing period	8th–7th centuries BC
Archaic period	6th–mid-5th century BC
Fifth and fourth centuries	450–300 BC
Hellenistic period	300–50 BC
Roman period	50 BC–AD 300

TECHNICAL TERMS

alabastron tall globular vase without handles, for perfume or unguents; made from alabaster or terracotta.

amphoriskos conventional name for a small, Etruscan two-handled vase ('small amphora'), usually of bucchero, typical of the seventh century.

anasyrmata gesture of pulling up the garment and uncovering the sexual organs in front; shown on images of goddesses in the ancient Near East, on Etruscan female mythological figures, and in the Greek myth of Baubo, who pulled up her skirt to make Demeter laugh.

aryballos a globular vase for oil, worn tied to the wrist by Greek and Etruscan athletes.

askos a vase shape: originally a Greek term referring to a wine skin, used more generally of a type of container for wine or oil, often an animal-shaped vessel.

bucchero a typically Etruscan material, used for a variety of vase shapes in the seventh and sixth centuries. It was fired to become black, imitating the dark colour of the more expensive bronze vases.

chiton a linen shirt or tunic, for men and women, long, short or medium length.

cippus a boundary stone or grave marker.

exergue the area below the base line of the circular space of a mirror or coin.

fasces in Rome, a bundle of rods carried before the highest magistrates by their attendants or lictors; outside the boundaries of the city, an axe was added, as the symbol of the power of life and death of the commander-in-chief over the citizens.

flamen member of an ancient Roman priesthood, dedicated to particular divinities; the highest rank was that of the flamen dialis, dedicated to Jupiter.

haruspex Etruscan priest who practised haruspicina, reading the will of the gods from the entrails of sacrificed animals.

iynx a bird (wryneck) used as a charm to recover unfaithful lovers, bound to a revolving wheel.

kouros a life-size statue of a beautiful, aristocratic naked youth, typical of Greek art of the seventh and sixth centuries; also generally used as the motif of a naked youth, adopted as an artistic type in Etruria.

krater a wide-mouthed, two-handled vase for mixing wine and water to serve at the symposium or banquet.

kylix a two-handled cup for drinking wine at the symposium or banquet.

lekythos a Greek term used for a small flask for pouring perfumed oil, for cosmetic or funerary use.

oinochoe a handled jug used to pour wine at the symposium or banquet.

olpe a vase shape: originally a Greek term referring to a leather oil flask, used more generally of a container for liquids.

peplos a rectangular woollen garment worn by women as a dress fastened with pins at the shoulders, belted at the waist and forming an overfold. A typically Athenian garment and an attribute of Athena in Greek iconography, it was not normally worn in Etruria, but it was used for images of Minerva in Etruscan art.

Sacre Conversazioni in Etruscan iconography, a term borrowed from Italian Renaissance painting showing groups of saints together as if in conversation, used to describe groups of heroes and heroines often shown on Etruscan mirrors of the Hellenistic period.

symposium a drinking party for men only (attended by the non-citizen party girls) in Greece, for which many of the Greek vases found in Greece and Italy from the seventh to the fourth century were made. In Greek and Etruscan art they were a popular subject, though in Etruria symposia were less common than banquets attended by men and women, in particular married couples.

PART ONE

HISTORICAL BACKGROUND

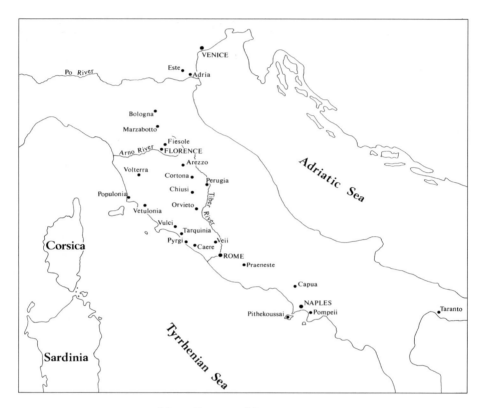

Map 1 Etruscan cities, 700–100 BC

ARCHAEOLOGICAL INTRODUCTION

Etruscan must be studied within a historical context. Like any other language, it was a creation of a particular people in a particular place, changing in the course of time. Then, too, Etruscan is known to us mainly through epigraphical documents, which need to be studied by linguists and archaeologists working closely together: any interpretation of an inscription must take into account the provenance, date, and historical context of the monument on which it appears. A brief survey of the archaeological record is thus in order before we proceed to examine more closely the language known to us from these inscriptions.

Recent discoveries confirm the theory that the history of the Etruscan people extends from before the Iron Age in Italy to the end of the Roman Republic – in chronological terms, from c.1200 to c.100 BC.[1] Many sites of the chief Etruscan cities of historical times (map 1) were continuously occupied from the Iron Age 'Villanovan' period on. Much confusion would have been avoided if archaeologists had used the name 'proto-Etruscan' instead of 'Villanovan' to refer to the Iron-Age material excavated near Bologna in the mid-nineteenth century, and later in all the major Etruscan sites.[2] For in fact the people who lived in central Italy between the Arno and Tiber rivers, whose language is first known from a thousand or so inscriptions of the seventh century. (when we begin to refer to them as the historical Etruscans), did not appear suddenly. Nor did they suddenly start to speak Etruscan. Rather, they learned to write from their Greek neighbours at Pithekoussai (Ischia) and Cumae,[3] thus revealing their peculiar language and officially marking the beginning of the historical period in Italy.

Archaeologists recognize the ancestors of these historical Etruscans in the inhabitants of central Italy before the Villanovan period.[4] Linguists

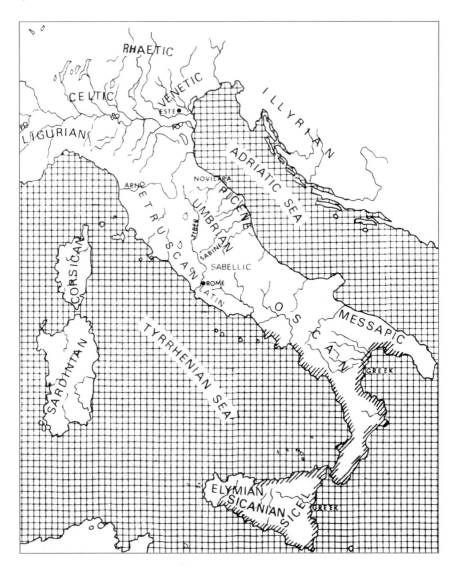

Map 2 The languages of ancient Italy, fifth century BC

have noted that the language we know is one which had already absorbed features of other languages from neighbours in Italy (map 2). Archaeologists and linguists agree, therefore, that the historical Etruscans had been developing their culture and language *in situ* – though they may disagree about the length of time – before we meet them in the epigraphic and historical record.

Two 'problems' which frequently come up in non-specialist discussions about the Etruscans, their language and their origins, need to be reformulated. In the first place, their language does not need to be 'deciphered', as the readers of this book know. In the second place, rather than the simplistic explanations of Etruscan origins still prevalent, based on Herodotus' story of a 'migration' from Lydia, or on Dionysius of Halicarnassus' theory of an 'autochthonous' people of Italy,[5] we need a historical account of their formation and development. Etruscan origins are indeed well described in modern terms, as the process of formation which culminated in early Etruscan history or proto-history: 'Perhaps the most important time in all its course was a period of a few decades that reached its climax in the eighth century, for it was then that groups of adjacent villages – each group on its own defensible plateau – became amalgamated to constitute larger entities which before long became recognizable as the Etruscan cities and city-states.'[6]

This progressive urbanization of the Etruscan settlements explains how, by the end of the eighth century, they were city-states ready to adopt the recent invention of writing, which spread with the same remarkable speed throughout Etruria as it had through Greece. As the more 'egalitarian' tomb provisions of the Villanovan period gave way to the princely elite furnishings of the seventh-century tombs of central Italy, at Tarquinia, Caere, and Praeneste (modern Palestrina), the use of writing became the mark of a rich, sophisticated member of an aristocratic society. The alphabet, a Greek import, was adopted as part of an Orientalizing style of life.[7]

The earliest Greek inscription of any length, a Homeric reference incised on the so-called Cup of Nestor (fig. 1), was found at Pithekoussai,[8] within a few miles of Etruscan territory.

Nestor's cup was sweet to drink. But whoever drinks from this cup, immediately the desire for Aphrodite of the beautiful crown will seize him

This inscription shows that the Etruscans of the southern coastal cities had their Greek models ready to hand. It also points up the contrast between our knowledge of the Greek and the Etruscan language. The Etruscans adopted writing, and left behind them thousands of

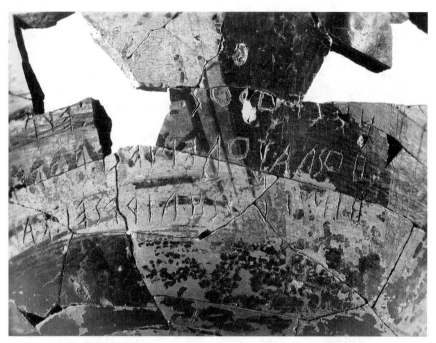

inscriptions, but no literature: they had no 'Homer, Sappho or
Herodotus, with all that they mean for our contemporary Western
culture: the memory of any conceivable spiritual adventure that accom-
panied the early flowering of Etruscan civilization was erased by its
equally early decline. That is why the Etruscans and their remains are
still remote, alien to ourselves and largely silent'.[9] As Momigliano points

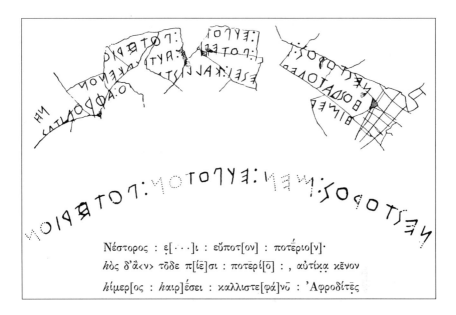

Νέστορος : ε[···]ι : εὔποτ[ον] : ποτέριο[ν]·
 hὸς δ'ἂ‹ν› τõδε π[ίε]σι : ποτερί[õ] : , αὐτίκα κ͂ενον
hίμερ[ος] : hαιρ]έσει : καλλιστε[φά]νō : ᾿Αφροδίτ͂ες

1 (facing and above) Nestor's cup from Pithekoussai (Ischia), 725–700 BC

out, 'no necropolis, however rich, can ever replace the living tradition of a nation'.[10]

That the Etruscans had a rich religious literature we know from Roman tradition, confirmed by archaeological evidence (the Zagreb mummy) and linguistic evidence (glosses of plants and birds).[11] It is tempting to believe that their dramatic literature was also important; but the evidence is archaeological or visual rather than epigraphic or literary, giving us only elusive glimpses of such productions, incomplete and hard to interpret.[12]

Etruscan scholarship looks to the Etruscans' 'material culture' in its own time to try to understand the changes that came about in historical terms. So linguists, attempting to understand the structure of the Etruscan language and how it compares with that of other known languages, study Etruscan inscriptions in the context of the monuments on which they appear. In order to understand a monument's historical context, we need to know its date and provenance. Provenance and context, usually funerary, can often be established. The chronology can rarely be known from external evidence. But a monument can at least be classified as Orientalizing, Archaic (seventh and sixth centuries BC), or later ('Classical' and Hellenistic, fifth to first centuries BC); and

indeed this is the way most are identified in Pallottino's basic selection
of Etruscan inscriptions, the *Testimonia Linguae Etruscae*, to which
reference is regularly made in our text. Linguists also distinguish two
phases, archaic Etruscan and late Etruscan ('neo-Etruscan'). As the
author of the grammar in this handbook points out, such a distinction
is based on phonology, the first phase (seventh and sixth centuries)
being distinguished from the second (fifth to first centuries) by the
gradual weakening of the vowels which takes place in Etruscan, as in
Latin, as a result of the intensive accent.

In order to provide a historical context for the provenance of in-
scriptions to be studied, it will be useful to survey the individual
Etruscan cities, focusing in each case on what archaeology has revealed
about its writing.

The extent of the territory each city-state controlled varied over the
course of time (map 1). Alliances between city-states, too, no doubt
changed. Though tradition tells of the League of Twelve Peoples
(i.e. cities) and its centre at the Fanum Voltumnae, there is no indication
that this league was anything but a religious federation.[13] Nor were
these 'twelve peoples' the same over the course of time. We do know
about the development of many of the important cities, however, mostly
through their necropolises.

Like the contemporary Greek cities, or the Tuscan cities of the
Renaissance, these Etruscan cities were characterized by their individ-
ualism, independence, and disunity. Each city had a highly developed
individuality in its art and culture. There never was an Etruscan empire.
There was an Etruscan people, who shared a language, a religion, a
geographical location, and certain customs and costumes which made
them recognizably different from other people in Italy and in the
Mediterranean. They also shared a name: the Etruscans called them-
selves Rasenna; the Greeks knew them as Tyrrhenians. This was the
name given to the sea they controlled to the west of the Italian
peninsula. The Romans called them Tusci. The name of one of the
streets of Rome, the Vicus Tuscus near the Capitoline Hill, long
preserved the memory of their residence in the city.[14]

Beyond the differences from city to city, north and south were also
generally distinguished by features of their art and language. The
boundaries between southern and northern Etruria were the Fiora and
the Paglia rivers. Southern Etruria included important coastal cities.
Tarquinia, Cerveteri, Veii, Vulci were the first to flourish, and were in
contact with the Greeks and the Phoenicians, from whom they imported

luxury items and new ideas. The cities of central and northern Etruria, both the coastal cities – Vetulonia, Roselle, Populonia – and those of the interior – Volsinii (Orvieto), Chiusi, Perugia, Arezzo – were less open towards the Mediterranean, and tended to look more towards the north. The land was fertile and the cities more dispersed, farther away from each other in a larger area. The diversity of Etruria, rightly emphasized by Luisa Banti and other scholars since, must be kept constantly in mind. Those who have lived or travelled in Tuscany and elsewhere in Italy have experienced this diversity, persisting in modern Italy as both its glory and its weakness.

THE CITIES AND THEIR CEMETERIES

Each city specialized in a type of monument, many of which were inscribed. There were labels of figures represented on paintings or engraved bronze mirrors, legends on coins, inscriptions dedicating objects as gifts to the dead or votive offerings to the gods, and epitaphs with name, family, age, rank, titles, and relationship of the deceased to the other members of the family.

THE SOUTHERN CITIES

The southern cities were the richest, especially the two coastal sites of Tarquinia and Caere.

Tarquinia
Tarquinia [15] (*Tarch[u]na* in Etruscan, *Tarquinii* in Latin) had the earliest flowering, in the Villanovan period; during the course of the Orientalizing period it was overtaken by Caere. Both cities were situated some distance from the sea, probably from fear of pirates. Tarquinia's port of Gravisca,[16] and Cerveteri's port of Pyrgi (map 1) [17] have revealed sanctuaries and settlement areas and documented foreign relations in their inscriptions. The gold tablets from Pyrgi of *c.*500 BC (fig. 5), written in Phoenician and in Etruscan, are very close to a 'bilingual' inscription. The Greek votive inscriptions from Gravisca reveal the existence of Greeks living in an enclave, on Etruscan soil, set apart from the Etruscan city. On a votive stone anchor dedicated to Apollo of Aigina, the 'Sostratos' recorded in the inscription may be the successful merchant mentioned by Herodotos (4.152) as trading with Tartessos

in southern Spain. All these inscriptions have far-reaching implications for the Etruscans' relations in the Archaic period with Greeks and Carthaginians or Phoenicians, on Etruscan soil or elsewhere.

Tarquinia's pre-eminence and its status as an independent city-state were marked by its founding legend. According to this legend, Tarquinia was founded by and named after the hero Tarchon, a figure whose story was closely bound up with the traditions of all the Etruscan people. Tarchon,[18] the companion (or son, or brother) of Tyrrhenus, who led the Etruscans from Lydia to Italy,[19] was also the legendary founder of Pisa [20] and Mantua,[21] and was connected with the wise infant Tages, who invented the art of haruspicina or divination, after having sprung from the earth in the fields of Tarquinia.[22] According to other sources, Tarchon himself was the inventor of divination from animal entrails,[23] and from the regions of the sky, two techniques in which the Etruscans were particularly skilled.[24] A mirror of the fourth century BC identifying Tarchon by means of an inscribed label illustrates this event, and perhaps celebrates the foundation myth, or 'history', of Tarquinia.[25]

One aspect of the story of Tages is of particular interest in connection with the Etruscan language and alphabet, and the importance writing had for the Etruscans, whose rites and religion were based on 'sacred books'. The traditional account insists on the fact that Tages himself ordered his revelation to be taken down in writing. A Praenestine cista of the fourth century,[26] unfortunately uninscribed, bears an engraved scene some have interpreted as Tages in the act of proclaiming his prophecy, which is being written down. In a book on prodigies a late author, John of Lydos, even describes the writing in which Tarchon took down the words of Tages as a 'different' kind of script – a statement some have taken to refer to an earlier, pre-Etruscan syllabic script.[27]

The story of Tarchon and the history of Tarquinia are thus related to important local myths of the Etruscans: the legendary 'migration' of the Lydian group to Italy, the foundation of cities in northern Italy, and the invention of Etruscan techniques of divination. The city's great antiquity and its prestige among the Etruscans themselves are confirmed. The Romans thought of their own kings, the Tarquins, as coming from Tarquinia, though later inscriptions record a *Tarchna* family from Caere.[28]

As at other Etruscan cities, it is the cemeteries that tell us of the life of their inhabitants. At Tarquinia the characteristic chamber tombs

carved from the local calcareous stone (*macco*) and covered with mounds appear soon after 700. From the mid-seventh century they were furnished more and more luxuriously. Thousands of tombs have been explored since the beginning of the last century. Six thousand were identified by the geophysical techniques of the Lerici Foundation. The earliest inscription known so far, on a Protocorinthian cup from Tarquinia, dates from around 700.[29] The rich Etruscans imported huge quantities of Attic vases, and the museum at Tarquinia contains some of the best examples of this sophisticated craft, such as the red-figure cup by Oltos on the foot of which has been scratched a dedicatory inscription to the Dioskouroi (Source 20).

Greek influence, always clear from the archaeological record of the tomb furnishings, was confirmed to have been close at hand with the excavation of the Greek sanctuary at Gravisca.[30] Once again, the traditional account seems to fit the archaeological record. According to Roman tradition a Greek aristocrat, Demaratus, having emigrated from Corinth as a political refugee,[31] decided to settle in Tarquinia. There his son, Lucumo, whose Etruscan name was Latinized as Lucius Tarquinius Priscus, later king at Rome, was born, grew up, and married. Demaratus is said by Pliny (*Natural History* 35.152) to have brought with him three terracotta sculptors, Eucheir, Eugrammos, and Diopos ('Skilled Hand', 'Skilled Draftsman', and 'User of the Level') – a remarkable testimony, in view of the importance of Greek, and especially Corinthian, influence on the art of Tarquinia (and other Etruscan cities), during the Orientalizing period, when Demaratus would have come. His son Tarquin ruled at Rome traditionally from the end of the seventh century, founding the dynasty which held the monarchy at Rome for one hundred years, until the beginning of the Republic in 510–509. Another early inhabitant of Tarquinia, whose grave and epitaph have been found, is Rutile Hipukrates:[32] like Demaratus, he lived in Tarquinia in the seventh century. In the early second century Laris Pulenas refers to his great-grandfather as *Creices*, 'the Greek' (Source 31, fig. 28).

From the mid-sixth century to the end of the Etruscan period, Tarquinia offers the largest continuous series of ancient paintings from the classical world decorating the walls of its tombs. The inscriptions included in these paintings consist of epitaphs, genealogies, and labels. Though East Greek painters (refugees from the Ionian cities invaded by the Persians) evidently painted many of these, and started workshops staffed with Etruscan artists,[33] the style of the Archaic paintings and

their subjects – aristocratic scenes of banquets, games, and luxurious living – reflect Etruscan taste and custom. They agree with Livy's description of Etruscan princesses attending splendid banquets 'in the company of their peers', in contrast to the chaste, virtuous Lucretia, who worked at her wool until late into the night surrounded instead by her maids.[34] The Archaic painting in the Tomb of the Bulls, one of the few with a mythological subject, shows Achilles' ambush of Priam's young son Troilos by the fountain outside Troy.[35] From a slightly later period come tomb paintings with gladiatorial fights – like the Romans, and unlike the Greeks, the Etruscans preferred spectator sports to athletic competitions, though these had been imported from Greece as well. Two of these participants, wearing a mask, a pointed hat, and a special stage costume, are labelled *Phersu*.[36] Linguists agree in seeing here the origin of the Latin word *persona*, long used to mean 'character in a play', and only in recent times applied to 'personality' in the sense of a person's real identity. This word seems to fit the context of Rome's debt to the Etruscan theatre, which also brought into Latin the Etruscan word *histrio*, from which derives our word 'histrionics'.[37]

The Tomb of the Jugglers (Tomba dei Giocolieri *c*.520) is one of the numerous tombs discovered in the Monterozzi necropolis by the excavators of the Lerici Foundation. On one wall is represented a scene of various entertainments in the presence of the deceased, seated on a folding stool. On the side wall, far away from the other figures, hidden behind a tree, a naked man is defecating: an inscription records his name, *aranth heracanasa*, 'Arnth, the slave of Heracana'. It has been suggested that this could be the artist's signature, while he himself is represented in a shocking attitude with apotropaic significance.[38]

In the fourth century, a change comes in the subject matter of the tombs, which now represent scenes from the Underworld. One of the most impressive, the Tomb of Orcus (Tomba dell'Orco), shows the souls of Greek heroes, for example *hinthial Teriasals*, 'the soul of Teiresias' (Source 53, fig. 49) The divine couple of the lower world, Hades and Persephone, are also present. The painted representations of members of the aristocratic Murina family have their epitaphs proudly displayed in the Tomb of Orcus.[39] Much later the *elogia* (statements of careers of generals inscribed on the bases of statues erected in their honour) of the Spurinnas, another noble family, were written at Tarquinia in Latin, and now constitute a rare and precious historical document. These *elogia* were written in the first century AD, but incorporate material from family archives; they tell of honours

received by citizens of Tarquinia in various military expeditions, probably in the fifth or fourth century, against Syracuse, and it seems also against Cerveteri and Arezzo.[40]

Another tomb, belonging to the Velcha family, is known as the Tomba degli Scudi, or Tomb of the Shields. Inscriptions inform us of its date and inhabitants. Here, as elsewhere, the generations of these aristocratic families are represented by couples, husband and wife together (a situation quite unlike either the Greek or the Roman idea of the male citizen, alone or in his public role).[41]

Apart from the tomb paintings, Tarquinia also produced stone sarcophagi bearing Etruscan inscriptions. Carved of *nenfro*, a local stone, of marble, or of alabaster, these stone sarcophagi are often decorated with figures or designs in relief on the front of the case, and represent the figure of the deceased reclining on the lid as on the banquet couch or death bed.[42] From the tomb of the Partunu family come several sarcophagi with interesting epitaphs, for example the one recording the career of Velthur Partunus, who died at the age of eighty-two.[43]

The end of the Etruscan language at Tarquinia and the beginning of Latin is marked by the Latin inscriptions on wall paintings and of the grave markers or cippi, which came into use in the third century, and of which we have about two hundred at present.[44] One tomb, the Tomb of the Typhon (Tomba del Tifone), of the third century, has wall paintings with funerary inscriptions in both Etruscan and Latin. Etruscan epitaphs commemorate the builder of the tomb, *Arnth Pumpu*, two of his sons, and a woman, *Hercnai* (CIE 5412); while a Latin inscription identifies someone named *Tercenna* or *Hercenna* (CIE 5413), probably belonging to the same family.[45] Here, as at Cerveteri, the language shift from Etruscan to Latin seems to have taken place around 100 BC, or slightly later, soon after the Social Wars.[46]

Cerveteri

Situated around forty-five kilometres from Rome, some six kilometres from the sea, Cerveteri, known to the Romans as Caere (Etruscan, *Cisra*; Greek, *Agylla*),[47] also had its Villanovan prehistory. Its period of greatest glory, however, was the Orientalizing seventh century, when it overtook and surpassed Tarquinia in importance and wealth. Its position on the coast, nearest to the southern boundary of the Etruscan area, put it in direct contact with the Greeks of Pithekoussai and overseas, and with the Phoenicians as well, as is shown by the bilingual inscriptions found in its port city, Pyrgi[48] (referred to as 'the towers'

Pithekoussai

Cumae	A	Γ	⪫	⪪	I	В	⊕	l	Ж	⅃	ᛙ	ᛉ	ᚱ		۹	٩	⪤	T	Y	Φ	Y
Etruria	A	Ɔ	⪫	⪪	I	В	⊗	l	Ж	⅃	ᛗ	ᛉ	ᚱ	M	۹	٩	⪤	T	Ч	Φ	Y

2 The alphabet, Greek (Euboean) and Etruscan

by the Greeks). The name of its other port city, 'Punicum', recalls a Phoenician, or rather Carthaginian, relationship.

Trade in copper and iron from northern mines evidently allowed the elite of Cerveteri to afford such luxury items as the massive gold, silver, and bronze implements which they commissioned from local and foreign craftsmen. It may be that it was just for the purpose of such profitable trade that the alphabet was first adopted at Cerveteri itself.[49]

It is important to note that the Orientalizing period so brilliantly exhibited in the chamber tombs of Cerveteri includes this importation and subsequent adoption of the alphabet, learned from Euboean Greeks stationed at Pithekoussai and Cumae, not far from Cerveteri (fig. 2). Over thirty inscriptions from this period are known. The alphabet was adopted at a remarkably early date – perhaps even before 700. Here, as elsewhere, it was incized on writing implements which were placed in tombs as a sign of their owner's wealth and sophistication. One of these, a vase, perhaps intended to hold ivory or bronze tools used to incise words on wax tablets, was included in a rich tomb of the seventh century (Source 2, fig. 13).[50] Made of bucchero, a black, shiny, metallic-looking ware which was a speciality of Cerveteri's potters,[51] and only six inches high, this vase was decorated not only with the usual alphabet, but also with a syllabary – letters in the form of syllables which were to be copied as an aid to learning the new art of writing. Other objects from the Regolini-Galassi tomb, now in the Etruscan Museum at the Vatican, were engraved with the name *Larthia* (Source 6, fig. 13).[52] The custom of inscribing the object with the owner's name before placing it in the tomb, at Cerveteri as elsewhere, has provided us with many of the examples of Etruscan included in this book, in which the object states its ownership: 'I belong to Larth', or 'Larthi', a woman. From Campania comes an Attic kylix or cup whose inscription is intended to protect it from theft: *qupes fulusla ... mi ei minpi capi mi nunar*, 'I [belong] to Cupe, the one of Fulu. Do not take me. I am sacred' (equivalent to Greek and Latin phrases: *noli me tangere*). A large impasto jar dating from the seventh century states proudly, *mi*

squrias thina mlach mlakas, 'I [belong] to Squria, the beautiful *thina* (vase) of a beautiful (woman).' [53]

Another seventh-century vase found at Tragliatella, near Caere, was made by an Etruscan in imitation of a Corinthian vase. This vase, which has been much discussed, bears a figured decoration which has not yet been satisfactorily explained, including armed soldiers in hoplite formation, erotic scenes, and a labyrinth-like shape labelled with the word *truia*. Some have interpreted this as the name of the 'Trojan' game, the archaic predecessor of the Trojan games for youths which Augustus re-established at Rome. Or the labyrinth, along with the scenes of conversation and of sexual intercourse, could refer to the story of Theseus and Ariadne as models for the real-life characters whose names – *mi thesathei, mi velelia*, and *mi amnu arce* (or *mamarce*) – are recorded next to the figures of the woman, the little girl, and the man.[54]

Cerveteri, the most hellenized of the Etruscan cities, was the only one to have a treasury at Delphi; and Arimnestos, 'who ruled among the Etruscans', sent the gift of a throne to the sanctuary of Zeus at Olympia.[55] Its geographical position explains its extensive contacts with the Greeks. A Greek who signed himself Aristonothos painted a sea battle and the Homeric scene of the blinding of Polyphemus on a seventh-century vase found at Cerveteri.[56] Greek artists came to Caere in the mid-sixth century and established workshops, producing special types of vases such as the 'Caeretan' hydriae with their colourful, often humorous mythological scenes.[57] It is not surprising to note that names of vases were also adopted. We know, from inscriptions, several Etruscan names of vases borrowed from the Greek.[58]

Excavations at the port of Pyrgi revealed, in 1964, three gold tablets, inscribed in Etruscan and Phoenician. Attesting to contacts elsewhere in the Mediterranean, these tablets constitute one of the most spectacular finds in the history of Etruscan archaeology and are the closest thing so far to the long-sought Etruscan bilingual inscription (Part two, note 25).

In the chamber tombs, which copy the designs of the houses of the living, rooms open out onto an entrance courtyard or *atrium* – the word, and the idea, may have come to the Romans from Etruscan architects.[59] The decoration is sculpted, rather than painted as at Tarquinia. Beds, chairs, shields are all carved out of the rock. A late tomb, the famous Tomb of the Reliefs (Tomba dei Rilievi), reproduces in relief all the furnishings of a home – pots and pans and pets, and

perhaps even a 'book' of linen, shown with its envelope, carefully folded on a chest.[60] Inscriptions were painted on the walls, as at Tarquinia: from these we learn that the tomb belonged to the Matuna family. The inscriptions of the Tarchna family in another tomb may be of historical interest because of a possible relation with the Tarquins of Rome.[61]

The Caeretan style of writing, which has certain peculiarities, influenced the script adopted in the south, in Campania.[62] Cerveteri's relation to the cities of Latium was also close: the great seventh-century Barberini and Bernardini tombs of Praeneste best illustrate the influence of Cerveteri.[63] In the Bernardini tomb, objects are inscribed for a woman, Vetusia; it is still not clear whether her name is Etruscan or Latin.[64] Other cities in Latium also show in their art a close relationship with Cerveteri in the seventh century and later.[65]

Cerveteri's relationship with Rome, its neighbour, was one of close friendship. Some scholars have supposed that the Tarquins actually came from Cerveteri, rather than Tarquinia (see text above). Tarquinius Superbus and his sons, it is said, took refuge there after the dynasty was expelled from Rome at the end of the sixth century. In the fourth century Roman nobles still sent their sons to Caere to complete their studies, probably in technical subjects, the *Etrusca disciplina* of the Etruscan haruspices, that is the art of divination and communication with the divine will that was a prerequisite for a Roman general. Cerveteri then served as the great Greek centre of the area, the 'Athens of the West'.[66]

It was the first Etruscan city to obtain Roman citizenship, and eventually became Roman in language as in law, thus signifying the end of its independence. The monuments showing this transition from Etruscan to Latin are some three hundred grave markers or cippi.[67] These have texts sometimes in Etruscan, sometimes in Latin: there are even some bilingual inscriptions. As we would expect of epitaphs, all are quite brief. Because these cannot be attributed to individual tombs, from which they were often removed already in antiquity, they must be dated on epigraphic and linguistic grounds: the letter forms of the Latin cippi are those of the second or first centuries, and the phonological features of archaic Latin are almost entirely absent.[68]

Veii

The wealth and power of Veii, the third great city of the south, started later than that of its two neighbours on the coast, but its inhabitants

started to write as early as those of the other great Etruscan city-states. In the seventh century, Veii adopted the alphabet, which we have in its 'model' form on an object from nearby Formello (fig. 11d).[69] In the sixth century, Veii became a great city-state, the most powerful in Etruria and second only to Rome in non-Greek Italy. Dionysius of Halicarnassus compared it to Athens (II. 54). Five temples have so far been identified. One of these, of the mid-sixth century, is among the earliest in all Etruria. Another, outside the city, in the sanctuary of Portonaccio – whose remains are still impressive today – dates from the last quarter of the sixth century.[70] Votive inscriptions found there suggest that the temple was sacred to Minerva (Menrva).[71] Its roof was decorated, in true Etruscan – but completely un-Greek – fashion, with free-standing, life-size terracotta figures representing Apollo (*Aplu*) struggling with Herakles (*Hercle*) over the possession of a hind, Hermes (*Turms*), and a goddess holding a child, probably Latona holding the baby Apollo. It is tempting to attribute these statues to the workshop of Vulca of Veii, active at the end of the sixth century. Such representations of the gods in human form, which the Etruscans had adopted from the Greek world, they passed on to the Romans, to whom they had earlier taught the Greek art of writing.[72]

Veii's ties with Rome were as close as Cerveteri's, though of a different kind. Its artists' pre-eminence was recognized by the tradition that a terracotta sculptor from Veii, Vulca (one of few Etruscan artists whose names have come down to us) was called by Lucius Tarquinius Superbus (535–509) to decorate the great Etruscan-style temple of Jupiter Optimus Maximus on the Capitol in Rome.[73] But Veii's proximity to the Tiber involved it in rivalry with Rome. We have a more detailed account of this conflict, told by Livy, than of any other aspect of Etruscan history. A ten-year siege culminated in the sack of Veii in 396. The destruction of the city marked the effective end of Etruscan power, overwhelmed by Rome to the south and the Gauls pressing down from the north. The absence of burial inscriptions, tombs, or sarcophagi shows that after the Roman conquest Veii was rarely inhabited.[74] The sanctuaries, however, continued to function and even flourished, judging from recent and not-so-recent finds which are being published for the first time. Beautiful sculpture of the fifth and fourth centuries, showing classical Greek influence, demonstrate that the skills of the artists and craftsmen who worked in terracotta had not diminished.[75]

Later, from the fourth to the second centuries, hundreds of votive

figurines were dedicated in the important sanctuaries of Portonaccio and Campetti. One of these, representing Aeneas carrying his old father Anchises over his shoulders, shows the interest of the Etruscans – or of the Romans, at this point? – in the Trojan stories. There were also many statuettes of mothers and children, the *kourotrophos* type, rare in Greece. These, together with other *ex voto* offerings signifying fertility, show the importance of this image and of the cult of mother goddesses in Italy.[76]

Five altars of the third century carry dedications to Roman gods in Latin. Three others carry dedicatory inscriptions dating from the same century, which bear the name, in Latin or Faliscan: *L. Tolonio, ded Menerva* – perhaps a member of the family of the legendary king of Veii, Lars Tolumnius. Not surprisingly, considering its proximity to Rome, Veii seems to be the only city where the language shift from Etruscan to Latin took place before the end of the second century BC.

Vulci

Vulci, north of Tarquinia, twelve kilometres from the sea, was one of the first Etruscan sites to be discovered and excavated. The wealth it revealed had much to do with the popularity of the Etruscans in the nineteenth century, after the Prince of Canino, Lucien Bonaparte (Napoleon's brother), started 'mining' the cemeteries for gold jewellery, metalwork, and pottery; he excavated huge quantities of Greek vases which today fill the museums of the world. By 1842 the yield was said to equal that of Pompeii and Herculaneum; fifteen thousand tombs were opened by the middle of the century. Ironically, the sites are hardly published.[77]

Already in the eighth century the existence of relations with the Greek centres of Pithekoussai and Cumae is clear from the style of the vases excavated in its rich necropolises. In the seventh century the wealthy tomb of the Polledrara necropolis (whose furnishings are today in the British Museum) testifies to Oriental and Greek influence and contacts in Vulci, as well as to its craftsmen's original taste and expertise in working bronze.[78]

In this century and the next huge quantities of Greek pottery were imported. The finds from Vulci contribute the largest absolute number of Greek vases available to us today – many more than those from Greece itself.[79] Greek wares were also imitated. Vulci was a great artistic centre, whose artists mastered a variety of crafts, including vase painting, stone sculpture, and perhaps most famous of all, an important

bronze industry. Part of a decorated bronze tripod from Vulci was even found at Athens, on the Acropolis.[80]

Particularly interesting from our point of view is the Etruscan custom of incising inscriptions on the body of a statue – a custom which is found in Greece in the Archaic period, but which continues in Etruria, like many other Archaic features of art, social life, and politics, long after it was abandoned in the Greek centres. This custom was by no means limited to Vulci. The bronze Chimaera from Arezzo has on its leg the dedicatory inscription, *tinścvil* (Source 26, fig. 26). Many bronze statuettes bear letters, cast into the bronze or scratched into their carefully finished surfaces, recording the name of the person giving the gift, and the god to whom it has been dedicated. A number of these dedications include the word *fleres̀*, 'statue':[81] for example, a charming female statuette is thus dedicated to Eileithyia (*TLE* 734).[82] A bronze statuette of a haruspex in the Vatican says 'this was dedicated by Vel Sveitus' (Source 46, fig. 43). A double-headed figure from Cortona was dedicated to Selvans, or Silvanus (Source 48, fig. 45). Even the life-size statue of the Arringatore, dating well within the Roman period, whose dress proclaims him to be a magistrate wearing the symbols of authority, bears an inscription on the hem of his toga (Source 66, fig. 56). Votive and funerary inscriptions name the giver or receiver of these gifts, rarely that of the artist. Craftsmen also used letters to guide them in assembling statues or complicated vases. Other markings, 'graffiti' or rather 'sigla', are harder to interpret.[83]

Many objects for the tomb bear the inscription *śuthina* (MVΘINA in Etruscan script), that is, 'for the grave' (Source 38, fig. 35). Sometimes it is brutally engraved on an object in such a way as to render it unusable. This is a manner known also from other cultures of removing the object from the world of the living, dedicating it instead irrevocably for the use of the deceased. Mirrors, for example, sometimes have the inscription across the brightly polished reflecting disc.[84]

Many of these engraved bronze mirrors,[85] an Etruscan speciality, were made by the craftsmen of Vulci.[86] It is often not possible, however, to attribute these to specific cities because many have no record of their origin or tomb context. Yet these are the objects which more than any other give us information on Etruscan mythology and religion, as well as language, thanks to Eva Fiesel's and de Simone's studies on Etruscan phonology.[87]

From the fourth century dates one of the most important documents of early Etruscan history told from the Etruscan point of view. The

François Tomb (Source 54, fig. 50), a chamber tomb whose rooms were decorated with a carefully planned and executed series of paintings, has inscriptions recording the triumph and augural status of the tomb's owner, a member of the Saties family, as well as labelling characters from the legendary, local saga of the Vipina (Vibenna) brothers and Macstrna. The latter, identified by the Romans as the king of Rome, Servius Tullius, is shown freeing a prisoner identified as Caile Vipina; elsewhere *Cneve Tarchunies Rumach* (Gnaeus Tarquinius of Rome) is being murdered by an ally of Macstrna. The group is related in position, theme, and political implications to another fresco opposite it with the Homeric scene of Achilles' slaughter of the Trojan prisoners (*Truials*) before the shade of Patroklos. The figure of Vel Saties, the resident of the principal 'master bedroom' of the tomb, was also placed in relation with figures from Greek mythology. The whole decorative plan certainly made a specific statement, though this is not as clear to us today as it was to the designer of its iconography. The tomb in any case illustrates the anti-Roman feeling of the fourth century, during the course of the violent wars between Rome and Vulci.

In the fourth century an artist from Vulci painted the red-figure vase representing a lively dialogue between Admetos and his wife Alkestis, who agreed to die in his stead. These figures, like those in the François Tomb, have their names written in Etruscan; and they also bear witness – though in quite a different tone – to Etruscan familiarity with Greek myths (Source 24, fig. 25).

The Tomb of the Inscriptions (Tomba delle Iscrizioni), discovered in 1958, contains archaeological material from the fourth century BC down to the first century AD, and includes a number of inscriptions: seventeen in Etruscan and six in Latin. The language shift at Vulci seems to have occurred in the first half of the first century BC, in spite of the Latin milestone of the Via Aurelia (built in 241 BC), dating from 144 or 119 BC.[88]

Other southern cities

Other cities of southern Etruria are less important in the context of this book. Indeed the famous 'Tuscania dice', dating from the Hellenistic period, may not have come from Tuscania at all, but rather from Vulci.[89] Nevertheless it is true that at Tuscania, in the territory of Tarquinia, excavations of the last few years have brought many inscriptions to light. Archaeologically, Tuscania resembles Tarquinia: the same type of cippus was used in both cities. At Tuscania, too, the use

of chamber tombs continues uninterruptedly into the first century BC: the last of these tombs have Latin epitaphs.[90]

The alphabet incised on a delightful bucchero inkwell from the seventh century, now in The Metropolitan Museum of Art in New York (fig. 14), was apparently found in the region of the rock-cut tombs between Viterbo and Tarquinia.[91]

THE NORTHERN CITIES

The northern cities had access to the minerals so sought after by the Greeks. The exploitation of the metals of the area of Massa Marittima seems to have begun in the eighth century, when the Greek markets of Pithekoussai and Cumae in Campania were founded in order to acquire them. Not surprisingly, these northern cities were skilled at metal-working.

Vetulonia

The earliest productions of Vetulonia (*Vetluna* or *Vatluna*) were wonderful sculpted figures of humans and animals.[92] The goldwork from the seventh century on was also very fine.[93]

There are other local specialities: some of the earliest examples of monumental Etruscan statues, male and female, come from the Pietrera tomb.[94] An inscribed grave stele of the late seventh century represents the fully armed warrior, Avele Feluske, holding an axe as the symbol of his rank and power (Source 14, fig. 18).

A study of Vetulonia's commerce from the eighth to the sixth century shows that its contacts were rich and varied.[95] It traded with the north, with Chiusi and beyond (the area that provided the huge quantities of Baltic amber that figured in the tombs of rich ladies), with Sardinia, with the Greek cities, and perhaps with Rome, which evidently derived the fasces from this northern city.[96] The bronze coins of Vetulonia, first issued in the third century, bear letters identifying the city, and are decorated with anchors and dolphins – symbols which seem to indicate the importance of its overseas contacts. Archaeological evidence seems to show, however, that the city suffered a rapid decline from the sixth century.[97]

Within the territory of Vetulonia lies Marsiliana d'Albegna, from which comes an inscription with one of the best-preserved alphabets, on a miniature 'wax tablet' found together with other writing implements, styluses and ivory erasers (fig. 12).[98]

Populonia

Some forty kilometres up the coast from Vetulonia lies the dramatic site of Populonia: Etruscan *Pupluna* or *Fufluna*, 'the city of Bacchus', as we learn from a number of inscriptions, including the legends on its coins.[99] Indeed, Populonia may have been one of the first Etruscan cities to issue coinage, in the fifth century. The Etruscans did without coinage far longer than the Greek cities. Many of their issues have the peculiarly Etruscan feature of an archaistic design (though some scholars still argue that these coins actually date from the Archaic period). The local coin designs include frontal Gorgon heads and designs reminiscent of Populonia's interest in metallurgy as well as youthful heads of torque-wearing Gauls.[100]

Volterra

Early material from the area of Volterra (Latin *Volaterrae*, Etruscan *Velathri*) includes the terracotta urn from Montescudaio, of the seventh century, with one of the earliest representations of the theme of the banquet. Volterra was also from early times a bronze-working centre. Later finds include the grave steles of the warriors Avile Tite (Source 15, fig. 19) and Larth Tharnie (Source 16, fig. 20). Though not too different in type from the seventh-century gravestone of Avele Feluske from Vetulonia (Source 14, fig. 18), it dates from around 530.[101]

Two exceptional works carved in marble – a material which was not favoured by Etruscan artists – show what the sculptors of Volterra were capable of creating. The life-size 'testa Lorenzini', probably dating from 490 or 480, belonged to the figure of a divinity, a cult statue. The 'kourotrophos Maffei' is the statue of a woman who, as Ranuccio Bianchi Bandinelli wittily remarked, lost her head and finds herself with a baby in her arms. It is also life-size, and could be thought to be a cult statue of a mother goddess except for the long votive inscription incised on her right arm (Source 51, fig. 47). The head, which had long been missing, was found in 1966. The Greek model from which the Maffei figure derives dates from the fourth century, and was much used for statues of Muses and funerary statues. It is interesting to note that the baby was a local addition, attesting to the Etruscan popularity of the image of the mother and child. Both statues are presently exhibited in Volterra's Museo Etrusco Guarnacci, founded in 1732 and containing one of the most important collections of Etruscan antiquities.

Likewise from Volterra comes one of the best-known examples of

the motif of mother and child, the engraved bronze mirror with Uni (Hera, Juno) who nurses at her breast an adult, bearded Hercle, in a ritual adoption scene solemnly witnessed by various Olympian divinities, while an inscribed tablet describes the significance of the scene (Source 36, fig. 33). Both the mirror and the statue of the Maffei kourotrophos date from around 300.

In the later period Volterra's craftsmen continued to specialize in sculpture, in particular the burial urns made to contain the ashes of the dead: cremation persisted in the northern cities. Many of these were inscribed, for example those of the Caecina (*Ceicna*) family, or clan, the leading family during much of Volterra's history. Dating from the Hellenistic period, the urns constitute the single most important source for a study of the Romanization of the city. They have today been much studied from a variety of points of view: the typology of the 'portrait' figures reclining on the lids, the iconography of the mythological scenes carved on the front of the urn, and the organization of the workshops which produced them. Contemporary Hellenistic bronze figures are the highly stylized 'Giacometti' statuettes, of which the largest and best known is the 'Ombra della Sera', or 'Shadow of the Night', representing the fantastically elongated image of a young boy. Also represented are armed warriors (Mars?), Minerva in armour, haruspices or priests, and draped women.[102]

Fiesole

This city (Latin *Faesulae*, Etruscan *Vipsul*) stands today as the northern hilltop extension of Florence, the Roman city founded, as became customary, in the valley. Etruscan *Faesulae* was the northernmost settlement of Etruria, situated on a major route from the Arno north across a main Apennine pass.[103] It became a real city only in the sixth or fifth century. Most characteristic are the horseshoe-shaped gravestones with carved relief figures of the deceased and inscriptions listing their titles. These are related to the earlier Volterra steles, and to the later steles of Bologna (*Felsina*), which were influenced by the Fiesole steles. Best known is the monument of Larth Ninie (Source 17, fig. 21) with spear and double-headed axe, similar to the Volterra steles of Avile Tite (Source 15, fig. 19) and Larth Tharnie (Source 16, fig. 20). Several inscriptions from this site refer to boundaries (*tular spural*).

Arezzo

This city, along with Fiesole, Perugia, Orvieto, and Cortona, was said to have been founded by the inhabitants of Chiusi (Latin *Clusium*).

Arezzo (Latin *Arretium*) some fifty kilometres from Chiusi, stood on a plateau, between the northern extremity of the Chiana valley and the southbound curve of the Arno; unlike other Etruscan cities, it was situated on a gentle slope rather than a steep cliff. Strabo (5.2.9.226) described it as the farthest inland of all the towns of Etruria. Arezzo specialized in bronzework from early times. Its craftsmen made delightful small figures used as votive gifts for the gods. Around 400 an artist created the famous Chimaera, the wounded monster, part lion, part snake, and part goat, with its dedicatory inscription to Tinia (Jupiter). It was originally part of a group showing the hero Bellerophon riding the winged horse Pegasus and destroying the three-headed monster (Source 26, fig. 26).[104]

The Etruscans, who were experienced in bronze-working, were also skilled in terracotta, which they often used as a less expensive material to reproduce bronze objects. Around the middle of the first century Arezzo began to become famous for its bright red, shiny ceramic ware with relief decoration, with which it continued in its ancient tradition as a metal-working city.[105] It was in fact probably the reputation of the northern cities, and of Arezzo in particular, for their metal exports that accounted for the use of the German word *Erz* to signify 'bronze'. The Germans derived the word from *Arretium*, the Latin name of the city, which had come to be closely connected with metal; just as *Byblos* was connected with papyrus books, *majolica* was derived from *Maiorca*, and the word for *copper* in various languages – German *Kupfer*, French *cuivre* – was derived from *Cyprus*, the 'copper island'.[106]

Livy's list (28.45) of the Etruscan cities' contributions to Scipio Africanus' campaign against Hannibal in 205 shows that Arezzo sent huge quantities of arms and tools – three thousand shields, three thousand helmets, fifty thousand each of 'Latin' and 'Gallic' javelins, spears, scythes, and all sorts of tools – enough to outfit forty ships. In the third century, therefore, and surely long before as well, Arezzo was an industrial centre, well known for its metal production.

The fourth century was a difficult time for most of the cities of Italy, and Arezzo was no exception. There was a rebellion, perhaps a slave uprising. At the end of the century a Roman commander came to protect the wealthy, powerful, originally royal family of the Cilnii,

ancestors of Maecenas, adviser and friend of Augustus. In the third century Arezzo passed peacefully into Rome's orbit.[107]

A 'peaceful process of Romanization' seems to be reflected in later inscriptions. There are three Etrusco-Latin bilinguals: one of these can be dated to 40 BC on the basis of the grave contents; the other two seem to be later. Arretine pottery, too, specifically the terra sigillata with its stamped decoration, provides epigraphic evidence for the end of Etruscan: stamps were inscribed with letters, monograms, names, or abbreviations, all in Latin. Many of the names are recognizable as Etruscan.[108]

Cortona

Cortona lies close to Lake Trasimeno, near the border of the modern regions of Tuscany and Umbria. The city rose on a high cliff, surrounded by powerful walls whose remains are still visible. In the Orientalizing and Archaic periods three tumulus burials, the so-called 'melons' (local word for tumulus) of the Camucia and the Sodo attest to the presence of aristocratic families of *principes*. These tombs continued to be used in later times, as shown by the grave goods they contained. The names of two later owners, Arnt Mefanates and Velia Hapisnei, appear in an inscription of the fourth century (*TLE* 630: *tuśthi thui hupninethi arnt mefanateś veliak hapisnei*). The Etruscan name of Cortona appears in another inscription, on the base of a bronze statuette: *mi unial curtun*, 'I am of [belong to; or for] Uni [of] Cortona' (*TLE* 644: the object speaks in the first person).[109]

The necropolis of Cortona, of the Hellenistic period, includes an interesting monument, the 'tanella di Pitagora' ('little lair of Pythagoras') once connected with the name of Pythagoras because of a learned confusion between the names of Cortona and Crotone, the home of Pythagoras.[110]

An inscription on a Janus-headed bronze statuette from Cortona dedicates it to the Etruscan god Selvans (Source 48, fig. 45). Like other northern cities, Cortona was a centre of bronze-working, as shown by the famous decorated bronze lamp of the late fifth century, with an inscription (perhaps a later addition) dedicating it to Tin or Tinia: *tinścvil*, 'gift for Tin'. It is exhibited in the recently restored museum of the Accademia Etrusca of Cortona, in the medieval Palazzo Pretorio. The Accademia is a venerable institution devoted to the study of Etruscan antiquities and inscriptions, continuously active since its foundation in 1727.[111] The bronze statue of Avle Meteli, the 'Arringatore', now in the Archaeological Museum in Florence (Source 66, fig. 56), is

usually held to have been discovered at Sanguineto, on the shores of Lake Trasimeno, south of Cortona, though there is some evidence that its provenance was a place near Perugia (*TLE* 651).[112]

The bronze Tabula Cortonensis, which came to light in Cortona in 1992 (but whose discovery was only made public in 1999), now takes its place as the third longest Etruscan inscription (two hundred words, twenty-seven of them not previously attested). Unlike the two longest, the mummy wrappings in the Zagreb Museum, and the Capua Tile in the Berlin Museum, the bronze tablet from Cortona is in an Italian museum, in Florence. It has not been possible so far to identify the exact place where it was found (Source 65, fig. 55).[113]

Perugia and Todi

These two Umbrian cities became Etruscan and helped spread Etruscan culture into Umbria. The Etruscan alphabet was transmitted from Perugia (Latin *Perusia*) in the fourth century, and used to write inscriptions preserving the local Umbrian language, closely related to Latin.[114] Both Todi (*Tuder*) and Perugia were also important for their bronze work; Perugia produced remarkable examples of bronze plates with *repoussé* decoration in the sixth century, as well as small bronze figures, starting from around 300. Both Perugia and Todi produced beautiful examples of bronze mirrors around 300. The remarkable, large-scale statue of the so-called Mars from Todi in the Vatican's Museo Gregoriano, of the early fourth century, bears a dedicatory inscription in the Umbrian language (*Ahal Trutitis dunum dede*, 'Ahal Truttidius gave [this as a] gift'), though its style is clearly Etruscan, and its dedicator's name is Celtic.[115]

A famous epigraphic monument, the cippus from Perugia, probably a boundary stone, has a long Etruscan inscription running along both faces of the block, recording an agreement concerning two families, the Velthina and Afuna, in relation to certain lands and tombs. It dates from the second century (Source 63, fig. 53).

Perugia offers rich tomb material of the late period, allowing its progressive Romanization to be observed more precisely than at other cities. Almost all the texts useful for such a study come from cinerary urns similar to those of Volterra and Chiusi. From Perugia come great family tombs, such as those of the *gens Raufe* or *Rufe* (*Raufia*) (*CIE* 3463–3506), found intact in 1887, with six of the thirty-nine inscriptions in Latin; one of these (*CIE* 3500) is bilingual. The tomb seems to have been in use from the third to the first century BC.[116]

The tomb of the Volumnii (*CIE* 3754–3767) includes one bilingual inscription on the marble urn of P. Volumnius Violens, of the end of the first century BC.[117] It is exceptional in combining the Latin first name or praenomen, *Publius*, with the Latinized cognomen, *Violens*, to identify an Etruscan. The tomb of the *gens Praesentia* records a person named *Presnte* and his mother in Etruscan, his wife and a third female in Latin. In the tomb of the *Pumpu Plute* family (*CIE* 3617–3631), Etruscan inscriptions coexist with Latin inscriptions. The Perusine War of 40 BC was a disaster for the city; it brought the end of the Etruscan tradition.

Volsinii

This may have been the site of the Fanum Voltumnae, the greatest Etruscan sanctuary and religious centre, whose exact location we do not know. (We do not hear of its existence, in fact, before the fifth century BC)[118] The site of Etruscan Volsinii (*Velsna*) is likewise unknown. Roman Volsinii was at Bolsena, and the French, who excavated a flourishing Etruscan city there, used to claim it as the site of the ancient Volsinii mentioned by our sources.[119] Most scholars today believe that Volsinii is to be identified with the important Etruscan site of Orvieto, whose Latin name (*Urbs Vetus*) indicated its antiquity.[120] The territory of Volsinii included not only Orvieto and Bolsena, but took in Viterbo, at the edge of the area of Tarquinia, Bomarzo (*Polimartium*), Orte, Acquarossa, Ferentum, and others.[121] Lars Porsenna was also called king of Volsinii, perhaps because, as king of Chiusi, he also ruled at Volsinii. The city was a great artistic centre: when Volsinii was destroyed by the Romans in 265, as many as two thousand statues were taken to Rome.[122]

In Roman Volsinii, cemeteries of the third, second and first centuries consisted of chamber tombs with mushroom-shaped grave cippi bearing the names of the deceased. Vases in the form of *askoi* have stamped on them the signature of one of the leading families of Volsinii, *Ruvfies*, Latin *Rufii*.[123]

Orvieto

Southwest of Perugia on a height overlooking the Chiana and Paglia Rivers, Orvieto (*Urbs Vetus*, 'Old City') is one of the most important centres from the point of view of epigraphy. The Chiana Valley provided a direct link with Chiusi. Orvieto's heavy bucchero (*bucchero pesante*) pottery is close to that of Chiusi, and the two cities use the

same distinctive version of the Etruscan alphabet.[124] New excavations at the Crocifisso del Tufo cemetery promise to yield important material. The necropolis is one of the most beautiful in Etruria, giving the impression of an ancient Etruscan city with regular streets and neat doorways over which are written the names of the inhabitants. In fact, the regularity and orderly consistency of these inscriptions, which appeared on each and every tomb, testify to an efficient civic organiz-ation, which passed and enforced zoning regulations on land property. Nothing like this situation in Archaic Orvieto is so far known elsewhere in Etruria. From the sanctuary of Cannicella came the startling find: a naked cult statue of a goddess, dating from *c.*500 made of Greek marble. It had evidently been commissioned to Etruscan specifications from a Greek artist used to carving male *kouroi*: its nudity, unique for a female figure in the Greek art of this period – and emphasized by the explicit rendering of the female sexual organ – was evidently called for by Etruscan religion.[125]

Chiusi

Chiusi (*Clusium* in Latin, *Clevsin* in Etruscan, *Camars* in Umbrian), dominating vast and fertile valleys, depended for its wealth on agricul-ture. Its vast territory included many smaller centres which shared in its culture. Rich necropolises have yielded material from all periods, testifying to its stable prosperity. Much of this material was unfortu-nately dispersed and is therefore hard to date.[126] Recent study has shown that Chiusi, far from being isolated, maintained important contacts with other Etruscan cities and with the world to the north, to which it brought such signs of civilization as writing and wine-drinking, and with Rome to the south.[127] More than three thousand inscriptions come from the territory, very few of them the result of scientific excavation.[128]

The wealth of the city-state can be seen from the quantity and quality of its imports in the Orientalizing period, when gold, ivory, and Phoeni-cian bowls were brought in from the coastal cities. A Phoenician bowl of the mid-seventh century bears the earliest Etruscan inscription from Chiusi, the name of its owner, *Plikaśna*.[129] Not long after, Chiusi was the chief centre from which the Etruscan alphabet, and the use of writing in general, spread northward to Bologna, Spina, the Veneto, and the north-east Alpine regions (map 3).[130] The northern type of alphabet in use in Chiusi became the foundation of the Venetic and Rhaetian alphabets, and eventually of the later Germanic runes (see below).

The importance and originality of Chiusi and of its art continued in

the Archaic period, when funerary statues, and stone cippi with relief decorations (related in style and subject matter to the paintings of Tarquinia), were made to decorate the graves. The sixth and fifth centuries saw a massive importation of Attic black-figure and red-figure vases. The most elaborately decorated Attic black-figure vase of the earlier sixth century, the François Vase, with its two hundred or so mythological figures and careful labels in Greek, was found near Chiusi. Recently restored and exhibited in the Florence Archaeological Museum, it may have arrived by way of Vulci.[131]

The territory of Clusium extended northward and apparently included Murlo (Poggio Civitate),[132] whose ancient name is unknown. Murlo has been excavated by American teams and, along with other sites in the region, and Acquarossa, provides us with a precious example of non-funerary art and architecture,[133] on the opposite edge of Chiusi's territory. The discovery of tiles with letters of the alphabet incised on them in the great building complex at Murlo provided Cristofani with an opportunity to carry out a study of the alphabet of Chiusi and its diffusion in centres directly influenced by the city's culture in the sixth century.[134]

A tradition of close relations between Rome and Chiusi existed, evidently facilitated by excellent river and road communications. Lars Porsenna of Chiusi, who according to tradition besieged Rome after the fall of the Tarquin dynasty, is described in Roman sources as king of Etruria – an impossible title, but indicative of the importance of his city. Porsenna stands at the centre of a cluster of heroic Roman tales of glorifying saviours of the city.[135] One in particular concerns Mucius Scaevola, who, mistaking the scribe who sat by the Etruscan king for his intended victim, failed in his assassination attempt and proudly burnt his hand on the fire.

The description of the scribe holding the tablets has been shown by Giovanni Colonna to fit into a peculiarly Etruscan artistic motif represented on relief cippi from Chiusi of the Archaic period and on later monuments, all of which show mortal or divine figures holding scrolls or tablets. This motif of the book (cf. figs 41 and 42), which celebrates the importance of writing in Etruscan culture, is still present in the Hellenistic period, when male portraits of the deceased reclining on their sarcophagi have as normal attributes linen 'books', scrolls, or wax tablets (see section on 'The Written Word'). Women instead hold fans or mirrors as symbols of a wealthy lifestyle, and in the case of the mirrors, as symbols also of the death which has overtaken them.[136]

In the Hellenistic period, the craftsmen of Chiusi turned to sculpted urns like those of Perugia and Volterra. On these, too, the inscriptions often survived. Easily recognizable by their style, these stone and alabaster (or, more often, terracotta) urns had as favourite themes for their relief scenes the duel between Eteokles and Polyneikes, and a battle scene in which a god or hero wields a huge plough – some have identified him as Echetlos, a hero who rose from the soil to fight at Marathon.[137] Other strange scenes and details show the continuing originality of Clusine artists and patrons.

It has been shown that the language shift from Etruscan to Latin took longer at Chiusi than elsewhere: many examples show that the progress of Latinization covered two or three generations. There are even married couples, and brothers, one of whom has an epitaph in Latin, another in Etruscan. Chiusi and Perugia together account for some ninety per cent of the inscriptions written in Latin characters which show Etruscan features.[138] In the linguistic area, as in its art, Chiusi shows itself to be conservative, keeping alive older features along with the new.

ROME AND THE AFTERMATH

We have often mentioned Rome. Roman historians have recorded the names of Etruscans in their accounts: Vulca, Porsenna, the Tarquin dynasty with Tarquinius Priscus and Tarquinius Superbus, Tanaquil, Mastarna, the Vibenna brothers, Mezentius. Some of these are known from inscriptions. The historical painting in the François Tomb from Vulci shows Mastarna, the Vibennas, and Tarquin of Rome. A bucchero vase from Veii is dedicated by Avile Vipiienna (*TLE* 35), and a bronze mirror in the British Museum shows the two brothers Caile and Avle Vipina (*ES* V.127). The name of Mezentius, the *contemptor deum* who appears in Vergil's *Aeneid* and in Livy's history, king of Caere and all the Etruscans, appears on an impasto vase made in the first half of the seventh century, probably in a workshop in Cerveteri. Such epigraphic evidence has caused modern historians to put more faith in the traditional accounts, and has resulted in a closer collaboration between historians and archaeologists. The history of archaic Rome and of the cities of Etruria shows them to have been closely connected in the world of the seventh and sixth centuries, when Etruscan cities were at their height.[139]

The Etruscan monarchy at Rome, whose historical reality was often doubted earlier in the century, is now generally accepted as a phase in the city's urban, religious, architectural, artistic, and cultural development, so that archaeological evidence and traditional accounts of the late seventh and early sixth century seem to agree, as long as they are continuously reinterpreted in the light of the evidence.

According to Livy (1.34), Tanaquil not only read the omens of Tarquin's coming kingship in the sky, but was also later able to interpret the omens concerning Servius Tullius' reign when he was still a child. The Etruscans were recognized experts in these matters. The interpretation of thunder and lightning, the reading of the gods' will from the livers of sacrificed animals and from other signs sent by the gods to men constituted the *Etrusca disciplina* so much respected by the Romans. This material was studied and translated at Rome, much of it for the benefit of Roman consuls and generals who needed to have these skills in order to carry out their duties. Many prophecies, portents, and answers of Etruscan haruspices known to us from Roman literature date from the great crisis of the Civil Wars of the first century BC. They show how much the Romans cared about religion, and valued the specialized Etruscan techniques which could help them keep the *pax deorum*.[140]

Among Etruscan inscriptions are the earliest writings from Rome. The Romans spoke Latin, but they did not write it readily in the early period. Of course much of their early writing is lost to us, for example the linen books (Livy 4.7.12, 20, 8, etc.), which must have looked much like the Etruscan linen book eventually cut up and reused for a mummy (Source 67). Etruscans residing in Rome wrote more. A bucchero patera found in Rome bears the inscription, *mi araziia laraniia*, 'I belong to Araz Larani' (*TLE* 24). Another Etruscan inscription was found in a deposit of votive material from the excavation at the archaic temple of Sant'Omobono, dated to 580–560. Incised behind an ivory lion carved in relief are the words, *araz silqetenas spurianas* (*ET* La 2.3) The name of *araz* appears in another inscription from Rome, while the other two names appear on the Tomb of the Bulls in Tarquinia. We therefore have the name of a noble from Tarquinia, a resident of Rome at the moment of the traditional installation of the Etruscan dynasty in Rome. He could have been one of the Etruscan aristocrats who commissioned the construction and decoration of the temple of Jupiter on the Capitoline Hill, who brought gifts to the sanctuaries and who, along with their followers, after whom the Vicus Tuscus may have gained

its name, beautified the city where they celebrated the triumphs of their wars.[141]

The names of the three ancient tribes – the Tities, Ramnes, and Luceres – are Etruscan names. Varro (*Lingua Latina* 5.55), says: *omnia haec uocabula tusca, ut Volnius, qui tragoedias tuscas scripsit, dicebat*, all these words are Etruscan, as Volnius, who wrote Etruscan tragedies, said'. Even Remus, the ill-fated brother of Romulus, had an Etruscan name, from which the name of Rome may have been derived.[142] In the streets of the great Rome of the Tarquins walked some of its most sophisticated and elegant inhabitants, speaking the Etruscan language. To a Greek traveller, Rome must have seemed like an Etruscan city in many ways.

Etruscan influence can be seen to the south, in Rome and Campania, as well as to the north, in the Po Valley and among the 'situla people' of the eastern Alpine regions. To the latter the Etruscans brought, transformed, and made readily available the culture of cities and the signs of this 'civilization' they had learned from their neighbours, the Greeks: the alphabet, the representation of the monumental large-scale human figure, mythological gods and heroes, the Homeric poems, the symposium with its related tableware. We can now begin to distinguish the part played by certain cities in this 'civilizing' of Italy and Europe, for example Cerveteri and Tarquinia for Rome and the south, Chiusi for the north.

As we have seen, the Etruscan cities varied widely in their history and their art. Yet the use of the alphabet begins at about the same time, early in the seventh century, both in the important cities of Cerveteri, Veii and their necropoleis in the south, and in the great northern centre of Chiusi. The end of the Etruscan language in the two areas is also more or less contemporary, according to the research of Kaimio: 'The use of Latin epitaphs begins in the southern Etruscan cities probably at the end of the second century BC, in north Etruria somewhat later. At this stage, many of the cities had acquired Roman citizenship.' [143] The corpus of sacred Etruscan books, the *Etrusca disciplina*, was translated or summarized in Latin. There has come down to us, for example, a fragment from the *libri Vegoici* which was included in the *Gromatici*: the nymph Vegoia's teachings on the division of the fields clearly belongs in the context of the Social War and the late Republic in Rome.[144]

Certain Etruscan traditions were preserved by the Romans, for different reasons; they are not always trustworthy (see Chaper II on the

glosses). The haruspex Spurinna – a well-attested Etruscan name – became famous for having warned Julius Caesar about the danger of the Ides of March on the basis of his reading of the entrails of a sacrificed animal: he is mentioned in Cicero, Valerius Maximus, Pliny's *Natural History*, Suetonius, Plutarch, Appian, and Dio Cassius. Shakespeare's *Julius Caesar* frequently refers to him, though not by name.[145]

Maecenas, Augustus' friend and advisor,[146] was descended from a noble Etruscan family. The scholarly emperor Claudius studied with Livy, whose early books preserve information on the Etruscans. Claudius wrote in Greek a history of the Etruscans, *Tyrrhenika*, in twenty volumes: they would have been a precious resource for us, and in fact his reference to Mastarna and to Etruscans who became Roman citizens is preserved in one of his speeches. He had been inspired by Livy early on; his historical interests included the development of the alphabet, and he even invented some new letters. He asked the Senate to help preserve the discipline of haruspicina, and praised the *primores Etruriae* for having maintained and taught this knowledge (Tacitus, *Annales* 11.14–15). Claudius' first wife, Urgulania, was Etruscan,[147] and seems to have passed on some knowledge of tradition to him. But by the time of Claudius the Etruscans had disappeared along with their language: those who had survived the Civil Wars had become Roman. By the later empire, Etruscan was a dead language. Aulus Gellius (*Noctes Atticae* II.7.3f.) tells of a lawyer who used such archaic Latin words that his hearers laughed, as if they had been hearing Etruscan or Gallic. Evidently the story represents the Roman equivalent of our expression, 'it's Greek to me'.

NOTES TO PART ONE

(Short titles refer to books listed in the Bibliography)

1. M. Pallottino, *The Etruscans* (1978) 42–57. For an excellent account of these questions to 1979, with bibliography, see D. and F. R. S. Ridgway, *IBR*.
2. D. Ridgway, 'Italy from the Bronze Age to the Iron Age', and 'The Etruscans', in *Cambridge Ancient History* 2nd edn, IV (1988) 623–675, 863–875.
3. C. Colonna, 'Il sistema alfabetico', in *L'etrusco arcaico* (Florence, 1976) 9. D. Ridgway, *The First Western Greeks* (Cambridge, 1992) 55–57, 139–142.
4. Pallottino, *Etruscans*, 80.
5. For the history of the discussion, see L. Aigner Foresti, *L'origine degli Etruschi* (Vienna, 1974). D. Musti, *QuadUrb* 10 (Rome, 1970). Pallottino, *Etruscans*, ch. 2. See also E. J. Bickerman, 'Origines Gentium', *CP* 47 (1952) 65–81. M. Torelli, 'History', in L. Bonfante, *Etruscan Life and Afterlife* (Detroit, 1986) 47–65; and in *Rasenna* (1986) 15–76.
6. M Grant, *The Etruscans* (New York, 1980), 235. G. Bartoloni, *La cultura villanoviana. All'inizio della storia etrusca.* (Rome, 1989) 89–104. M. A. Fugazzoli Delpino, *La cultura villanoviana*, Museo di Villa Giulia (Rome, 1984).
7. There has been much discussion about the route, the manner, the chronology, and the reasons for the development of the Greek alphabet. The problems are set forth clearly in R. Wachter, 'Zur Vorgeschichte des griechischen Alphabets', *Kadmos* 28 (1989) 19–78. W. Burkert, *The Orientalizing Revolution* (Cambridge and London, 1992) 25–33. B. Powell, *Homer and the Origin of the Greek Alphabet* (Cambridge, 1991). R. D. Woodard, *Greek Writing from Knossos to Homer* (New York and Oxford, 1997), believes in a transmission by way of Cyprus. In fact such a route could explain why the Greeks changed the direction of their writing from left to right, while the Etruscans – with some variations – continued the retrograde direction of Semitic writing. (Cf. Burkert, p. 27). For the Etruscan alphabet see Pandolfini and Prosdocimi. H. Rix, 'La scrittura e la lingua', in M. Christofani (ed.), *Gli Etruschi. Una nuova immagine* (Florence, 1984) 210–239.
8. G. Buchner, C. F. Russo, 'La coppa di Nestore e un'iscrizione metrica da Pitecusa dell'VIII secolo a.C.', *RendLinc* 10 (1955) 215–234. M. Guarducci, 'Nuove osservazioni sull'epigrafe della "coppa di Nestore"', *RendLinc* 16 (1961) 3–7. E. Peruzzi, *Origini di Roma* II (Bologna, 1973) 24–26. C. A. Faraone, 'Taking the "Nestor Cup" seriously: erotic magic and conditional curses in the earliest inscribed

hexameters', *Classical Antiquity* 15 (1996) 77–112. The earliest Greek inscription, which comes from Osteria dell'Osa, a few miles from Etruria, consists of five letters on the cremation vessel of a (possibly) female burial of *c.*775. These letters have been read as EULIN and interpreted as an abbreviation of εὔλινος, 'spinning well', an epithet found in Pausanias 8.21.3: Hodos *infra*, n. 83, and David Ridgway, *Classical Association News* 23 (2000) 4, citing La Regina and Ampolo. G. Bagnasco Gianni places it in the context of the role of women and the metaphor of weaving in the adoption of writing in Etruria (*Scritture mediterranee tra il IX e il VII secolo a.C.* (Milan, 1999) 85–106). Others read it as EUOIN, a Dionysiac cry (E. Peruzzi, *Civiltà greca nel Lazio preromano* (Florence, 1997); T. P. Wiseman, *Classical Association News* 21 (2000)). For a discussion of the context by the excavator, see A. M. Bietti Sestieri, *La necropoli laziale di Osteria dell'Osa* (Rome, 1992); and in D. Ridgway, F. R. S. Ridgway, M. Pearce, E. Herring, R. Whitehouse, and J. B. Wilkins (eds), *Ancient Italy in its Mediterranean Setting. Studies in Honour of Ellen Macnamara* (London, 2000) 13–31, esp. 27–29. F. Cordano, in *Alfabeti Preistoria e storia del linguaggio scritto*, ed. M. Negri (Demetra, Colognola ai Colli, Verona, 2000) 134, fig. 8.

9. Pallottino, *Etruscans* 238.
10. A. Momigliano, *JRS* 53 (1963) 98.
11. T. J. Cornell, 'Etruscan historiography', *AnnPisa* 6 (1976) 411–439. On the glosses and their relation with the *Etrusca disciplina*, see M. Torelli in *L'Italie préromaine et la Rome républicaine. Mélanges offerts à J. Heurgon* (Rome, 1976) 1001–1008. G. Bonfante, 'Problemi delle glosse etrusche', *Atti del X Convegno di Studi Etruschi e Italici. Grosseto 1975* (Florence, 1977) 84. L. Bonfante, *Etruscan Dress* (Baltimore and London, 1975), 103–104, 153–154.
12. J. Heurgon, *La Vie quotidienne des Étrusques* (Paris, 1961) 264–269, 298–304. J. C. Szilágyi, '*Impletae modis saturae*', *Prospettiva* 24 (1981) 2–23. Volnius wrote tragedies in Etruscan, evidently at the time of Plautus and Terence, in the third or second century (Varro, *Lingua Latina* 5.55). Pallottino, *Etruscans*, 155.
13. G. Camporeale, G. Colonna, M. Torelli, F. Roncalli, M. Cristofani, C. de Simone, P. E. Arias, W. V. Harris, in *Volsinii e la dodecapoli etrusca. AnnFaina* 2 (1985). F. Roncalli (ed.), *Antichità dall'Umbria a New York*. Catalogue of the Exhibit (Perugia, 1991), and others of the series (e.g. Vatican, 1986. Leningrad, 1990). *Volsinii e la dodecapoli etrusca.* Convegno Internazionale di Studi sulla Storia e l'Archeologia del Territorio Orvietano, Orvieto 1983. *AnnFaina* 2 (1985). D. Briquel, 'I passi liviani sulle riunioni della lega etrusca', in *Federazioni e Federalismo nell'Europa antica*, ed. L. Aigner Foresti (Milan, 1994) 351–372; L. Aigner Foresti, '*La lega etrusca*', 327–350; and *La lega etrusca dalla Dodecapoli ai 'Quindici Popoli'*, Giornata di Studio, Chiusi, October 1999.
14. The name of the Etruscans: S. Ferri, *Studi Calderini e Paribeni* (Milan, 1956) 111–115; G. Devoto, *StEtr* 28 (1960) 276; J. Heurgon, *MEFRA* 83(1971) 9–28; but see C. de Simone, *StEtr* 40 (1970) 153–181, L. Aigner Foresti, 'Tyrrhenoi und Etrusci', *Grazer Beiträge* 6 (1977) 1–25. G. B. Pellegrini, 'Metodologia nell'esplorazione della toponomastica etrusca', *Atti del II Congresso Internazionale Etrusco, Firenze 1985. Supplemento di Studi Étruschi* (Rome, 1989) vol. 3, 1591. *Vicus Tuscus*: Ogilvie, *Commentary on Livy I–V (Oxford, 1965)*, *s.v.*; Pallottino, *Etruscans* 109. F. Zevi, in M. Cristofani, *La Grande Roma dei Tarquinii* (Rome, 1990)

52. The Adriatic was named after the settlement of Adria, or Atria, on the eastern coast, inhabited by Etruscans and Greeks.

15. M. Pallottino, *Tarquinia, Monumenti antichi dell'Accademia nazionale dei lincei* 36 (1937). Boitani, *Etruscan Cities* 181–213. H. Hencken, *Tarquinia. Villanovans and Early Etruscans* (Cambridge, Mass., 1968). M. Cataldi, *Tarquinia* (Rome, 1990). M. Bonghi Iovini, C. Chiaramonte Treré (eds), *Gli Etruschi di Tarquinia*, Catalogue (Modena, 1986). C. Chiaramonte Treré, *Preistoria e Protostoria in Etruria* (Milan, 1995) 241–248. M. Bonghi Iovini, C. Chiaramonte Treré, *Tarquinia. Testimonianze archeologiche e ricostruzione storica* (Rome, 1997).

16. M. Torelli, *ParPass* 32 (1977) 398–458; idem, *ParPass* 37 (1982) 304–325; idem, 'Les Adonies de Gravisca: archéologie d'une fête', in F. Gaultier and D. Briquel, *Les Etrusques, les plus religieux des hommes* (Paris, 1997) 233–291. J. MacIntosh Turfa, 'International contacts', in L. Bonfante, *Etruscan Life*, 70–72.

17. Pallottino, *Etruscans*, 111–112. Several authors, *Pyrgi. Il santuario etrusco e l'antiquarium* (Rome, 1990); and 'Pyrgi. Scavi nel santuario etrusco, 1959–1967', *Notizie degli Scavi di Antichità* 24 (1970) Suppl. 2. G. Colonna, 'Novità sui culti di Pyrgi. Ancora sul nome etrusco di Apollo', *Rendiconti della Pontificia Accademia Romana di Archeologia* 57 (1984–85) 57–88. F. R. Serra Ridgway, 'Etruscans, Greeks, Carthaginians: The Sanctuary at Pyrgi' in J. -P. Descoeudres (ed.), *Greek Colonists and Native Populations* (Oxford, 1990) 511–530.

18. Strabo 5.219.

19. Herodotus 1.94.

20. Cato, *Origines*, fragment 45 P.

21. Pallottino, *Etruscans*, 97. Servius, *ad Aeneidem* 10.198, 200.

22. Johannes Lydus, *De ostentis*, Prae. 3, fifth–sixth century AD. Other references in A. J. Pfiffig, 'Zum "Puer senex"', *Gesammelte Schriften* (Vienna, 1995) 506–510.

23. L. B. van der Meer, *BABesch* 54 (1979) 49–64; and *The Bronze Liver of Piacenza*. A. J. Pfiffig, *Religio Etrusco* (Graz, 1975) 115–146. Dumézil, *Archaic Roman Religion*, 650–654.

24. M. Torelli, 'La religione', in *Rasenna* 159 ff. J. R. Jannot, *Devins, dieux et démons* (Paris, 1998). F. Gaultier, D. Briquel (eds), *Les Etrusques*. See Livy (1.34) on Tanaquil's reading the omens of Tarquin's coming kingship in the sky. The Sibylline books of Rome were originally Etruscan (Ogilvie, *Commentary*, 46, 654–655, with refs.). In the fourth century BC Roman youths were sent to Etruria to study, probably to perfect this art (Livy 9.36.3; O. J. Brendel, *Etruscan Art* (New Haven, 1995), 408).

25. For Tages, Tarchon, Tarchunus, see Pfiffig, *Religio* 37–40, 354, and R. E. Wood, 'The Myth of Tages', *Latomus* 39 (1980) 325 ff. N. T. de Grummond, 'Mirrors and Manteia: Themes of Prophecy on Etruscan Mirrors', in A. Rallo (ed.), *Aspetti e problemi della produzione degli specchi etruschi figurati. Atti dell'incontro internazionale di studio, Roma, 1997* (Rome, 2000) 27–67, with bibliographical references. Still valuable are M. Pallottino, 'Uno specchio di Tuscania e la leggenda etrusca di Tarchon', *RendLinc* 6 (1930) 49–87; and 'Sullo specchio tuscanense con leggende di Tarchon', *StEtr* 10 (1936) 193. The story of Tages, the *puer senex* or 'boy – old man', has been connected by the excavator, Maria Bonghi Iovino, with a surprising discovery during recent excavations at Tarquinia, the ninth-century burial of a boy affected by epilepsy, considered to be a sacred

disease in antiquity: Bonghi Iovino, Treré 1986 (see above, n. 15) 197; Bonghi Iovino, Treré 1997 (see above, n. 15) 158, with review by N. Terrenato, *AJA* 104 (2000) 404–405. See also S. Haynes, *Etruscan Civilization* (Los Angeles and London, 2000), 27. See 'Mythological Figures', s.v. Tages, Tarchunus, with bibliography.

26. Rome, Villa Giulia Museum. Pfiffig, *Religio*, 38–39. F. Coarelli, *Roma medio repubblicana* (Rome, 1973) 278–281. G. Bordenache Battaglia and A. Emiliozzi, *Le ciste prenestine* 1.2 (Rome, 1990) No. 100, pls 459–461. F.-H. Pairault Massa, *Iconologia e politica nell'Italia antica* (Milan, 1992) 164–167.

27. Johannes Lydus, *De ostentis* 2.6B. A. Hus, *Les Étrusques et leur destin* (Paris, 1980) 42, 175–177; cf. 163–164. But see E. Peruzzi, *Mycenaeans in Early Latium* (Rome, 1980) 137–149.

28. M. Cristofani, *La tomba delle Iscrizioni a Cerveteri* (Florence, 1965); idem, *CIE* II. 1.4 (Florence, 1970) 5907–5974.

29. Pallottino, *Etruscans*, 279–280. R. E. Linington, F. R. Serra Ridgway, *Lo scavo del Fondo Scataglini a Tarquinia* (Milan, 1997). Inscription: Cristofani, 'Recent Advances', *IBR* 378. H. Jucker, *StEtr* 37 (1965) 501–505.

30. See above, n. 16.

31. A. Blakeway, 'Demaratus', *JRS* 25 (1935) 129–148. T. Gantz, 'The Tarquin Dynasty', *Historia* 24 (1975) 539–554. Ridgway, *First Western Greeks* (1992) 119, 143, 154. D. Ridgway, *Before Demaratus*. Jerome Lectures 27 (Ann Arbor, MI, forthcoming). D. Musti, 'Etruria e Lazio arcaico nella tradizione (Demarato, Tarquinio, Mezenzio)', in M. Cristofani (ed.), *Etruria e Lazio arcaico* (Rome, 1989) 139–153.

32. M. Cristofani, *L'arte degli etruschi. Produzione e consumo* (Turin, 1978) 52. His first name, *Rutile*, is Latin (cf. Rutilius Namatianus), while *Hipukrates* is Greek. De Simone, *Entlehnungen* II.197, p. 228. Laris Pulenas: Pallottino, *Etruscans* 200, 219. Heurgon, *La Vie* 292.

33. M. Cristofani, *Prospettiva* 7 (1976) 2–10; idem, *L'arte*, 84–91. On the change brought by Greek art and artists in Etruscan workshops see Brendel, *Etruscan Art* 143–173, and Torelli, *L'arte degli Etruschi* (1985; 1998 reprint) 163 ff.

34. Livy 1.57. Heurgon, *La Vie*, 101–102.

35. Brendel, *Etruscan Art*, 165–168. S. Steingräber, *Etruscan Painting* (New York, 1986) 353, No. 120. M. Menichetti, *Archeologia del potere* (Milan, 1994) 119–121.

36. S. Haynes, '*Ludiones Etruriae*', *Festschrift H. Keller* (Darmstadt, 1963) 13–21. J. G. Szilágyi, '*Impletae modis saturae*', *Prospettiva* 24 (1981) 2–23. J. -R. Jannot, 'Phersu, Phersuna, persona. A propos du masque étrusque', in J. P. Thuillier (ed.), *Spectacles sportifs et scéniques dans le monde étrusco-italique* (Rome, 1993) 281–320. See 'Mythological Figures', s.v. Phersu.

37. A. Ernout and A. Meillet, *Dictionnaire étymologique de la langue latine* (4th edn, Paris, 1959–60), s.v. See section on Glosses, 837n. and Livy 7.2.4.

38. Tomb of the Jugglers: Steingräber, *Etruscan Painting*, 310–311, No. 70.

39. Tomb of Orcus: Steingräber, *Etruscan Painting*, 329–332, No. 92. Brendel, *Etruscan Art*, 337–339. M. Morandi, G. Colonna, 'La *gens* titolare della tomba tarquiniese dell'Orco', *StEtr* 61 (1997) 95–102.

40. E. Gabba, in *Numismatica e antichità classiche. Quaderni ticinesi* 8 (1979) 143

ff. G. Colonna, 'Apollon, les Étrusques et Lipara', *MEFRA* 86 (1984) 557–578. Torelli, *Elogia Tarquiniensia*, with review by T. J. Cornell, *JRS* (1978) 167–173.

41. Steingräber, *Etruscan Painting*, 346–347, No. 109. L. Bonfante, 'Etruscan couples and their aristocratic society', 157–187. Heurgon, *La Vie*, 99–102.

42. R. Herbig, *Die jüngeretruskischen Steinsarcophage* (Berlin, 1952). M. Martelli, *Prospettiva* 3 (1975) 9–17. M. D. Gentili, *I sarcofagi etruschi in terracotta di età recente* (Rome, 1994).

43. Velthur Partunus, the so-called Magnate: Brendel, *Etruscan Art*, 390. Herbig 120; *CIE* 5423.

44. J. Kaimio, 'The ousting of Etruscan by Latin in Etruria', in *Studies in the Romanization of Etruria*. Acta Instituti Romani Finlandiae V (Rome, 1972) 85–245, at 196–200. M. Pallottino, *Tarquinia, Monumenti antichi dell'Accademia nazionale dei lincei* 36 (1937) 377, 545–546, 559–560. For Hellenistic cippi, see Linington and Serra Ridgway, *Fondo Scataglini* (1997) 51, 72 I.2; M. Blumhofer, *Etruskische Cippi* (Cologne, 1993).

45. Tomb of the Typhon: Cristofani, *L'arte*, 200. On the chronology of the Tomb of the Typhon, see G. Colonna, 'Per una cronologia della pittura etrusca di età ellenistica', *Dialoghi di Archeologia* 3 (ser. 2) (1986) 18 ff. Steingräber, *Etruscan Painting*, 347, No. 118.

46. Kaimio, 'Ousting', 198. O. Carruba, 'Sull'iscrizione etrusca dei Claudii', *Athenaeum* 52 (1974) 301–313.

47. *Gli Etruschi di Cerveteri* (Modena, 1985). *Cerveteri e il suo territorio* (Rome, 1995). M. Cristofani, *Tre itinerari archeologici* (Rome, 1991). *Caere* 3.1, 3.2 *Lo scarico arcaico della Vigna Parrocchiale* (Rome, 1992, 1993). For the name of Caere, see G. Proietti, 'L'ipogeo monumentale dei Tamsnie: considerazioni sul nome etrusco di Caere e sulla magistratura cerite del IV secolo', *StEtr* 51 (1985) 557–571, esp. 565, n. 28, with previous bibliography.

48. Pyrgi: see above, n. 17.

49. For literacy in Etruria, see T. Cornell, 'The tyranny of the evidence: a discussion of the possible uses of literacy in Etruria and Latium in the archaic age', in *Literacy in the Roman World* (Ann Arbor, MI, 1991) 7–33.

50. For writing implements see L. Pareti, *La tomba Regolini-Galassi* (Vatican, 1947) 373, No. 413. W. Helbig, *Führer durch die öffentlichen Sammlungen klassischer Altertümer in Rom*, 4 vols, ed. H. Speier (Tübingen, 1963–72) IV, No. 653. Peruzzi, *ParPass* 126 (1969) 181–183. Cristofani, in *Nuove letture di monumenti etruschi* (Florence, 1971) 31–44, Nos. 16, 32, 38–39. J. C. Szilágyi, 'Un style étrusque en bronze', *Bulletin du Musée Hongrois des Beaux-Arts* 54 (1980) 13–27, with rich bibliography. L. Bonfante, *Etruscan* (1990) 23–26. M. Pallottino, 'Lingua e letteratura degli Etruschi', *StEtr* 61 (1997) 208–209. E. Macnamara, *Everyday Life of the Etruscans* (London and New York, 1973) 186. For styluses from Marzabotto, see G. Gozzadini, *Di un'antica necropoli* (Bologna, 1865) 33.

51. T. Rasmussen, *Bucchero Pottery from Southern Etruria* (Cambridge, 1979). Cristofani, *L'arte* 54, fig. 2: map of Etruscan bucchero distribution in the Mediterranean, 630–550.

52. Helbig, *Führer* IV, Nos 631, 637. Pareti, *Tomba Regolini-Galassi* 219, No. 152, pl. 16. The name can refer to a woman: see Cristofani, *Introduzione* 72, 102. Contra, see M. Torelli, *DdA* I (1967) 39–40.

53. M. Cristofani, 'Il "dono" nell'Etruria arcaica', *ParPass* 30 (1975) 132–52. Agostiniani, *Le 'iscrizioni parlanti' dell'Italia antica* (Florence, 1982). Agostiniani, *AGI* 69 (1984) 86ff. Agostiniani, *StEtr* 49 (1981) 104 ff. *ET* Cr 2.33.

54. G. Q. Giglioli, *StEtr* 3 (1929) 111–159. *TLE* 74. Agostiniani, *Iscrizioni parlanti* 88, No. 192. G. Becatti, 'La leggenda di Dedalo', *RömMitt* 60–61 (1953–54) 22–36. A. Alföldi, *Early Rome and the Latins* (Ann Arbor, 1965) 280–283. L. B. Van der Meer, 'Le jeu de Truia. Le programme iconographique de l'oenochoé de Tragliatella', *Ktema* 11 (1986) 169 ff. J. P. Small, 'The Tragliatella oinochoe', *RömMitt* 93 (1986) 63–96. M. Martelli (ed.), *La ceramica degli Etruschi. La pittura vascolare* (Novara, 1987) 270–272, No. 49. F. H. Pairault Massa, *Iconologia e politica nell'Italia antica* (Milan, 1992) 27–33. M. Menichetti, 'L'oinochoe di Tragliatella: mito e rito tra Grecia ed Etruria', *Ostraka* 1 (1992) 7–30; and *Archeologia del potere* (Milan, 1994) 57–65, 86–87. M. Torelli, *Il rango, il rito e l'immagine* (Milan, 1997) 29–30, 48–49, 182–183.

55. Pausanias 5.12.3. G. Colonna, *MEFRA* 96 (1984) 568 ff.

56. Martelli, *Ceramica*, 263–265, No. 40. For a contemporary vase (c.670) with the representation of a chariot, see A. Emiliozzi, *Carri da guerra e principi etruschi* (Rome, 1998) pl. I.

57. J. M. Hemelrijk, *De Caeretaanse Hydriae* (Amsterdam, 1956). Brendel, *Etruscan Art*, 171–174.

58. Colonna, 'Nomi etruschi di vasi', *ArchClass* 25–26 (1973–74) 132–150; and *Prospettiva* 53–56 (1989) 30–32. See also the articles by L. Biondi (listed in the Bibliography under 'Language'), and L. Bonfante and R. Wallace, 'An Etruscan pyxis named *suntheruza*', *StEtr* 64 (2001) 201–212.

59. On *atrium* see A. Ernout, *Philologica* III (Paris 1965) 30. F. Prayon, *Frühetruskische Haus- und Grabarchitektur* (Heidelberg, 1975) 159–160. Heurgon, *La Vie*, 188–192.

60. F. Roncalli, *JdI* 95 (1980) 263.

61. Cippus of Vel Matunas, in the Tomb of the Reliefs, M. Cristofani, *StEtr* 34 (1966) 232. See above, n. 28.

62. In the seventh century, for example, the writing was left to right. Colonna, 'Il sistema alfabetico', 22–3. C. de Simone, 'L'etrusco in Campania', in *Atti del XIV Congresso di Studi Etruschi e Italici*, 107–117; G. Colonna, *La presenza etrusca nella Campania meridionale* (Florence, 1994) 343 ff.

63. C. D. Curtis, *Memoirs of the American Academy in Rome* 3 (1919); *Memoirs of the American Academy in Rome* 5 (1925). Canciani–von Hase, *Tomba Bernardini* 5. Brendel, *Etruscan Art*, 60–62. F. Canciani and F.-W. von Hase, *La Tomba Bernardini di Palestrina*. Latium Vetus II (Rome, 1979). A. Emiliozzi, in *Archeologia Laziale* 9 (1988) 288 ff.

64. Canciani and von Hase, *Tomba Bernardini* 39–40, No. 23. Principal discussions: Alföldi, *Early Rome* 192. Torelli, 'L'iscrizione "latina" sulla coppa argentea della tomba Bernardini', *DdA* I (1967) 38–45. Cristofani, *Prospettiva* 5 (1976) 64. A. L. Prosdocimi, *StEtr* 47 (1979) 379 ff.

65. Colonna, in *Civiltà del Lazio Primitivo* (Rome, 1976) 35.

66. Livy 9.36.3. Brendel, *Etruscan Art*, 112.

67. Cristofani, 'Caere' *CIE* II. 1.4. M. Sordi, *I rapporti romano-ceriti e l'origine della civitas sine suffragio* (Rome, 1960). M. Blumhofer, *Etruskische Cippi* (Cologne, 1993).

68. Kaimio, 'Ousting' 194.

69. Veii's influence in Latium precedes that of Caere: Colonna, *Civiltà del Lazio Primitivo* 34–35. G. Bartoloni (ed.), *Le necropoli arcaiche di Veio* (Rome, 1997). D. Ridgway, *The First Western Greeks* (Cambridge, 1992) 128–136. Formello alphabet: Pallottino, *Etruscans* 292, fig. 94. Colonna, *L'etrusco arcaico* 19: it comes from the same tomb as the Chigi vase in the Villa Giulia. M. Pandolfini and Prosdocimi, *Alfabetari e insegnamento della scrittura in Etruria e nell'Italia antica* (Florence, 1990) I.4, p. 24.

70. G. Colonna and others, in *Santuarii d'Etruria*. Catalogue of exhibit (Milan, 1985) 39–109. G. Colonna, 'Note preliminarie sui culti del santuario di Portonaccio a Veio', *ScAnt* I (1987) 419–446.

71. Pfiffig, *Religio*, 58, 256–257. G. Colonna, 'Le iscrizioni votive etrusche', *ScAnt* 3–4 (1989–90) 877–879.

72. Brendel, *Etruscan Art* 237–245. E. H. Richardson, 'Etruscan Origin of Early Roman Sculpture', *Memoirs of the American Academy in Rome* 21 (1953) 77–124. G. Colonna, 'Il maestro dell'Ercole e della Minerva. Nuova luce sull'attività dell'officina veiente', in *Opuscula Romana* (Swedish Academy in Rome) 16 (1987) 7–41.

73. Vulca: Livy 1.53.3. Pliny *HN* 35.157. O. W. von Vacano, *Aufstieg und Niedergang der Römischen Welt* 1,4 (1973) 528. Brendel, *Etruscan Art* 463, n. 27. M. Pallottino, *La scuola di Vulca* (Rome, 1945). G. Colonna, 'Tarquinio Prisco e il tempio di Giove Capitolino', *ParPass* 36 (1981) 41–59; and *Enciclopedia dell'arte antica, classica e orientale*, II Suppl. *s.v.* Etrusca Arte, 574.

74. Livy 1.5.33–50. Ogilvie, *Commentary*, 699–741. M. Torelli, 'Veio, la città, l'ara, e il culto di Giunone Regina', in *Miscellanea Archeologica T. Dohrn dedicata* (Rome, 1982) 117–128.

75. Kaimio 'Ousting' 205. Lars Tolumnius, Livy 4.17; Ogilvie, *Commentary*, 558. Pfiffig, *Religio* 257.

76. L. Vagnetti, *Il deposito votivo di Campetti a Veio* (Florence, 1971), *ex votos* were offered to a female divinity protecting fertility well into the first century BC. L. Bonfante, 'Iconografia delle madri: Etruria e Italia antica', in A. Rallo (ed.), *Le donne in Etruria* (Rome, 1989) 85–106.

77. The account that follows is taken from G. Riccioni, 'Vulci: A topographical and cultural survey', in *IBR* 241–76. See now A. M. Sgubini Moretti, *Vulci e il suo territorio* (Rome, 1993); F. Buranelli, *Gli scavi a Vulci (1835–1837)* (Rome, 1991). For Etruscan jewellery: G. Bordenache Battaglia, 'Gioielli antichi', *Il museo nazionale etrusco di Villa Giulia* (Rome, 1980); M. Cristofani and M. Martelli (eds), *L'oro degli Etruschi* (Novara, 1983).

78. *La civiltà arcaica di Vulci e la sua espansione. Atti del X Convegno di Studi Etruschi ed Italici* (Florence, 1977). On the Polledrara Tomb, see S. Haynes, *Antike Kunst* 5 (1963) 3–4; 'Zwei archaisch-etruskische Bildwerke aus Vulci', *Antike Plastik* 4 (1965) 13–16. Most recently, S. Haynes 'The Bronze Bust from the Isis Tomb Reconsidered', *StEtr* 57 (1991) 3–9.

79. Beazley's indices of attributed vases include 1700 pieces from Vulci (Riccioni 269–271). Cristofani, *L'arte* 56–62. Something like seventy-five per cent of all Attic pottery with known provenance from *c*.525 to 500 comes from Etruria. A. W. Johnston, *Trademarks on Greek Vases* (Warminster, 1979) 12. T. B. L. Web-

ster, *Potter and Painter in Classical Athens* (London, 1972) 157, 179, 227, 291. J. P. Small, *JRA* 8 (1995) 317–319.

80. A. Hus, *Recherches sur la statuaire en pierre archaïque* (Paris, 1961). S. Haynes, *Etruscan Bronzes* (London, 1985) 71–80; M. Cristofani, *I bronzi degli Etruschi* (Novara, 1985). A. Naso, *Etruscan Bronzes in Greece* (forthcoming).

81. On *flere(ś)* = 'statue' see A. Buffa, *StEtr* 7 (1933) 445–450. G. Sigwort, *Glotta* 8 (1916) 159–65. See also Gerhard, *ES*, pl. 170. K. Olzscha, *Interpretation der Agramer Mumienbinde* (Leipzig, 1939) 20–30.

82. Florence, Museo Archeologico 553. C. Laviosa, in *Arte e Civiltà degli Etruschi* (Turin, 1967) 118, No. 328.

83. T. Dohrn, *Der Arringatore* (Berlin, 1968). Colonna, 'Firme arcaiche di artefici nell'Italia centrale', *RömMitt* 82 (1975) 181–192. For so-called graffiti or sigla, see N. T. de Grummond, C. Bare and A. Meilleur, 'Etruscan sigla (graffiti): Prolegomena and some case studies', *Archaeologia Transatlantica* (2000) 25–38, with good bibliography. They stress how difficult it is to interpret these marks because many excavators fail to report them properly, or even to publish them at all. 'Graffiti' and owners' marks on vases, many of them consisting of only a few letters, were inventoried by G. Colonna, in C. M. Stibbe and others, *Lapis Satricanus* (The Hague, 1980) 53–69. For craftsmen's marks, see Colonna, 'Il sistema alfabetico', 20; and M. Cristofani, K. M. Phillips, 'Poggio Civitate: Etruscan letters and chronological observations', *StEtr* 39 (1971) 409–430. For Greek and Etruscan letters on women's woolworking equipment dating from the eighth century, see T. Hodos, 'The asp's poison: women and literacy in Iron Age Italy', in R. Whitehouse (ed.), *Gender and Italian Archaeology: Challenging the Stereotypes*. Accordia Research Institute (University of London, 1998) 197–208, esp. 198, 204.

84. On *śuthina*, see *CSE* USA 3.11, 4 (Bonfante), the Prometheus mirror (Source 32, fig. 29), where the inscription *śuthina*, incised on the reflecting side, rendered the object useless for the living and consecrated it for the funerary use of the deceased. P. Fontaine, 'A propos des inscriptions "suthina" sur la vaisselle métallique étrusque', in J.-R. Jannot (ed.), *Vaisselle métallique, vaisselle céramique. Productions, usages et valeurs en Étrurie. Revue des études anciennes* 97 (1995) 201–216. D. Briquel, *REL* 97 (1995) 217–223.

85. The basic corpus is Gerhard, *Etruskische Spiegel*, completed by A. Klügman, G. Körte (Berlin 1840–97). J. D. Beazley, 'The World of the Etruscan Mirror', *JHS* 69 (1949) 1–17. De Grummond, *Guide*. Recent interest in the subject has produced a large bibliography, including numerous fascicles of the *Corpus Speculorum Etruscorum* (*CSE*).

86. U. Fischer-Graf, *Spiegelwerkstätten in Vulci* (Berlin, 1980).

87. E. Fiesel, *Namen des griechischen Mythos im Etruskischen* (Göttingen, 1928), and *Etruskisch* (Berlin, 1931). De Simone, *Entlehnungen*.

88. Kaimio, 'Ousting' 204. On the inscriptions from the tomb, see M. T. Falconi Amorelli, *StEtr* 31 (1963) 185–195. *ET* Vc 1.47–60.

89. Pallottino, *Etruscans* 292, fig. 95. Colonna, 'I dadi "di Tuscania"', *StEtr* 46 (1978) 115. Other ivory dice: Helbig, *Führer*, IV no. 2956 (from Praeneste, Barberini Collection).

90. Kaimio, 'Ousting' 200.

91. Pallottino, *Etruscans*, 115.

92. Pellegrini, 'Toponomastica', 1600. C. B. Curri, *Vetulonia* I. *Forma Italiae*. Regio VII. 5 (Florence, 1978). E. H. Richardson, *Archaic Etruscan Bronzes* (Mainz, 1983). F. von Hase, in *RömMitt* 79 (1972) 155–165.

93. Cristofani and Martelli, *L'oro*, 114 ff.

94. Hus, *Recherches* 100–134, pls 1–3, 17–18. L. Bonfante, *Etruscan Dress* fig. 57. Brendel, *Etruscan Art* 92–93. M. Sprenger, G. Bartoloni, and M. and L. Hirmer, *The Eruscans* (New York, 1983) pl. 47. The two earliest monumental Etruscan statues, from the Orientalizing necropolis of Casale Marittimo, near Volterra, were discovered in 1987 and recently featured in an exhibit at Villa Guerrazzi: A. M. Esposito (ed.), *Principi guerrieri* (Electa, Milan, 1999) 33–39.

95. G. Camporeale, *La Tomba del Duce a Vetulonia* (Florence, 1967); *I commerci di Vetulonia* (Florence, 1969).

96. Pallottino, *Etruscans*, 129–130.

97. On the coins: F. Catalli, *Monete etrusche* (Rome, 1990) 81–87.

98. Pandolfini and Prosdocimi, *Alfabetari* No. I. 1. Pallottino, *Etruscans* 291–292, pl. 93. Peruzzi, *Origini di Roma*, II.35–48.

99. Pallottino, *Etruscans* 291, pl. 91. On the name: Pellegrini, 'Toponomastica', 1600–1601. The city: De Agostino, *Populonia. La città e la necropoli* (Rome, 1965). A. Romualdi (ed.), *Populonia in età ellenistica. Atti del seminario 1986* (Florence, 1992). *L'Etruria mineraria* (Milan, 1985).

100. L. Breglia, 'L'oro con la testa di leone', *Contributi introduttivi allo studio della monetazione etrusca*. Atti del V Convegno del Centro Internazionale di Studi Numismatici 1975 (Naples, 1976) 75–85; discussion 131–9, 211–15. Catalli, *Monete etrusche* 41 ff. D. Tripp, 'Coinage', in L. Bonfante, *Etruscan Life* 202–214.

101. Name: Pellegrini, 'Toponomastica', 1599. *TLE* 386. Pallottino, *études étrusco-italiques* (Louvain, 1963) 145, pl. 17.2. L. Bonfante, *Etruscan Dress*, fig. 68. Brendel, *Etruscan Art*, 133–134.

102. H. Brunn, G. Körte, *I rilievi delle urne etrusche* (Rome and Berlin, 1870–1916). C. Laviosa, *Scultura tardo-etrusca di Volterra* (Florence, 1964). CUE I, *Urne volterrane. I complessi tombali*, ed. M. Cristofani (Florence, 1975). *Caratteri dell'ellenismo nelle urne etrusche. Prospettiva*, I Supplemento, ed. M. Martelli and M. Cristofani (Florence, 1977). L. Manino, *Le urne volterrane nel quadro della diffusione dell'arte e della cultura ellenistica* (Turin, 1977). A. Maggiani, 'Contributo alla cronologia delle urne volterrane: i coperchi', *Memorie dell'Accademia Nazionale dei Lincei* 19 (1976) 3 ff. S. Haynes, *Etruscan Bronzes* (1985) 118–122, 348–349.

103. The name: Pellegrini, 'Toponomastica', 1601.

104. Livy (9.37.12), tells us that in 310 Perugia, Cortona, and Arezzo were among the most important cities of Etruria. *La Chimera e il suo mito. Catalogo della mostra* (Florence, 1990). *Il Museo Archeologico Mecenate* (Florence, 1987).

105. H. Comfort, *Corpus Vasorum Arretinorum. A Catalogue of the Signatures, Shapes and Chronology of the Italian Sigillata* (Bonn, 1968). L. Pedroni, 'Riflessioni sulla nascita dell'aretina', *Ostraka* 4 (1995) 195–204.

106. *Arezzo* and *Erz*: G. Bonfante, in L. Bonfante, *Out of Etruria* 127–130.

107. Livy 10.3.2; 10.5.13. Harris, *Rome in Etruria and Umbria* 115, 201, 267, 320–321.

108. Kaimio, 'Ousting' 214–215. Bilinguals: E. Benelli, *Le iscrizioni bilingui etrusco-latine* (Florence, 1994). CIE 378, 428; TLE 930. Pallottino, *StEtr* 23 (1954) 299.

109. Agostiniani, *Iscrizioni parlanti*. A. D'Aversa, *Curtun. Cortona etrusca* (Brescia 1986). *La Cortona dei principes*. Catalogue of exhibit (Cortona, 1992).

110. The name: Pellegrini, 'Toponomastica', 1601.

111. N. de Grummond (ed.), *An Encyclopedia of the History of Classical Archaeology* (1996) s.v. 'Accademia Etrusca'. P. Bruschetti, *Sul lampadario di Cortona* (Cortona, 1972).

112. Cristofani, *Prospettiva* 17 (1979) 8 ff.

113. L. Agostiniani, F. Nicosia, *Tabula Cortonensis* (Rome, 2000). For a different interpretation, see C. de Simone, *AnnPisa* 53 (1998)[2000], and E. Peruzzi, 'Sulla Tavola etrusca di Cortona', *ParPass* 56 (2001) 203–210.

114. A. Morandi, *Epigrafia italica* (Rome, 1982). F. Roncalli (ed.), *Gens antiquissima Italiae. Antichità dall'Umbria al Vaticano* (Perugia, 1988), and the catalogues for the following exhibits, in Budapest and Cracow (1989), Leningrad (1990), and New York (with L. Bonfante, 1991).

115. Brendel, *Etruscan Art* 317. T. Dohrn, in Helbig, *Führer* IV, No. 736. F. Roncalli, *Il 'Marte' di Todi* (Vatican, 1973).

116. Kaimio, 'Ousting' 210–213.

117. Pallottino, *Etruscans* 119, 278, pl. 22. A. von Gerkan, F. Messerschmidt, *RömMitt* 57 (1941) 122 ff. *CIE* 3763.

118. See above, n. 13.

119. L. Banti, *The Etruscan Cities and Their Culture* (Berkeley and Los Angeles, 1973; originally published in Italian, 1968) 120: 'Up to 1946 the favorite hypothesis was the one identifying it with Orvieto. After the recent French excavations at Bolsena, many feel inclined to identify it with the Etruscan city above Bolsena.' R. Bloch, *Recherches archéologiques en territoire volsinien de la protohistoire à la civilisation étrusque* (Paris, 1972). A. Timpari, I. Berlingò, D. Gallavolti, M. Aiello, *Bolsena e il suo lago* (Rome, 1994). G. Colonna, 'Ricerche sull'Etruria interna volsiniese', *StEtr* 41 (1973) 45 ff; *Bollettino di Studi e Ricerche* 6 (Bolsena, 1991) 13 ff.

120. Pellegrini, 'Toponomastica', 1599. A. Morandi, *Epigrafia di Bolsena etrusca* (Rome, 1990).

121. Pallottino, *Etruscans* 114–116. M. P. Baglione, *Il territorio di Bomarzo* (Rome, 1976). G. Nardi, *Le antichità di Orte* (Rome, 1980). E. Östenberg, *Case etrusche di Acquarossa* (Rome, 1975).

122. Pliny *HN* 34.34. Banti, *Etruscan Cities* 33. Brendel, *Etruscan Art* 293, 467, 470–471.

123. Kaimio, 'Ousting' 201–203.

124. Colonna, 'Il sistema alfabetico', 21–22. *La scrittura nell'Etruria antica. Atti* 1985. *AnnFaina* 4 (1990). F. Roncalli (ed.), *Gens antiquissima Italia*. Catalogues listed above, n. 114.

125. Mario Bizzarri's excavations at Crocifisso del Tufo have been published (*StEtr* 30 [1962] 1 ff.; 34 [1966] 3 ff.). Francesco Roncalli, Simonetta Stopponi, Friedhelm Prayon and others have excavated at the necropolis of Cannicella. For the 'Cannicella Venus' see Pfiffig, *Religio* 65–68, and *Santuario e culto nella necropoli della Cannicella. AnnFaina* 3 (1987). L. Bonfante, 'Etruscan Nudity', in *Source* 12 (1993) 49–50.

126. R. Bianchi Bandinelli, *Clusium. Monumenti antichi dell'Accademia nazionale dei Lincei* 30 (1925). Pellegrini, 'Toponomastica', 1598.

127. Cristofani, *L'arte*, 136, and *passim*. L. Bonfante, *Out of Etruria*, ch. 2.

128. Kaimio, 'Ousting' 206. C. de Simone, 'Le iscrizioni chiusine arcaiche', in *La civiltà di Chiusi e il suo territorio*. Atti del Convegno (Florence, 1993) 25–38. Rix, *ET*.

129. M. Cristofani and M. Martelli, 'Documenti di arte orientalizzante da Chiusi', *StEtr* 41 (1973) 97–120. Sprenger, Bartoloni and Hirmer, *The Etruscans*, No. 26, fig. 25. J. Turfa, in L. Bonfante, *Etruscan Life* 66–69.

130. Cristofani, 'Recent Advances', *IBR* 382; and 'L'alfabeto etrusco', in *Popoli e Civiltà dell'Italia antica* 6 (Rome, 1978) 414–416, with fig. 6.

131. M. Cristofani, *Il vaso François* (Florence, 1981). J. D. Beazley, *The Development of Attic Black-Figure*, rev. edn (Berkeley and Los Angeles, 1986) ch. 3. J. R. Jannot, *Les Reliefs archaïques de Chiusi* (Rome and Paris, 1984).

132. Cristofani, *L'arte* 131–138. *Poggio Civitate. Catalogo della Mostra* (Florence, 1970). E. Nielsen, K. M. Phillips, Jr, *Notizie degli scavi di Antichità* (1976), 113–147. R. D. De Puma, J. P. Small (eds), *Murlo and the Etruscans* (Madison, WI, 1994). K. M. Phillips, *In the Hills of Tuscany. Recent Excavations at the Site of Poggio Civitate (Murlo)* (Philadelphia, PA, 1993), with bibliography.

133. C. Östenberg, *Case etrusche di Acquarossa* (Rome, 1975); Cristofani, *L'arte*, 132–134.

134. M. Cristofani, K. M. Phillips, Jr, 'Poggio Civitate: Etruscan letters and chronological observations', *StEtr* 39 (1971) 409–430. Cristofani, 'Recent advances', *IBR* 382.

135. Livy 2.9–15. Ogilvie, *Commentary* 255, 270. Livy 2.12.7. Colonna, '*Scriba cum rege sedens*', *Mélanges Heurgon* 187–95. For Mucius Scaevola, see L. Bonfante, *JRS* 60 (1970) 60, n. 71.

136. M. Nielsen, in A. Rallo, *Le donne in Etruria* (1989) 121–145. CUE. *Volterra. Il Museo Guarnacci* 1–2 (1986).

137. Pausanias, Ekhetlos, I. 15.3; Ekhetlaios, I. 32.5: a man of rustic appearance and dress, who slaughtered many of the barbarians with a plough and then vanished. M. H. Jameson, 'The hero Echetlaeus', *Transactions of the American Philological Association* 82 (1951) 49–61; *LIMC* 3.1 (1986) 677–678, s.v. 'Echetleus' (J. Gy. Szilágyi). Cristofani (*Etruscans*, 52) suggests an episode of class warfare concerning possession of the land.

138. Kaimio, 'Ousting' 206–210.

139. On the relations between the Etruscans and Rome, see A. Momigliano, *Terzo contributo alla storia degli studi classici e del mondo antico* (Rome, 1966) 545–608; and *Settimo contributo* (Rome, 1984) 379–436; 437–462. A. Momigliano, A. Schiavoni, *Storia di Roma* I (Turin, 1988) s.v. Mezentius: Vergil *Aeneid* 7.647–50; 8.478–95 and *passim*. Livy 1.2.3. F. Gaultier, D. Briquel, *CRAI* 1989, 99–115. De Simone, in *Miscellanea etrusca e italica in onore di M. Pallottino* (Rome, 1991) 559–573. Bruce Mac Bain, *Prodigy and Expiation: A Study in Religion and Politics in Republican Rome*, Collection Latomus 177 (Brussels, 1982). N. T. de Grummond, 'Mirrors and Manteia: Themes of prophecy on Etruscan and Praenestine Mirrors', in *Aspetti e problemi della produzione degli specchi figurati etruschi*, ed. A. Rallo (Rome, 2000) 17–43, with good bibliography. The statement by Ogilvie, *Commentary*, 41, *ad loc.*, 'the name of Mezentius, not elsewhere attested' is no longer true. The Tarquin dynasty has long been considered historical. Today 'Romulus', too, is seen as either a historical figure (Peruzzi, *Origini di Roma* (1970, 1973)) or a mythological personification of the foundation of Rome

(Carandini, *La nascita di Roma* (1997)). See also E. Peruzzi, *I Romani di Pesaro e i Sabini di Roma* (Florence, 1990) 114 and *passim*. E. Fentress, A. Guidi, review of Carandini, *Antiquity* 73 (1999) 463–467. T. Cornell, *The Beginnings of Rome* (London, New York, 1995) downplays or denies Etruscan influence.

140. D. Briquel, 'Etrusca disciplina et origines étrusques', in *La Divination dans le monde étrusco-italique*. *Caesarodunum* Suppl. 52 (1985) 3–22. L. Bonfante, '*Fama nominis Etruriae*', *Analecta Romana* 26 (1999) 167–171.

141. M. Pallottino, 'Lo sviluppo socio-istituzionale di Roma arcaica alla luce di nuovi documenti epigrafici', *Studi romani* 27 (1979) 1–14. *La grande Roma dei Tarquinii*. Catalogue of Exhibit (Rome, 1990). G. Pasquali, *La grande Roma dei Tarquinii* (1936); *Terze Pagine Stravaganti* (Florence, 1942; reprinted 1968) 1–24.

142. Etruscan names of the tribes, W. Schulze, *Zur Geschichte lateinischen Eigennamen* (Berlin, Zürich, and Dublin, 1966) 218, 581. Remus: H. Rix, *Rätisch und Etruskisch* (Innsbruck, 1998) 10, 34–35: *remi* = personal name, *remi-na* patronymic, *Remie*. L. R. Palmer, *The Latin Language* (London, 1954; reprinted Norman, OK, 1989) 47 derives the name of Rome from Etruscan *ruma*, related to Remus. T. P. Wiseman, *Remus. A Roman Myth* (Cambridge, 1995).

143. Kaimio, 'Ousting' 227.

144. Pallottino, *Etruscologia* 271–272, 373. and Harris, *Rome in Etruria and Latium*, *passim*. R. Turcan, 'Encore la prophétie de Végoia', *Mélanges Heurgon* 1009–1019. N. T. de Grummond (ed.), *The Religion of the Etruscans*. Conference held in Tallahassee, FL 1999 (forthcoming).

145. D. Musti, *QuadUrb* 10 (1970). M. Torelli, *Elogia Tarquiniensia* (Florence, 1975).

146. Horace, *Odes* 1.1. 1: *Maecenas atavis edite regibus*. Heurgon, *La Vie*, 318–328.

147. Suetonius, *Life of Claudius*, 41–42. Tacitus, *Annales* 11, 15; 2.34, 21, 22. Heurgon, *La Vie*, 105–107.

PART TWO

THE LANGUAGE

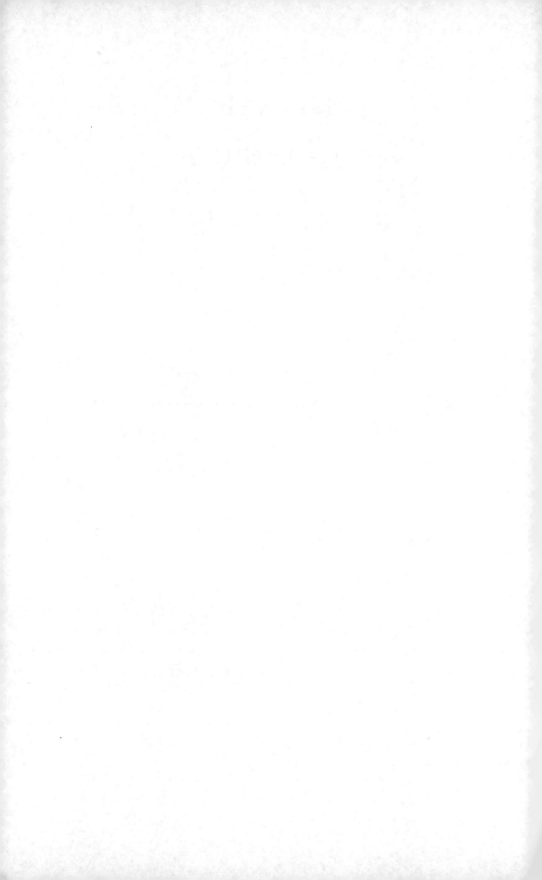

CHAPTER II

INTRODUCTION
TO THE LANGUAGE
OF THE ETRUSCANS

Etruscans were already flourishing in Italy in the eighth century, at the time of Greek colonization in the West, Phoenician trade, and the Orientalizing period of Greek art which spread throughout the Mediterranean. As noted in Chapter I, this period marked the beginning of the use of the alphabet in Greece and Italy. It is the alphabet, in fact, which reveals to us the people living in central Italy, between the Arno and Tiber Rivers, as non-Indo-European Etruscans, writing in the Etruscan language.

Two things seem certain: there was no large-scale 'invasion' of Etruscan-speaking people, and the Etruscans did not arrive during the historical period of Greek colonization (eighth century). For the language of the Etruscans reflects the influence of their neighbours, the Latins and the Umbrians whose languages belong to the Indo-European family of languages (compare Latin *nepos*, 'nephew', with Etruscan *nefts*), an influence which implies a certain period of proximity.

On the other hand, the originality of much of Etruscan custom agrees with the alien character of a group surrounded by peoples speaking a totally different language. The difference between Etruscan and Indo-European is shown by a comparison of the words in the Comparative Word Chart (Part three). For the ancient historians, the question of Etruscan origin was a problem.[1] The Greeks had an answer available, since they had available a 'prehistory', the Homeric Trojan saga, with its many heroes and their descendants. Thus a passage at the end of Hesiod's *Theogony*, which may date anywhere from the eighth to the sixth century, derives the Etruscans from the children of Odysseus and Circe.[2] More complex is the case of Herodotus' report,[3] which he attributes to the Lydians, concerning the Lydian origin of the Etruscans.

In Roman times, too, Vergil and Horace speak of Etruscans as 'Lydians'. For Herodotus, in any case, the origins of this rich people fitted another scheme of Greek history, that of barbarian *truphe*, or luxurious living; for both Lydians and Etruscans had the reputation, among Greeks, for luxurious habits and decadent morals.

Dionysius of Halicarnassus, writing in 7 BC, claimed that the Etruscans were autochthonous. He too was influenced by a need to fit the Etruscans into a scheme. The focus of his book, *Roman Antiquities*, on the history of Rome and Italy, was to show that the Romans were not in fact barbarians but originally Greeks. He proved this point by tracing Roman origins to Greek sources, and by comparing Roman customs, institutions, and rituals whenever possible to Greek equivalents. In his view the Romans were originally Greeks who had long ago immigrated to Italy. What, then, was the status of the Etruscans, so clearly different in language and custom? They must have been the 'natives'. In spite of his pro-Greek bias, Dionysius shows good ethnological method by citing as evidence the languages and customs of the people involved.

> And I do not believe either that the Tyrrhenians were a colony of the Lydians; for they do not use the same language as the latter, nor can it be alleged that, though they no longer speak a similar tongue, they still retain some other indications of their mother country. For they neither worship the same gods as the Lydians nor make use of similar laws or institutions, but in these very respects they differ more from the Lydians than from the Pelasgians. Indeed, those probably come nearest to the truth who declare that the nation migrated from nowhere else, but was native to the country, since it is found to be a very ancient nation and to agree with no other either in its language or in its manner of living.[4]

His statement that neither the Lydian language nor any other features of their life show any similarity to the Etruscan has been confirmed by an analysis of the Lydian language, which is Indo-European, and therefore unrelated to Etruscan.[5] Nor have excavations in Lydia turned up any particularly 'Etruscan' finds. Linguists worry about Etruscan origins more than archaeologists do. Archaeology shows clear continuity between the Etruscans of the seventh century and the prehistoric, Iron Age (Villanovan) populations which preceded them in every major Etruscan city. Yet the Etruscans were a pocket of non-Indo-European speakers in an area where almost everyone else spoke an Indo-European language (map 2). Like the Basques, their language is different from that of any of their neighbours. Unlike the Basques, enclosed by high

mountains and cut off from the rest of the world, the Etruscans controlled some of the richest, most fertile land in the Mediterranean, and its fine harbours along the coast.

The name by which they called themselves was also different from that used by their neighbours. The Etruscans called themselves *Rasenna* (Dionysius Halicarnassus I.30: first century BC), or *Rasna*. In other languages, the Etruscans' name comes from a stem *turs-*[6] (Latin *Tuscus*, from **Turs-cos*, archaic Umbrian *turskum* (*numen*), later Umbrian *tuscom* (*nome*), Latin *Etrūria* from **E-trūs-ia* (?), Greek *Tyrs-ēnoi* (from Greek *tyrsis*, Latin *turris*, 'tower')). In fact we can imagine a scenario in which the peoples of Italy – Latins among them – who lived in huts, began to notice that the Etruscans were building taller houses, which they called 'towers'. And when Etruscan influence spread into the rest of Italy, they called them the 'people who build towers', *Tursci*, or *Tyrsenoi*.[7]

It often happens, in fact, that a people calls itself by one name, and is called by other people – or some others – by a different name.[8] Traces of the names of the ancient Etruscans have remained in Italy: the toponym Rasna in southern Etruria,[9] in Rome the *Vicus Tuscus*. In Rome the Etruscans evidently lived in a specific area of the city, just as much later, in the Renaissance, the Lombards, the Florentines, the Genoese, etc. lived in their own areas; and this part of Rome, the *Vicus Tuscus*, was named after them. This name eventually had its own history: from *Vicus Tuscus* came the Spanish word *tosco*, which means 'vulgar'.[10]

The Etruscan language can be traced through written documents from the seventh century BC to the first century after Christ. The Etruscans appear in Italy, within the international world of the Orientalizing period, as wealthy, spirited inhabitants of what later became Tuscany. From roughly 700 to 500 their power and prestige were at their height: they almost succeeded in uniting Italy from the Alps to Magna Graecia.[11] Their influence moved southward across the Tiber, taking over Rome itself, and all the cities throughout Latium, down to Campania, including Paestum (map 3). Rome and her neighbours thus received the full effect of the Etruscans' high civilization, all the outward signs of culture, the alphabet, the arts, the symbols and insignia of power. Greek culture first came to Rome by way of Etruria, for the Etruscans, having learned from the Greeks how to represent divinities in human form, build cities and temples, organize armies, drink wine, and use the alphabet, passed on many of these

signs of civilization to their neighbours in Italy; and eventually, through the Romans, to all of Europe. But the Romans continued throughout to speak their own language, Latin, a sign of their peculiar character, and the instrument with which they united the peninsula at last.

THE SPREAD OF THE ALPHABET

Since a historical people is usually defined by its language, we are accustomed to speaking of 'Etruscans' only from the day we have a text written in the Etruscan language, at the beginning of the seventh century. We have, dating from this time, some inscriptions from Tarquinia, and some alphabets.

The invention of the alphabet, one of the greatest debts we owe the Phoenicians, changed the history of western civilization. According to the Roman historian Tacitus, the Phoenicians adopted the alphabet from the Egyptians. He also says that the Etruscans and the Latins – the latter he calls Aborigines – received their alphabet from the Greeks.[12]

We can follow the various phases of the alphabet, from the alphabetic Canaanite script of the Phoenicians, without vowels, to the Greek alphabet, whose innovation it was to adapt certain consonantal signs to signify vowels (A, E, H = E, I, O; and later, Ω, *omega*) (fig. 3). So powerful is historical conservation that we still recite the alphabet almost in the order in which the Greeks first received it.

From the Western Greeks originating in Euboea the Etruscans took over this invention which had been brought to Italy early in the eighth century (figs 2, 6, 11). At first they copied the alphabet, just as they had learned it, as decoration on their vases and other objects. Very soon they adapted it to their own needs, dropping some letters that did not correspond to sounds in the Etruscan language and converting other letters to different uses.

The Etruscan alphabet derives, like the Latin, from the Western type of Greek alphabets, where X has the value of occlusive *k* + sibilant *s* (*ks*). In Etruscan X represents a sibilant (*ś*), whereas Latin X represents the occlusive *k* plus the dental sibilant *s* (*ks*, or *x*, as in English *axe*). (In the Eastern group of Greek alphabets, including Attic, X has the value of *kh*, as in Greek *chaos*, English *character*.)

On the other hand, the Etruscan alphabet also seems to preserve the traces of a very early Greek alphabet, older in part than the split between 'Western' and 'Eastern' Greek alphabets, since it preserves all

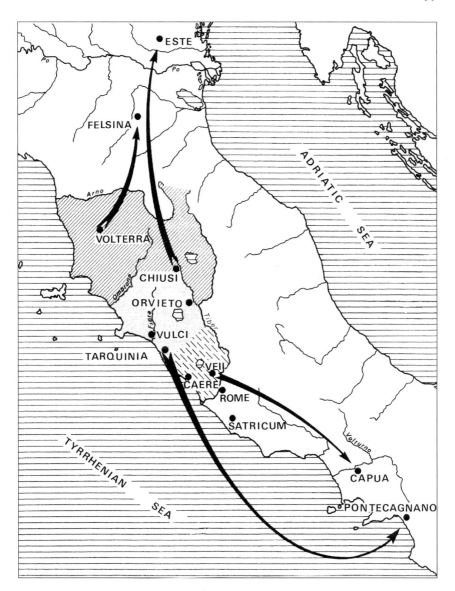

Map 3 The spread of the Etruscan alphabet in Italy
North Etruria: from Volterra, northward to Felsina. Central Etruria: from Chiusi,
northward to Este. Southern Etruria: from Tarquinia and Veii southward to
Campania (Capua and Pontecagnano)

Phoenician	Corinth	Athens	Ionia	The West		Latin
					Archaic Greek	
𐤀 ʾAleph	Δ	Δ	Δ	Δ	Alpha	A
𐤁 Bet	ſ	B	B	B	Beta	B
𐤂 Girnel	Γ	Λ	Γ	<,C	Gamma	C, G
𐤃 Dalet	Δ	Δ	Δ	Δ,D	Delta	D
𐤄 He	B	E	E	E	Epsilon	E
𐤅 Vav	F	F	–	⌐,F	Digamma	F
𐤆 Zayin	I	I	I	I	Zeta	Z
𐤇 Ḥet	🄷 / –	🄷 / –	– / 🄷	🄷 -h / – ē } (H) Eta		H
𐤈 Ṭet	⊗	⊗	⊗	⊗	Theta	
𐤉 Yod	⟨	I	I	I	Iota	I
𐤊 Kaph	K	K	K	K	Kappa	K
𐤋 Lamed	Γ	L	Γ	L	Lambda	L
𐤌 Mem	M	M	H	M	Mu	M
𐤍 Nun	N	N	N	N	Nu	N
𐤎 Samekh	E	X	土	⊞	Xi	X
𐤏 ʿAyin	O	O	O	O	Omicron	O
𐤐 Pe	Γ	Γ	Γ	Γ	Pi	P
𐤑 Ṣade	M	–	–	M	San (=s)	
𐤒 Qoph	ϙ	(ϙ)	(ϙ)	ϙ	Koppa	Q
𐤓 Resh	P	P	P	R	Rho	R
𐤔 Shin	–	⟨	⟨	⟨	Sigma	S
𐤕 Tav	T	T	T	T	Tau	T
	V	Y	V	Y	Upsilon	V, Y, U
	Φ	Φ	Φ	Φ	Phi	
	X	X	X	Ψ	Chi	
	†	–	†	–	Psi	
	–	–	Ω	–	Omega	

3 Table of alphabets, Phoenician, Archaic Greek, and Latin

three Phoenician sibilants, the signs *samekh, sade*, and *šin* (each of which signs represents a different sound in Phoenician), which neither 'Western' nor 'Eastern' Greek alphabet possesses any longer (*s* is written with either *sigma* or *san*; archaic Etruscan had two different sounds, written with altogether four characters).

The Etruscans evidently considered this alphabet to be decorative, a sign of status, and probably magic, and copied it on various objects, especially vases like those found at Viterbo, Caere, and Formello, near Veii (fig. 11). More than seventy-three alphabets have come down to us. Most important is the alphabet from Marsiliana d'Albegna, dating from the seventh century, inscribed on an ivory writing tablet (fig. 12). The one from Viterbo, now in The Metropolitan Museum of Art, New York, decorates a bucchero container in the shape of a rooster which may once have held a coloured liquid like ink (Source 3, fig. 11c). These writing implements, to which we should add the bucchero vase or inkwell from Cerveteri (Source 2), were placed in the tombs of rich people who were thus distinguished by displaying this new sign of civilization.[13]

The model (Greek) alphabet was adopted by way of Pithekoussai, or Cumae, the Euboean Greek colony near Naples. A Greek inscription of the eighth century on the so-called Nestor cup (fig. 1), discovered in 1954 at Pithekoussai, confirms the hypothesis that the Etruscan alphabet came from that area (see Chapter I).

The direction of the writing usually goes from right to left, the reverse of classical Greek, Latin, or English, but the same direction as Phoenician and other Semitic languages, such as Hebrew. Lucretius may have had this peculiarity in mind when he talks of unrolling backwards the sacred verses of the Etruscans, hoping to discover the hidden will of the gods: *non Tyrrhena retro uoluentem carmina frustra/indicia occultae diuum perquirere mentis*, 'not unwinding Etruscan poems from back to front, searching in vain for signs of the gods' hidden will'.[14] In seventh-century inscriptions from Cerveteri the direction is left to right. In archaic times *boustrophedon* (also used in Greek) sometimes occurs, that is, 'as the ox ploughs', one line going from right to left, the next from left to right. In more recent inscriptions of the third century or later we find that, under Latin influence, the direction goes from left to right. In this late period we even find some inscriptions in the Etruscan language written with a Latin alphabet, and some in the Latin language written with Etruscan letters.

In the earliest inscriptions the words are not separated at all, but the

letters run on one after the other (*scriptio continua*). From the sixth century on, words are often separated from each other by a dot, or two or more dots placed vertically one above another (e.g. figs 25, 34). Sometimes this 'punctuation' separates groups of letters within a word (perhaps Source 36, fig. 33). Syllabic punctuation constitutes a peculiar feature of Etruscan writing (closed syllables are so marked). Such syllabic punctuation is to be found on inscriptions of the mid-sixth to the end of the fifth century in southern Etruria and in Campania, but it ends about the time that the custom of separating words from each other has become the norm.[15]

There were differences in spelling, as well as in pronunciation, between the cities of southern Etruria and those of northern Etruria. There were also differences between the languages of the city and of the country. Livy (10.10), referring to an event of 302, speaks of the different pronunciation of the *sermo agrestis* (country speech) and *sermo urbanus* (city speech) which allowed the Romans to become aware of the trap the Etruscans had set.

THE EXTENT OF THE ETRUSCAN LANGUAGE

The first Etruscan texts can be dated around 700, though Etruscan must have been spoken in Etruria for quite some time before it was written. There are a number of reciprocal influences and exchanges of words between Etruscan and the Latin and Italic[16] languages of their neighbours, as well as borrowings from their Greek neighbours in Italy. At the other end of the chronological range, the latest Etruscan inscriptions date from the time of Augustus (d. AD 14). By the time of Christ's birth, very little Etruscan, if any, was spoken. The mummy bandages in Zagreb, our longest Etruscan text (Source 67, fig. 57), of the second century, apparently contain several mistakes, which may indicate that the language was no longer really used.[17] It probably long continued to be read and used by priests as a sacred language, however, as Latin was in modern times. In AD 408, when the Gothic chieftain Alaric threatened to destroy Rome, Etruscan *fulguriatores* visited the Roman emperor and offered to perform certain magic operations, reciting special formulas in order to avert the sack of the city by the barbarians. Clearly at that time the Etruscan religion and Etruscan priests still existed, as did their prayers and incantations, presumably in the Etruscan language.

As to the geographical extent of the Etruscan language, inscriptions have been found mostly in Etruria proper, but also in Latium, Campania, northern Italy and the Po Valley, Corsica, North Africa, and on the Black Sea.

ETRUSCAN TEXTS

The total number of Etruscan inscriptions (incised on stone, lead, clay vases, and bronze mirrors, and painted on the walls of tombs, etc., is between nine thousand and thirteen thousand (depending on whether or not one counts very fragmentary inscriptions, graffiti, etc.); more are constantly being discovered. This is an enormous number, if we consider how few we have for the other non-Latin languages of ancient Italy. All that remains to us in writing of the Umbrian language are the Iguvine tables, eleven inscriptions describing a religious ritual – written partly in an Etruscan, partly in a Latin alphabet. There are a few hundred, altogether, of Venetic and Oscan. There are only three inscriptions of the language of the Gauls, and none of the indigenous idioms of Sardinia and Corsica. Of the Faliscan language there are more – some two hundred inscriptions because Falerii belonged politically to Etruria. Of archaic Latin itself we have very few indeed. Before the third century (the date of the earliest epitaphs, the inscriptions of the Scipios, and of the beginning of the first literary texts, by Naevius, Ennius, and Plautus) there are only nine inscriptions, including one new one. Another, the Praenestine gold fibula – *manios med vhevhaked numasioi*, 'Manius made me for Numerius', is now generally recognized to be a forgery. From the point of view of culture, Etruria appears in ancient Italy as a great centre, second only to the Greeks of South Italy. For a time, indeed, Etruria exercised on Rome the same kind of influence that was later exercised by the Greeks. We know from Livy (9.36.3) that in 310 the Romans still used to send their sons to study in the Etruscan city of Caere, just as they sent them later to Athens or Rhodes.[18]

Many of these thirteen thousand or so inscriptions can be understood. But the majority are funerary inscriptions and contain only the name, patronymic or father's name, sometimes the matronymic or mother's name, and the surname of the deceased. Sometimes there is also the age and the public office held; more rarely, if the deceased was a woman, the name of the husband and the number of children. The vocabulary is limited because there are so many repetitions.

What would be known of the English language if there were hardly anything but tombstones left to read? Very little. And of Etruscan there is even less. We know the words for 'father', *apa*, and 'mother', *ati*. We do not know the word for 'husband': Etruria was not a matriarchy, so that we know only the name of the 'wife (*puia*) of so and so', not the 'husband of so and so'. We know the word for 'brother', *ruva*, but not for 'sister'.

Only a few of the preserved texts are of any length.

1. The longest known Etruscan text is a sacred linen book, parts of which were preserved by being used as linen bandages on a mummy, found in the mid-nineteenth century in Egypt by a Croatian traveller. The mummy was given in 1862, after his death, to the Zagreb National Museum in Croatia, where it is still preserved today. How this text came to Egypt in the first place is not known. Perhaps some Etruscan brought it there and then threw it away. A poor Egyptian, who could not afford to buy new bandages, might have used this cloth, after cutting it up into strips, to wrap up the mummy of his relative or friend, the woman who was found inside them. Even as it is, spotted and damaged by blood and the unguents used for mummification, it is uniquely precious (*TLE* 1) (Source 67, fig. 57).

 The text clearly represents some kind of sacred calendar, but its detailed interpretation is largely doubtful. It contains prayers, names of gods, dates (the words 'day', 'month', and 'year' appear). There are at least twelve vertical columns, containing about twelve hundred readable words. As is often the case with religious texts and prayers, there are many repetitions. The actual number of vocabulary entries this text brings is little more than fifty.

2. The next-longest inscription is on a tile from Capua, of the fifth century. Sixty-two lines are preserved, with almost three hundred words that can be read (*TLE* 2).[19]

3. A text written on both sides of a lead plate, found in fragments near Santa Marinella on the sea, dates from around 500. Inscribed in a miniature style, it contains traces of at least eighty words, of which forty or so can be read with certainty (*TLE* 878).[20]

4. A small, lenticular-shaped lead plate found at Magliano (probably dating from the fifth century) has a strange spiral inscription, running from the exterior margin inwards toward the centre. There are about seventy words (the division of words is not always clear) (*TLE* 359).[21]

5. An important find took place at Pyrgi, the harbour of Caere, in 1964: three gold tablets, of which two are in Etruscan and one in Phoenician, recording the same event; a fourth text, in bronze and fragmentary, also

had an Etruscan inscription. These date from around 500. The longest Etruscan inscription has sixteen lines and thirty-six or thirty-seven words (*TLE* 873–876) (fig. 5, see text, below).

6. Among the later inscriptions, on stone, is a cippus (probably a boundary stone) from Perugia: on two of its four faces is a sharply engraved inscription of forty-six lines and a hundred and thirty words. The date is the third or second century (*TLE* 570) (Source 64, fig. 54).

7. Similar to the Perugia cippus in date and content is an important recent find (presented in 1999) which now takes its place as the third longest Etruscan inscription: the *Tabula Cortonensis*, a bronze tablet the size of a large sheet of paper, around 28 × 46 cm, inscribed on both sides. It was broken into eight pieces: one of these is missing. Around two hundred words include the names of the people for whom the contract was written, and of the witnesses, as well as the titles of two magistrates. Florence, Museo Archeologico (Source 65, fig. 55).

8. The famous bronze model of a sheep liver from Settima, near Piacenza, is divided into many sections, each of which contains the names of one or more gods (there are fifty-one names listed, but several are mentioned twice or three times). The sections of the liver correspond to the sections of the sky which were under the protection of each of the gods. There was a mystic correlation between the parts of a sacred area, like the sky, and the surface of the liver of a ritually sacrificed animal. A teaching device, it was meant to be used by the Etruscan priest for his divinatory practice of reading the entrails of animals. According to the place where the liver of a sacrificed animal showed some special mark, the priest could read the future, or even bend it to his will. The Etruscans were particularly skilled in this haruspicina, or science of reading omens, and the Romans respected, hired, and imitated them. A number of names of divinities appear not only on the liver, but also in a copy of an ancient text that Martianus Capella (fifth century AD) included in a Latin work, *The Marriage of Mercury and Philology*.[22] This work was enormously popular throughout the Middle Ages, thus preserving some of this esoteric lore into modern times (Source 60, fig. 51).

9. The *elogium* or epitaph of Laris Pulenas of Tarquinia is engraved on a roll held by the figure of the dead man, who reclines on his stone sarcophagus as if on a couch. It has nine lines and fifty-nine words, which can be in large part interpreted by means of a comparison with the Latin *elogia* of the Scipios at Rome (*TLE* 131) (Source 31, fig. 28).

One may ask why so many Etruscan texts are religious. Ancient authors familiar with Etruscan customs offer an answer. Livy (5.1.6) describes the Etruscans as *gens ante omnes magis dedita religionibus,*

quod excelleret arte colendi eas, 'a people more concerned than any other with religious matters, especially since they excelled in the skill of cultivating them'. St Augustine (*Adversus Gentes* 7.26) said that Etruria was *genetrix et mater superstitionum*, 'the parent and mother of superstitions'. The Etruscans surely had literary texts and a certain Volnius, we are told, wrote Etruscan tragedies. But what has come down to us are religious writings, legal documents, and funerary epitaphs. The reason must be that the Romans were interested in and therefore carefully preserved the teachings of Etruscan prophets and technical treatises on divination and haruspicina, while literary or dramatic texts in the Etruscan language were no longer needed when such texts became available in Latin, the language which became prevalent.

4 Stele from Lemnos, sixth century BC. Athens, National Museum

Shorter inscriptions, too, are of great importance. Painted inscriptions labelling figures in wall paintings in the tombs of Tarquinia and on engraved mirrors illustrating scenes drawn from Greek mythology make the interpretation of many words easier. The frescoes from the François Tomb at Vulci are particularly interesting, for they are historical, and celebrate victories over Rome (Source 54, fig. 50). Other, shorter inscriptions occur on mirrors, painted vases, armour, furniture, coins, votive offerings, and a variety of monuments.

Many of the names of divinities, heroes, and heroines of myth which occur on mirrors and in tomb paintings are Greek. Even when they have Etruscan names, many of them seem to be Greek divinities in Etruscan dress, except for such figures as Tuchulcha, or Charu, a frightful demon quite unlike the Greek Charon. See 'Mythological Figures' below.

Haruspicina, in contrast, an Etruscan speciality known to us especially from the Piacenza Liver, preserved the names of Etruscan divinities who were worshipped. *Nethuns* and *Selvans* could be Etruscan names of Latin origin – *Selva* or *Selvans* derives from *silva*, 'forest', a Latin word of uncertain derivation. The etymology of *Uni* is uncertain: Latin *Iuno*, with which it is connected – *-i* is the feminine ending in Etruscan – could be of Etruscan origin. In the *haruspicina*, a technique on which depended the very existence of the Etruscan people, the names are national. In myth, on the other hand, Greek names and types of divinities and heroes were freely admitted.

We must now consider a remarkable inscription from outside Etruria written in an alphabet and a language akin to Etruscan. This relatively long inscription appears on a stele with the figure of a warrior, found in 1885 at Kaminia on the island of Lemnos and dated to the sixth century. Its 198 letters form thirty-three words (fig. 4). As is normal in archaic Greek and Latin, the direction of part of the inscription is boustrophedon. Following is a transcription (A and C are in boustrophedon):

A. (front) *holaieś naphothśiaśi*
 maraś: mav
 sialchveiś aviś
 evistho śeronaith
 sivai

B. (front) *aker tavariśio*
 vanalasial śeronai morinail

C. (side) *holaieśi: phokiasale: śerosaith evistho toverona* [...]

rom: haralio: śivai: epteśio arai tiś phoke
śivai aviś sialchviś maraśm aviś aomai

It is a funerary inscription, referring to the grave (*tavariśio*) of Holaie, a man of Phokia, on the Ionian coast of Anatolia (*phokiasale, phoke*) who died when he was forty (*sialchviś*) years (*aviś*) old. For the type of monument we can compare a number of funerary steles from northern Etruscan cities, on which the profile of the armed warrior is represented, with the inscription incised at the side (Sources 14–17, figs 18–21). Although the inscription cannot be called Etruscan, there are a number of striking similarities. Words are separated by two dots. The alphabet used is derived from the Western Greek, that is, Chalcidian (actually Euboean) alphabet. There are no signs for the voiced consonants *b*, *d*, or *g*. The language is similar: grammatical endings, and even some expressions are close to Etruscan. There are such remarkable similarities as the parallel phrases recording dates: 'Lemnian' *holaieśi phokiasale*, 'in the magistracy of Holaie the Phokian', and Etruscan *velusi hulchniesi*, 'in the praetorship, that of Vel Hulchnie' (*ET* Ta 5, 415). The formula indicating the age of the dead man is *aviś sialchviś*; 'of forty years': we can compare an Etruscan inscription which speaks of a woman who died *avils machs śealchls*, '(when she was) five-and-forty years old'. But the differences, including the presence of the vowel *o*, which appears several times, show that the languages, though related, are not identical. The stele is not the only inscription of this type, though it is by far the longest. There is general agreement about the existence of a relationship between Lemnian and Etruscan, though not about the possible significance of the presence of Etruscan inscriptions on Lemnos.[23]

Etruscan language studies have from the first been a field of research filled with discoveries, successes and surprises, along with forgeries, starting with those included in Annio di Viterbo's (1432–1502) collection of Etruscan inscriptions, and wrong turns, including Michael Ventris's original hypothesis, which he continued to hold until 1952, that the language of Linear B might turn out to be Etruscan. Contrary to what many believe, Etruscan was already read almost completely two hundred years ago by Luigi Lanzi (who died in 1810) in a three-volume work, *Saggio di lingua etrusca e di altre antiche d'Italia* (1st edn 1789, 2nd edn 1821–25). He understood the pronunciation of Μ as a sibilant (perhaps Greek Ξ, four-bar sigma turned around, as frequently happens with alphabets). The correct interpretation of Ι as *z*, on the other hand, we owe to R. Lepsius (*De Tabulis Eugubinis*, 1883). German

and Italian scholarship have made important contributions to the study of the language, in the early nineteenth century with the work of R. Lepsius, K. O. Müller (*Die Etrusker*, 1828), and E. Gerhard (*Etruskische Spiegel*, beginning in 1840). Soon after, the Italian Fabretti was the author of the *Corpus Inscriptionum Italicarum* (1867) and G. F. Gamurrini, of the *Supplementi* to the *CIE* (1872, 1874, 1878). Other important studies are those of W. Corssen (in spite of some serious mistakes) and W. Deecke. C. Pauli (1878 and later), together with O. A. Danielsson, G. Herbig, and A. Torp, published the *Corpus Inscriptionum Etruscarum* (1893–1902). Important contributions were made by E. Fiesel (who interpreted X as *ś*, 1936), M. Runes, K. Olzscha, A. J. Pfiffig, and most recently H. Rix, whose *Etruskische Texte* (1991) constitutes an invaluable repertory of inscriptions, organized by provenance. From the beginning of this century, with E. Lattes (*Correzioni al CIE*, 1904), F. Ribezzo, M. Pallottino, M. Cristofani, C. de Simone and others, Italian scholars have been extremely active. Publication of the *CIE* (1970, 1980) has continued in Italy. The Istituto di Studi Etruschi, in Florence, has organized yearly Congresses, whose *Atti* are regularly published. It has held two International Congresses, in 1928 and 1985, and sponsored numerous exhibits, research projects and publication series, not least *Studi Etruschi* since 1927, which includes the *Rivista di epigrafia etrusca*, the annual survey of new inscriptions and new readings, and the ongoing *Thesaurus Linguae Etruscae*, as well as the *CSE*, and other corpora. The *Consiglio Nazionale delle Ricerche* also maintains, since 1970, the Istituto di Studio per l'Archeologia Etrusco-Italica in Rome, which carries out projects in collaboration with the Archaeological Soprintendenza, the Istituto di Studi Etruschi, and the University of Rome. These two centres thus span the territory of the historical Etruscans from the Tiber and the Arno – from Rome and Florence.

5 Pyrgi tablets with Phoenician (Punic?) and Etruscan inscriptions, c.500 BC

CHAPTER III

THE STUDY OF THE ETRUSCAN LANGUAGE

Scholars have made cautious but steady progress toward the under-
standing of the language by using a variety of methods, including the
close study of bilingual inscriptions, of glosses, comparisons with other
languages, archaeological context, and internal evidence.

BILINGUAL INSCRIPTIONS

We have more than forty Latin–Etruscan bilingual inscriptions.[24] These
are unfortunately not nearly as helpful for the understanding of Etrus-
can as the Rosetta Stone was for our understanding of Egyptian. Not
only are most of them very short; they also contain free translations,
as might be expected, rather than exact word-by-word equivalents.

The discovery at Pyrgi in 1964 of three gold tablets with inscriptions
of some length in Etruscan and Phoenician (fig. 5) was an outstanding
event in the history of Etruscan studies, and allowed scholars to make
some progress, though not great strides, in understanding the language
of the Etruscans. Their greatest contribution was in the fields of religion
and history. Found at the sanctuary of Pyrgi, the port of Caere (Cer-
veteri), the Etruscan city which most influenced Rome and served as
mediator for Greek culture in Italy, they give tangible proof of the
Phoenician presence in Italy at the end of the sixth century (just as the
Greek sanctuary at Gravisca emphasized the importance Greeks had
in Etruria in the Archaic period). Of the three gold tablets, the one in
Phoenician script and the longer of the two Etruscan ones can be said
to be 'quasi-bilingual'. The fact that the ruler of Caere felt it necessary
to publish a Phoenician translation of his religious dedication may attest

to a close relationship with Carthage, or with Cyprus, another important Phoenician centre at this time.[25]

The approximate dimensions of the tablets are 19 × 9 cm. The Phoenician inscription consists of eleven lines and some thirty-nine words (not counting prefixes or suffixes). The longer Etruscan inscription, containing sixteen lines and thirty-six or thirty-seven words, is one of the longest Etruscan inscriptions found to date. The shorter Etruscan inscription has nine lines and fifteen words (*TLE* 874–875).

Both the longer texts record a historical event: the dedication of a cult place and perhaps a statue to the Phoenician Astarte, or Ishtar, here identified with the Etruscan Uni (and thus the Roman Juno), by Thefarie Velianas, the ruler of Kyšry' (the Phoenician name for the city of Caere or Cisra). This he did out of gratitude for a favour the goddess had granted him – perhaps because she had raised him to power – in the third year of his reign.

The Phoenician inscription is more specific about these events, recording the exact months when they took place, and, for the favour received, the exact day. The future is counted as being as many years long 'as these stars'. There is a question as to whether this means 'years without number', or whether it refers to some precise number of years.

The longer Etruscan inscription (A) describes, additionally, rites carried out in reference to the events by which the goddess's favour had evidently shown itself.

The shorter Etruscan inscription (B) refers to other ritual procedures established by Thefarie Velianas to be carried out annually, or at the anniversary of the foundation of the sanctuary.

Phoenician inscription
LRBT L'ŠTRT 'ŠR QDŠ
'Z 'Š P'L W'Š YTN
TBRY'. WLNŠ MLK 'L
KYŠRY'. BYRH. ZBH
ŠMŠ BMTN' BBT WBM
TW. K'ŠTRT.'RŠ. BDY
LMLKY ŠNT ŠLŠ III BY
RH KRR BYM QBR
'LM WŠNT LM'Š 'LM
BBTY ŠNT KM HKKBM
'L

For the Lady, for Astarte (is) this holy place which Thefarie Velunas (TBRY' WLNŠ), king over Kaysrye (KYŠRY'), made, and which he put

in the temple in Mtn, the month of solar sacrifices. And he built a chamber because Astarte requested (this) from him, year three of his reign, in the month of KRR, on the day of the deity's interment. And (as for) the years of one who makes a gift to the deity in her temple, (may) these (be) years like the stars.

(Translation: Philip Schmitz, *JAOS* 115 (1995) 559–575).

Etruscan inscription A
ita. tmia. icac. he
ramaśva [.] vatieche
unialastres. themia-
sa. mech. thuta. thefa-
riei. velianas. sal.
cluvenias. turu-
ce. munistas. thuvas
tameresca. ilacve.
tulerase. nac. ci. avi-
l. churvar. teśiameit
ale. ilacve. alśase
nac. atranes. zilac-
al. seleitala. acnaśv-
ers. itanim. heram-
ve. avil. eniaca. pul-
umchva.

This is the temple (or chapel, cella) and this is the place of the statue (?) which he has dedicated to Uni-Astarte, the lord of the people (or king, or tyrant), Thefarie Veliana, *sal cluvienias* (?), he gave it, this one place (?); since on the one hand she raised him for three years (in the third year?) in this way, *churvar tesiameitale* (?) and since on the other hand he has been protected, here is the statue (or: in the month of August); (and may the) years (be) as many as the *pulumchva* (?) (stars?).

Notes

Thefarie in Etruscan = TBRY' in Phoenician, cf. *Tiberius* in Latin, and the Etruscan name *Thybris*, all related to the Tiber River.[26] Tiberius, found in Latin only much later, seems to have been a common Italic name much earlier than was thought. North Etruscan examples of names include *Thefri, Thefrina, Thepri, Theprina.*
ci avil = three years = ŠNT ŠLŠ III (three bars in the Phoenician text).

Etruscan inscription B
nac. thefarie. vel-
iiunas. thamuce
cleva. etanal.

<div style="text-align:center">

masan. tiur-
unias. śelace. v-
acal. tmial. a-
vilchval. amuc-
e. pulumchv-
a. snuiaph

</div>

(Thus) here Thefarie Veliuna established; the offering of the *etan* in the month of *masan* he offered; for the annual purification of the temple he made celestial (or numerous, or fruitful) *snuiaph* (ritual driving of the nails, or rites).

Notes

pulumchva – this word, appearing near the end of both inscriptions, has been connected with the Phoenician word for 'stars'. It has a collective ending.
avilchval – has the same root (*avil-*) as the word *avil*, meaning 'year'; here, therefore, translated as 'yearly', or 'anniversary'. *vacal tmial avilchval amuce*: 'the rite [libation] of the temple has been an annual one'?

If the Phoenician text was Punic, as many have thought, and Carthaginians were involved, Rome's paranoia in regard to this hated rival can be better understood. The close political alliance between Carthage and the Etruscan ruler of Caere implied by these inscriptions would agree with Aristotle's statement about the constitution of Carthage and the Etruscans – Etruscans and Carthaginians were so close, he says, as to form almost one people. The discovery of the inscription also tends to corroborate the account that Carthage and Rome signed a treaty in 509, perhaps confirming an earlier one between Carthage and the Etruscan king of 'Rome of the Tarquins', which re-emerges as an important, powerful city flourishing under Etruscan rule.[27]

The other forty or so bilingual inscriptions in Latin and Etruscan are in most cases short funerary epitaphs of the second and first centuries. Of lesser historical importance, they nevertheless provide information concerning Etruscan language and society and the relation between the Etruscan cities and Rome near the end of the period of Etruscan independence. We learn about the chronology of the language shift from Etruscan to Latin in the various Etruscan cities. We learn the word for 'freedmen', *lautni*, and the names of priesthoods, and see how Etruscans acquired Roman praenomina when they became Roman citizens.[28]

Here is an example (missing letters have been supplied and abbreviations expanded):

Etruscan: *cafates l(a)r(th) l(a)r(is) netśvis. trutnvt. frontac.*
'Cafates Larth son of Laris, *haruspex*, priest, interpreter of thunderbolts'

Latin: *L. Cafatius. L(uci) f(ilius) Ste(llatina tribu) haruspex fulguriator.*
'Lucius Cafatius, son of Lucius, of the Stellatina tribe, *haruspex*, interpreter of thunder bolts'
(TLE 697; Benelli, *Le iscrizioni bilingui*, 1; stone, from Pesaro)

A problem here is that we have three words (*netśvis, trutnvt, frontac*) where the Latin has two (*haruspex, fulguriator*). What is the translation of each of the Latin words? Both *netśvis* and *trutnvt* occur at the end of two other Etruscan funerary inscriptions after the name and patronymic of the dead man, and therefore indicate his profession, some kind of priesthood. But what of *frontac*? Apparently it goes with *trutnvt*: the Etruscans used a phrase with two words to indicate a priesthood which in Latin had a single name, *fulguriator*.[29]

Here is another bilingual:

Etruscan: *cuinte. śinu. arntnal*

Latin: *Quintus Sentius L(uci) f(ilius) Arria natus*
'Quintus Sentius, son of Lucius, son of Arria'. (*TLE* 523; Benelli, *Le iscrizioni bilingui*, 13; on an urn from Chianciano)

Cuinte is obviously the Etruscan transcription of *Quintus*; *śinu*, a *cognomen* used by the Seiante family, is here used as the equivalent of *Sentius*. *Arntnal* is the genitive of 'son'. The Etruscan has only the matronymic, *arntnal* (*ar[u]ntal*), '(son of) Arntna', translated as 'Arria natus', with *Arntna* (or *Arntni*) Latinized as *Arria* (from *Arrius*). The Latin inscription adds the patronymic *L(uci) f(ilius)* to the Etruscan matronymic.

In another inscription the Etruscan has a matronymic, *Cahatial*, genitive of the *Cahati* family name (*nomen gentile*) of the mother (*-i* is a feminine ending in Etruscan). The Latin translation is *Cafatia natus*, or 'son of Cafatia'. The whole text reads:

Etruscan: *pup(li). velimna au(le) cahatial*

Latin: *P(ublius) Volumnius A(uli) f(ilius) Violens Cafatia natus*
'Publius Volumnius, son of Aulus, Violens, son of Cafatia'
(*TLE* 605; Benelli, *Le iscrizioni bilingui*, 7; from Perugia, tomb of the Volumnii, in the Palazzone cemetery)

Pup(li) shows the Etruscan *p* for Latin *b*; *velimna* corresponds to *Volumnius*, *au(le)* to *Aulus*. When he became a Roman citizen, this *Publius Volumnius* added the Latin cognomen, *Violens*, to his Etruscan

name. We are in the time of Augustus, in the last gasp of Etruscan civilization, as shown by the decoration of the sarcophagus in the main tomb of the Volumnii.

Another bilingual inscription, all in Latin letters, reads as follows:

Etruscan: *arnth spedo thocerual clan*
 'Arnth Spedo son of Thoceru' (*CIE* 714)

Latin: *Vel Spedo Thoceronia natus*
 'Vel Spedo son of Thoceronia'
 (cf. *Arria natus*, above) (*CIE* 715)

This marked the grave of two brothers, Arnth and Vel. (Their name, Spedo, shows Latin influence in the *d*.) We have here *clan* = *natus* (or *filius*). We already knew that *clan* meant 'son'. Here too, as in a previous Etruscan inscription, only the name of the mother – Thoceru – is recorded. What is particularly interesting about this inscription is that the Latin is not a translation of the Etruscan. Each inscription is a separate epitaph for each of the two brothers: one brother, more conservative, records his name in Etruscan; the other uses Latin. This is the only Etruscan inscription where – certainly under Latin influence – the letters *d* and *o* are used. The name Spedo very probably stands for Etruscan *Spitu*, known from other Etruscan inscriptions (Source 59). *Spedo* is unknown in Latin.[30]

Here is another bilingual, also on an urn from Perugia (*TLE* 606; Benelli, *Le iscrizioni bilingui* 25; *CIE* 3692), on two lines, one Latin, one Etruscan:

Etruscan: *larth scarpe lautni* (on the body of the urn)
 'Larth, freedman (of the family) of Scarpe'

Latin: *L(ucius) Scarpus Scarpiae l(ibertus) popa* (on the cover)
 'Lucius Scarpus, freedman of Scarpia, priestly assistant'

Lautni means *libertus*, 'freedman', as in many other inscriptions. *Scarpe* has the usual nominative ending of Etruscan personal masculine names (thus *marce* = Latin *Marcus*, *plaute* = Latin. Plautus, tite = Latin *Titus*.) The extra word in the Latin inscription, *popa*, is the title given to the priest's assistant who, at a sacrifice, killed the animal with an axe.

From Montepulciano, near Perugia, comes another bilingual inscription, also late Etruscan. (It is not a coincidence that so many bilingual inscriptions were found at or near Perugia; this Umbrian city, though heavily influenced by the neighbouring Etruscan culture, was not originally Etruscan-speaking. The native language was Umbrian, and in fact we have Umbrian inscriptions from that area.)

Etruscan: *larthi lautnitha preśnts*

Latin: *Larthi lautnita Praesentes*

Both inscriptions translate as 'Larthi, freedwoman of Praesens'. The Latin text was written by an Etruscan stonecutter, evidently the same person who wrote the first line in Etruscan, who knew little Latin, and he writes the inscription right to left, the Etruscan way. He writes *lautnita*, an Etruscan word, instead of *liberta*, and *Praesentes* instead of *Praesentis* (in the genitive case, 'of Praesens').[31]

GLOSSES

Glosses, words translated into Latin or Greek and preserved for us by Roman or Greek authors, are also of use for our knowledge of Etruscan vocabulary (see below 'Glosses', Part three).[32]

A number of the glosses that have come down to us preserve genuinely Etruscan words. Of Etruscan origin may be the name of the entrance hall of the Roman house, the *atrium*. *Aisar*, which we are told by Roman authors, means 'god' in Etruscan (it actually seems to mean 'gods', in the plural); *uerse* (*uersum*) means 'fire'. *Aclus* is 'June'. Sometimes these translations can be checked from the inscriptions: the text of the Zagreb mummy wrappings, for example (Source 67), has *aiser*, 'gods' and *acale*, 'June'.[33]

The great majority of glosses refer to words commonly used in the *Etrusca disciplina*, the technique by which Etruscan haruspices read the will of the gods in the flight of birds, in lightning, thunder, or in the entrails of animals. Names of animals and plants derive from books on medicinal magic herbs.[34] Particularly interesting are the glosses informing us that the Etruscan word for 'monkey' is *arimos*. The word in Greek is *pithekos*: so *Pithekoussai*, the ancient name for the island of Ischia, may have meant 'monkey island'. Another ancient name for *Pithekoussai*, Latin *Inarime*, may be the Etruscan name, also meaning 'monkey island'.[35]

Also important is the information that *lucumo* means 'king' in Etruscan. Lucius Tarquinius, who became king of Rome and founded the dynasty of the Tarquins, may have been originally called *lauchume*, Latin *lucumo*, or 'king'; his name may have been changed to Lucius when he became, so to speak, naturalized at Rome.[36]

A number of these words were not really Etruscan, but in a later period seemed to Greek and Roman scholars to belong in the context

of the Latin debt to Etruscan civilization, and were therefore thought to be of Etruscan origin. This may be the case for words connected with music, like *subulo*, 'pipe-player', or arms, like *balteus*, 'sword belt'. Neither can be purely Etruscan, because of the *b*, which the Etruscans did not use: but *subulo* may have been Latinized from *suplu*. This material must obviously be used with caution. Other words identified as Etruscan in glosses, or 'explanations', by Greek authors, written in Greek letters, are also not Etruscan at all: *dea*, 'goddess', and *kapra* (Latin *capra*), 'goat', are Latin words, not Etruscan, as their Greek glosses claim (*TLE* 851, 816, 828, 820). The letters *g*, *d*, and *b*, as we have seen, do not exist in Etruscan. The word *italos* is not Etruscan, although it has been claimed as such. *Italos*, that is *uitulus* (diminutive *uitellus*, from which derives the English word 'veal'), 'calf' in Latin, is the word from which *Italia* (Italy) derives. (A. Walde, J. B. Hofmann, *Lateinisches etymologisches Wörterbuch*, 3rd edn (Heidelberg, 1930–56) s.v. Dionysius of Halicarnassus, *Roman Antiquities* I.35; Varro, *On Agriculture*, II.5.3.) It was originally an Oscan word, which the Greek colonists of southern Italy adopted from the natives. Later Greek authors mistakenly attributed this word to the Etruscans in Italy, just as they attributed to them other words which came from Italy, and they knew were not Greek. The Greeks did not always distinguish clearly between the Etruscans and other peoples of Italy: 'For there was a time when the Latins, the Umbrians, the Ausonians and many others were all called Tyrrhenians by the Greeks' (Dionysius of Halicarnassus 1.29.1). When Rome was under Etruscan cultural influence and political domination, the Greeks must have thought of a Roman as an Etruscan. (In the same way we might say that someone is 'French' if he has a French passport, though he might be Basque, Flemish, Alsatian, or Corsican by birth and language.)

Some glosses are clear, but not very useful. Yet the statement that '*nepos* is an Etruscan word', which we find as a gloss, is quite correct: it confirms that the Latin word *nepos* occurs in the Etruscan language, a fact we already knew from the inscription on the roll held on the sarcophagus of Laris Pulenas from Tarquinia, for example, where the word *nefts* appears.

A close study of Latin vocabulary reveals numerous debts to Etruscan. Most of these words occurred in the area of luxury and higher culture: the Etruscans introduced into Rome the words *persona* (from *phersu*), *taberna*, *lacerna*, *laena*, *histrio*, as well as *atrium*. The very word for 'writing', *litterae* (from Greek *diphthera*, 'skin') came into Latin via

Etruscan, just as the Greeks adopted the Semitic word *deltos* for their writing-tablets.[37] The Latin word *elementum*, which according to a number of scholars comes from Etruscan, has as its earliest meaning, which it still maintains in Latin, 'letter of the alphabet'. An early word, **elepantum*, from Greek *elephas*, 'ivory (object)' has been proposed as the origin of *elementum*. And indeed the tablet from Marsiliana with the inscribed alphabet, as well as the inscribed 'Tuscania' dice, are of ivory (figs 7, 12). In favour of an Etruscan rather than a Latin origin is the fact that we would expect the Latin to be **olimentum* since velar *l* would cause the *e* to become *o*, and the *ĕ* in the second syllable would become *i*.[38] These two very important words would confirm the Etruscan origin of the alphabet in Rome: Latin *elementum* and *littera*.[39] (The same origin has been suggested for the Latin words for writing instruments, *stilus*, and the material used in wax tablets, *cera*.) None of these could have directly come from Greek. And what other way if not through the language of the Etruscans, given the high level of their culture in the Orientalizing and Archaic periods, and given the penetration of their alphabet in peninsular Italy? All these words of Etruscan origin of course tell us more about the relations between Rome and her Etruscan neighbours than about the Etruscan language.

OTHER METHODS FOR THE STUDY OF ETRUSCAN

The so-called 'etymological method', which involves a comparison of Etruscan with other languages, living or dead, was widely used until about 1885, but gave little or no results. Though now generally abandoned by scholars, a naive brand of it continues to flourish in amateur circles. There is hardly any language in the world which has not at some time been compared to Etruscan: Greek, Armenian, Turkish, Aztec, Hittite, and many others. Aside from that of the inscription from Lemnos, there is no other known language to which Etruscan can be related. There are a number of Greek words in Etruscan, and there were certainly exchanges, in historical as well as prehistoric times, between the neighbouring Latin, Etruscan, and Italic languages, for example in the field of personal names. The Etruscans learned to drink wine in Italy, and they learned what was by then the local word for it, *uinum*.[40] But these contacts have nothing to do with the basic nature of the language or its origin.

A number of scholars have used the technique of 'combinatory'

analysis. This internal, inductive method, which was in part a reaction to the failure of the etymological method, resulted in considerable progress in the study of Etruscan grammar and in the translation of some inscriptions. Just as codes to which we do not have the key can be deciphered by trying out different combinations of letters until the right one is found, so in Etruscan different words are tried out in different contexts. Obviously the meaning of a particular word must make sense in the contexts in which it appears and make a proper 'combination'. This method has been useful, but it is too limited to be used by itself.

Another approach is the 'quasi-bilingual', or cultural method. The cultures of Italy were in close contact and similar in many ways. It is therefore reasonable to expect that a number of formulas were used in most of these languages (just as the English expression *took place* has an equivalent in French *eut lieu*, or Italian *ebbe luogo*). Rituals described on the mummy bandages in Zagreb are, for example, comparable to those of another text, that of the Umbrian Iguvine Tables. The funerary epitaph, *elogium*, on the roll of the Tarquinia sarcophagus of Laris Pulenas (Source 31, fig. 28) recalls the Latin epitaphs of members of the noble Roman family of the Scipios, likewise inscribed on their stone sarcophagi.[41] The 'cultural' approach interprets words in the context of the object on which the inscription is found. A tomb, for example, will give us the names and titles of the people buried there, while a vase will be inscribed with the owner's name or the name of the god to whom it is dedicated or offered.

There are also 'picture bilinguals'. Engraved bronze mirrors, vase paintings, and tomb paintings from Tarquinia have inscriptions which label or explain the various figures in the scene being illustrated (cf. Sources 5, 32–45, 49–50).

THE ALPHABET AND
PRONUNCIATION
. OF ETRUSCAN

Alphabets when they are first used are strictly phonetic, that is they reflect the actual pronunciation. Etruscan[42] never developed a 'historical' spelling, as used in English (where e.g. the *oo* of *spoon*, once pronounced with a long *o*, now has the same sound as the *u* in *rule*). In Etruscan an *a* (as in *father*) is therefore always pronounced *ah*; *e* was always *eh*; *i* (as in *machine*) is always *ee*; *u* was *oo*. Changes in pronunciation, during the approximately seven centuries when Etruscan was spoken and written, were regularly reflected in the spelling (so when *ai* became *ei*, and eventually *e*, it was spelled the way it was pronounced: *Aivas*>*Eivas*>*Evas*).

The Etruscans copied the Greek alphabet as they had learned it in the so-called 'model' alphabets (figs 2–3, 6, 11. Marsiliana d'Albegna, *c*.650. Source 1, figs 11a, 12) which they used for didactic, decorative, and perhaps magic purposes. But for practical purposes they dropped those Greek letters they did not use: *d*, *b*, and *o*. For the sound *k* (English *think*) they used three signs: *k* before *a* (*ka*); *c* before *e* and *i* (*ce*, *ci*); and *q* before *u* (*qu*). Such a distinction is exclusively phonetic, that is articulatory, but has no semantic or 'phonemic' value. The same system was used in early Latin. In English the three letters survive (*kernel*, *cat*, *quit*), but the distinction between them is purely conventional, representing an orthographic tradition and not any phonetic differences.[43]

Since they did not have voiced stops, the Etruscans used the third letter of the Greek alphabet (*gamma*: Γ or C) with the value of *k*. Imitating the Etruscans, the Latins did the same (note Latin *cena*, *corium*, *cura*, *catena*, *ciuis*). The *k* of early Latin survived before *a* in a few words (*Kaeso*, *Karus*, *Kalendae*).[44] Further proof of the influence

Etruscan alphabets			
Model alphabet	Archaic seventh–fifth century BC	Neo-Etruscan fifth–first century BC	Transcription
A	A	A	a
B			[b]
C))	c
			[d]
E	E	E	e
F	F	F	v
I	I	I	z
B	B	B	h
⊗	⊗ ⊙ X	O	th
I	I	I	j
X	X	X	k
L	L	L	l
M	M M	M	m
N	N N	N	n
⊞			ś [o]
O			[o]
P	P	P	p
M	M X	M	ś
Q	Q	Q	q
R	R R	R	r
S	S S S S	S 3	s, š
T	T	T	t
Y	Y V	V	u
X	X		ṡ
Φ	Φ	Φ	ph
Y	Y	Y	ch
8	8	8	f

Etruscan numerals	
I	I (1)
Λ	V (5)
X	X (10)
↑	L (50)
C X	C (100)
⊙	C (100) or M (1,000)?
⊕	M (1,000) or M̄ (10,000)?

6 Table of Etruscan alphabets and Etruscan numerals

of Etruscan on the Latin alphabet is the use of *q* in *qualis, quattuor, queritur, quidam, quoque,* etc. For the sound *g,* which the Latins also pronounced,[45] they introduced, around 250 BC, a new letter, G (a slight modification of C, adding a little mark to it). In order not to change the order of the alphabet, this new letter G was placed in the slot of the ancient Z, which at that time the Latins no longer used (it had formerly had the value of English *z-* as in *zeal, zoomorphic,* etc.). Later, in the first century BC, more intimate contact with the Greeks brought with it the need for Z in order to write Greek words. The Latins then reinstated this letter Z, which, having lost its place in line, was put at the end, where it is today.

Both the Etruscans and the Latins eventually simplified the system of the velars. Arezzo and Cortona in the north kept only *k,* while the southern cities kept only *c.* In Latin, *c* was generally used (under Etruscan influence), except before the semivowel *u* (as in *qualis*). The letters *c* and *q* are still used this way in English (*candy, quiz*).

The letter *z* in Etruscan always had a voiceless sound, as *ts* in English *gets, cats* (not as in *zeal*).

The Etruscan *v* was certainly bilabial, like Latin *u* in *uincit* (English *w*), since diphthongs like *au* are frequently spelled *av*: so *lautni: lavtni; avle: aule.*[46] There was often an oscillation between the two: *puina* and *pvinei, tiurs* and *tivr* and so on.

Since the Etruscans only had the voiceless stops *k, t,* and *p,* they changed the letters *g, d,* and *b* whenever these appeared in foreign words – Greek, Latin or Umbrian – to *k, t,* and *p.* (These they pronounced as in the English words *skin, stay, spun,* or like the final consonants in *think, spit,* and *thump.*) Thus from the Greek word *amorge* came the Latin word *amurca,* 'oil dregs', by way of Etruscan. The Etruscans also wrote (and no doubt pronounced) *creice* for *Graecus* (*TLE* 131. Source 31, fig. 28. Cf. *Kraikalu, ET* Fa 2.7). Etruscan also had the aspirate voiceless stops *χ, θ,* and *φ,* which we will transcribe in this volume as *ch, th,* and *ph.* These aspirate consonants were pronounced something like initial *k, t,* and *p* in *kin, tin,* and *pin.* (The difference between voiceless aspirate and non-aspirate consonants is one which the speaker of English hardly perceives: it is a distinction which has no semantic or phonemic value in English, as it had in Etruscan – and has today in Chinese.)

In Etruscan each *letter* represents one *sound* and one *phoneme,* except for *s* and *ś,* which may be allophones or variant forms of a single phoneme. The alternation of *c: ch, t: th; p: ph* may be due to a purely

graphic oscillation, but *puia* is always written with *p*, and *thesan, thancvilus* with *th*.

There were several ways of representing sibilants, though not all were used at the same time in the same area. Four appear on the 'model alphabet' of the seventh century (fig. 11): the three-stroke *sigma* ≷; *samech* ⊞; *sade* M (as in the archaic alphabet of Corinth); and a special cross sign X. In the Archaic period in the north two signs were used, the three-stroke *sigma* ≷ and *sade* M. In the southern cities, such as Veii and Caere, and in Campania, the four-stroke *sigma* ⧢ was used as a variant of the three-stroke *sigma* ≷; in the area of Caere, around the end of the sixth century, this sign was used to represent a phoneme in opposition to the three-stroke *sigma* ≷, representing another phoneme. In the southern cities of Veii, Caere, and Tarquinia the cross sign also took the place of the three-bar *sigma* in the Archaic period (from the end of the seventh to the mid-sixth century). And at Caere, in the later period, a new sign, something like a 3, was developed from the Greek four-stroke *sigma* **3**. Typical of the north Etruscan cities is the spelling of *s* with a *ś* (M).

We do not know for certain how these various *s*-signs were pronounced. They seem to have represented only two different sounds, since the Etruscans usually used only two different signs concurrently at any one time. Scholars conventionally distinguish four signs in transcribing Etruscan inscriptions. We will distinguish only two: *s* and *ś*, perhaps pronounced as *s* in *sin* and *sh* in *shin*, respectively. M is transcribed as *ś*, ≷ as *s*, ⧢ as *š*. They are indicated thus in Pallottino's *TLE*, and Rix, *ET*.[47]

The Etruscans had a sound *f* (a bilabial, voiceless fricative, pronounced approximately as in English labiodentals: *find, soft, stuff*) for which the Greeks had no sign. At first the Etruscans wrote the digraph *FH* (*vhelepu, vhelmus*, cf. *TLE* 56, 429, etc.). Later they adopted a new sign, 8, the origin of which is obscure (it may be a modification of ⊟, which was used in initial position with the value of *h*). The Latins, conversely, kept only the first element of the digraph, *F*, the letter familiar to us today with the sound of *f*.

In most languages the sound *f* is an infrequent sound. Its presence in Etruscan, and its spread, is a striking feature of the originality and the influence of the Etruscan language in its time. The sound *f* is absent in all Indo-European languages outside Italy before the Roman Empire, except in Germanic, where it is an innovation introduced around 400 BC, and in Iranian, where it appears late.[48] Since the sound *f* is also

absent from all the pre-Indo-European languages of Europe, the sound of *f* must be characteristic of Etruscan, and it must be from Etruscan that it penetrated into the other languages spoken in Italy: Latin, Faliscan, Umbrian, Oscan, Marsian, Venetic, etc. In Italy, it seems that all languages had *f* except for Greek, Celtic, Rhaetic, and Ligurian.[49] Words with initial *ph* are also rare: many of these are Greek words.[50]

F frequently alternates with *h* (as in Faliscan and Latin): *fasti: hasti; cafatial: cahatial; fastntru: hastntru*. This alternation of *h* with *f* may be due to Italic influence. *p* alternates with *f (pupluns: fufluns; Apuna: Afuna).*[51] Etruscan *h* is pronounced as an aspirate, as in English and German.

The voiceless stops *c* (*k*, *g*), *t*, and *p* sometimes alternate with *ch*, *th*, *ph*, for no apparent reason (*sec = sech*). But after the liquids *l*, *r*, *m*, *n*, we almost always find *ch*: *sulchva, fulumchva, flerchva, śrenchva.*[52] After vowels the sounds *ch* and *c* are evidently interchangeable, since we have both *sech* and *sec*, *zilach* and *zilc*, *zach* and *zac*, *zich* and *zic*. But as verb endings the two sounds, *c* (or *k*) and *ch* definitely have different meanings, since -*ce* is the past active ending, as in *turce*, 'he gave', and -*che* is the passive ending, as in *mi menache*, 'I was given' (see Chapter IV).[53]

The Etruscan vowel system is simple. There are only four vowels, *a*, *e*, *i*, *u*. The vowel *o* is absent; there is no reason to believe it ever existed before the late period, when it sometimes appeared under Latin influence, as in *frontac* in the bilingual inscription from Pesaro. In the transcription of Latin and Greek words into Etruscan, the vowel *o* (and in Greek *ω* or *omega*) is always written as *u*: the Greek word *Phoinix* becomes *Phuinis*; *Acheron* becomes *Achrum*; *Prometheus* (*Promatheus*) becomes *Prumathe*. The ancients themselves noted this absence of the letter *o*. The Roman author Pliny tells us that 'some peoples of Italy have no letter *o*, and use the letter *u* instead, specifically the Etruscans and the Umbrians'.[54] And indeed until they adopted the Latin alphabet the Umbrians, close neighbours of the Etruscans, shared this peculiarity – which for them was purely graphic, since Umbrian had the sound *o*.

The Etruscan letter *e* was pronounced as in northern English *a* in *hate*. It was a very closed vowel, as proved by the fact that it is often interchanged with *i*: so we see both *ica* and *eca*, *mini* and *mine*, *cliniiaras* and *clenar*, etc. The Greek name *Iason* (English Jason) becomes *Eason*; and the Etruscan genitive form -*ial* often becomes -*eal*. Etruscan had only short vowels (like several other languages, e.g. Spanish, Romanian).[55]

Greek diphthongs are usually preserved, except that of course *oi* becomes *ui*. In later inscriptions (fifth to first century) *ai* often becomes *ei* (by assimilation of the first vowel of the diphthong to the second) and even *e:* so the Greek name *Aivas* (Ajax) is written as *Aivas*, *Eivas*, or *Evas* in Etruscan. *Graikos*, 'Greek', written *Graecus* in Latin, becomes *Creice* in Etruscan, and the name of the hero Aeneas, *Aineias* in Greek, is written *Eine* in Etruscan. We find this change from *ai* to *ei* taking place also in Etruscan words, for example *aiser*, which becomes *eiser* in some late inscriptions.

There is a general trend toward the simplification of two different vowels forming a diphthong into a single vowel. The Greek sound *eu* is sometimes preserved (as in the name of the Muse *Euterpe*, who is called *Euturpa* in Etruscan), but *eu* sometimes becomes *u* in Etruscan, as for example in the name of Castor's brother Pollux, called *Polydeukes* in Greek, whose name in Etruscan becomes *Pultuce*. Latin *au* also becomes *a* in a number of Etruscan words.[56]

Sometimes extra vowels are inserted in consonant clusters in order to make words easier to pronounce (anaptyxis). This tendency accounts for the transformation of the Greek name of the goddess *Ártemis* into *Aritimi* in Etruscan, or the Etruscan name of Hercules, *Hercle*, into *Herecele*.

Then, too, liquid consonants – both the nasals *n, m* and the vibrants *l, r* – are frequently 'vocalic'. The consonant becomes sonant, that is a syllabic sound, pronounced as though it were a vowel and could stand on its own, as *al, ar, an*, or *am*. (The vowel sound was faintly pronounced, as in English *button* or *bottom*. *Atalanta* is thus written *Atlnta*, with a sonant *l*, as in English *castle*.) [57]

In conclusion, the pronunciation of Etruscan was apparently reflected in its spelling: there was no historical spelling.

Italy owes, it seems, two important innovations to the Etruscans. The first is the sound *f*, rare in all of Europe, which came into Latin, Faliscan, Venetic, and the Italic languages even before the introduction of the alphabet. The second Etruscan innovation is the intensive initial accent which also spread in Latin and the Italic languages, and which produced a larger number of syncopated words in Etruscan than in Latin.

Etruscan was being written by 700 and was spoken in Italy before that date, perhaps several centuries earlier. Around 500 the evidence of the inscriptions shows that a change took place in the way both Etruscan and Latin were pronounced, when the so-called initial stress

accent came into Etruscan and Latin (as well as other languages of Italy). At this time all words were heavily stressed, or accented, on the first syllable. The rest of the word was proportionately less stressed, and vowels dropped out ('syncope'), or were replaced by 'weaker' vowels, less strongly pronounced. An example will show most clearly the nature of this intensive, or stress, accent. In a bilingual text (*ET* Cl 1.2137–2138; Benelli, *Le iscrizioni bilingui*, No. 30), the Latin word *praesentis* (*praesentes*) is rendered in Etruscan as *preśnts*. The Etruscan word has lost two vowels as a result of an intensive initial accent which caused the first syllable to be heavily stressed: the following vowels received proportionately less stress, gradually weakened, and eventually dropped out altogether. Already in the oscillation between *velianes*: *veliiunes*, *ilacve*: *ilucve* of the Pyrgi tablets (*c.*500) we can see early signs of the vowel weakening *a > u*, as in *itan*: *itun*, *ikan*: *ikun*, *ramatha*: *ramutha*. The stress accent which caused such vowels to drop out was stronger in Etruscan than in Latin, and its results are most obvious in the later Etruscan or 'Neo-Etruscan' inscriptions of the Hellenistic or Roman period. In Etruscan we find, for example, the Greek name *Alexandros* (used to refer to Paris Alexander) written in an abbreviated form, *Alcsentre*. There are many other examples: *Ramutha* (a woman's name) becomes *Ramtha*; *Rasenna* (the name of the Etruscans) becomes *Rasna*; *Menerva* (Minerva) becomes *Menrva*; *Klytaimestra* (Clytem-nestra) becomes *Clutumsta*, then *Clutmsta*; *turice* becomes *turce; amake* becomes *amuce*, then *amce*.

The pronunciation of English gives us a number of examples of such syncope: *Leicester* and *Worcester* are both pronounced in a 'syncopated' way. The origin of the word 'alms' in English was Latin *eleēmosyna*, Greek *eleēmosýnē*. Final vowels are also frequently dropped because of the initial accent: *śuthithi* becomes *śuthith*, 'in the grave'.

CHAPTER V

GRAMMAR

Etruscan, like Latin, uses various inflections or changes of ending for nouns, pronouns, and verbs. It is possible to set up a systematic, even if incomplete, description of Etruscan grammar, and to illustrate it with examples.[58]

We have made use of the terminology familiar to us from Greek and Latin grammar – nominative, genitive, dative, etc. – because they more or less describe the situation in Etruscan: differences will be pointed out as we go along. Our use of these Latin terms for Etruscan is obviously an approximation. Neither in Latin nor in Etruscan does the genitive (or dative, or accusative) correspond exactly to the Greek or to the German cases. Doubtful cases such as the modalis, the adlative, the ablative, will not be listed. Following Pfiffig, *Etruskische Sprache* 78, we call 'definite accusative' a form which is certainly an accusative, but has an ending -*ni* or -*i*, which the 'usual' accusative (identical with the nominative) does not have. Scholars have up to now failed to discover any difference in function between the two accusatives. The genitive frequently has the function that we attribute to the dative: e.g. 'Venel Atelinas gave this to the sons of Jupiter' (Source 20).

NOUNS

In Etruscan, different endings characterise men's and women's names, that is personal names have affixes indicating natural gender; common nouns do not. Both types of nouns are, however, declined regularly. There are different forms for the different case endings, according to the function of the noun in the sentence.

Many endings are the same for the singular and the plural. Often, however, the plural is formed by adding the suffix *-ar*, *-er*, or *-ur*. So we have *clan*, 'son' (singular), and *clenar*, 'sons' (plural).[59]

As in some other languages, with numerals the singular is often used: since the number itself indicates plurality, the noun does not have to. So, for example, in *ci avil*, 'three years', or *ša šuthi cerichunce*, '(he) built four tombs'.[60]

Following are sample declensions. Here and elsewhere in the book, an asterisk is used to indicate a word whose existence can be deduced from other evidence, though it does not appear in any text.

	Singular	Plural
Nominative or accusative	*clan*, 'son'	*clenar*, 'the sons'
Genitive ('of' or 'to')	*clans*, 'of the son'	
Dative	*clenši*, 'to the son'	*clenaraši, cliniiaras*, 'to the sons'
Locative ('in' or 'at')	*clenthi*, 'in the son'	

Example: *ci clenar* [...] *anavence* (*TLE* 98, on a tomb wall in Tarquinia), 'she bore three sons' (three sons she bore).

For emphasis there are special forms of the accusative we call 'emphatic' ('I see *him*, not her – *he's* the one I see'). An example of an emphatic 'definite' accusative is *spureni lucairce*, 'the city he governed as *lucumo*' (*TLE* 131).

	Singular	Plural
Nominative or accusative	*spur*, 'city'	*spurer*
Genitive	*spures, spural*	*spurers*
Dative	*spure*	
Definite accusative	*spureni*	*spureri*
Locative	*spurethi*	

Example: *tular špural* (*TLE* 675, stone *cippus*, from Fiesole), 'the boundaries of the city' There are also datives in *-ale*, in *-ane* and in *-i*.

	Singular	Plural
Nominative or accusative	*methlum*, 'nation', 'district'	*methlumer*
Genitive	*methlumes*	*methlumers*
Definite accusative	*methlumi*	*methlumeri*
Dative	*methlumsi*, *methlumale*	
Locative	*methlumthi*, *methlumth*	*methlumerthi*

For the nominative we can cite: *ramtha matulnai sech marces matuln[as] [...] puiam amce śethres ceisinies* (TLE 98, second century), 'Ramtha Matulnai was the daughter of Marce Matulna and wife of Sethre Ceisinie'. This is a good example of the predicate which is also in the nominative. For the accusative we can cite *larthi ateinei flereś [...] turce* (TLE 653), 'Larthia Ateinei gave the statue' . *tite cale atial turce / malstria cver* (TLE 752), 'Tite Cale gave to his mother the mirror (as a) gift'. *larth ceisinis velus clan ci zilachnce / methlum [...]* (TLE 99), 'Larth Ceisinis, son of Vel, three times governed the district as praetor'.

Luciano Agostiniani was probably correct when he recently described Etruscan as an agglutinative language that was evolving into an inflectional language. Looking at the paradigm of e.g. **spur* or *methlum*, one can consider Etruscan a kind of agglutinative language since to the nominative singular *methlum*, genitive *methlum-es*, locative *methlum-th(i)*, etc., are opposed the nominative plural *methlum-er*, genitive *methlum-er-s*, definite accusative *methlum-er-i*. We observe that the endings of the plural are the same as those of the singular; but in the plural, between the stem and the endings, the (pluralizing) element *-er-* is added.

Those nouns whose stem ends in a velar or liquid frequently have a genitive in *-(a)l*: *zilach*: *zilachal*; *mech*: *mechl*; *murs*: *mursl*.

Nominative or accusative	*tina, tinia, tins, tin*, 'day', 'Jupiter'
Genitive	*tins*
Dative (?)	*tinsi, tins*

The usual *-s-* genitive is frequently added to the stem by means of an euphonic vowel: *vel*: *velus*; *śech*: *śechis*; *zathrum*: *zathrumis*.

l(a)ris pulenas larces clan [...] tarchnalth [...] lucairce
'Laris Pulenas, son of Larce, governed in Tarquinia'
(Source 31, fig. 28, TLE 131; sarcophagus from Tarquinia)

Here are some examples of the dative, including the dative of agent:

mi titasi cver menache
'I was offered as a gift to or by Tita' ('I to Tita (or by Tita) as a gift was offered' (TLE 282; on the border of a mirror, from Bomarzo, *c.*300)

mi liciniesi mulu hirsunaieśi
'I have been given by Licinie Hirsunaie' (dative of agent) (TLE 769)

epl tularu auleśi. velthinaś arznal clenśi
'as far as the boundary stones (the property belongs) to Aule Velthina, son of Arzni' (*TLE* 570, l. 8, cippus of Perugia, Source 64, fig. 54). Compare the French idiom, *ce livre est à moi*.

mi spurieisi teithurnasi
'I (have been given) by Spurie Teithurna' (dative of agent) (*TLE* 940).

mi zenaku larthuzale kuleniieśi
'I (have been) made by Larthuza Kulenie' (Nicosia, *REE* (1972), 1).

auleśi meteliś vel(us) vesial clenśi cen flereś tece
'[He] set up this statue for Aule Metelis, son of Vel and Vesi' (*TLE* 651, Arringatore, Source 66, fig. 56).

A special case deserves our attention. The word *avil*, 'year', which occurs very frequently (over a hundred times), in funerary inscriptions, is found with the simple stem (*avil*) when it is used with the verbs *svalce* or *svalthas*, meaning 'to live'. With *lupu*, 'dead', we have instead *avils*. This shows that *avil* indicates a continuous action, 'he lived for so many years ...', while *avils* expresses a precise action or occurrence, 'he died in such-and-such a year':[61]

arnth apunas velus [...] mach cezpalch avil svalce
'Arnth Apunas (the son) of Vel lived eighty-five years' (literally, 'Arnth Apunas [the son] of Vel five [and] eighty years [he] lived') (*TLE* 94; Tomba Bruschi, Tarquinia, third century).

velthur larisal clan cuclnial thanchvilus lupu avils XXV
'Velthur, the son of Laris (and) of Thanchvil Cuclni, died at twenty-five years' (*TLE* 129; sarcophagus from Tarquinia)

PROPER NOUNS

Various Etruscan names of gods are known from our sources, especially in the engraved decoration on the backs of mirrors, and on the bronze liver from Piacenza. *Tin* (*Tinia, Tina*) corresponds to the Latin Iuppiter or Jupiter and to the Greek Zeus; *Fufluns* to Bacchus or Dionysos; *Uni* to Iuno (Juno) or Hera; *Usil* to Sol or Helios, 'the Sun'; *Selvans* is Silvanus (the Etruscan name perhaps comes from the Latin). In *Turan ati* (*TLE* 74), 'Mother Turan', 'Aphrodite the Mother', and *Uni*, identified with Astarte on the Pyrgi tablets, we recognize local divinities, many of them mother goddesses, who were worshipped in Etruria. This

is probably also the case with *Cel*: see *Celsclan*, 'son of (the goddess) Cel' (*TLE* 368). Many other Etruscan names refer to gods completely unknown to us. (See the Study Aids: 'Mythological Figures'.) On the other hand in the tombs, on many mirrors and elsewhere, names of gods are often Greek: thus *Aita* = *Haides (Hades)*, *Phersipnai* = *Persephone* or Latin *Proserpina*, *Tinas clenar*, 'sons of *Tinia*' = the *Dioskouroi*, 'sons of Zeus', evidently a translation from the Greek. We learn a great deal about Etruscan phonetics, as we have seen, from the way the Etruscans transcribed these Greek names. There are also many cases when we have both the Latin and Etruscan equivalents of a name.

Names of gods, unlike other personal names, often show no indication of gender. We have no way of knowing from the form of the name whether *Tin*, *Turan*, *Pacha*, *Vanth*, or *Aplu* are male or female divinities. (Though *Uni* has a feminine ending). Male gods sometimes have a nominative ending in *-s*: thus we have *cilen* and *cilens*, *fuflun* and *fufluns*, *tin* and *tins*, *selvan* and *selvans*. The same nominative in *-s* is found in common nouns, added to the genitive form to form a new noun, for example *papals*, 'the one of the grandfather', that is 'the grandfather's grandson'; *tetals*, 'the one of the grandmother', or 'the grandmother's grandson'; *truials*, from *truial* (genitive), 'of Troy', 'the one from Troy', referring to a Trojan prisoner in the François Tomb (Source 54, fig. 50).

Personal names in Etruscan have the gender clearly indicated: the masculine ends in a consonant or *-e*; the feminine usually in *-a* or *-i*. The Greek name of one of the three Fates, *Atropos*, is written *athrpa* on a bronze mirror with an ending in *-a* (Source 41, fig. 38). Etruscan *praenomina*, first names, are very few, as in Latin, while there are many different family or gentilicial names identifying individuals.

Masculine	Feminine
aule	*aula, aulia*
vel	*vela, velia*
sethre	*sethra*
arnth	*arnthi*
larth	*larthi*

There are also specifically feminine names, *thana*, *thanchvil*, 'Thanchvil, Tanaquil', *ramtha*, *hastia* (*fastia*).

Abbreviations of masculine praenomina:

A., Ar., Ath.	Arnth
Au., Av.	Aule or Avle (Latin Aulus)
C., Ca.	Cae (Latin Gaius, written Caius)
V., Ve., Vl.	Vel
Vth.	Velthur
Lc.	Larce
L., La., Lth.	Larth
L., Li., Lr.	Laris
M.	Marce (Latin Marcus)
S., Sth.	Sethre
Ti.	Tite (Latin Titus)

Abbreviations of feminine praenomina:

H., Ha., F., Fa.	Hasti(a), Fasti(a)
Th., Tha.	Thana, Thania
Thch.	Thanchvil
R., Ra.	Ramtha
Rav., Rn.	Ra(v)ntha

The genitive ends in -al or -s or -us (for both masculine and feminine,[62] after a liquid consonant, as for example vel-us masculine and thanchvil-us feminine). A special ending, -sa or -isa, is a demonstrative pronoun used with the genitive of personal names, meaning 'the one of', indicating a patronymic. aule velimna larthal clan = 'Aule Velimna, son of Larth'. aule velimna larthalisa = 'Aule Velimna, the one of Larth' (from the tomb of the Volumnii, Perugia). The suffix -sa is also used for matronymics, gamonymics (the spouse's name), and for husband and son (CIE 1390); -sla has the same function as -sa.[63]

Personal names also have a dative in -la or -iale (vestiricinala, dative of vestiricinai), aside from the dative in -si (titasi, hulchniesi).

There also seems to be a special case of the 'agent':

Nominative	tarna (masc.)	ramtha	vel	thanchvil
Genitive	tarnas	ramthas	velus	thanchvilus
Agent	tarnes	ramthes	veluis	thanchviluis

thanchvil tarni an farthnache marces tarnes ramthesc chaireals (TLE 321; sarcophagus from Vulci) 'Thanchvil Tarnai [who was] begotten by Marce Tarna and Ramtha Chairei'.

The special double genitive indicates the grandfather, as originally did the Irish 'O' in names like O'Connor. Thus a man is called aule velimna larthal, 'Aule Velimna, (son) of Larth'. His son will be arnth

velimna aules, 'Arnth Velimna, son of Aule'. *arnth velimna aules clan larthalisla*, 'Arnth Velimna, son of Aule, the one of Larth'. Larth is the father of Aule and therefore the grandfather of Arnth.

	Patronymics		
Nominative	*larth*	*arnth*	*laris*
Genitive	*larthal*	*arnthal*	*larisal*
Demonstrative pronomial	*larthalisa*	*arnthalisa*	*larisalisa*

By the end of the Orientalizing period, in the seventh century, the Etruscan cities were headed by aristocratic families, oligarchies similar to those ruling in the Greek cities of the time. In Etruria, these great families, which remained as the dominant structure of society, developed the system of two names that was adoped throughout Italy: the personal, individual first name, or praenomen, and the family name, the nomen gentile or gentilicium. In other parts of the ancient world, for example in Greece, a person was identified by a single name and the father's name or patronymic: 'Achilles son of Peleus', or with an epithet referring to his parentage or ancestor, 'Telamonian Ajax'. The family name expresses the idea of family continuity, and anticipates our current system of first name and last name that developed in modern times, stimulated by social, political and cultural contexts.

The new organization of the Etruscans in cities required a new distinction, since the patronymic system was no longer sufficient.[64] Hence, the new system of the family name was created (even though the use of the patronymic was not completely dropped). A similar change occurred once more, much later, in Europe. In a rural society, during the Middle Ages, one name was long sufficient; but around the year 1300, with the growing importance of city life, the family name developed again. Dante's great-grandfather, *Cacciaguida*, had only one name. Dante had two: *Dante Alighieri*, as he specifically tells us in the *Divine Comedy* (*Paradiso* 15.91, 138).

The earliest element was the single *praenomen*. For men, it was often a simple word, 'Vel' or 'Larth', related to other names: so to *vel*, *velthur* are related family names (*velthina*, *veliana*), place names (*velc-*, Vulci; *velsna*, Volsinii, *velathri*, Volterra), a divine name (*voltumna*). Women, like men, had a *praenomen*, often like the masculine *praenomen* but always ending in -*a* or -*i*: *aulia*, *sethra*, *arntia*, *lartha*; *larthi*, *veli*, *vipi*, *fasti*. Other frequent first names were *ramtha*, *thanchivil* (a theophoric name, 'gift of *thana*': Tanaquil).

The family name in Etruscan usually has the adjectival suffix -*na*

(and, under Italic influence, also -ie, from -ios, -ius): *avile vipiiennas* (*TLE* 35), *larth paithunas* (*TLE* 256), *avle tarchnas* (*CIE* 5914), *laris tarnas* (*CIE* 5914).

Etruscans also used, along with the two names – the individual praenomen and the family nomen – the patronymic, the matronymic, and sometimes the names of the grandparents. Women sometimes used their husband's name, the gamonymic. An individual was identified by the father's and sometimes the mother's name. The matronymic or mother's name may appear by itself (at times it could perhaps indicate a male slave freed by his mistress). More frequently it appears together with the name of the father: *avle tarchnas larthal clan* (*CIE* 5904). Sometimes (but much less often) the name of the mother is placed after the father's name: *laris tarnas velus clan ranthasc matunial herma* (*CIE* 5904), 'Laris Tarna son of Vel and Rantha Matuni Herma'.

In this last inscription we also find, as in Rome, the third name or cognomen. We have, then: (a) the personal name (*laris*); (b) the family name or nomen gentile (*tarnas*); (c) the patronymic (*velus clan* = the son of *Vel*, gen. *Velus*); (d) the matronymic (*ranthas-c matun-ial* = the son of *rantha matuni*); (e) the cognomen (*herma*).

The use of the three names (*tria nomina*) was common in both Etruscan and Latin: praenomen, nomen gentile, cognomen. Oscan and Umbrian, on the other hand, used the praenomen, the nomen gentile and the patronymic:

Latin: *Caius Iulius Caesar*, 'Gaius, of the family of the Iulii, nicknamed Caesar'

Etruscan: *vel tutna tumu*, 'Vel, of the Tutna family, nicknamed Tumu'

Oscan: *gnaíus staiís maraheís*, 'Gnaeus Statius, son of Marahis'.

The patronymic is sometimes absent from Italic names: Oscan: *niumsis statiis meddiss túutiks*, 'Niumsis Statiis (Numerius Statius) public magistrate'. Umbrian: *ma(rcs) puplece* 'Marcus Publicus'. It is true that in Etruscan the cognomen is also often left out, as in *vel pumpus*. Sometimes it is left out in Latin, too, as in Caius Marius, or Marcus Antonius. But the fact remains that the Etruscan three-name system is very close to the Latin, and that a reciprocal influence is probable.[65] It is unclear whether Etruscan influenced Latin or vice versa.[66] Very probably the use of the three names was limited to the aristocracy. Indeed, both in Rome and in Etruria the use of three names remained synonymous with membership in the nobility.[67]

Family names are formed with *-na*.

First name	Family name	
	archaic	later form
ar(a)nth	*ar(n)thena	arnthna
thuker	thucerna	
laucie	laucina	lucina
pumpu	pumpuna	pumpna
puplie	*pupliena	puplina
spurie	*spuriena	spurina (Latin *Spurinna*)

Several first names ending in *-ie* in Etruscan are obviously of Latin or Italic origin, for example, *spurie* from *Spurius*; *Cae* from *Caius* (the *i* disappears between two vowels); *laucie* from *Lucius* (originally *Loucios* in Latin); *puplie* from *Publius*.[68]

In southern Etruria, the family name, which eventually simply corresponded to our modern last names, such as 'Smith' or 'Jones', has an added *-s*, a genitive ending indicating that the individual belonged to the family: thus *avile vipiiennas* (*TLE* 35; in an inscription from Veii, dating from about 550), and *larth alethnas* (*TLE* 172; from Musarna, near Tarquinia, second century). This custom can be compared to the use of *von* in some German names, *de* in French, *di* in Italian (von Bothmer, de Staël, di Pietro). We follow the convention of giving the family name without the *s* when it is not the name of an individual, Partunu, Pulena, Alethna.

Women's personal names reflected the different status of women in Roman and Etruscan society. A clear distinction between Etruscan and Latin is apparent. In Rome free women, in contrast to the men, did not have their own, individual proper names. Instead of an individual name, or praenomen, the father's nomen gentile was used by itself in the feminine: *Lucretia, Tullia, Sempronia*, etc. If there was more than one daughter, the ordinal number of their birth was used: *Prima, Secunda, Tertia*, etc.[69] Such a system confirmed the importance of the pater familias in Roman society. We have seen that in Etruria women, like men, had a *praenomen*. Women also had, like men, the nomen (the family or gentile name), the patronymic, and at times the matronymic. In some cases a woman is also identified by her husband's name, the gamonymic: *ramatha viśnai arntheal tetnies puia*, 'Ramtha Viśnai, wife of Arnth Tetnie' (*TLE* 320). Women's names were often included in the men's epitaphs, as matronymics, showing the importance of descent from the mother's family.

PRONOUNS

PERSONAL PRONOUNS

First person

mi- 'I' (nominative)

> *mi culichna* [...] *Venelus*
> 'I (am) the cup [...] of Venel' (*TLE* 3; on an Attic red-figure cup from Capua, *c.*475)

The verb 'to be' can be omitted, a feature of grammar found in many languages, including Greek and Latin. In addition, it may be noted that the cup is speaking for itself, as though it were animated: this, too, is a frequent feature in ancient languages like Greek and Latin.

> *velchaie pustminas mi*
> 'Of Velchaie Pustmina I (am)' 'I belong to Velchaie Pustmina' (*TLE* 22; vase, Campanian)

mini- 'me' (accusative)

> *mini muluvanece avile vipiiennas*
> 'Aule Vibenna offered me' (*TLE* 35; on a bucchero cup from Veii, *c.*550)

> *mini turuce larth apunas velethnalas*
> 'me gave Larth Apunas to Velethna' ('Larth Apunas gave me to Velethna'). If *Velethnalas* is a dative of agent, with the ending *-alas* (*-als*), then the translation is 'Lars Apunes (born of, by) Velethnai, gave me' (*TLE* 760; on a pitcher, bucchero oinochoe, uncertain provenance).

Second person

A form for the second person appears in the text of the Zagreb mummy wrappings (*TLE* 1).

	Etruscan	
Accusative	*un*	'you'
Dative	*une*	'for, to you'
Accusative plural	*unu*	'you (plural)'

Third person

There is only one personal pronoun for 'he', 'she', or 'it'. Etruscan makes no distinction in gender for 'he', 'she', 'it', but *an* is personal, *in* is inanimate.

vel matunas larisalisa an cn śuthi cerichunce
'Vel Matunas (the son) of Laris he this tomb built' ('Vel Matunas, the son of Laris, built this tomb') (*TLE* 51; cippus from Cerveteri)

[…] [M]*urinas an zilath amce …*
'… [M]urina; he was praetor …' (*TLE* 87: *Elogia Tarquiniensia*, 'Murina', not 'Spurina'. Fourth century)

Demonstrative pronouns

There are a great many demonstrative pronouns. For the demonstrative pronoun 'this' we find either *ca* or *ta* used, without any apparent difference between the two words. The following forms are found:

	Singular	*Plural*
Nominative or accusative	*ica, eca, ca, ita, ta*	*cei, tei*
Genitive	*cla, tla, cal*	*clal*
Accusative	*can, cen, cn, ecn, etan,* or *tn*	*cnl*
Locative	*calti*	*caiti*
	ceithi, clth(i), eclthi	*ceithi*

For example:

Nominative
By the doors of tombs:

> *ca śuthi* *ta śuthi*
> 'this (is) the grave' 'this (is) the grave'

Genitive

> *cla thesan* […]
> 'of (during) this morning […]' ('in daylight') (*TLE* 1 (5.23). Source 67, fig. 57, on the mummy wrappings from Zagreb)

> *lautn velthinaś eśtla afunaś*
> 'the family of Velthina and of Afuna' (*TLE* 570 (1). Source 64, fig. 54, on the grave marker from Perugia)

Accusative

> *cn turce murila hercnas* […]
> 'Murila Hercnas gave this' ('this gave Murila Hercnas') (*TLE* 149; bronze staff from Tarquinia)

> […] *cen fleres tece* […]
> '[…] this statue (he) placed […]' (Source 66, fig. 56; bronze statue of Arringatore from Perugia)

tn turce ramtha uftatavi selvan
'Ramtha Uftavi gave this to Selvan' ('This gave Ramtha Uftavi to Selvan')
(*TLE* 696; bronze statuette of a man, from Carpegna in Umbria). The
writer has written *uftatavi* instead of *uftavi*.

Locative

thui clthi mutniathi [...]
'here in this sarcophagus [...]' (*TLE* 93; Tomba Bruschi, Tarquinia, sec-
ond century)

calti śuthiti
'in this grave' (*TLE* 135; sarcophagus from Tarquinia)

It may be noted that all cases save the nominative are formed from
the stem (*cal* or *cl*). When such a pronoun is attached to the end of a
noun, as an enclitic, it is used as an article. So, on the Zagreb mummy
wrappings (*TLE* 1) we find *sacni-cn*, or *sacni-tn*, 'the priest'.
 Other forms of the demonstrative have an initial vowel:

Nominative	*ika* (archaic)	*eca* (later form)
	ita	
Accusative	*ikan* (archaic	*ecn* (later form)
	itan, itun	
Locative	*eclthi*	

For example:

Nominative

eca mutana cutus velus
'This (is) the sarcophagus of Cutu Vel' (*TLE* 115; on a sarcophagus from
Tarquinia, second century)

eca sren tva [...]
'This image shows [...]' (*TLE* 399, Source 36, fig. 33; on a mirror from
Volterra, *c.*300)

Accusative

ecn turce larthi lethanei [...]
'Larth Lethanei gave this [...]' ('This gave Larthi Lethanei [...]') (*TLE*
559; Neo-Etruscan; bronze statuette of a man)

itan mulvanice th [...]
'Th ... offered this' ('This offered Th ...') (*TLE* 39; bucchero oinochoe
from Veii)

itun turuce venel atelinas tinas cliniiaras
'Venel Atelinas gave this to the sons of Jupiter' – i.e. to the Dioskouroi, Castor and Pollux ('This gave Venel Atelinas to Tina's sons') (*TLE* 156, Source 20; Attic red-figure cup from Tarquinia, *c.*475)

Locative

eclthi ramtha cainei
'In this (sarcophagus) (is) Ramtha Cainei' ('Here lies Ramtha Cainei') (*TLE* 276; sarcophagus from Ferento, Southern Etruria)

eclthi śuthith larth zalthu . . .
'In this grave (is) Larth Zalthu . . .' (*TLE* 116; gravestone from Tarquinia)

There are thus two series: *ita, eta, ta;* and also *ica, eca, ca.*

The relative pronoun 'who', 'which' is *ipa*, which is indeclinable, like English 'that', Italian *che.* The indefinite, 'whoever', is *ipe ipa* (probably from *ipa ipa;* compare the Latin word for 'whoever', *quisquis*, related to the relative pronoun *qui).* The pronoun *an*, however, is used more frequently than *ipa.*[70]

We do not know the form of the interrogative pronoun, since there are no dialogues, where it would be used.

NUMBERS

Etruscan numbers have long presented a problem. Numbers appear in many funerary inscriptions indicating the age of the deceased. We have the good fortune to have a set of dice (now in Paris) on which the numbers are written out in words, spelled phonetically, not in figures (fig. 7). We therefore know the numbers from one to six: *thu, zal, ci, śa, mach, huth.* The problem is, which is one, which is two, and so on? We know that among the ancients the two opposite faces of a die add up to seven, *mach + zal* = seven, *thu + huth* = seven, *ci + śa* = seven. Yet this still does not tell us what the value of each number is, for *mach + zal* could be 1 + 6, or 2 + 5, or 3 + 4. An early investigator, the Norwegian scholar Torp, theorized that the numbers were as follows: *thu* = one; *zal* = two; *ci* = three; *śa* = four; *mach* = five; *huth* = six. Torp's theory received partial confirmation from the inscriptions on the Pyrgi tablets (fig. 5), which give us the value of *ci* beyond any possible doubt, for the word is repeated three times: we have *ci avil* on one of the Etruscan tablets, and, in the Phoenician

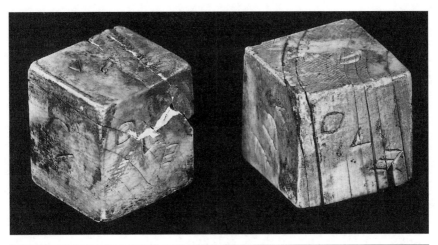

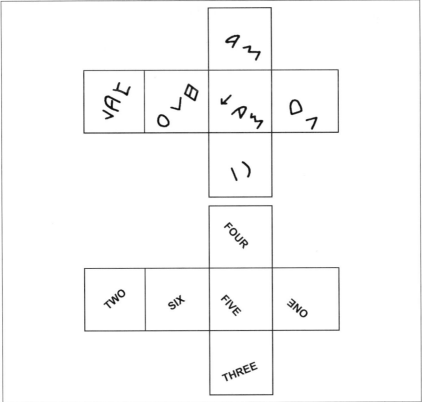

7 Inscribed Etruscan names of numerals on ivory dice, with English translation.
Hellenistic period

inscription, the symbol III, as well as the Phoenician translation *šlš* meaning 'three'. Knowing that *ci* = three, we suppose that *ša* is four, because *ci* + *ša* (or 3 + 4) = seven. The translation *mach* = one is impossible because, in the inscription *hušur mach acnanas* (*TLE* 887), 'he had *mach* children', *hušur* is a plural form, so *mach* cannot mean 'one' in the singular. The new Tabula Cortonensis (Source 65, fig. 55) contains the numbers ten (*sar*), four (*ša*), and two (*zal*). The number *cezp* is believed to be eight because of the gloss *chosfer* = 'October' (*TLE* 838).[71]

The number ten is *šar*: *huth-zar* is sixteen. The number twenty is *zathrum* (related to *za-* or *sa-*, two). Multiples of ten are formed by adding *-alc* or *-alch*. (Asterisked forms are reconstructed.) Above ten, counting proceeds by addition as far as six (for instance, *huthis zath-rumiš*, 'on the twenty-sixth [day]'), and by subtraction from seven to nine (for example *esl-em-zathrumiš*, 'on the twentieth minus two', that is 'on the eighteenth [day]'. *TLE* I).[72] Forming numerals by subtraction is a highly unusual system, found only in Etruscan and in Latin. 18 = 20 − 2, 19 = 20 − 1: Latin *duodeuiginti*, *undeuiginti* (eighteen, nineteen). The Roman system was probably due to Etruscan influence.[73]

1	*thu*	20	*zathrum*
2	*zal (esal)*	23	*ci zathrum*
3	*ci*	27	*ci-em-ce-alch*
4	*ša* (6?)	28	*esl-em-ce-alch*
5	*mach*	29	*thun-em-ce-alch*
6	*huth* (4?)	30	*ci-alch (ce-alch)*
7	*semph* (?)	40	*se-alch*
8	*cezp*	50	*muv-alch* (**mach-alch*)
9	*nurph* (?)	60	**huth-alch*
10	*šar*	70	*semph-alch* (?)
13	**ci-šar*	80	*cezp-alch* (?)
16	*huth-zar*	90	**nurph-alch* (?)
17	*ci-em zathrum*	100	(?)
18	*esl-em zathrum*	1000	(?)
19	*thun-em zathrum*		

Numerals are declined like nouns:

Nominative or accusative	*thu(n), zal, ci, mach, huth, semph* (?)
Genitive	*thuns, esals, cis, machs, huthis, semphs* (?)
Emphatic ('definite') accusative	*thuni*
Locative	*thuni*

When numerals are compounds both elements are inflected. In the genitive, we have *ciś śariś*, 'on the thirteenth', *huthiś zathrumiś*, 'on the twenty-sixth'. Only the subtractive element (*em*) and the numeral that precedes it are indeclinable. So on the mummy wrappings we have *eslem zathrumiś acale*, 'on the eighteenth (day) of June'; *thunem cialchus*, 'on the twenty-ninth', *ciem cealch us*, 'on the twenty-seventh'.

Ordinals are formed with the suffix *-na* (see below, Adjectives): *thunina*, 'the first'. There is also a distributive ending: *thunur*, 'one at a time'; *zelur*, 'two at a time', etc.

Certain numeral adverbs are formed with the ending *-zi* or *-z: thunz*, 'once', *eslz*, 'twice', *ciz*, 'three times', *huthz*, 'six times', *cezpz*, 'eight times' (?), *nurphzi*, 'nine times' (?), etc. These adverbs are used to record the number of magistracies held by public officials:

> *larth ceisinis velus clan cizi zilachnce methlum nurphzi canthce* [...]
> 'Larth Ceisini, the son of Vel, three times as praetor governed the district, (and) nine (?) times was censor' (*TLE* 99; Tarquinia, wall painting)

> [...] *tute arnthals* [...] *zilchnu cezpz purtśvana thunz lupu avils esals cezpalchals*
> 'Tute, (the son) of Arnth, having been praetor eight times, dictator once, (was) dead in the year eighty-two (of his life)' (*TLE* 324; man's sarco-phagus from Vulci, second century)

The Etruscan numerals are listed with the alphabet (fig. 6). In a 1988 article Paul Keyser solved a long-standing argument about the origin of the Latin numeral signs.[74] Like the alphabet, the Latin numerals derive from the Etruscan signs, which have undergone some alteration and abbreviation of their forms. The Etruscan system is shown to have been a tally-mark system, in which | = 1 represents a single stroke or tally, X = 10 represents two crossed strokes for the second rank (or place) of the base-ten numbers. The symbol for 100 (✱) is the 'third-rank' symbol and is formed from three lines. The Etruscan symbols for 5 and 50 are the lower half of the symbols for 10 and 100: ∧ is the (lower) half of X, and ↑ is the (lower) half of ✱.

The numerals >, |, ∧, X, and ↑ are well attested on coins and funerary inscriptions. The numerals ⋃ and Ψ are unattested, and are tentative suggestions for the forms, using the lower half of the succeeding decade symbol. The Etruscan numeral ✱ = 100 is well attested, for example in the funerary inscription of Larth Felsnas, who lived 106 years and fought with (or against?) Hannibal (fig. 53). The later rounded form ⋇ is found on coins; C, though rare, is attested. The Etruscan numeral

⊕, ⊗ is shown on a fifth-century gem in Paris with a boy looking at a tablet, inscribed *apear*, 'abacus', and on the lead tablet from Santa Marinella (*TLE* 779, 878; *CIE* 6310). It probably represents 1000; the next sign, ⊕ 10,000. The Romans inverted V and Ѱ (only later did Ѱ become ⊥ and then L, as numerals were accommodated to the alphabetic forms, and the (rare) Etruscan C was adopted for CENTVM, and similarly M for MILLE). They also inverted all these symbols, including | and X: Etruscan numbers, like the letters, were read right to left, and the Romans changed them to fit their system, left to right. The numbers seem to have been flipped vertically in the process. Certainly, Etruscan numerals, written retrograde, may be read left to right and inverted: | ∧ X ↑ becomes ↓ X ∨ |, 66 in both cases. The various steps in the adaptation of the Etruscan symbols to the Roman, or at least most of them, can be tracked in Latin inscriptions. For example, Ѱ = 50 (e.g. *CIL* I², 2.2871); ⊥ = 50 (*CIL* I², 2.2585, etc.). Etruscan ⊕ or ⊗, which became ∞ when written quickly, is attested in Latin as ∞, the 'horizontal-8' figure, leading to the formal Latin numeral M. The origin of the familiar but mysterious Roman numerals, I, V, X, L, M, can thus be traced back to the Etruscan system (fig. 8).

| > | | | ∧ | X | ↑ | *⚹C | [Ѡ] | ⊕ ⊗ | Ѱ | ⊕ |
|---|---|---|---|---|------|-----|-------|-------|-------|
| ½ | 1 | 5 | 10 | 50 | 100 | 500 | 1000 | 5,000 | 10,000 |

8 Table of Etruscan numerals

ADJECTIVES

There are three types of adjectives in Etruscan.

I ADJECTIVES OF QUALITY

(*a*) Ending in *-u* or *-iu* (*i* disappears between vowels):

ais, 'god'	*aisiu*, 'godly', 'divine'
hinth, 'below'	*hinthiu*, 'underground', 'infernal'
etera, 'stranger', 'client', 'slave'	*eterau*, 'connected with an *etera*'
**sarsnach*, 'tenth'	*sarsnau*, 'a group of ten', or '*decuria*'

(*b*) Ending in -*c*:

zamathi, 'gold'	*zamthic*, 'golden'
athumi, 'nobility'	*athumic*, 'noble'

II ADJECTIVES OF POSSESSION OR REFERENCE

Ending in -*na*:

ais, eis, 'god'	*aisna, eisna*, 'pertaining to a god', 'divine'
lauchumu, 'magistrate', 'lucumo'	*lauchumna*, 'pertaining to a magistrate', or 'lucumo'
pacha, 'Bacchus'	*pachana*, 'pertaining or belonging to Bacchus'
spura, 'city'	*spurana*, 'pertaining or belonging to the city'
śuthi, 'tomb', 'grave'	*śuthina*, 'pertaining or belonging to the grave', 'grave gift'
thunś, 'one'	*thunśna*, 'first'

The suffixes -*na*, -*ne*, -*ni*, indicating adjectives derived from both proper names (of persons or places) and common nouns, are related to this class of adjectives. Family names or *nomina gentilia* belong to this group, for example, the names *velthurna* from *velthur*; *vipina* from *vipi*; *papni* from *papa*, 'grandfather'; *lautni*, 'freedman', from *laut*, 'family', etc.

III ADJECTIVES EXPRESSING A COLLECTIVE IDEA

Ending in -*cha* (-*cva*, -*cve*), -*va*, -*ia*:

math, 'inebriating drink'	*math-cva*, 'full of inebriating drink'
sren, 'ornament', 'image'	*sren-cve*, 'full of ornament'
avil, 'year'	*avil-cva*, 'perennial' (compare Latin *perennis* = *per* + *annos*)
purth, 'title of magistracy'	*eprthieva*, 'connected with the *purth*'
raśna, 'Etruria', 'the Etruscan people'	*raśna-ia*, 'connected with the Etruscans'
etera, 'stranger', 'client', 'slave'	*etera-ia*, 'connected with the etera'

After a liquid consonant (*l*, *r*, *m*, *n*) the *c* may become *ch*:

sren-chve, 'full of ornament'	*fler-chva*, 'group of sacred statues', sacrifice

This ending forms words denoting collective plurals, which exist alongside the usual individual plural forms: so, for example, from *flere*,

'sacred statue', comes the individualizing plural *flereri*, 'sacred statues', as well as the collective plural *flerchva*, 'a group of sacred statues' (cf. Latin *locus*, singular, *loci, loca*, plural).

As in other languages, several suffixes or endings may be used in combination: see, for example, *sarsnau*, 'group of ten', 'decuria'; *purtsvau, purtsvana*, 'group of magistrates, magistracy'.

Adjectives are as a rule indeclinable (but see *mlakas*, Source 9), unless they are used as nouns (as in English).

 tarchnal-thi, 'in Tarquinii' (plural); *velsnal-thi*, 'in Volsinii' (plural).

VERBS

We do not know the verbal forms for the first person, 'I', and second person, 'you' in the present active indicative. The past passive form *-che* is used for both the first and the third persons. The past active form, *-ce*, is regularly used for the third person (and in one case perhaps for the first person as well: *TLE* 868). The third person of the past, both active and passive, seems to have been the same in the singular and plural.

I FINITE VERBS

(a) Active present
Either the radical form is used (*ar, rach, tur, puth*, etc.), or a form with an ending in *-a (ara, ama, tva)*.

 eca sren tva (*TLE* 399) 'This image shows ...'

(b) Active preterite
There are many words ending in *-ce* (or *-ke*). These indicate a third person singular form of the past tense of the verb. We have already come upon a number of these, as for example:

 itun turuce venel atelinas tinas cliniiaras
 'This gave Venel Atelinas to Tina's sons' ('Venel Atelinas gave this to the sons of Jupiter') (*TLE* 156; Attic red-figure cup from Tarquinia, *c.*475)

The later, shortened form of *turuce* is *turce*.
 Here are some other examples:

 papalser acnanasa VI manim arce
 'Having acquired six grandchildren he elevated the monument' ('He had

six grandchildren, and built this monument')[75] (*TLE* 169; man's sarco-phagus from Musarna

mini muluvanice mamarce apuniie venala
'Me dedicated Mamarce Apunie Venala' ('Mamarce Apunie Venala dedi-cated me') (*TLE* 34; bucchero pitcher from Veii)

mini urthanike aranthur
'Aranthur made me' (*TLE* 764; bucchero cup, provenance unknown)

The past ending of the third person *-ce* was used for both the singular and the plural. For the singular, note, for example, *vel matunas* [...] *cn śuthi cerchunce* 'Vel Mathunas built (singular) this tomb' (*TLE* 51). In a new inscription from Cerveteri (*ET* Cr 5.2) we read: *laris avle larisal clenar* [...] *cn suthi cerichunce* 'Laris (and) Aule, sons of Laris, built this tomb', where 'built', obviously a plural, has the same ending as the singular (as in English).

(c) Active future (?)
A form in *-ne* is probably a future, in the third person:

velthina acilune turune ścune
'Velthina will do, give, yield'[76] (*TLE* 570; Source 64, fig. 54; cippus from Perugia)

(d) Passive preterite
While the ending *-ce* indicates the active preterite, the ending *-che* indicates the passive preterite for the first person singular:

mi arathiale zichuche
'I was written for Arath'; or, 'I was written by Arath' (*TLE* 278; bucchero aryballos)

mi titasi cver menache
'I was offered as a gift to Tita' or, 'I was offered as a gift by Tita'.[77] (*TLE* 282; bronze mirror from Bomarzo, *c*.300)

II PASSIVE PARTICIPLES: PAST PARTICIPLE OR VERBAL NOUN

If we compare two inscriptions, both dating from approximately 600, we can see that one has an active verb, the other a passive:

mini alice velthur
'Velthur gave me' (*TLE* 43; bucchero vase from Veii)

and:

mi spurieisi teithurnasi aliqu
'I was given to Spurie Teithurna' (*TLE* 940; bucchero kylix, uncertain provenance)

Since *mi* is the nominative, the form *aliqu* must be a passive verb. We therefore translate the second sentence as, 'I (was) given to Spurie Teithurna' (or 'by Spurie Teithurna'). So too:

mi lartuzale kuleniiesi zinaku
'I (was) made for Lartuza Kulenie' (*ET* Fs 6.1; *REE* 40 (1972) No. 1; from Artimino, *c*.600)

These forms in *-u* seem to be past participles. If the verb is transitive, the meaning is passive: *mulu*, 'offered'; *turu*, 'given' (from the roots *mul-* and *tur-*). If the verb is intransitive, the meaning is active: *lupu*, 'dead', or *cesu*, 'lying'. We can compare the Latin middle form, *secutus*.

larth auclina ceśu thui
'Larth Auclina (is) lying here' ('Here lies Larth Auclina'; or, in Latin, *hic iacet*) (*TLE* 553; urn, near Chiusi)

mi licinesi mulu hirsunaieśi
'I (was) offered to (or 'by') Licine Hirsunaie' (*TLE* 769; Corinthian alabastron, uncertain provenance)

A verb which occurs frequently in funerary inscriptions is *lupu*, 'dead', or the related form *lupuce*, 'died'. It is used with the noun *avils*, 'year', to mean 'died' (at a certain age): *avils LXX lupu*, 'In (his) seventieth year he (was) dead'; or *avils LX lupuce*, 'he died (at the age of) sixty years'.

This active past participle ending in *-u* is very close to that of the verbal form in *-ce*, together with which it is often used:

semni ramtha spitus larthal puia amce lupu avils [X]XII huśur ci acnanas
'Semni Ramtha was the wife of Larth Spite; she died when she was twenty-two years old, having had three children'.[78] (*TLE* 889; wall of tomb in Tarquinia, third or second century. Cf. Source 59)

III ACTIVE PARTICIPLES

(*a*) There is an active past participle ending in *-thas*. Compare, for example: *avil svalthas LXXXII* (*TLE* 126), 'having lived eighty-two years', with *svalce avil XXVI*, 'He lived (during) twenty-six years'. Or: *eslz zilachnthas* (*TLE* 136; sarcophagus from Tarquinia, third century), 'having been praetor twice', with *cizi zilachnce* (*TLE* 99; Tomba

Bruschi, Tarquinia, fourth or third century), 'Three times he was praetor'.

(b) Another active past participle ends in *-asa*:

> *clenar ci acnanasa elsśi zilachnu*
> 'Having procreated three sons, he was praetor for the second time' (*TLE* 169; man's sarcophagus from Musarna)

(c) Another participle ending in *-as* expresses contemporary action, something like English 'living', 'doing':

> *spurethi apasi svalas*
> 'While living in the city of his father (?)'; or, 'in the city (with) his father living ...' ('while his father was living ...') (*TLE* 171; man's sarcophagus from Musarna)

> *vacl aras thui useti*
> '(While) making the libation, draw (from) here' (*TLE* 1.10.18; the Zagreb mummy)

(d) A participle denoting obligation is formed with the ending *-(e)ri*:

> *huthiś zathrumiś flerchva nethunsl* [...] *thezeri-c* (*TLE* 1.8.3; Zagreb mummy wrappings) 'and on the twenty-sixth the sacrifices for Neptune are to be made'

IV IMPERATIVE

(a) Imperative I
The simple verbal stem can be used as an imperative form (as in the Indo-European languages, e.g. Latin *canta*, 'sing', etc.). For example, *vacl ar*, 'make the libation' (*ar* = 'make', 'do').

(b) Imperative II
Another imperative, ending in *-ti*, *-th*, *or -thi*, and used for the second person, is also found in the text inscribed on the mummy wrappings from Zagreb (*TLE* 1).

> *hathrthi repinthi-c śacnicleri cilthl śpureri methlumeri-c enaś śveleri-c*
> 'Be benevolent and bow to the temples of the people, to the cities and districts and hearths'

> *rachth tura(,) nunthenth cletram śrenchve tei faśei*
> 'Prepare the incense, offer with the decorated cup these breads'

> *tur rachti*, 'Prepare the incense'

Verb synopses

	mul- 'dedicate'	tur- 'give'	sval- 'live'	zich- 'write'	rach 'prepare'
3rd sing. indicative	mulu	tura			
future?	mulune	turune			
3rd sing. and plur. past active		turce	svalce		
imperative I		tur			rach
imperative II					rachti, rachth
past passive 3rd person				zichuche	
present participle active			svalas		
past participle or verbal noun passive	mulu	turu		zichu	
participle of obligation passive		turi (tur + ri)			
past participle active			svalthas		

CONJUNCTIONS AND ADVERBS

COORDINATE CONJUNCTIONS

-*c* is 'and' (after *l* it is often written *ch*). It is added, as an enclitic, after both nouns which are being connected, or else only after the second noun. When there are three nouns it can be placed after the first one. (Compare the Latin ending -*que*, 'and'). Hence:

apac atic
'both father and mother' (*CIE* 6213)

marces tarnes ramthesc chaireals
'[born from] Marce Tarna and Ramtha Chairei' (*TLE* 321; sarcophagus from Vulci with figures of husband and wife reclining together)

-*m* (-*um* after a consonant) also means 'and':

ramtha matulnai [...] *ci clenar* [...] *anavence lupu-m avils machs śealchlsc*
'Ramtha Matulnai [...] three sons she bore and (was) dead in the forty-fifth year (of her life)' (*TLE* 98; wall of tomb, Tarquinia, second century)

vel leinies larthial ruva arnthialum clan velusum prumathś [...]
'Vel Leinies, brother of Larth and son of Arnth and great-grandson of Vel' (*TLE* 232; painted over figure of a serving boy, in Tomba Golini I, Sette Camini, near Orvieto, fourth century)

Sometimes the conjunction is left out (asyndeton):

arnth larth velimnaś arzneal husiur [...]
'Arnth (and) Larth Velimnas, children of Arzni' (*TLE* 566; Tomba dei
Volumnii, Perugia, second or first century)

OTHER CONJUNCTIONS AND ADVERBS

sve,	'likewise'
ic, ich, ichnac	'how, as'
etnam,	'also'
ratum,	'according to ritual' (Latin *rite?*)

ADVERBS OF TIME (TEMPORAL)

thuni,	'at first' (cf. *thu,* 'one')
etnam,	'again'
(e)nac,	'then', 'after'
matam,	'before', 'earlier'
epl, pul,	'until'
thui,	'now'
une,	'and then' (?)

ADVERBS OF PLACE (LOCAL)

thui,	'here'
hinththin,	'from below' (with reference to the underworld; cf. *hinthial,* 'shade', 'ghost')
ipa,	'where' (relative)
thar,	'there', 'thither' (motion towards)

SYNTAX

Since long texts are rare and Etruscan literature unknown to us, we
do not know much about Etruscan syntax. Word order is similar to
that of Latin. The subject is placed at the beginning, followed by the
predicate.

Examples of the placement of the subject at the beginning of the
sentence:

vipia alśinai turce
'Vipia (Vibia) Alsinai gave (this image)' (*TLE* 328)

larth ceisinis velus clan cizi zilachne methlum nurphzi canthce
'Larth Ceisinis, son of Vel, three times governed the territory as praetor,
nine times (?) was *canth* (magistrate)' (*TLE* 99)

Examples of the placement of the predicate:

an zilath amce mechl rasnal
'He was praetor of the Etruscan territory' (*TLE* 87)

The accusative after a verb can indicate extent of time:

lucer latherna svalce avil XXVI
'Lucer Latherna lived for 26 years' (*TLE* 119)

Example of the simple accusative, object of the verb:

larthia ateinei fleres̀ [...] turce
'Larthia Ateine the statue gave' (*TLE* 653)

We follow Pfiffig, *Etruskische Sprache*, 79, in admitting the existence
of an 'emphatic accusative' (he calls it 'definite'), that is, a form that
is certainly an accusative, but has an ending in *-ui* or *-i*, which is
different from the usual accusative.

The genitive, as in Latin, has a number of functions: possessive,
temporal, separative, genealogical (for patronymic, matronymics,
gamonymics indicating the husband).

Example of a genitive of time when:

avils machs semphalchls lupu
'Died at the age of 75 (?) years' (*TLE* 165)

The possessive genitive is so close to the genealogical genitive as to be
confused with it:

arnthal clan
'son of Arnth' (*TLE* 102)

The dative is used, as in Latin, with its own function, as indirect object:

mi(ni) aranth ramuthas̀i vestiricinala muluvanice
'Aranth dedicated me to Ramutha Vestiricina' (*TLE* 868)

The dative is also used like the Latin ablative in absolute phrases:

clens̀i [...] svalasi
'While the son was alive (living)' (*TLE* 173)

larthiale hulchniesi marcesic caliathesi
'(during the magistracy of) Larth Hulchnie and Marce Caliathe' (*TLE* 84,
Tarquinia, Tomb of Orcus, fourth century)

zilci velusi hulchuniesi
'(at the time when) Velus Hulchnie was *zilc* (praetor)'[79] (*TLE* 90, Tarquinia, Tomb of the Shields)

This formula in the dative corresponds to the Latin system of dating by consulships in the ablative absolute: M. *Tullio Cicerone oratore et C. Antonio consulibus* (62 BC), 'while Marcus Tullius Cicero the orator and Caius Antonius were consuls'. (This was the way of giving a date in Rome; compare the *eponymous archon*, the magistrate after whom the year was named, in Athens.)

The dative also serves as dative of agent, as it does at times in Latin *barbarus hic ego sum, qui non intellegor ulli*, 'Here I am a barbarian, who am understood by no one' (Ovid, *Tristia* 5.10.37).

mi arathiale zichuche
'I was written by Arath' (*TLE* 278)

mi titasi cver menache
'I have been offered as a gift by Tita' (*TLE* 282)

The locative indicates place where:

śuthiti
'in the grave' (*TLE* 100)

alethnas arnth larisal zilath tarchnalthi amce
'Arnth Alethna, son of Laris, was praetor at Tarquinia' (*TLE* 174)

An important feature which Etruscan shares with some Indo-European languages is a so-called 'group inflection', meaning that when there are two nouns, sometimes it is only the second one that receives the case ending:

maerce (for *mamerce*) *paziathes-mi*
'I (am) of (or 'belong to') Mamerce Paziathe' (only *Paziathe* has the genitive case ending *-s*) (*StEtr* 4, 1974, 306, No. 284; fifth century)

In noun propositions, when there is no verb, the subject stands at the beginning:

mi venelus numclanies
'I (am) of Venel Numclanie' (*TLE* 10)

ta śuthi avles thansinas
'This (is) the grave of Aule Thansina' (*TLE* 158)

When there is a direct object, the verb usually comes second:

vipia alśinai turce versenas cana
'Vipia (Vibia) Alsinai gave to Versena (this) image' (*TLE* 328)

cn turce murila hercnas
'Murila Hercna gave this' (*TLE* 149)

Otherwise the verb comes last, as in Latin:

ve(lia) cuinti arnthiaś culśanśl alpan turce
'Velia Quintia (daughter) of Arnthia willingly gave' (Latin *dedit libens merito*) (*TLE* 64)

larth paithunas prezu turuce
'Larth Paithuna Prezu gave (this object)' (*TLE* 256)

When the clause begins with the accusative pronoun *mini* ('me'), the verb also usually comes second:

mini muluvanece avile vipiennas
'Aule Vibenna offered me' (*TLE* 35)

In simple clauses the verb usually comes last::

metru menece
'Metru (Metron) offered' (*TLE* 370)

cver turce
(He) gave as a gift' (*TLE* 505)

In more complex sentences it comes last as well:

thaura clan line
'The grave the son prepared' (*TLE* 419)

arnth larth velimnaś arzneal husiur suthi acil hece
'Arnth (and) Larth Velimnas, children (sons) of Arzni, the grave (?) placed' (*TLE* 566)

This is also true of the participle of obligation, *caresri*, *heczri*, etc. The genitive comes after the word it modifies:

flerchva nethunsl
'The sacrifice to (for) Nethuns' (*TLE* 1.8.1)

Words referring to family relationships and to magistracies usually follow the *cognomen*:

larth ceisinis velus clan
'Larth Ceisinis, son of Vel' (*TLE* 99)

But *ati*, 'mother', *ati nacna*, 'grandmother', and *papa*, 'grandfather',

precede the genitive modifying them (we have an example of *apa*, 'father', appearing in such a sentence):

ati cravzathuras velthurs l(a)rthalc
'Mother of Cravzathura Velthur and of Larth' (*TLE* 176)

ati nacna velus
'Grandmother of Vel' (*TLE* 95)

An attributive adjective normally follows the noun:

marunuch spurana
'Maro (magistrate) of the city' (*TLE* 156)

In relative clauses the verb follows the relative pronoun *ipa*:

ipa ama hen naper XII
'12 *naper* (measure) which are here' (*TLE* 570 a. 5–6)

The demonstrative pronoun usually comes first:

eca mutana cutus velus
'This sarcophagus (is of, belongs) to Cutu Vel' (*TLE* 115)

eclthi suthith larth zaltu
'In this grave (is, lies) Larth Zaltu' (*TLE* 116)

Noun clauses without verbs are as frequent in Etruscan as in Indo-European. When the subject is *mi*, it always comes first:

mi venelus numclanies
'I (am of, belong) to Venel Numclanie' (*TLE* 10)

The accusative pronoun *mini*, like *mi*, also comes first. The imperative usually comes first:

rachth tura nunthenth cletram śrenchve tei faśei
'Prepare the incense; offer with the decorated cup these loaves' (*TLE* 1.2.10)

VOCABULARY

In the absence of any works of Etruscan literature, our knowledge of Etruscan vocabulary is clearly limited. The fact that what we have are mostly ritual or religious texts and epitaphs means that there is a good deal of repetition, as well as a large number of proper names of people and divinities. So, although there are as many as thirteen thousand

inscriptions, we have a vocabulary consisting of only about two hun-
dred and fifty words. Even some of these are uncertain in meaning.
There are several words meaning 'to give', 'to offer', 'to build', and so
on, each of which must have had a more precise meaning.[80]

For several areas there is a good deal of evidence. Names of divinities,
as well as religious vocabulary in general (for example *ais*, 'god', plural
aiser) are quite well known.[81] We also know something about both
Greek and native mythological figures from the way they are represented
in art. For examples of names of Greek divinities and mythological
figures in Etruscan, see the section on Mythological Figures. These bring
up intriguing relationships, such as the possibility that the Latin name
of Persephone, *Proserpina*, might come from Etruscan *Phersipnai*.
Catamite, which has come into English as 'a boy used in pederasty',
derives from the Latin *Catamitus* (Plautus, *Menaechmi* I.2.23), repre-
senting an Etruscan transformation of the Greek *Ganymedes*.

Proper names other than those of divinities, of course, form the
largest part of the vocabulary that has come down to us, from funerary
epitaphs, votive inscriptions, and legal documents such as the Tabula
Cortonensis. Scholars have been able to derive a good deal of infor-
mation about Etruscan society from the use of the matronymic, the
gradual development of the aristocratic use of the three names, and
the rise of an urban culture and other observations about nomenclature.
Bilingual inscriptions and the 'translations' of Etruscan names into Latin
tell us about the end of the Etruscan identity. In the early period of
Etruscan history, on the other hand, the Etruscanization of the Greek
names of people whose families had become Etruscan citizens and
adopted the Etruscan system of names reflects an open society – this
is the case for Laris Pulenas's great-grandfather *Creice*, 'The Greek',
and for Rutile Hipukrates, as for Larthaia Telicles, perhaps formerly
of the Greek Telekles or Teleklos family. *Metru menece*, a signature
on a fifth-century red-figure Attic kylix, is an Etruscan translation of
Metron epoiesen, used by a Greek potter who had moved to Etruria
to work for Etruscan clients (*TLE* 370). From their names we see that
Greek craftsmen who set up workshops in Etruscan cities in the Archaic
period were not slaves, but metics or resident aliens.

Two other types of words are also rather well known. Numerals are
known from epitaphs recording the ages and terms of office of the
deceased, and from such a ritual calendar as the mummy wrappings
in Zagreb. Nouns indicating various family relationships are also
frequently found on funerary inscriptions or epitaphs.

Following are some terms of family relationships:

clan	'son' (very frequent)
sech	'daughter' (fairly frequent)
nefts, nefiś, nefś	'grandson' (from the Latin word *nepos*, related to English 'nephew')
prumathś, prumts	'great-grandson' (from the Latin word *pronepos*, 'great-grandson')
papa	'grandfather'
teta	'grandmother'
papals	'grandson', 'the son of the son' (literally, 'he of the grandfather')
puia	'wife' (frequent)
husiur, huśur	(= Latin *liberi*) 'children'
ati	'mother' (*ativu*, 'Mummy')
apa	'father'
ati nacn(u)va	'grandmother' ('dear' or 'venerable mother'; a euphemism, for which compare French *belle-mère, beau-père*, 'beautiful mother', 'handsome father', i.e. 'mother-in-law' and 'father-in-law')
ateri	'parents', 'ancestors'
ruva	'brother'
clante, clanti	'adoptive (?) son'
tusurthiri	'spouse' (?)

Since Etruscan society was patriarchal, we do not (yet) know the words for 'husband', 'uncle', 'cousin', etc. But new inscriptions are constantly being found, and our vocabulary is enriched by these new discoveries.

We know the names of a number of magistrates and magistracies, but their ranks, duties and privileges are not always clear to us. In the translations given we have used, for the sake of convenience, some conventional equivalents. They are listed below according to their approximate relative importance, from highest to lowest.

purth	'dictator'
lauchume	'consul' (Latin *lucumo*, 'high priest', 'king', or 'ruler')
zilath, etc.	'praetor'. In the Pyrgi tablet (fig. 5) the word is equivalent to 'ruler', perhaps 'king'.
camthi	'censor'
maru	'Maro' (cf. Umbrian *maron-*)

We know the words for 'city', **spur*, 'district' or 'nation', *methlum*, and the national name of the Etruscan people, *rasna* (Greek *Rasenna*).[82]

We know the names of household ware and sacred containers and objects, feasts, offerings, priests, etc.: 'cup', *cupe*,[83] and *culichna*; 'grave', *śuthi*; 'wine', *vinum*; 'urn', *capra*; 'sarcophagus', *murs* or *mutana*; 'mirror', *malena, malstria*; 'statue', *fleres̩*; 'incense', *tura* (Latin *tus, turis*, from Greek *thyos*). See below for foreign words for vases. We know the words for 'year', *avil*; 'month', *tiur*, the name of the moon goddess written on the bronze liver from Piacenza (Source 60, fig. 51); 'day', *tin*, the same word as the name of the sky god, *Tinia*. The religious, ritual character and context of this vocabulary is also reflected in the glosses.

FOREIGN WORDS IN ETRUSCAN

Aside from proper names of gods or heroes, numerous other foreign words were adopted and transformed. The Etruscans took part in the civilization and culture of the peninsula of Italy, and had close contacts with the other neighbouring Italian peoples: the Latins, the Umbrians, the Veneti, the Oscans, and others (map 2). When the Greeks brought their civilization into Italy in the eighth and seventh centuries the Etruscans were strongly influenced by their culture. Not only did they adopt the alphabet and the art of writing, but they also adopted and adapted many outer signs of civilization along with the words that went with them. This included, as we have seen, the characters and names of Greek mythology, a sign of culture then as it still is today.[84] It also included imported Greek pottery, types of clothing, ways of dressing, religious rites, theatrical performances, and the related vocabulary. The word *triumph* came into Latin from Etruscan, where it was transformed from the Greek *thriambos*, 'celebration for Dionysos' to **triumpe*. The Romans evidently took over the name along with the ceremony at the time of the Etruscan kings.[85]

The Greek *symposium* was a feature of Greek life that was adopted by other peoples of Europe and the Mediterranean, including Italy, as a sign of Greek culture, along with the required symposium ware. Not surprisingly, considering how many vases were imported into Italy from Greece, we recognize a number of names of Greek vases in Etruscan: from the Greek word *kothon* comes *qutun*, a handled jug or oinochoe, and the diminutive *qutumuza*; from Greek *lekythos*, a container for unguents or oil comes *lechtumuza*, 'little lekythos'; from Greek *askos*, 'leather bag','wineskin' comes *aska*, a flask for oil or other liquids; from

Greek *kylix* comes *culichna*, a type of handled cup (Sources 7–11). The word *capra*, 'urn', was perhaps derived from the Greek *kamptra*, 'box'. *Thina*, from Greek *thinos*, comes into Latin by way of Etruscan as *tina*: in Varro's account of symposia it indicates a wine vessel. From the Latin comes the Italian word *tino*, 'vat' (cf. *tinello*).[86] (Sources 7–9, 11).

A number of words were borrowed from the Umbrian neighbours to the east: *etera*, the word for 'client' or 'stranger' (equivalent to Latin *peregrinus*); the word for 'basket', *cletram*; more importantly, perhaps, the word for 'city' or 'community', *tuthi* (from the Umbrian word *tota*), and the name of a local god, *crapsti* (**Grabouius*, Umbrian *Grabouie*). *Maru*, the name for a magistracy, which occurs in Umbrian, perhaps as a loanword from Etruscan *maru*, is known in Latin as the *cognomen* of Vergil, P. Vergilius Maro.

From Latin come some important words related to religious ritual spoken by their neighbours to the south: *fanu*, 'sacred place', 'sanctuary', from Latin *fanum*; *tura*, 'incense', from *tus*, *turis* (Greek *thýos*); *cupe*, 'cup', from *cuppa*; *Nethuns*, 'Neptune', from *Neptunus*, and *Selvans*, 'Silvanus'. The word *macstre*, 'master', comes from Latin *magister*, and the word *nefts*, for 'grandson', from *nepos*. The chronology of these loan words has to be examined case by case.

ETRUSCAN WORDS IN LATIN

We have seen above that the history of early Rome was closely connected to that of the Etruscan cities in the seventh and sixth centuries. The word for *triumph*, an Etruscan procession and ceremony which was given a special meaning in Roman religion and, eventually, politics, belongs to the vocabulary of authority and power, like the fasces and other symbols of power which came into Rome from the Etruscan sphere and which Roman conservatism preserved as precious reminders of a past whose precise details had been forgotten and transformed.

Triumph and *catamite* are not the only Etruscan, originally Greek, words that have come into English by way of Rome. The Latin debt to the Etruscans in terms of vocabulary is considerable, and reflects the kind of Etruscan influence at work at a moment which can be recognized as the late sixth century, traditionally the time of the 'Etruscan kings'. The religious and ritual costume of Rome preserved much of what had been everyday Etruscan dress in this period. At this time, too, vocabulary, much of it originally Greek, was introduced into

the Latin language which was indicative of the Etruscans' greater luxury and more sophisticated culture. These are words related to the theatre, *persona* (*phersu*), *histrio*, *scaena* (and perhaps *Acheron*, and names of tragic characters); fashions, *laena* (from Greek *chlaina*), *lacerna*, *tebenna* (the Etruscan name for the rounded garment which was the ancestor of the Roman toga), *tunica*, and the woman's ritual hairstyle, the *tutulus*. (See the section on Glosses.) *Taberna*, a word which has come into our times as 'tavern', reminds us of the Etruscans' reputation as a pleasure-loving people, and Livy's story (1.57) of the Tarquin women partying with their friends while Lucretia sat at home directing the women of the household as they worked the wool and wove the family's clothes, blankets, and shrouds.

Most impressive in the present context is the Latin word for writing, *litterae*, deriving from Greek: *litterae* < *diphtherai*, skins of sheep and goats used for writing before the use of papyrus (Herodotus 5.58). It has come down to us with a meaning similar to that of the Latin word, 'things written', 'letters', or literature. Etruscan influence on Rome was important, though it never touched the base of the Latin language or the conservative Roman religion.

THE WRITTEN WORD

The luxurious writing implements buried with the dead indicated the importance of writing in the seventh century, an importance emphasized in the fourth century and later by specific references to books and writing in the documents themselves, and by their representation in art. The solemnity of the written style comes through even in the limited amount of written material that has come down to us – like the tip of an iceberg, as Roncalli has noted. Religion, the art of divination, the stability of boundaries, the security of society all depended upon the inviolability of the written word. Prophecies, which were crucial to the Etruscan system of religion and life, were often specifically stated to have been written down. The act of writing itself defined the character of rituals or sacred law and the very nature of the religion concerned.[87] The place of writing in Etruscan religion is a striking example of its symbolic, religious significance, which has been the subject of much recent study.[88]

The importance of the written word is underlined by the frequent appearance of the word for 'writing', or 'book', *zich*, on religious and

legal documents. Five of the longer Etruscan inscriptions that have
come down to us refer specifically to the fact that a particular document
or book is written – a strikingly large proportion given our small
sample. On the Capua Tile (*TLE* 2) an individual whose name is lost
was responsible for the text, which he wrote down or ordered to be
written: *zichunce*. The Zagreb mummy wrappings have *zichne*, as well
as the phrase *zichri cn*, 'let this be written down'.[89] The epitaph of
Laris Pulenas (*TLE* 131) refers to the book on divination he has written,
the *zich nethsrac*, probably the very scroll he is holding out to the
viewer. The cippus from Perugia (*TLE* 570. Source 64, fig. 54) ends
with the solemn ruling, *cecha zichuche*, 'as this sentence has been
written down, prescribed' – the sentence has in fact been written
in stone. The bronze tablet from Cortona, the Tabula Cortonensis
(Source 65, fig. 55), gives us a new example of the verb: here too, *zich*
refers to the contents of the document.

A special style characterizes these written texts. In spite of the loss
of Etruscan literature and paucity of long, continuous texts, several of
the longer texts that have come down to us echo the solemn rhythm
characteristic of religious and legal documents, with their repeated
symmetries, parallel clauses, and synonyms. When Laris Pulenas (Source
31, fig. 28) lists his titles and priesthoods, recording the ceremonies,
sacraments, functions, and sacrifices at which he has officiated, their
ritual order determines the rhythm of the repeated *pul, pul, pul* – 'first,
then, then'. In the Pyrgi tablets (fig. 5) a similar rhythm appears from
the beginning: *ita tmia icac heramasva*, 'This is the *tmia* and this is
the *heramasva*', and later, *ilacve* [...] *ilacve*, 'since on the one hand ...
since on the other hand'. In calendars such as the Zagreb mummy
wrappings (Source 67) or the Capua Tile, which prescribe specific
sacrifices, libations and prayers to be offered to particular divinities at
given dates, the repetitions are necessitated by their very nature. On
the Perugia cippus (Source 64) the patterns, symmetries, and other
rhetorical devices of ritual language are reflected in the spacing of the
words and lines of the inscription.[90] The ritual form of the texts assures
the permanence of the destiny of an individual or a group, much like
the ritual gesture of the female divinity hammering the nail of Fate on
an engraved mirror (Source 41, fig. 38).

Written texts – books, scrolls, and tablets – are also frequently shown
in Etruscan art, emphasising the solemnity of the written style of such
religious and legal texts on the monuments themselves. Such a visual
rendering of a document recording the very ceremony being represented

appears on the mirror from Volterra with the symbolic ritual of Uni's adoption of Hercle (Source 36, fig. 33). The solemn moment of this divine rite of passage is witnessed by an assembly of divinities; one of them points to the tablet which records the divine ceremony and assures its legality, like the human contracts and legal documents recorded on the Perugia cippus and the Tabula Cortonensis (Sources 64, 65). This documentation of a rite of passage is paralleled by funerary scenes of Lasa or Vanth holding out a scroll with the names of the dead heroes (Source 44), or of Laris Pulenas exhibiting his scroll on his sarcophagus (Source 31).

The signs of the gods were themselves a kind of writing that had to be deciphered by men.[91] Prophecies abound in Etruscan religion, mythology, and art – and these prophecies are written down. Tages, Vegoia, and others all preserved their prophetic utterances in written form. Urns and, above all, mirrors show with surprising frequency figures holding out the tablets on which these are written, often gesturing in surprise at the revelations they bring to people. The *Etrusca disciplina* could be read, and learned, from books of revelation. After the 1985 Perugia exhibit on Etruscan texts, *Scrivere Etrusco*, Massimo Pallottino remarked that we could well call the Etruscans the People of the Book. Livy tells us that the Romans used to send their children to Etruria to learn letters in the fourth century BC, as they later used to send them to Athens. These were the children of the aristocrats. The Roman oligarchy needed to learn the art of divination as part of its training, to be able to lead armies in the field and carry out religious rituals in peace. With the study of the Etruscan books of divination they received a technical training which prepared them for their careers as leaders in Rome.

CHAPTER VI

ETRUSCAN WRITING:
THE AFTERMATH

The Etruscan alphabet spread throughout the whole of Italy and was used for all the languages spoken in the peninsula, with the exception of Greek, Messapic, and the native languages of Sicily (maps 2 and 3). The whole of central and northern Italy eventually used alphabets that derived directly from the Etruscan: Umbrian, Oscan, Venetic, Lepontian, Gallic (Gaulish, of north Italy), Picene, Rhaetic or Raetian,[92] and, in part, Latin.

This alphabet spread much farther north as well. Also derived from the Etruscan alphabet, by way of the Venetic script, were the Germanic runes – the writing used by the Goths (in the Ukraine, the former Yugoslavia, Romania, etc.), the Germans, the English, the Danes, Norwegians, Swedes, and Icelanders (map 4).[93] These runes, originally

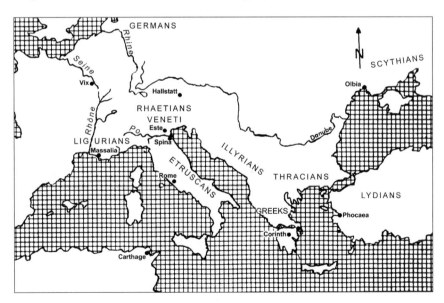

Map 4 Peoples of Europe, eighth century BC

considered to be magic signs, were carved on some objects as protection, and on weapons or armour to make them more powerful. Several early runes have come down to us carved on spearheads or helmets (fig. 9). As an example of later runes we can look at the beautiful ivory casket in the British Museum, the Franks Casket, a whalebone box dating from the eighth century AD, whose decoration consists of a mixture of Christian and pagan motifs – Romulus and Remus, the Magi, the Lame Smith

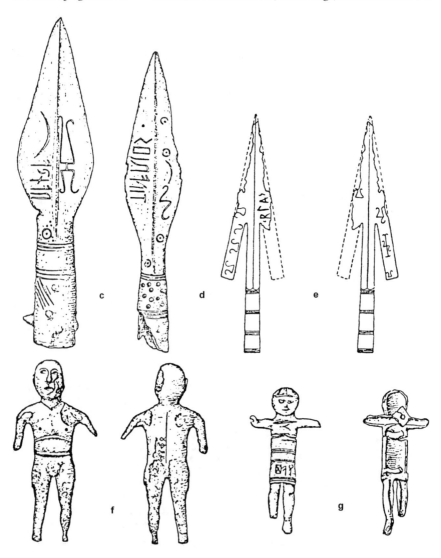

9 Runic inscriptions on spearheads and bronze statuettes

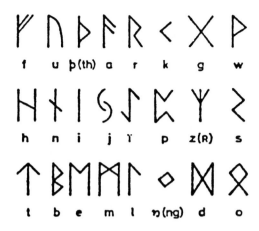

10 Runic alphabet: 'futhark'

– while the inscription mixes Latin and runic scripts and texts; the runic inscription, running all round the frame, includes a riddle about a whale.[94] Most of these runic inscriptions were incised on stone[95] and date to a period well within the Christian era, at a time when Etruscan civilization had long been forgotten. Yet they testify to the lasting influence of Etruria and its role in bringing civilization, and above all the art of writing, to Europe.

Two questions must be considered concerning the origin of the runes. When were these runes (fig. 10) first adopted from the Etruscan alphabet? And how did this Etruscan influence spread so far north?

Let us take the question of date first. The earliest of these inscriptions date from the first or second century AD. The earliest reference to such inscriptions occurs around the same date; the Roman historian Tacitus mentions the runes in his book on Germany, the *Germania*, written in AD 98.[96] Yet the runes must have been developed from a North Italic (Venetic) alphabet deriving from the Etruscan alphabet long before this time, for the Romans conquered northern Italy around 200 BC, and thereafter the Germanic tribes would have adopted the Latin alphabet, not a system of writing which by then belonged to a culture rapidly diminishing in importance. This brings us to the third century BC at least, probably much earlier, for the introduction of this writing into Germany. Why is it then that no runes have been found earlier than the first or second century AD? The answer is very simple: they were all destroyed. As Tacitus tells us (*Germania* 10.1.3), 'signs' (*notae*) were carved on bits of wood, particularly beech wood (Latin *fagus*, 'beech',

which is cognate with the English word 'book').[97] Such pieces of wood (*surculi*) would soon rot in a damp northern climate like that of Germany.

The route of this writing can be traced without too much difficulty. A northern Etruscan alphabet was first borrowed from the area of Chiusi[98] by the Venetic- and Rhaetic-speaking peoples of northern Italy, and then, across the Alps, by the Germanic tribes of Europe (map 4). Direct contacts between Etruria and the north go far back in time, to the period of Etruscan supremacy, when everyone flocked to trade with the Etruscan cities and buy some of the mineral wealth they controlled. Northerners imported not only the raw materials, but also the finished bronze work for which the Etruscans were famous throughout the ancient world. Such contacts between Germany and Etruria are confirmed by the German word *Erz*, 'bronze', which comes from the name of the Etruscan city of *Arretium*, Arezzo, famous for its working on metal. The famous Chimaera of Arezzo, discovered during the Renaissance (1554), testifies to the skill of the bronze workers of that Etruscan city (Source 26, fig. 26). And when Scipio Africanus asked the Etruscan cities for supplies for his expedition against Hannibal in the second Punic war, Arezzo's principal contribution consisted of arms, weapons, and tools.[99] Its flourishing workshops, producing quantities of the shiny red-glazed, relief-decorated Arretine pottery (later imitated in the north as well) continued this tradition of metal-working into the first centuries BC and AD.

Long before Roman merchants reached Germany, Etruscan craftsmen and tradesmen had arrived in these northern regions, bringing with them objects and techniques and introducing into Europe the invention of writing and thereby the beginning of the civilization we know.

NOTES TO PART TWO

1. L. Aigner-Foresti, *Tesi, ipotesi e considerazioni sull'origine degli Etruschi* (Vienna, 1974). E. J. Bickerman, 'Origines gentium', CP 47 (1952) 65–81.
2. Hesiod, *Theogony* 12, 101 ff. Translated by Norman O. Brown (New York, Library of Liberal Arts 1953): 'Circe, the daughter of Hyperion's child, the Sun-god, loved Odysseus, famous for his endurance, and bore Agrius and Latinus, the strong man with no stain. This pair rule over all the famous Tyrsenians in their far-away retreat deep in the sacred islands.' The Lipari islands (also called 'Aeolian' or 'Volcanian') are probably referred to.
3. Herodotus I. 93–96: 'Apart from the fact that they prostitute their daughters, the Lydian way of life is not unlike our own. The Lydians were the first people we know of to use a gold and silver coinage and to introduce retail trade, and they also claim to have invented the games now commonly played both by themselves and by the Greeks. These games are supposed to have been invented at the time when they sent a colony to settle in Tyrrhenia, and the story is that in the reign of Atys, the son of Manes, the whole of Lydia suffered from a severe famine. For a time the people lingered on as patiently as they could, but later, when there was no improvement, they began to look for something to alleviate their misery. Various expedients were devised: for instance, the invention of dice, knuckle-bones, and ball-games. In fact they claim to have invented all games of this sort except draughts. The way they used these inventions to help them endure their hunger was to eat and play on alternate days – one day playing so continuously that they had no time to think of food, and eating on the next without playing at all. They managed to live like this for eighteen years. There was still no remission of their suffering – indeed it grew worse; so the king divided the population into two groups and determined by drawing lots which should emigrate and which should remain at home. He appointed himself to rule the section whose lot determined that they should remain, and his son Tyrrhenus to command the emigrants. The lots were drawn, and one section went down to the coast at Smyrna, where they built vessels, put aboard all their household effects and sailed in search of a livelihood elsewhere. They passed many countries and finally reached Umbria in the north of Italy where they settled and still live to this day. Here they changed their name from Lydians to Tyrrhenians, after the king's son Tyrrhenus, who was their leader.' Translated by A. de Sélincourt, *Herodotus, The Histories*, Penguin Classics (Harmondsworth 1954).

4. Dionysius of Halicarnassus, *Roman Antiquities*. 1.30.1–3. Translated by E. Cary, Loeb Classical Library (1914).

5. M. Durante, *Studi Micenei ed Egeo-Anatolici* 7 (1968) 31 ff.

6. See also *Tusculum, Tuscania*, and the Etruscan gentilicial *Tursikina* (Chiusi), for which see de Simone, *StEtr* 40 (1972) 153–181.

7. F. Skutsch, *Pauly–Wissowa s.v. Etrusker, Sprache*. For the name of the Etruscans, see below ch. I, n. 14. For *turris, tursis*, see Ernout and Meillet, *Dictionnaire s.v.* Accusatives in *im* (rather than *-em*) as in *turrim*, are used for foreign words.

8. This is the case for the Albanians, who call themselves *Shqipëtar*, and the Germans, called *Tedeschi* by the Italians, *Allemands* by the French, *Nemtsy* by the Russians, and *Deutsche* by themselves. See A. Tovar, *Boletín de Filología de la Universidad de Cile* 31 (1980–81) 371.

9. S. Pieri, 'Toponomastica della Toscana meridionale' (Siena, 1969) *s.v. Rasna*, with syncope of *e*.

10. J. Corominas, *Breve diccionario de la lengua castellana* (3rd edn, Madrid, 1973), *s.v. tosco*. G. Bonfante, *The Origin of the Romance Languages* (Heidelberg, 1999), ed. L. Bonfante.

11. Livy 1.2: 'Etruria, indeed, had at this time both by sea and land filled the whole length of Italy from the Alps to the Sicilian strait with the fame of her name' Cf. Cato (Servius, *ad Aeneidem* 11.567): In *Tuscorum iure paene omnis Italia fuerat.*

12. *Annals* 11.14.

13. Pandolfini and Prosdocimi, *Alfabetari*, Nos I.1, I.3, I.6. N. de Grummond, 'Etruscan sigla' (see Part I, n. 83) 32, on alphabets and sigla.

14. Lucretius, *De Rerum Natura*, 6.381–382. Heurgon, *La Vie*, 278, credits Niebuhr with this explanation of *retro*.

15. The problem of syllabic writing has been studied by E. Vetter, F. Slotty, A. Pfiffig, and M. Lejeune. E. Peruzzi (*Mycenaeans in Early Latium* (Rome, 1980), Appendix I, 'Mycenaeans and Etruscans', 137–149) denies any relationship between the development of a syllabic script in Etruria and the earlier Mycenean syllabic writing and considers the Etruscan system to be, not a relic of an earlier system, 'but the development of well-mastered alphabetic practices'.

16. By 'Italic' we understand Oscan, Umbrian, Marsian, Pelignian and other minor dialects of central Italy, as distinct from Latin, which we do not call Italic.

17. Roncalli points out the similarity between the religious ritual text, with its many 'levels', to modern religious texts: *JdI* 95 (1980) 227–264.

18. For pre-Roman inscriptions in Italy, see G. Bonfante (ed.), *Iscrizioni pre-latine.* Add to these the Gaulish–Latin bilingual from Vercelli: M. Lejeune, *CRAI* 1977, 582 ff.; M. -G. Tibiletti Bruno, *RendLinc* 31 (1977) 355–76; and a new Latin inscription, *c.*500: C. Stibbe and others, *Lapis Satricanus* (1980). On the Praenestine Fibula as a forgery: A. F. Gordon, *The Inscribed Fibula Praenestina*. University of California Publications. Classical Studies 16 (Berkeley, Los Angeles and London, 1975); D. Ridgway, 'Manios faked?', in *BICS* 24 (1977) 17–30; M. Guarducci, *Memorie dell'Accademia nazionale dei lincei* 24 (1980) 415–574, *Memorie dell' Accademia Nazionale dei Lincei* 28 (1984) 125–177. Several scholars consider the question to be still open, and compare the Vetusia inscription, which some take to be Etruscan: A. Morandi, *Epigrafia italica* (Rome, 1982) No. 5; T. Cornell in,

Literacy in the Roman World (1991) 16; A. Emiliozzi, 'Sulla tomba Bernardini di Palestrina', Bollettino della Unione Storia ed Arte 36 (1993) 7–13.

19. M. Cristofani, *Tabula Capuana. Un calendario festivo di età arcaica* (Florence, 1995).

20. *CIE* 6310. M. Torelli, *ArchClass* 18(1966) 284 ff. K. Olzscha, *Glotta* 47 (1969) 309.

21. A. Morandi, *Epigrafia Italica* (Rome, 1982) 36–38. No. 2. H. Rix in Cristofani (ed.), *Gli Etruschi. Una nuova immagine* (Florence, 1985) 217.

22. S. Weinstock, 'Martianus Capella and the cosmic system of the Etruscans', *JRS* 36 (1946) 101–129. Pallottino, *Etruscans*, 144, 261 n. 15.

23. In a recent examination of the grammatical, lexical, and textual similarities between Lemnian and Etruscan, Helmut Rix concludes that there was no direct relationship between them, but rather a derivation from a common language, which he calls – for convenience – 'Original Tyrrhenian' (*Urtyrsenisch*), a language which must go back to the turn of the millenium, around 1000 BC. This conclusion does not imply anything about the original 'homeland' of the language, nor about the perennial problem of 'Etruscan origins' (H. Rix, *Rätisch und Etruskisch* (Innsbruck, 1998) 36, 57–60). In *Tirreni a Lemnos* (Florence, 1996), Carlo de Simone identifies the Lemnian language as archaic Etruscan, based on a new inscription, a loomweight of *c*.500 BC; Luigi Beschi points out that the inscription reads *atital*, and not *La Tita* (*ParPass* 187 (1996) 132–136). For Luciano Agostiniani (in M. Torelli (ed.), *The Etruscans* (Venice, 2000) 485), the language of the Lemnos stele is Etruscan; but we have no way of knowing what Etruscans brought it there, when and in what circumstances.

24. Benelli, *Le iscrizioni bilingui*. For the bilinguals illustrated here see also H. Rix, *Die etruskische Cognomen* (Wiesbaden, 1963).

25. The bibliography on the Pyrgi tablets is enormous. See Pallottino, *Etruscans* 90, 93, 221, 249, 255, pls. 12–14. G. Colonna, 'Tempio e santuario nel lessico delle lámine di Pyrgi', *ScAnt* 3–4 (1989–90) 197–216. Heurgon, *JRS* 56 (1966) 1 ff., presents a good account in English. A seminar was held at Tübingen in 1979 on the subject of the goddess to whom the dedication was made (see Bibliography, *Die Göttin von Pyrgi*). Many scholars take the Phoenician inscription as Punic, confirming a Carthaginian presence. See Garbini's translation, *ArchClass* 16 (1964) 74 = A. Morandi, *Epigrafia Italica* (Rome, 1982) 35. Philip Schmitz reviewed the evidence (*JAOS* 115 (1995) 559–575), and concluded, as Giorgio Levi della Vida had done earlier, that it has Cypriot features: 'the language of the Pyrgi text is not Punic, as was assumed by earlier scholars, misled by later close ties between Italy and Carthage; nor is it a mixed dialect. Its language is rather the Mediterranean dialect of Phoenician.' See also J. N. Coldstream, 'The beginnings of Greek literacy: An archaeologist's view', *Macquarie University Resources for Teachers. Ancient History* 20 (1990) 144–159. For comparisons between Etruscan and Cypriot culture, see the Proceedings of the Conference held in New York, November 2000; L. Bonfante and V. Karageorghis (eds), *Italy and Cyprus in Antiquity: 1500–450 BCE* (Nicosia, 2001).

26. Vergil, *Aeneid* 8.72 etc. C. de Simone, 'Il nome del Tevere', *StEtr* 43 (1975) 119–157.

27. Aristotle, *Politics* 3, 9, 1280a, 36. G. Pasquali, *La grande Roma dei Tarquinii: Terze pagine stravaganti* (Florence, 1942; reprinted 1968) 5–21.

28. Kaimio, 'Ousting'. See now Benelli, *Le iscrizioni bilingui*, for a study of bilingual

inscriptions. Kaimio, 'Ousting', 114: 'The Roman citizen praenomina emerge, although scattered at first, in the latest phase of the Etruscan inscriptions, evidently after Roman citizenship had been granted to the Etruscans.' Lucius became the most common praenomen, followed by Caius (Kaimio 175–76).

29. According to A. J. Pfiffig, *Die Etruskische Sprache* (Graz, 1969) 279), *frontac* (onomatopoetic) is related to Greek *bronte*; 'thunder', and therefore equivalent to *fulguriator*. For all the following see Benelli, *Le iscrizioni bilingui*, and Rix, *Cognomen*.

30. For *Spitus* see also, from Tarquinia, *TLE* 887–889; *ET* Ta 1.111, 124, 164–168; Kaimio, 'Ousting', 120, 135, 151. *Thoceronia, Thocerual*, Kaimio, 'Ousting', 123–124, 138, 151, 158, 179. For the matronymic with *natus*, see Kaimio, 'Ousting', 165–167.

31. Benelli, *Le iscrizioni bilingui* 32, No. 30; Cristofani, *Introduzione* 129–130, No. 21. *Presnt-* occurs in several other inscriptions from Chiusi and elsewhere: see *ET*, s.v. Kaimio, 'Ousting', 121.

32. *TLE* 801–858. G. Bonfante, 'Problemi delle glosse etrusche', *Atti di Grosseto* (Florence, 1977) 84. M. Torelli, in *Mélanges Heurgon* 1001–1008. M. M. T. Watmough, *Studies in the Etruscan Loanwords in Latin*. Biblioteca di Studi Etruschi 33 (Florence, 1997).

33. See Glosses, below. A. Walde and J. B. Hofmann, *Lateinisches etymologisches Wörterbuch* (3rd edn, Heidelberg, 1930–56), Ernout and Meillet, *Dictionnaire s.v.* A. Ernout, *Philologica* III (Paris 1965) 30. F. Prayon, *Frühetruskische Grab- und Hausarchitektur* (Heidelberg, 1975) 160. Aisar: *TLE* 803 (Suetonius, Dio Cassius). The name of the falcon, *capys*, is explained by a supposed relation to the Latin word *capio*, 'to take or hold'.

34. Torelli, in *Mélanges Heurgon*, 1001–1008. V. Bertoldi, '*Nomina tusca* in Dioscoride', *StEtr* 10 (1936) 295 ff. Some botanical glosses might derive from the *ostentarium arborarium* of Tarquitius Priscus (Macrobius, *Saturnalia* 3.20.3).

35. *TLE* 811. Arimos = 'monkey'. Servius, *ad Aeneidum* 9.712: *simiae ... quas Etruscorum lingua arimos dicunt.* Hesychios: *arimos, pithekos;* cf. Strabo 13.4 6 For monkeys, see D. Rebuffat Emmanuel, *StEtr* 35 (1967) 633–644, and J. Szilágyi, *Revue Archéologique* 1972, 111–126. Inarime: Vergil, *Aeneid* 9.716; Ovid, *Metamorphoses* 14.89; also Pliny, Lucan, Statius, etc. Cf. Homer, *Iliad* 2.783.

36. *TLE* 843: Servius, *ad Aeneidum* 2.278; 8.475. Livy 1.34, and Ogilvie, Commentary, 142–143.

37. Watmough, *Etruscan Loanwords*, on *subulo* (from *suplu*), *histrio, lucumo, persona, populus*. For *litterae*, see Peruzzi, *Origini di Roma*, II.16–24; and *Aspetti culturali del Lazio primitivo* (Florence, 1978) 31, 153–154. L. Bonfante, *Etruscan Dress*, 'Vocabulary', 101–104.

38. For Latin *elementum* see Ernout and Meillet, *Dictionnaire*, Walde and Hofmann, *Wörterbuch* s.v., and W. Vollgraff, '*Elementum*', in *Mnemosyne*, s. 4, 2 (1949) 89–115, etc.

39. Peruzzi, *Origini di Roma*, II.33–48.

40. The word *uinum* apparently came into Etruscan from Latin. It is originally *not* Indo-European, and probably came from the Eastern Mediterranean area (Georgia): G. Bonfante, 'Das Problem des Weines und die linguistische Paläontologie', *Antiquitates Indogermanicae. Gedenkschrift fur H. Gunter* (Innsbruck, 1974) 85–

90; and L. Bonfante, *Out of Etruria*, 10. For the history of the interpretation of Etruscan, see Pallottino, *Etruscans*, 189–208.

41. F. Coarelli, 'Il sepolcro degli Scipioni', *DdA* 6 (1972) 36–105. Iguvine tablets: J. W. Poultney, *The Bronze Tablets of Iguvium* (Baltimore, 1953). G. Devoto, *Tabulae Iguvinae* (3rd edn, Rome, 1962). A. Morandi, *Epigrafia Italica* (Rome, 1982) 75–114. A. Prosdocimi, *Le tavole iguvine* (Florence, 1984). J. B. Wilkins, 'Nation and Language in Ancient Italy', *Accordia Research Papers* 1 (London, 1990) 53–72. J. B. Wilkins, 'The Iguvine Tables: Problems in the interpretation of ritual text', in C. Malone and S. Stoddart (eds), *Territory, Time and State* (Cambridge, 1994) 152–172. J. B. Wilkins, *Auspices and Auguries. The Bronze Tables of Gubbio* (forthcoming).

42. See chart of alphabet and transcription. Linguists classify consonants according to the place and manner of articulation. The sounds to which we refer are generally those of English. Glottal: *h*. Velars: *k*, *g*, *n* (as in *think*). Dentals: *t*, *d*, *th* (in *think*), *th* (in *that*), *s*, *z*, *n*. Bilabials: *p*, *b*, *m*, *w*. Labiodentals: *f*, *v*. Nasals: *n*, *m*. Stops (or occlusives): *k*, *ch*, *t*, *p*, *g*, *j*, *d*, *b*, of which *k*, *ch*, *t*, *p* are voiceless, and *g*, *d*, *b* voiced. Fricatives: *h*, *th*, *f*, *s*, *v*, *z*, of which *h*, *th* (in *think*), *f*, *s* are voiceless, and *th* (in *that*), *v*, *z* are voiced. Sibilants; *s*, *z*. Liquids: *r*, *l*. Aspirates: *k*, *t*, *p* in initial position when not preceded by another consonant. Semiconsonants: *y* (in *yes*), *w*.

43. In English we have *karat, quality, cart*; but *Celt, city* (*c* can indicate two different sounds). The phonetic distinction still exists, however: the *k* in German *Kehle, Katze, Kuh* exemplifies the three places of articulation represented in Etruscan by *c*, *k*, and *q* respectively.

44. Cristofani, *Introduzione* 17. C. Boisson, 'Note typologique sur le système des occlusives en étrusque', *StEtr* 56 (1991) 175–187. K stands for *Kalendae*, from which comes the word 'calendar'.

45. C stands for *Caius*, pronounced *Gaius*. The same sign was also pronounced as a *k*, as in *Kaiser* (from *Caesar*).

46. The sign here transcribed as *v* always had a bilabial pronunciation, like English *w*. Latin *u* had two similar values: as a vowel in *bucca*, and as a semivowel in *uinum, uenit, uincit, nauis*. The Romans were thus free to use the Greek *digamma*, Ϝ, to represent the sound of our *f*, while the Etruscans could not, because they needed Ϝ for the *w* sound. In Etruscan, as in Latin, *f* was probably bilabial, like *w*, *p*, and *b*, and not labiodental, as is English *f*. Latin inscriptions often have *m* before *f*, like *imferi* for *inferi*. M. Lejeune, 'La notation de F dans l'Italie ancienne', *REL* (1966) [1967] 141–181.

47. The two sibilants M and ⟨, corresponding respectively to the Phoenician letters *sade* and *šin*, are transcribed as *ś* and *s*. For the transcription of the other signs for *s*, see *ET* 21–22; *TLE* p. 13; Pfiffig, *Etruskische Sprache*, 20. In the north Etruscan cities, M is regularly used to indicate the genitive ending: Roncalli, *JdI* 95 (1980) 252. In the new inscription of the *Clavtie* family, *CIE* 6213 (Source 58), ⟨ and ⟨ are used for the sibilants. The use of a variety of signs may of course simply betray the survival of earlier forms of spelling (i.e. 'historical spelling', as in English), or of conventional signs, like the German *scharfes s*, ß: G. Bonfante, *AGI* 56 (1971) 168. The distinction was considered to be important by the Etruscans themselves. Cristofani (*IBR* 380) suggests that the sound [s] was represented by

sade, [ss] by the three-stroke sigma (but see G. Bonfante, *AGI* 61 (1976) 269; 272). There seems to have been some confusion between *s* and *ś*, which are often used without distinction in the same place and with the same function. But *s* was probably pronounced as a dental fricative (English *same*), while *ś* represented a palatal fricative (English *shame*): for *husiur*, 'children', was also written *huśur* (*husiur* must have become **husyur* and then *huśur*, with palatal *ś*). The form *husiur* is likely to be the older, since it is found near Perugia, in a peripheral and therefore more conservative area.

48. For *f* in Iranian see Abajev, *Studia Pagliaro*, I (Rome, 1969) 21. For the *f* in Lydian see P. Meriggi, *Festschrift H. Hirt, Germanen und Indogermanen* II (Heidelberg, 1936) 28 ff., and *MemLinc* 24.3 (1980) 260. Cf. R. Gusmani, *Lydisches Wörterbuch* (Heidelberg, 1964); *Ergänzungsband* (The Hague, 1982) 1–2. For the relationship of Etruscan and Lydian see also M. Durante, *Studi micenei ed egeo-anatolici* 7 (1968) 31 ff. See note 46 above.

49. G. Bonfante, 'Il suono *f* in Europa: è di origine etrusca?' *StEtr* 51 (1983) [1985] 161–166.

50. In the *Thesaurus Linguae Etruscae* there are eight pages for *f*. Words with initial *p* take up twenty-five pages (262–287), those with *ph* take up only one (361–362). The normal number of pages devoted to each letter of the alphabet in the *TLE* is around ten pages. This is a sign that the space that would have been devoted to the phoneme *ph* has been swallowed up by another, that is *f*.

51. In internal position in Etruscan, *f* is probably a rather late innovation: it has swallowed up *ph*, which is almost completely absent in initial position. Cristofani, *Introduzione* 48, takes for granted the change *p* > *ph* > *f*, citing *Pupluna* > *Fufluna* 'Populonia', *Thupltha* > *Thufltha*, *thapna* > *thafna* 'cup, chalice'.

52. For *p* and *t* we have no examples, perhaps because none has yet been found.

53. C. de Simone, *StEtr* 37 (1970) 115–39. M. Cristofani, *AGI* 56 (1971) 40, n. 9; *StEtr* 37 (1973) 181ff.; *Introduzione* 78, 83. Contrast Italian *ceppo* ('log', 'branch') and *zeppo* ('full to the brim'), where the words have different meanings, with *rinuncia: rinunzia* ('he renounces'), *annuncia: annunzia* ('he announces'), or *pronuncia, pronunzia* ('he pronounces'), where the *z* and *c* represent only phonetic variants. The conclusion is important: the phonetic or phonemic value of a phoneme depends on its position in the word. G. Bonfante, *AGI* 61 (1976) 272. *Zilath* is the magistrate, *zilach* the magistracy: A. Maggiani, *StEtr* 62 (1998) 35.

54. Pliny *apud* Priscian II. 26.16: 'o aliquot Italiae gentes non habebant, sed loco eius ponebant *u*, et maxime Umbri et Tusci'. Pfiffig, *Etruskische Sprache* 29.

55. De Simone (*L'etrusco arcaico* 72) thinks that in *Atmite* (from Greek *Admētos*) and in *Catmite* (from *Gadymēdēs* instead of *Ganymēdēs*) the *i*, corresponding to Greek *ē* (eta), was preserved because the Etruscans also pronounced it as a long vowel. Even if he were right, these words, of foreign origin, constitute insufficient evidence for the existence of these long vowels in Etruscan. Every language treats foreign words in a special way.

56. Cristofani, *Introduzione* 47. *Faustus* > *Fasti*; *Raufe* > *Rafe* (Latin *Rūfus*, from early Latin **Roufos*).

57. The letter *a* is often not dropped. See for example Latin *cápio: óccupo, ágō: éx-ĭgo, alter: ad-ulter*, in which *ă* becomes *ŭ* or *ĭ*. *Amake* in Etruscan becomes first *amuce*, then *amce*.

58. D. Briquel, 'Perspectives actuelles sur la langue étrusque', *Ktema* 10 (1985) 111–125.

59. The word *clan*, 'son', very frequent on tombs, shows a mysterious change in the vowel: *clan: clenśi: clenar*. H. Rix, in M. Cristofani, *Gli Etruschi. Una nuova immagine* (Florence, 1984) 227, explains it as a metaphony of the vowel preceding the suffix.

60. For the numbers, see *TLE* 880, 882, two versions of the same text. *s* and *ś* frequently alternate without any clear reason; but see below.

61. M. Cristofani, 'L'indicazione dell'età in etrusco', *AGI* 58 (1973) 157–164; 'Recent Advances', in *IBR*, 400.

62. Sometimes the genitive form is ambiguous. Scholars argue about the gender of the person buried in the Regolini-Galassi tomb, whose silverware is dedicated, *larthial* (probably an archaic masculine genitive form). Ch. 1 (Source 6, fig. 13).

63. Cristofani, *Introduzione* 56–57; the genitivus genitivi.

64. G. Colonna, 'Nome gentilizio e società', *StEtr* 45 (1977) 175 ff. C. de Simone, 'Fremde Gentilnamen in Etrurien in archaischer Zeit', *Aufnahme fremder Kultureinflüße in Etrurien und das Problem des Retardierens in der etruskischen Kunst. Schriften des Deutschen Archäologen-Verbandes* 5 (Mannheim, 1981) 89–93. On proper names, Cristofani, *Introduzione* 92–103. Pfiffig, *Etruskische Sprache*, 175–194.

65. G. Bonfante, in *Mélanges de philologie, de littérature et d'histoire ancienne offerts à J. Marouzeau par ses collègues et élèves étrangers* (Paris, 1948) 43 ff.

66. In our opinion, the gentile name was originally a patronymic, and the origin of the Latin *gentilicium* is to be found in the Italic languages. Originally both Etruscan and Latin used only one name: Latin *Romulus, Remus, Amulius*, Etruscan *arnth, venel*, etc. These became gentilicial by the seventh century: the single names of Remus and Romulus contrast with Titus Tatius and Numa Pompilius. G. Bonfante, 'The origin of the Latin name-system', *Mélanges Marouzeau* (Paris, 1948) 43–59.

67. Cicero, *Topica* 6.29. Juvenal, *Satire* 5.125–127: *Duceris planta velut ictus ab Hercule Cacus / et ponere foris, si quid temptaveris umquam / hiscere, tamquam habeas tria nomina*, 'Just try to open your mouth, as if you had three names, and you will be dragged by the feet and taken out, like Cacus struck by Hercules.'

68. C. de Simone, 'Etrusco *Laucie Mezentie*', *ArchClass* 43 (1991) 559–573.

69. G. Bonfante, 'Il nome della donna nella Roma arcaica', *RendLinc* 35 (1980) 3–10.

70. A. Morandi, 'Etruscan *ipa*', *Revue belge de philologie et d'histoire* 65 (1987) 87–96. Second person: H. Rix, '*Un, une, unu = te, tibi, vos*, e le preghiere dei rituali paralleli nel *Liber Linteus*', *ArchClass* 43 (1991) 665–691.

71. Torp's theory has been generally accepted; there is still, however, an ongoing discussion among scholars about the attribution of *śa* and *huth* as four and six respectively. Two reasons are given for taking *huth* as four: (a) Another name for the city of *Tetrapolis, Huttenia*, is related to *huth*, meaning 'four'. (b) In the Tomb of the Charons, the fourth figure of the demon Charun is labelled *Charun huths*, 'the fourth Charun' (*TLE* 885). On the other hand the study of Adriana Emiliozzi ('Per gli Alethna di Musarna', in *Miscellanea Etrusco-Italica* I (Rome, 1993) 109 ff.) confirms the use of *śa* for four (referring to a quadruple burial), and therefore of *huth* for six. For the numerals, see Cristofani, *Introduzione*, 75–79. The two sides of the dice add up to seven: *Anthologia Palatina*, 14.8. The 'Tuscania dice', as they are called, actually came from Vulci: G. Colonna, *StEtr*

46 (1978) 115. On the numerals 'one' to 'six', A. Torp, *Etruskische Beiträge* I
(1902–03) 64 ff, 100 ff. A. Pfiffig, 'Die etruskische Zahlwörter von eins bis sechs',
Gesammelte Schriften, 168–179. J. Wilkins, 'Etruscan Numerals', *Transactions of
the American Philological Association* 1962 (1963) 132–141. M. Lejeune, 'Les six
premiers numéraux étrusques', *REL* 59 (1981) 69. For *Charun huths*, see Stein-
gräber, *Etruscan Painting* 300, No. 55.

72. Agostiniani, Nicosia, *Tabula Cortonensis*. G. Giannecchini, 'Un' ipotesi sul num-
erale etrusco per dodici', *ParPass* 52 (1997) 190–206.

73. M. Lejeune, *BSL* 76 (1981) 241–248.

74. P. Keyser, 'The Origin of the Latin Numerals 1–1000', *AJA* 92 (1988) 529–546. I
am grateful to Nancy de Grummond for the illustration of the shift from the
Etruscan to the Roman symbols.

75. A. Emiliozzi, 'Per gli Alethna di Musarna', in *Miscellanea Etrusco-Italica I* (Rome,
1993) 109 ff.

76. Pfiffig, whose translation of the Perugia cippus we give, takes this form as a future,
while Pallottino and others take *mulune* (*TLE* 420) as an active past participle,
'having offered'; cf. *cerine* (*CIE* 5321), *tenine* (*TLE* 651).

77. An 'opposition' of *-ce* and *-che* exists only in this position. The ending *-che* is
phonemically distinct from *-ce* and indicates a passive: *mi titasi cver menache* =
'I was given as a gift to Tita'. *Titasi* could also be a dative of agent, as sometimes
happens in Latin with participles. The same holds true for other examples of
passive we examine below (*mi* is certainly a nominative).

78. Cristofani, *Introduzione*, 70.

79. Cristofani, *Introduzione*, 135.

80. '*Muluvanice* can be used in both sacred and profane contexts, while *turuce* can
only express the concept of sacred dedication. *Menace* and *zinace* can be related
to pottery activities.' Cristofani, *IBR* 406–407; cf. Colonna, *RömMitt* 82 (1975)
181–192. B. Schrimer, 'I verbi muluvanice e turuce', *ParPass* 48 (1998) 38–56.

81. Eva Fiesel and Carlo de Simone have studied the way in which Greek names of
mythological figures were transcribed into Etruscan. Fiesel, *Mythos*. De Simone,
Entlehnungen. See also H. Rix, 'Das Eindringen griechischer Mythen in Etrurien
nach Aussage der mythologischen Namen', *Schriften das Deutschen Archäologen-
Verbandes* 4–7 (1978–84) = *Aufnahme fremder Kultureinflüße* (1981) 96–106.

82. Dionysius of Halicarnassus 1.30.3: 'The Etruscans call themselves Rasenna from
the name of one of their leaders.'

83. Related to Latin *cupa*, Italian *coppa*, French *coupe*, English *cup*. G. Breyer,
*Etruskisches Sprachgut in Lateinischen unter Ausschluss des spezifisch onomasti-
schen Bereiches*. Orientalia Lovanensia Analecta 53 (Leuven, 1993) 197.

84. Pfiffig, *Religio*; and review by E. Simon, *GöttGelAnz* 232 (1980) 204. See section
on 'Mythological Figures'.

85. Still basic is Ernout, *BSL* 30 (1930) 82 ff. Most recently, Watmough, *Studies in
the Etruscan Loanwords in Latin* (1997). G. Bonfante, 'Etruscan words in Latin',
Word 36 (1985) 203–210. On dress: L. Bonfante, *Etruscan Dress*, 81–104, and
Aufstieg und Niedergang der Römischen Welt I. 4 (Berlin, New York, 1973)
584–614. On the triumph: L. Bonfante, *JRS* 60 (1970) 49–66, and *Studies in Honor
of J. A. Kerns. Ianua Linguistica* (Mouton, 1970) 108–120; H. S. Versnel, *Trium-
phus* (Leiden, 1970); Breyer, *Etruskisches Sprachgut* 232–234.

86. G. Colonna, 'Nomi etruschi di vasi', *ArchClass* 25–26 (1973–74) 132–150. C. de Simone, 'Per la storia degli imprestiti greci in etrusco', *Aufstieg und Niedergang der Römischen Welt* I. 2 (1972) 430–521. L. Biondi, '*Aska eleivana*', *ParPass* 48 (1993) 52–64; 'Presunti grecismi del lessico vascolare etrusco', *ParPass* 47 (1992) 67–71. G. Bagnasco Gianni, 'Imprestiti greci nell'Etruria del VII secolo a.C.: osservazioni archeologiche sui nomi dei vasi', in A. Aloni, L. de Finis, eds. *Dall'Indo al Thule: I Greci, i Romani, gli altri* (Trento, 1996) 307–317. *Capra*: Paulus Diaconus, *Epitome Festi* 48. F.-H. Pairault Massa, in *Caratteri dell'ellenismo nelle urne etrusche* 155, 164. *Tina*: Varro, *Apud Nonius Marcellus* 544.6; cf. Sextus Pompeius Festus, 365, ed. Müller, *tinia vasa vinaria*. *Litterae < diphtherai*: Peruzzi, *Origini di Roma*, II.22–23; idem, *Aspetti culturali del Lazio primitivo* (1978) 153: cf. *elementum, cera*, idem, *Origini* III.33–34, 46–47. R. M. Cook, *Greek Painted Pottery* (3rd edn, London, 1997) 221: 'there is no evidence that "askos" was ever used by Greeks of a pot'.

87. On the importance of writing in Etruscan art and society, see F. Roncalli, *Scrivere etrusco* (Milan, 1985) and G. Colonna, 'Scriba cum rege sedens', in *Mélanges Heurgon* 187–195. A. Maggiani, 'La divination oraculaire en Etrurie', *Caesarodunum* Suppl. 56 (1986) 6–48. For prophecies, see N. T. de Grummond, 'Themes of prophecy on Etruscan mirrors', in A. Rallo (ed.), *Aspetti e problemi degli specchi figurati etruschi* (Rome, 2000) 17–43.

88. M. Beard, 'Ancient Literacy and the Function of the Written Word in Roman Religion', in *Literacy in the Roman World* (Ann Arbor, 1991) 35–58: 'The simple fact, for example, that writing becomes used, even by a tiny minority, to define the calendar of rituals or sacred law inevitably changes the nature of the religion concerned.' T. Cornell, *The Beginnings of Rome* (London and New York, 1995) 104, comments on the close causal connection between the rise of the city-state in the Greco-Roman world and the advent of literacy. See also M. Corbier, 'L'écriture en quête de lecteurs', in *Literacy* (1991) 99–118; and 'L'écriture dans l'espace public romain', in C. Pietri (ed.), *L'urbs* (Rome, 1987) 27–60. For Etruscan writing, see Heurgon, *La Vie*, 271–273. Heurgon cites a bilingual epitaph from Chiusi of *Vel Zicu*, who takes on the name of *Q. Scribonius* (*TLE* 472). See also M. Lejeune, *Revue belge de philologie et d'histoire* 26 (1952) 204, on the priestly character of the Venetic tablets given as votive objects in the sanctuary of the goddess Reitia.

89. New reading, by Roncalli, *Scrivere etrusco*, 52, instead of *zachri*, in *Thesaurus Linguae Etruscae I. Indice Lessicale* (Rome, 1978) s.v., *TLE* 1. C. de Simone, 'La radice etrusca *zich*- "ritzen"', in *Etrusca et Italica. Scritti in ricordo di Massimo Pallottino* (Pisa and Rome, 1997) 235–237.

90. H. Rix, 'Etrusco *un, une, unu*, "te, tibi, vos" e le preghiere dei rituali paralleli nel *liber linteus*', *Miscellanea Pallottino* 665–691. Cristofani, *Tabula Capuana*, 85–87, 125. On the Perugia cippus, see Roncalli, *Scrivere Etrusco*, 81; and *StEtr* 53 (1987) 161–170.

91. L. Aigner Foresti, *AJAH* 4 (1979) 144–149, on the nail of Fate. L. Bonfante, 'Il destino degli Etruschi', in A. Bongioanni and E. Colonna (eds), *Libertà o necessità? L'idea del destino nelle culture umane* (Turin, 1998) 53–65.

92. H. Rix, *Rätisch und Etruskisch* (Innsbruck, 1998). An up-to-date, useful collection of Raetian inscriptions can be found in A. Morandi, *Il cippo di Castelcies*

nell'epigrafica retica. Studia archeologica 103 (Rome, 1999) 92. J. V. Hubschmid, 'Etruskische Ortsnamen im Räitien', in 6 *Internationaler Kongress für Namenforschung* (Munich, 1961) 403–412.

93. R. W. Elliot, *Runes: An Introduction*, 2nd edn (Manchester, 1989. Originally published 1959). On the origin of the runes, G. Bonfante, in L. Bonfante, *Out of Etruria* (1981) 124–134.

94. The casket has been in the British Museum since 1867; the right side is in the Museo Nazionale (Bargello), Florence. R. I. Page, *Reading the Past – Runes* (British Museum Publications, London, 1987) 40–41.

95. The Germanic people learned to write on stone from the Romans: G. Bonfante, in *Iscrizioni pre-latine in Italia* (1979) 223. A. Tovar, *Zeitschrift für Celtische Philologie* 34 (1975) 14.

96. Tacitus, *Germania* 10, 1–2: *Sortium consuetudo simplex: uirgam frugiferae arbori decisam in surculos amputant eosque notis quibusdam discretos super candidam uestem temere ac fortuito spargunt.* '... the method of drawing lots is the same among them all. A branch is cut from a fruit-bearing tree and split up into slips; these are distinguished by certain signs and spread casually and at random over a white cloth'. (Translation adapted from *Tacitus, Dialogus, Agricola, Germania*, ed. W. Peterson, Loeb Classical Library, Cambridge, MA, 1914).

97. All these derive from an Indo-European word. Cf. German *Buch-stabe*, 'letter', Latin *fagus*, German *Buch*, English *book*: E. Klein, *Comprehensive Etymological Dictionary of the English Language* (Amsterdam, 1971), s.v. G. Bonfante, in L. Bonfante, *Out of Etruria* 128–129. Page, *Runes* (above, note 94) 6–8 remarks that the runes were designed for incising on wood. See now R. Grendse, 'Il *futhark*', in *Alfabeti Preistoria e storia del linguaggio scritto*, ed. M. Negri (Demetra, Colognola ai Colli, Verona, 2000) 225–241.

98. G. Bonfante, in L. Bonfante, *Out of Etruria* 133. M. Cristofani, in *Popoli e Civiltà* fig. 6; ibid, *IBR* 385, fig. 2.

99. Livy 28.45.

PART THREE

STUDY AIDS

a 𐤘 ΥΦΧΥΤϞϘΡΜΊΟ⊞ΨΨΙΧ⊗ΘΙΊΊΓΊΘΑ

b ΑϠϹϽϝϝΙΒϴΙΚ𐌋Ϻ⊞ϴΡΜϺΠΤΙΥΦΨ

c ΑΒϹϽϝϝΙΒϴΙΚΙ ΓΓ⊞ϴΡ ΜϞΡϤΤΙΧΦΨ

d ΑΒϹϽΕϹΙΒϴΙΚΙΜΝ⊞ΟΡΜϘΡϚΤΥϚΦΨ

11 Etruscan model alphabets, 650–600 BC
(a) Marsiliana d'Albegna, ivory tablet (Source 1)
(b) Cerveteri, Regolini-Galassi tomb, bucchero vase (Source 2)
(c) Viterbo, bucchero vase in the shape of a rooster (Source 3)
(d) Formello, Veii, bucchero amphora (Source 4)

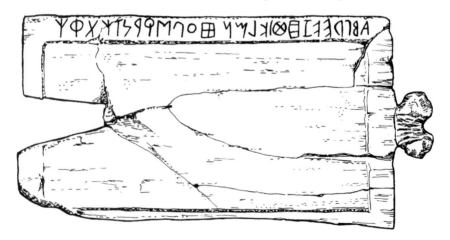

12 Ivory tablet from Marsiliana d'Albegna with model alphabet. Florence, Museo Archeologico (Source 1)

SOURCES
(Sample inscriptions and texts)

1 (*figs 11a, 12*) Alphabet on a miniature (88 × 51 mm) ivory writing tablet from the 'circolo degli Avori' or Tomb of the Ivory Objects at Marsiliana d'Albegna, *c*.675–650 BC. It was meant to be hung from a lion-head hook, and was originally decorated with gold leaf. A model Euboean Greek ('red') alphabet of twenty-six letters is engraved on one side. The object, which was found together with writing stylus and flat-ended eraser, was used as a small notepad as shown by the remains of wax and scratches on the surface. Florence, Museo Archeologico.

> Pallottino, *Etruscans* pl. 93; Pandolfini and Prosdocimi, *Alfabetari* 19, No. I. 1. Peruzzi, *Origini di Roma*, II.35–38.

2 (*fig. 13*) Bucchero flask from the necropolis of Sorbo (in the area of the Regolini-Galassi tomb) at Cerveteri, *c*.625. Syllabary and alphabet are both written left to right (typical of Cerveteri in this period). Missing from the syllabary are the dead letters, as well as *k, l, ph*; only one sibilant is present.

<div align="center">

ci ca cu ce vi va vu ve
zi za zu ze hi ha hu he
thi tha thu the mi ma mu me n
ni na nu ne pi pa pu pe ri ra ru re
si sa su se chi cha chu che qi qa qu qe ti ta tu te
a b c d e v z h th i k [l m n] š o p ś r s t u ś ph ch

</div>

> *TLE* 55; *ET* Cr 9.1. Pandolfini and Prosdocimi, *Alfabetari* 26–29, No. I. 6.
> F. Buranelli (ed.), *The Etruscans. Legacy of a Lost Civiliation from the Vatican Museums* (Memphis TN, 1992) 55, No. 23; in *Principi Etruschi tra Mediterraneo ed Europa* (catalogue of exhibition, ed. C. Morigi Govi, Bologna, 2000) 318–320, No. 431.

3 (*fig. 14*) Bucchero vase or inkwell in the shape of a rooster, incised with the Etruscan alphabet from Viterbo *c*.630–620. New York, The Metropolitan Museum of Art.

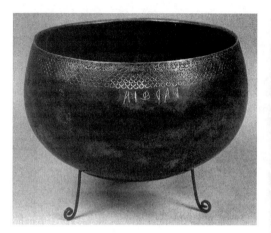

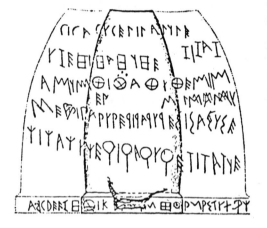

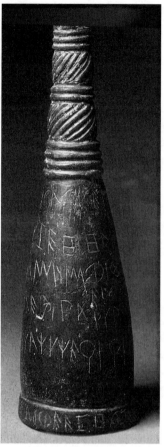

13 Alphabet, syllabary, and inscriptions on objects from Cerveteri. Vatican, Museo Etrusco Gregoriano (Sources 2 and 6)

Pandolfini and Prosdocimi, *Alfabetari* 22, No. I. 3. *CIE* 10494.

4 *(fig. 11d)* The 'Formello Alphabet', incised around the neck of an Archaic bucchero amphora from Veii, *c.*625. Rome, Villa Giulia Museum.

TLE 49. *ET* Ve 9.1, 3.1, 6.1. Pandolfini and Prosdocimi, *Alfabetari* 24, No. I. 4.

5 *(fig. 15)* Bucchero *olpe* by a painter from Cerveteri with mythological scenes. Discovered in Cerveteri in 1988, *c.*650–625.

metaia	*taitale*	*kanna*
'Medea'	'Daidalos'	'kanna', caṇa, 'gift'

The representation consists of two (or three) scenes. One shows two youths, wearing *perizomata*, engaged in what looks like a boxing match. The next

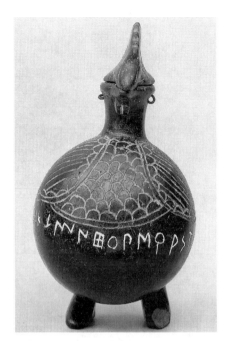
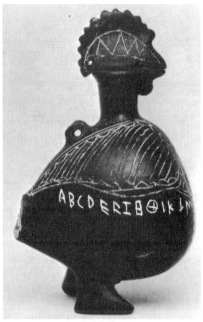
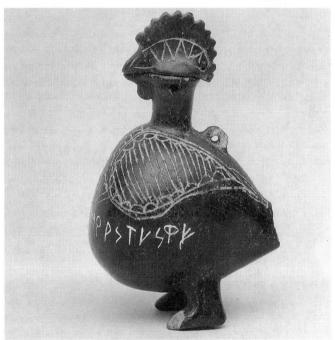

14 (a–c) Bucchero vase or inkwell in the shape of a rooster (Source 3)

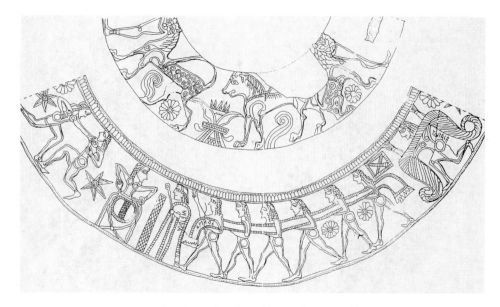

15 Bucchero olpe from Cerveteri (Source 5)

scene depicts a figure shown frontally, face in profile: it is unidentified and could be a youth whose upper part emerges from a cauldron. On the other side of a pillar, a female figure, completely in profile (identified as Medea, *metaia*, by an inscription running along her side on the heavy mantle), holds up her arm and gesticulates towards the first figure. Behind her six long-haired youths, wearing perizomata, carry a long, heavy cloth, perhaps a prize (Greek *agalma*) – the Golden Fleece? Behind them is a winged male figure, dressed like the others but with arms up and legs in running position, with huge wings curling up at the bottom. This is Daidalos, *taitale*, known also from other Etruscan representations, such as an inscribed gold bulla in the Walters Art Gallery in Baltimore with the figures of *taitale* and his son, Ikaros (*vicare*). The interpretation of the scenes is controversial: perhaps they illustrate stories of the Argonauts, and the magic powers of Medea and Daidalos.

M. A. Rizzo and M. Martelli, 'Un incunabulo del mito greco in Etruria', *Annuario della Scuola Archeologica di Atene e delle Missioni Italiane in Oriente* 66/67 n.s. 50/51, 1988–89 [1993] 7–56. M. Schmidt, *LIMC* 6 (1992) 388, *s.v.* Medeia No. 1. E. Simon, *LIMC* 7 (1994) 833, *s.v.* Taitale No. 1. F.-H. Massa-Pairault, *ParPass* 279 (1994) 437–468. E. Simon, *ArchAnz* 1995, 483–487; eadem, in F. Prayon and W. Röllig (eds), *Der Orient und Etrurien. Zum Phänomen des 'Orientalisierens' im westlichen Mittelmeerraum (10–6 Jh v. Chr.)*. Akten des Kolloquiums zum Thema, Tübingen, Juni 1997 (Pisa and Rome, 2000) 171–181. C. Zaccagnini, in M. Torelli (ed.), *The Etruscans* (Venice, 2000) 608, no. 212. For the gold bulla in Baltimore, see G. M. A. Hanfmann, *AJA* 39 (1935) 189–194; L. Bonfante, *Etruscan Life* 250, 276, fig. VIII 27.

6 (*fig. 13*) Small silver amphora (amphoriskos) from the Regolini-Galassi tomb at Cerveteri, *c*.650. 'Speaking inscription' (*iscrizione parlante*) in which the object 'speaks' in the first person.

larthia

'I (belong to) Larth' (or 'Larthi', a woman)

TLE 54. *ET* Cr 2.13–14. Agostiniani, *Iscrizioni parlanti*, 78, Nos 139–140. Buranelli, *Etruscans* 130–132, No. 105; cf. No. 108, *mi larthia*.

7 Oinochoe from Cerveteri, *c*.650.

mi qutum karkanas

'I (am) the pitcher of Karkana'

Cf. *kothon*, 'pitcher'. *qutum* instead of *qutun*: cf. *qutumuza*?

TLE 63. *ET* Cr 2.18–19. Agostiniani, *Iscrizioni parlanti*, 78, No. 137.

8 Impasto *oinochoe* or pitcher from Narce, *c*.650.

mi qutun lemausnaś ranazu zinake

'I (am) the pitcher of Lemausna, Ranazu made [me]'

TLE 28. *CIE* 8415a. *ET* Fa 2.1, Fa 6.2. Agostiniani, *Iscrizioni parlanti*, 68, No. 87.

9 Bucchero aryballos, provenance unknown, *c*.650–625. Monte Carlo, Musée Charles Albert.

mlakas se la aska mi eleivana

'I am the unguent-bottle of the beautiful Sela'

The translation assumes that, like *mlakas*, *sela(s)* is in the genitive, and that the genitive flection has been erroneously omitted. Note the Greek words *askos*, 'bottle', and *elaion*, 'oil', or 'unguent'.

TLE 762. *ET* Fa 2.3. Agostiniani, *Iscrizioni parlanti*, 140, No. 532.

10 (*fig. 16*) Buccheroid impasto *pyxis* with lid, provenance unknown, with inscription on the lip. 8 cm high, 10.2 cm maximum diameter, *c*.625–600. Private collection.

mi suntheruza spurias mlakas

'I (am) the little container (?) of Spuria the beautiful'

The decoration and type of vase as well as the letter forms and direction of the inscription (left to right) suggest a southern Etruscan or Faliscan origin. The diminutive form of the vase agrees with the diminutive form of the word *suntheruza*, so far found only here, and probably descriptive rather than the name of a vase, such as *aska, qutun, qutumuza* or *lechtumuza*. The vase is beautifully decorated and was obviously made to hold an unguent or other precious substance which was protected by tying the container and the lid together with a string or thong passed through holes in the handles of the vase and of the lid.

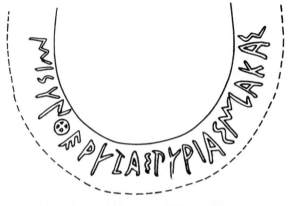

16 Buccheroid impasto
pyxis (Source 10)

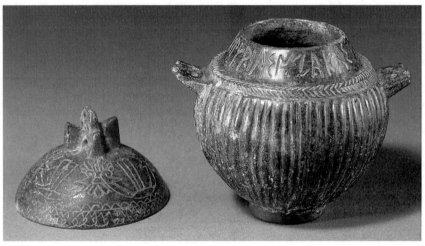

L. Bonfante, R. Wallace, 'An Etruscan pyxis named *suntheruza*', *StEtr* 64 (2001)
201–212.

11 (*fig. 17*) Bucchero squat lekythos, provenance unknown, 5 cm high, with
inscription on the shoulder. Sixth century. Private collection.

> *mi larthaia telicles lechtumuza*
> 'I am Larthaia Telicles' little lekythos'
> or 'I am the little lekythos of Larthaia [daughter of] Telicles'

Both the size of the vase (only two inches high) and the form of the word are
diminutive. Though scholars call it an *aryballos*, the shape is that of a squat
lekythos with a foot (Camporeale). The inscription refers to it by its proper
name, 'little lekythos'. The owner, a woman Larthai, or Lartha (for Larth,
Larthi, Lartha cf. Source 6), comes from a naturalized Greek family whose
father's name was Telekles, or Teleklos; it could have been used as a gentilicial

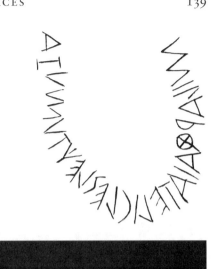

17 Bucchero aryballos (squat lekythos)
(Source 11)

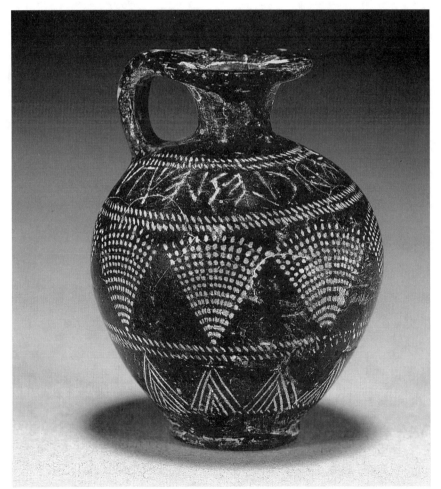

name in Etruria. The writer miscalculated the space that was available, and has run the last letters of the inscription off the shoulder.

> *TLE* 761. *ET* OA 2.2. M. Hammarström, *StEtr* 4 (1931) 261–266. De Simone, *Entlehnungen*, I.89. Agostiniani, *Iscrizioni parlanti*, 138, No. 522; 63; 188; 193. G. Camporeale, *La collezione C. A. Impasti e buccheri I* (Rome, 1991) 144. L. Bonfante, '*Nunc ubi sit comperi: lechtumuza*', *Miscellanea di studi in memoria di Mauro Cristofani. Prospettiva* (forthcoming).

12 Bucchero amphora from Cerveteri, *c.*600.

> *mini mulvanice mamarce velchanaś*
> 'Mamarce Velchana dedicated me'

> *TLE* 57. *ET* Cr 3.11. Agostiniani, *Iscrizioni parlanti*, 84, No. 167.

13 Votive inscription on a bucchero vase from the Portonaccio temple at Veii, *c.*550.

> *mini muluv[an]ece avile vipiiennas*
> 'Avile Vipiiennas dedicated me'

This proves that Aulus and Caelius Vibenna could have been real people and not mythical figures. The date, mid-sixth century, is according to Roman tradition the date of Servius Tullius, king of Rome.

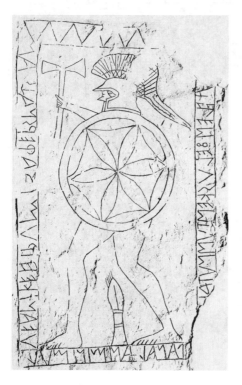

18 Stele of Avele Feluske, from Vetulonia (Source 14)

TLE 35. *ET* Ve 3.11. Agostiniani, *Iscrizioni parlanti*, 71, No. 97. Pallottino and Boitani, in F. Buranelli (ed.), *La tomba François di Vulci* (Rome, 1987) 225–233 (Pallottino); 234, No. 93 (Boitani).

14 (*fig. 18*) Stele representing a warrior armed with crested helmet and round shield, brandishing a double axe, from Vetulonia, *c.*600.

> [a]*veleś feluskeś tuśnut*[ala] *panalaś*
> *mini muluvaneke hirumina phersnalaś*
> 'of Avele Feluske, [son of] Tusnute and of […] panalaś
> Hirumina Phersnalaś dedicated me'

This is the earliest use of the new Etruscan letter 8 for the sound 'f'. Perhaps *phersnalaś* means 'from Perugia (Perusia)'? The inscription is divided into two parts, one indicating possession and the other a dedication.

TLE 363. *ET* Vn 1.1. Vetter, *StEtr* 24 (1955–56) 301–310; G. Colonna, *StEtr* 45 (1977) 183–189. Agostiniani, *Iscrizioni parlanti*, 114, No. 374.

15 (*fig. 19*) Funerary stone stele from Volterra, representing a male figure armed with lance and knife, wearing shoulder-length hair and short chiton, *c.*530. Volterra, Museo Guarnacci.

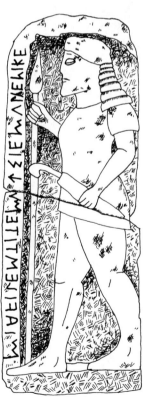

19 Stele of Avile Tite, from Volterra (Source 15)

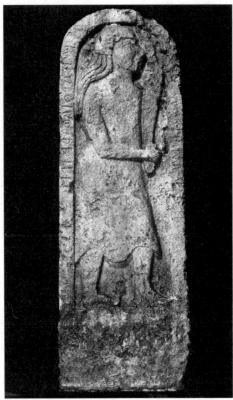

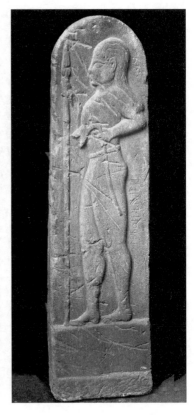

20 Stele of Larth Tharnie, from Pomarance
(Source 16)

21 Stele of Larth Ninie, from
Fiesole (Source 17)

mi avileś titeś [...] *uchsie mulenike*
'I (belong to) Avile Tite [...] uchsie dedicated (me)'

TLE 386. *ET* Vt 1.154. L. Bonfante, *Etruscan Dress*, fig. 68. Agostiniani, *Iscrizioni parlanti*, 116, No. 384.

16 (*fig. 20*) Funerary stone stele from Pomarance, near Volterra, with representation of a male figure with long hair, three-quarter-length chiton and pointed shoes, holding a large knife in the right hand, 550–540. Florence, Museo Archeologico.

mi larthia tharnieś ... uchulni muluveneke
'I (belong to) Larth Tharnie ... Uchulni dedicated (me)'

TLE 407. *ET* Vt 1.85. L. Bonfante, *Etruscan Dress*, fig. 69. Agostiniani, *Iscrizioni parlanti*, 115, No. 380.

17 (*fig. 21*) Funerary stone stele from Fiesole with representation of a male

figure wearing long hair in the Ionic style and a perizoma, and holding a spear and an axe. H. 1.38 m. *c*.525. Florence, Casa Buonarroti.

larthia ninieś
'(I belong to) Larth Ninie'

CIE I. L. Bonfante, *Etruscan Dress*, fig. 33. ET Fs 1.1.

18 On a plate from the sanctuary at Pyrgi, *c*.500.

unial
'[I am] of Uni'

TLE 877. ET Cr 4.8.

19 On the architrave of a chamber tomb in the necropolis of Crocifisso del Tufo at Orvieto. *c*.550–500.

mi mamarces velthienas
'I (am the grave) of Mamarce Velthiena'

TLE 242. ET Vs 1.4. Agostiniani, *Iscrizioni parlanti*, 99, No. 270.

20 On a red-figure Attic kylix from Tarquinia attributed to Oltos, *c*.500.

itun turuce venel atelinas tinas cliniiaras
'Venel Atelina dedicated this to the sons of Tinia', i.e. the Dioskouroi, Castor and Pollux

TLE 156. ET Ta 3.2. CIE 10021. de Simone, *Entlehnungen*, II.142.

21 (*fig. 22*) Dedication incised under the foot of an Attic red-figure kylix from

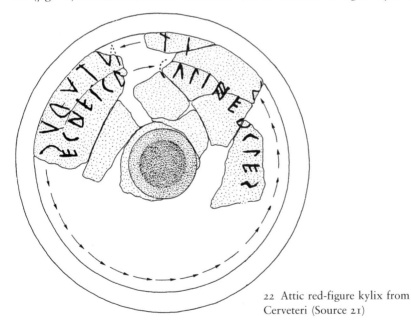

22 Attic red-figure kylix from Cerveteri (Source 21)

Cerveteri, signed by Euphronios. 46.5 cm diameter *c.*500–490. Formerly in the
J. Paul Getty Museum, returned to Italy in 1999. Rome, Museo di Villa Giulia.
 Outer inscription:

it[u]n turuce [e ...]s
'This (vase) has dedicated ... s'

Inner inscription:

[]e cavi []uli hercles
'() *cavie* (in this place) of Hercle'
'*cavie* (dedicated this vase) in the sanctuary of Hercle'

Or:

eca vicr [...]culi hercles
'This is the culi[chna], the cup of Hercle'

On the vase, which is very large, were depicted scenes from the Iliupersis, the
Destruction of Troy. Greek inscriptions identify Cassandra, Astyanax, Neopto-
lemos, and Patroklos: many are missing or fragmentary. Also fragmentary are
the two concentric Etruscan dedications scratched by two different hands at a
later time on the bottom of the vase. Only about a third of the outer inscription
has been preserved. The restoration of the foot in antiquity might have been
the occasion when the second, shorter inscription was added (Colonna).
 It is the earliest epigraphic evidence for a late sixth-century cult of Hercle
(Hercules) at Cerveteri, in whose sanctuary have been found such votive objects
as statuettes of the divinity, and the clubs which are his standard attribute.

 G. Colonna, 'Iscrizioni votive etrusche', *ScAnt* 3–4 (1989–90) 901–903. M. Martelli,
 ArchClass 43 (1991) 613–621. M. A. Rizzo, in A. M. Moretti Sgubini, *Euphronios
 epoiesen: un dono d'eccezione ad Ercole cerite* (Rome, 1991).

22 *(fig. 23)* Bronze greaves from the Palazzone necropolis, Perugia. Made in
the sixth century (*c.*550–525), but inscribed later (500–450). Perugia, Museo
Archeologico.

arnth savpunias turce menrvas
'Arnth Savpunias gave to Menrva'

Discovered in the 1840s and cleaned in the 1990s, the bronze greaves seem to
have been made in a north Etruscan city in the sixth century. They were
probably dedicated at the sanctuary of Volsinii at Orvieto in the following
century, and brought to Perugia after the sack of 264, in which Perugia
participated as an ally of Rome. They were subsequently placed in the grave
of the Acsi family of Perugia.

 A. E. Feruglio, in *Miscellanea Pallottino* 1231–51. G. Colonna, 'L'offerta di armi
 a Minerva e un probabile cimelio della spedizione di Aristodemo nel Lazio', in
 *Pallade di Velletri. Il mito, la fortuna. 1797–1997 bicentenario del ritrovamento.
 Atti* (Rome, 1999) 95–103.

23 Bronze greaves from Perugia (Source 22)

23 (*fig. 24*) Bronze cone-shaped object (weight?). Unknown provenance, 3.9 cm high, diameter at base 3.95 cm, weight 143.9 g. Fourth or third century. Private collection.

> *ecn: turce: laris: thefries: espial: [estial?] atial: cathas*
> 'Laris Thefrie dedicated this to [*espial*] [*estial?*] the Mother Catha'

ecn turce is the normal formula for post-archaic votive dedications. *Thefrie* is a later form of *Thefarie*, found on the Pyrgi Tablets. The last three words, all in the same case, seem to refer to the divinity to whom the object was dedicated, Mother Catha. *Espial* is unknown: the reading may be *estial*; Cristofani preferred to take it as the matronymic of Laris Thefrie. Nancy de Grummond translates *atial cathas* as 'the mother of Catha', taking Catha as the daughter rather than the mother.

L. Bonfante, *REE, StEtr* 59 (1994) 269–270, with comment by M. Cristofani, 270–271. N. T. de Grummond, 'For the Mother and for the Daughter', in *Studies in Honor of Sara Immerwahr* (forthcoming).

24 Bronze cone-shaped object (weight?) (Source 23)

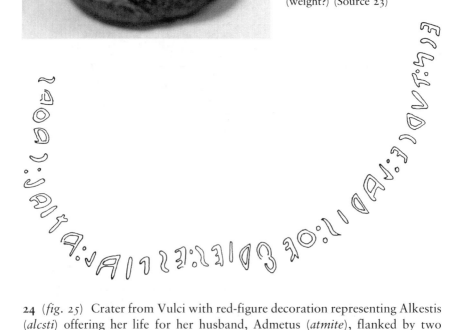

24 (*fig. 25*) Crater from Vulci with red-figure decoration representing Alkestis (*alcsti*) offering her life for her husband, Admetus (*atmite*), flanked by two demons. Second half of fourth century. Paris, Bibliothèque Nationale.

atmite. alcsti.
'Admetos. Alkestis.'
eca: ersce: nac: achrum: flerthrce
'She, Alkestis, went, and in this way she satisfied Acheron with a sacrifice'

The text, which explains the image, paraphrases Euripides, *Alcestis* 233, cf. 445.

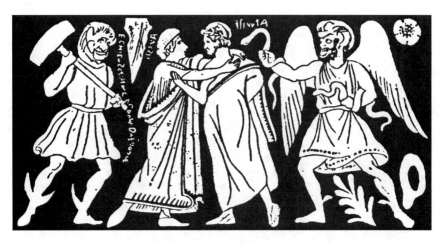

25 Red-figure crater from Vulci (Source 24)

TLE 334. *ET* Vc 7.38. J. D. Beazley, *Etruscan Vase Painting* (Oxford, 1947) 133. de Simone, *Entlehnungen*, 15, 29, 37. F. Slotty, *StEtr* 19 (1946–47) 243. A. Morandi, *Nuovi lineamenti di lingua etrusca* (Rome, 1991), 181–184.

25 Inscriptions on wall in the Tomb of Orcus, Tarquinia. Fourth century.

> ... [m]urinas an zilath amce mechl rasnal ...
> purth ziiace [read zilace] ...
> ravnthu thefrinai ati nacnuva
> 'Murinas who was *zilath* (praetor) of the people of Etruria ...
> (he) presided as *purth* (dictator?) ...
> Ravnthu Thefrinai, (his wife) the grandmother'
> (identifying the figure of the wife, now lost)

Two separate texts, published together in *TLE* 87.

TLE 87. *ET* Ta 7.59–60. Torelli, *Elogia Tarquiniensia*, '*Spurinas*': but see M. Morandi, G. Colonna, *StEtr* 61 (1996) 95–102.

26 (*fig.* 26) Bronze statue of the Chimaera, from Arezzo. Inscribed on front right leg, early fourth century. Life size. Florence, Museo Archeologico.

> *tinścvil*
> 'Offering belonging to Tinia'

TLE 663. *ET* Ar 3.2. G. Colonna, in *Santuari d'Etruria* (1985) 173, No. 10.1.

27 (*fig.* 27) Stone cippus (marker) from Cortona, third century.

> *tular raśnal* (repeated twice)
> 'boundaries of the Etruscan people'

TLE 632. *ET* Co 8.2. R. Lambrechts, *Les Inscriptions avec le mot 'tular' et les bornages étrusques* (Florence, 1970). A. Morandi, 'Cortona e la questione dei

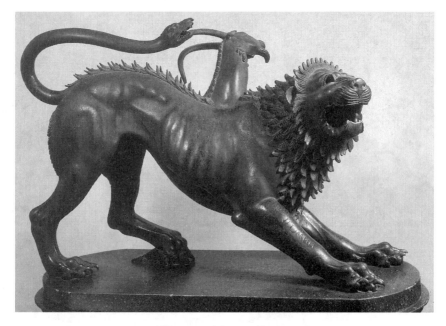

26 Chimaera of Arezzo (Source 26)

27 Stone marker from Cortona (Source 27)

confini etruschi', *Annuario dell'Accademia di Cortona* 23 (1987–88) 7–37; idem, *Nuovi lineamenti* 184–187, No. 21.

28 Funerary inscription of a man's sarcophagus from Tarquinia. Life size. Third century. Tarquinia, Museo Nazionale:

partunus vel velthurus śatlnalc ramthas
'Partunus Vel, of Velthur and of Satlnei Ramtha
clan avils XXIIX lupu
the son, of years (was) dead (at) 28'

'Vel Partunus, son of Velthur and of Satlnei Ramtha,
died [when he was] 28 years old'

TLE 128. ET Ta 1.15. M. Cataldi, *I sarcofagi etruschi delle famiglie Partunu,
Curuna e Pulena*. Catalogue of exhibit. (Rome, 1988) 7, 11, No. 6.

29 Funerary inscription of a man's sarcophagus from Tarquinia (Sarcofago del Magnate). Life size. Third century. Tarquinia, Museo Nazionale:

*velthur partunus larisaliśa clan ramthas
cuclnial zilch cechaneri tenthas avil svalthas LXXXII*

'Velthur Partunus, the one who is of Laris, [and] the son of Ramtha Cuclni,
praetor of sacred functions (he) served; years he lived 82'
'Velthur Partunus, son of Laris and of Ramtha Cuclni, served as magistrate
in charge of sacred functions [cf. Latin *praetor*]. He lived for eighty-two years'

TLE 126. ET Ta 1.9. Cataldi, *Sarcofagi*, 7, 9, No. 2.

30 Funerary inscription of a man's sarcophagus from Tarquinia, from the same tomb as the Sarcofago del Magnate (above). The deceased, like those of the two preceding inscriptions, belonged to the Partunu *gens* or family. Life size. End of fourth century.

velthur larisal clan cuclnial thanchvilus lupu avils XXV
'Velthur, son of Laris and of Thanchvil Cuclni, died at [the age of]
twenty-five years'

TLE 129. ET Ta 1.14. Cataldi, *Sarcofagi*, 7, 10. No. 5.

31 (*fig. 28*) Funerary inscription of Laris Pulenas incised on a scroll held out by the deceased (Sarcofago del Magistrato). Life size. Traces of red color can still be seen on some of the letters. Second half of the third century. Tarquinia, Museo Nazionale.

*laris. pulenas. larces. clan. larthal. papacs. velthurus.
nefts. prumts. pules. larisal. creices. ancn. zich. nethśrac.*

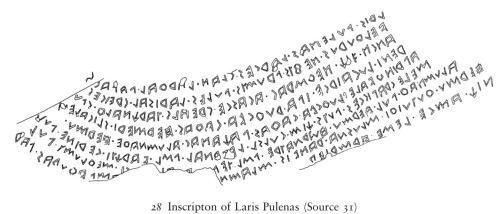

28 Inscripton of Laris Pulenas (Source 31)

acasce. creals. tarchnalth. spureni. lucairce. ipa. ruthcva.
cathas. hermeri. slicacheś. aprinthvale. luthcva. cathas.
pachanac. alumnathe. hermu. melecrapicces. puts. chim. culsl.
leprnal. pśl. varchti. cerine. pulalumnath. pul. hermu.
huzrnatre. pśl. ten ... x. xx ... ci. methlumt. pul. hermu. thutuithi.
mlusna. ranvis. mlamna ... mnathuras. parnich. amce. leśe.

hrmrier.

'(This is the epitaph) of Laris Pulenas – son of Larce, [grandson] of Larth, grandson of Velthur, great-grandson of Laris Pule, the Greek – who wrote this book on divination. He held the office of *creals* in this city, Tarquinia ...'

The 'book' referred to in the sentence *ancn zich nethśrac acasce*, 'he this book of haruspicina made', may in fact be the partially unrolled scroll or volumen he is proudly exhibiting to the viewer. Only the first three lines, as far as *lucairce*, can be translated with any certainty. The deceased traces his genealogy back three generations, to his great-grandfather Laris Pule, the Greek, possibly related to the famous Greek seer, Polles (Heurgon, *La Vie*). Like his great-grandfather, Laris Pulenas devoted himself to religious duties, perhaps including the cult of ancestors: *aprinthvale* – a priestly title? – may be related to *apa*, 'father', cf. Latin *parentare*, 'to hold ceremonies for the dead'. He evidently presided as *creals* (*acasce creals*); *lucairce*, that is he was in charge of the cult of Catha Slicache and Pacha (Bacchus), and made a libation of honey and wine in the sacred vessel for Culsu Leprina. The number three (*ci*) may be recorded after a lacuna, so it is not clear what it refers to. He also carried out sacred duties in (*pul*) the *alumnathe*, among the Young Disciples (?) (*huznatre*); (*pul*) in (for?) the district (*methlumt*, locative); and in (for?) the congregation (*alumnathuras*), where he acted (*amce*) with the title of *parnich*.

Though the general idea can be understood, technical terms for priesthoods, functions, and ceremonies, as well as their order, significance, and location are unclear. The names of three divinities can be recognized – Catha, Pacha, and Culsu, the latter with the epithet Lepr(i)na, while Slicache may be an epithet of Catha. Catha and Bacchus are connected elsewhere too in a joint worship. The cult of Bacchus was important in Italy from the third to the first century BC: the Romans repressed the Bacchanalian conspiracy in 186 BC, and saw it as a plague originating in Etruria (Livy 39.9.1). Hermes has sometimes been included as a fourth divinity, with a question mark. But the words *hermu* (repeated four times), *hermeri*, *hrmrier*, like *heramasva* (Pyrgi tablet, fig. 5), even if originally connected with Hermes, need not refer to the god. *heramasva* on the Pyrgi tablet is usually translated as 'statue' (cf. 'herm'). In this text it seems to refer to a place – 'sanctuary' (?). Compare *varchti cerine*, 'sacred place' (?). See Glossary. His name could be either Pulena or Pulenas.

TLE 131. *ET* Ta 1.17. *CIE* 5430. G. Devoto, *StEtr* 10 (1936) 287 = *Scritti minori* II (Florence, 1967) 199. L.B. van der Meer, *The Bronze Liver of Piacenza*

(Amsterdam, 1987) 129–130, 172–173, 187, fig. 78. A. Morandi, *Nuovi lineamenti di lingua etrusca*, 156–167, No. 15, fig. 20. Cataldi, *Sarcofagi* 15–17, No. 2, figs 17–18. R. S. P. Beekes and L. B. van der Meer, *De Etrusken spreken*, 57–59.

32 (*fig. 29*) Bronze mirror from Bolsena with engraved decoration, representing Prometheus unbound. Diameter of disc, 14.5 cm. Early third century. New York, The Metropolitan Museum of Art. *Prumathe* (Prometheus) has just been freed by *Hercle* (Herakles) in the presence of *Menrva* (Minerva). On the left *Esplace* (Asklepios) is bandaging the wounded *Prumathe*. On the reflecting side is scratched the word *śuthina*, 'for the tomb'.

ET Vs. S. 23. de Simone, *Entlehnungen*, *s.v.* CSE USA 3.11.

29 Bronze mirror from Bolsena with Prumathe unbound (Source 32)

30 Bronze mirror from Civita Castellana with Atmite and Alcestei (Source 33)

33 (*fig. 30*) Bronze mirror from Civita Castellana with engraved decoration, representing *Atmite* (Admetos) and *Alcestei* (Alkestis). Diameter 16.5 cm. Fourth century. New York, The Metropolitan Museum of Art. They are flanked by two figures, without labels. The young male figure on the left turns away, holding a torch in his right hand, and in his left his shoes in order to slip away quietly: it is probably Hymenaios, or Death, leaving the married couple. On the right, an old woman, a demon, perfumes *Alcestei*. *c.*400–350.

ET Fa S. 1. de Simone, *Entlehnungen, s.v. CSE* USA 3.6.

31 Bronze mirror from Castel Giorgio (Orvieto) with Pele, Thethis, and Calaina
(Source 34)

34 (*fig. 31*) Bronze engraved mirror from Castel Giorgio, between Orvieto
and Bolsena. Diameter 16.2 cm. Mid-fourth century. Represented are *Thethis*
(Thetis) at her toilette, looking at her image in a mirror. Her attendant, *Calaina*
(Galene) holds her jewellery; from the left enters *Pele* (Peleus), hands held out
before him, hair flying from speed or surprise. New York, The Metropolitan
Museum of Art.

ET Vs S. 7. de Simone, *Entlehnungen*, *s.v.* CSE USA 3.14. N. T. de Grummond,
in A. Rallo (ed.), 'Mirrors and manteia ...', in *Aspetti e problemi della produzione
degli specchi figurati etruschi* (Rome, 2000) 27–67, on nuptial scenes and prophecy.

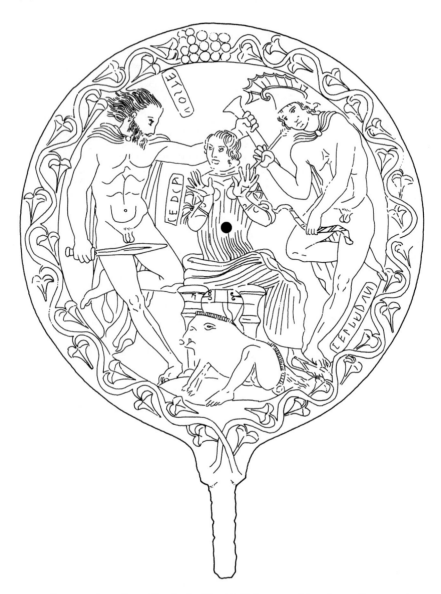

32 Bronze mirror from Vetulonia (?) with Uthste attacking Cerca (Source 35)

35 (*fig. 32*) Bronze mirror, perhaps from the vicinity of Vetulonia. Diameter of disc 16.4 cm. 350–300. Represented are *Uthste* (Odysseus) attacking *Cerca* (Kirke) with his unsheathed sword, while *Velparun* (Elpenor) readies his bow and arrow. New York, The Metropolitan Museum of Art.

ET Po S. 2. de Simone, *Entlehnungen*, *s.v.* CSE USA 3.15.

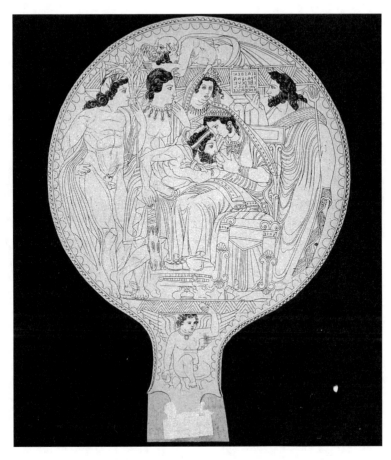

33 Bronze mirror from Volterra showing Uni nursing Hercle (Source 36)

36 (*fig. 33*) Bronze mirror from Volterra with engraved decoration. *c*.325–300. Diameter 29.5 cm. *Uni* (Hera or Juno) is shown suckling *Hercle* (Herakles) in order to make him immortal, in an Italic variant of the Greek myth. Here Uni adopts Hercle in the solemn presence of gods who serve as witnesses. The inscription explains the scene, and calls Hercle the son of Uni (*Uni-al clan*). *c*.300. Florence, Museo Archeologico.

> *eca: sren: tva: ichnac: hercle: unial: clan: thra: sce*
> 'This image shows how Hercle, the son of Uni, suckled [milk]'

tva must be the third person singular of a verb. If the word division is syllabic, *thrasce* is one word. Some take *thrasce* as two words ('suckled milk'). In either case, it is a the third person singular past perfect.

TLE 399. *ET* Vt S. 2. *ES* 5.60.

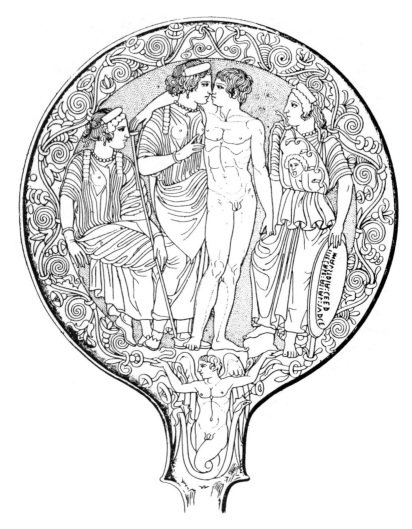

34 Bronze mirror with Turan and Atunis (Source 37)

37 (*fig.* 34) Bronze mirror with engraved decoration, *c.*300. *Turan* and *Atunis* (Venus and Adonis), a seated attendant, and *Menrva* (Minerva). The figures are not labelled. Inscribed on Menrva's shield:

tite cale: atial: turce malstria: cver

'Tite Cale gave (this) mirror to his mother as a gift'

or 'Tite Cale, son of Aty [matronymic] gave this mirror as a gift'

TLE 752. *ET* AH 3.3. L. Bonfante, *Etruscan Dress*, fig. 83. G. Colonna, *StEtr* 51 (1983) [1985] 147. N. T. de Grummond, 'For the Mother and for the Daughter', (see Source 23), interprets it as a dedication to 'The Mother', a goddess.

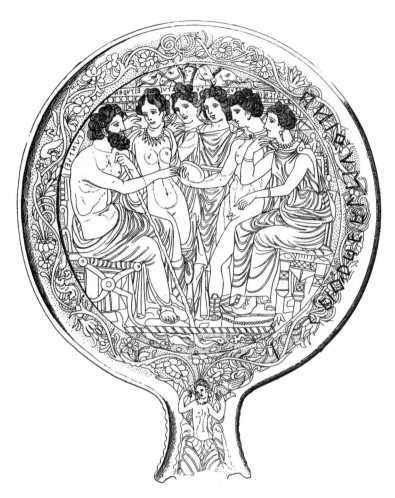

35 Bronze mirror from Porano with Latva's family and the egg (Source 38)

38 (*fig. 35*) Bronze mirror from Porano (Volsinii) with engraved decoration. Third century. Perugia, Museo Civico. *Castur* hands the egg from which Helen is to be born to his father *Tuntle* (Tyndareus), in the presence of his mother *Latva* (Leda), his brother *Pultuce* (Pollux or Polydeukes), and *Turan* (Venus). On the border is an additional inscription, incised when the mirror was put in the tomb:

<div style="text-align:center">

ceithurneal śuthina
'grave offering (or 'tomb furnishing') of Ceithurna'

</div>

TLE 219. *ET* Vs 4.74. *CIE* 10680; Beazley, *JHS* 69 (1949) 15 fig. 20. de Simone, *Entlehnungen*, I.106.7. For *śuthina* see P. Fontaine, *Revue des études anciennes* 97 (1995) 201–216. D. Briquel, *REL* 97 (1995) 217–223.

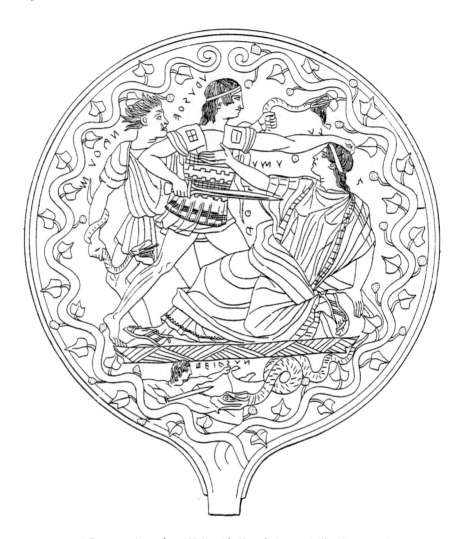

36 Bronze mirror from Veii with Urusthe's matricide (Source 39)

39 (*fig. 36*) Bronze mirror from Veii with engraved decoration. Fourth century. Shown are *Urusthe* (Orestes) killing *Cluthumustha* (Clytemnestra), while *Acharum*, a Fury, brandishing two snakes, looks on. Below, in the exergue, *Heiasun* (Jason) slays a dragon. Berlin, Antiquarium.

> *ES* 238. *ET* Vc S. 3; de Simone, *Entlehnungen*, I.45.3; 53.123. *LIMC* I.1.36 s.v. Acheron.

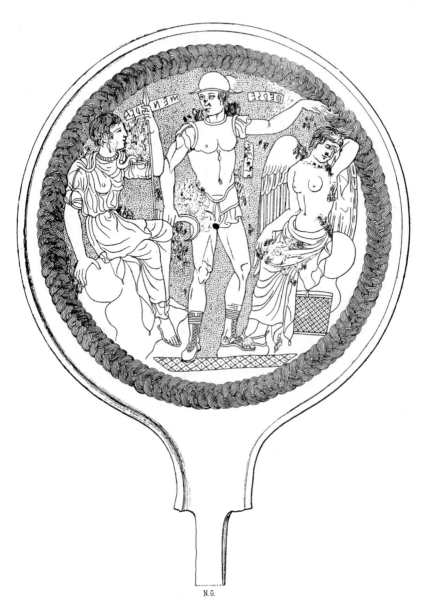

37 Bronze mirror from Chiusi with Pherse and Metus (Source 40)

40 (*fig. 37*) Bronze mirror from Chiusi with engraved decoration. Third century. *Pherse* (Perseus), with *Menrva* (Minerva) seated behind him, prepares to behead the sleeping *Metus* (Medusa).

ES 5.67. *ET* Cl S. 10. de Simone, *Entlehnungen*, I.94.

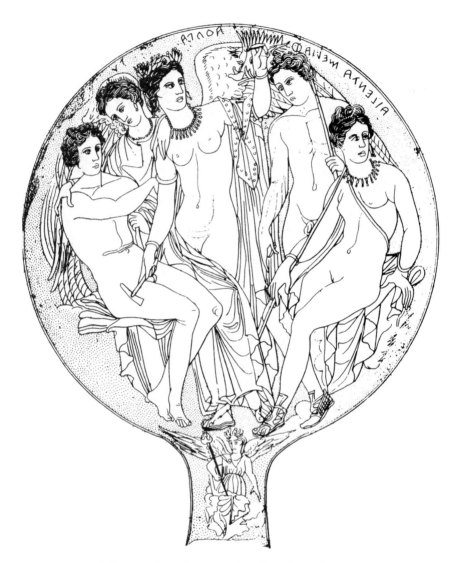

38 Bronze mirror from Perugia with Athrpa (Source 41)

41 *(fig. 38)* Bronze mirror with engraved decoration. *c.*320. *Athrpa* (Atropos) hammers the nail of Fate in the presence of the two pairs of lovers, *Atlenta, Meliacr* (Atalanta and Meleager), and *Turan, Atunis* (Venus and Adonis). Berlin, Antiquarium.

ET Pe S. 12. *ES* 2.176. Beazley, *JHS* 69 (1949) 12, fig. 15. Herbig, *Götter und Dämonen*, pl. 7; de Simone, *Entlehnungen*, I.90. Pfiffig, *Religio*, 61–63.

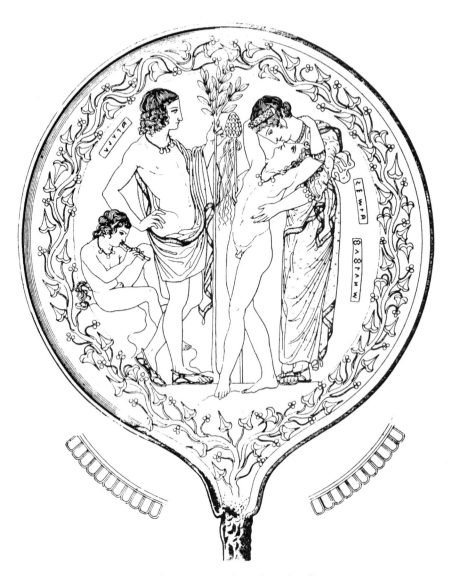

39 Bronze mirror from Vulci with Semla and Fufluns (Source 42)

42 *(fig. 39)* Bronze mirror from Vulci with engraved decoration. Fourth century. *Semla* (Semele) embraces her son *Fufluns̒* (Dionysos, Bacchus) in the presence of *Apulu* (Apollo). Berlin, Antiquarium.

ET Vc S. 12. *ES* 1, 83. Beazley, *JHS* 69 (1949) 6, pl. 6A, fig. 7. de Simone, *Entlehnungen*, I.110, pl. 9, fig. 13.

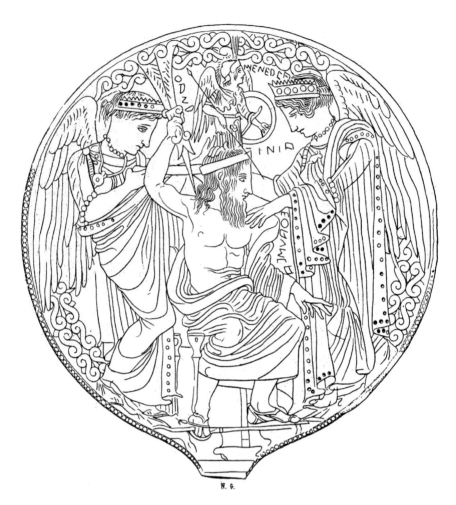

40 Bronze mirror from Palestrina with Tinia giving birth to Menerva (Source 43)

43 (*fig. 40*) Bronze mirror from Palestrina (Praeneste) with engraved decoration. Fourth century. *Tinia* (Zeus) gives birth to *Menerva*, assisted by two attendants, *Thanr* and *Ethauśva*. London, British Museum.

ET La S. 3; *ES* 5, pl. 6; BM 67.

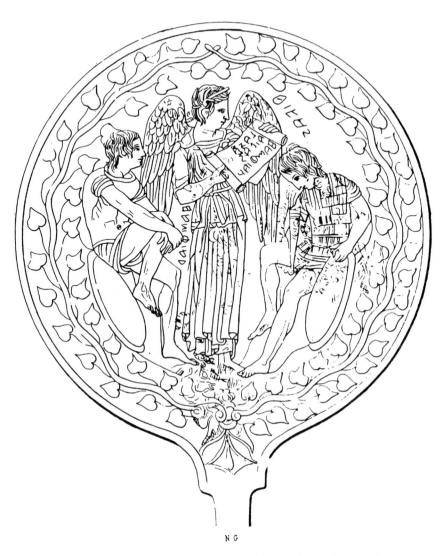

41 Bronze mirror with Lasa, Aivas, and Hamphiare (Source 44)

44 (fig. 41) Bronze mirror with engraved decoration. Provenance unknown. Diameter 16.5 cm. To the left, a seated male figure, *Hamphiare* (Amphiaraos); to the right, *Aivas* (Ajax). In the centre, a winged female figure unrolls a scroll on which are written the characters' names: *Lasa, Aivas, Hamphiare*. London, British Museum.

CII 2514. *ET* OI S. 6. *ES* 359. A. Rallo, *Lasa. Iconografica e Esegesi* (Florence, 1974), No. 1. De Simone, *Entlehnungen*, I.12, No. 14; I.16, No. 5. De Grummond, *Guide*, 115, fig. 93.

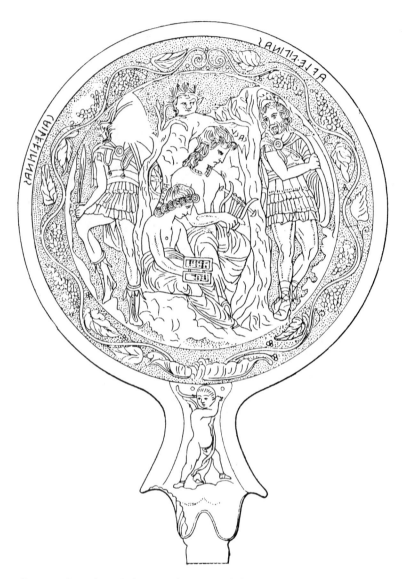

42 Bronze mirror from Bolsena with Cacu and the Vibenna brothers (Source 45)

45 (*fig.* 42) Bronze mirror from Bolsena with engraved decoration. Third century. Diameter 15 cm. *Cacu*, playing the lyre, and *Artile*, reading an open diptych on his knees, are ambushed by the Vibenna brothers, *Avle Vipinas* and *Caile Vipinas* (Aulus and Caelius). London, British Museum.

CIE 10854. *CII* I Suppl. 376. *ET* Vs S.4. *ES* 5.127. BM 633. Beazley, *JHS* 69 (1949), 16–17, fig. 22. A. Morandi, *Epigrafia di Bolsena etrusca* (Rome, 1990) 82, No. 26.

43 Bronze votive statuette of a
haruspex (Source 46)

44 Bronze votive statuette of Apollo (?)
(Source 47)

46 (*fig. 43*) Bronze votive statuette of *haruspex*, provenance unknown, fourth century. Vatican, Museo Etrusco Gregoriano.

<div align="center">

tn turce vel sveitus
'Vel Sveitus gave this'

</div>

TLE 736. *ET* Vs 3.7. Cf. A. Maggiani, 'Immagini di aruspici', in *Atti Firenze 1985*, III.1557 ff.

47 (*fig. 44*) Bronze votive statuette of a young man (Apollo?), wearing laurel wreath, jewellery, and boots. 26 cm. Fourth century. Paris, Bibliothèque Nationale.

<div align="center">

mi flereś spulare aritimi fasti rufriś t(u)rce clen cecha
'I am the statue, or votive offering, (which) Fasti Rufris gave according to ritual to Artemis Spulare on behalf of her son'

</div>

TLE 737. *ET* OB 3.2. Pfiffig, *Religio*, fig. 110. G. Colonna, *StEtr* 51 (1983) 274, No. 181.

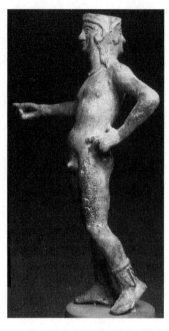

45 Bronze votive statuette of a double-faced
divinity (Source 48)

48 (*fig. 45*) Bronze votive statuette of double-faced divinity, from Cortona,
fourth or third century.

v. cvinti arntiaś. culśanśl. alpan. turce.

'Velia Quintia, the daughter of Arnth, willingly gave [this] to Culsans'

A similar statuette was dedicated to the god Selvans, probably Silvanus (Source
50, fig. 46).

> *TLE* 640. *ET* Co 3.4. See Pfiffig, *Religio*, 246, fig. 108. A. Morandi, 'La lingua
> etrusca: da Cortona a Tarquinia', in *Annuario dell'Accademia di Cortona* 27
> (1995–96) 77–121.

49 Identical inscription incised on the front of five bronze statuettes, male and
female, from a sanctuary near Lake Trasimeno. Fifth century.

mi celś atial celthi

'I (belong to, have been given) to Cel the mother, here (in this sanctuary)'

The genitive ending written with an *ś* is typical of north Etruria. *Celthi* is
the locative of the demonstrative pronoun *ca* (*clthi, calthi*), in an older variant
(cf. *TLE* 135, *calti śuthiti*). The inscription mentions only the god to whom
the gift is dedicated; Archaic monuments also gave the name of the person
giving the gift. *Cel* is a mother goddess: her son, *Celsclan*, appears on a mirror
of the fifth century (*TLE* 368). *Cel* appears on the Piacenza Liver (Source 60,
fig. 51).

> *TLE* 625, corrected by Colonna, *RivStAnt* 6–7 (1976–77) 45–67. *ET* Co 4.5.

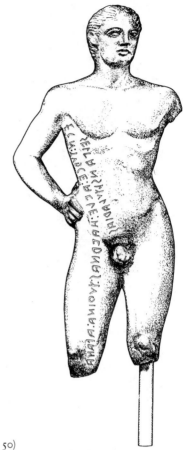

46 Bronze votive statuette of an athlete (Source 50)

50 (*fig. 46*) Bronze statuette of a youthful athlete, left arm and lower legs missing. An inscription runs along his right chest and upper leg. Provenance unknown. End of fourth century. J. Paul Getty Museum, Malibu (California).

ecn turce avle havrnas tuthina apana selvansl tularias
'Aule Havrnas gave this (*tuthina apana*) to Selvans of the Boundaries'

tuthina may refer to a district: compare to *tuthines* on the inscription of the Arringatore (Source 66, fig. 56), perhaps related to the Umbrian word *tota*, 'the city', 'the community', 'the people.' *apana* would seem to be related to *apa*, 'father.'

C. de Simone, *StEtr* 55 (1987–88) 346–351. L. Bonfante in S. Fabing, *The Gods Delight* (Cleveland, 1988) 254–258. van der Meer, *Bronze Liver* (1987) 61. L. Bonfante, 'Un bronzetto da Bolsena(?)', in *Miscellanea Pallottino* 835–44. Cristofani, *Introduzione* 148, No. 36. A. Morandi, *Epigrafia di Bolsena etrusca* (Rome, 1990) 85–86, No. 29.

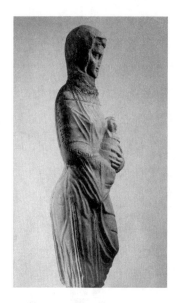

47 Marble statue from Volterra, kourotrophos
Maffei (Source 51)

51 (*fig. 47*) Marble statue of standing woman holding a baby, the kourotrophos Maffei. From Volterra, third century. 1.65 m. The votive inscription runs along the figure's right arm and shoulder. Volterra, Museo Guarnacci.

> *mi: cana: larthiaś: zanl: velchinei: sethra: turce*
> 'I (am) the image of Larthia Zan. Velchina Se(thra) gave me'

Cana can also mean 'gift'. Pfiffig, *Etruskische Sprache*, 283, translates it as *Kunstwerk*, 'work of art': see also Source 5.

> *TLE* 397. *ET* Vt 3.3 (*selvansl*). Agostiniani, *Iscrizioni parlanti*, 116, No. 388. R. Bianchi Bandinelli, *RevArch* 2 (1968) 225 ff.; and *L'arte etrusca*, 301–314, with note by M. Torelli. L. Bonfante, *Etruscan Life*, 240, fig. VIII 15.

52 (*fig. 48*) Wall painting from the Tomba della Querciola II, Tarquinia.

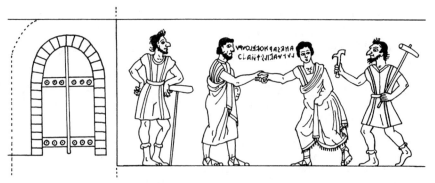

48 Wall painting from the Tomba della Querciola II (Source 52)

Third century. Arnth is accompanied by a Charun to the Gates of the Underworld, where his father (also accompanied by a Charun) greets him.

anes arnth velthuru(s) clan lupu avils ↑

'Anes Arnth, son of Velthur, (was) dead at the age of fifty'

↑ is the Etruscan symbol for 'fifty'.

ET Ta 1.150. *CIE* 5493. Pfiffig, *Religio*, fig. 97.

53 (*fig. 49*) Wall painting from the Tomb of Orcus II, Tarquinia. Fourth century. The Greek Underworld, with the ghosts of Agamemnon [...] *memrun*, that is *achmemrun*, and of Teiresias, *hinthial teriasals*. Fourth century. *Hinthial* means 'shadow', 'ghost', 'reflection in a mirror', Latin *umbra*.

CIE 5368–5369. *TLE* 88. *ET* Ta 7.67. De Simone, *Entlehnungen*, 37, 117. Steingräber, *Etruscan Painting*, 329–332, No. 94.

54 (*fig. 50*) Painted decoration on the walls of the François tomb at Vulci,

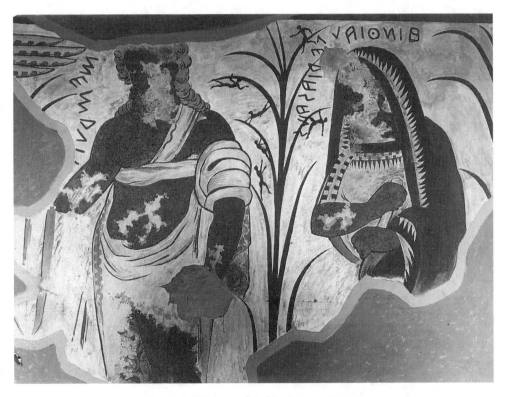

49 Wall painting from the Tomb of Orcus II (Source 54)

50 (*overleaf*) Wall painting from the François Tomb. Sacrifice of the Trojan prisoners (Source 54)

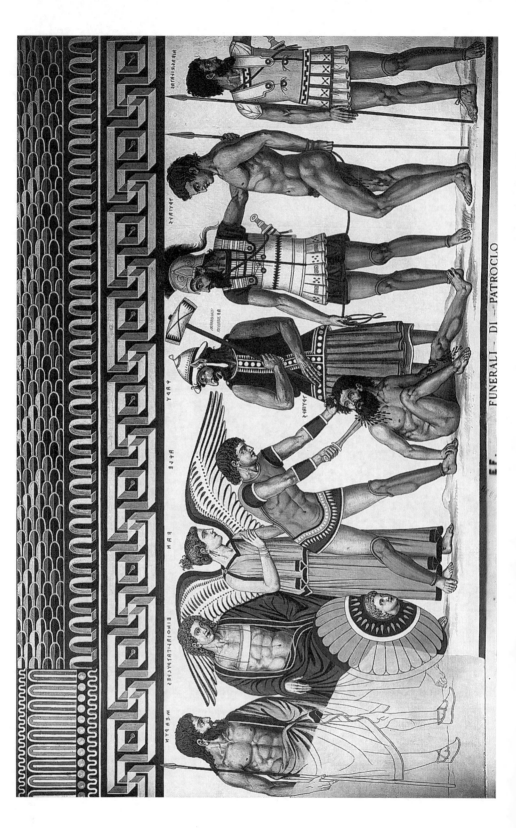

FUNERALI - DI - PATROCLO

EF.

belonging to the Satie family. The tomb construction dates from the fifth century, the elaborate decorative program from the fourth century. In each of the three groups or cycles of decoration, painted inscriptions identify the individual figures.

Names of members of the family and mythological characters

Family

<p style="text-align:center">vel saties. arnza</p>
<p style="text-align:center">'Vel Satie. Little Arnth' (CIE 5276–5277)</p>

<p style="text-align:center">thanchvil verati helś atrś</p>
<p style="text-align:center">'Thanchvil Verati, her own grave' (CIE 5278)</p>

<p style="text-align:center">tarnai thana satial sec</p>
<p style="text-align:center">'Tarnai Thana, of Sati the daughter' (CIE 5285)</p>

<p style="text-align:center">ravnthu seitithi. ativu sacniśa aturś</p>
<p style="text-align:center">'Ravnthu Seitithi (lies here). The mother dedicating to her descendants'</p>
<p style="text-align:center">(CIE 5247: grave cippus in entrance)</p>

Mythological figures

<p style="text-align:center">aivas. caśntra. Ajax and Cassandra (CIE 5248–5249)</p>
<p style="text-align:center">phuinis. nestur. Phoinix and Nestor (CIE 5251–5252)</p>
<p style="text-align:center">evzicle (?) (pul)nice. Eteocles and Polyneices (CIE 5254–5255)</p>
<p style="text-align:center">sisphe. amphare. Sisyphos and Amphiaraos (CIE 5280–5281)</p>

Battle scene

Larth Ulthes (Lars Voltius) is killing *Laris Papathnas Velznach* (Lars Papatius, or Fabatius, of Volsinii). *Rasce* (Rascius) is killing *Pesna Arcmsnas Sveamach* (Pesna Arcmsnas from Sovana[?]). *Aule Vipinas* (Aulus Vibenna) is killing an adversary whose name (*Venthica … plsachs*) is mutilated. *Marce Camitlnas* (Marcus Camitlnas) kills *Cneve Tarchunies Rumach* (Cnaeus Tarquinius of Rome). Finally, *Macstrna* (Mastarna) cuts the bonds of *Caile Vipinas* (Caelius Vibenna) (*CIE* 5266–5275).

Sacrifice of the Trojan Prisoners

Achle (Achilles) slits the throat of a Trojan prisoner (*Truials*) in the presence of *Achmemrun* (Agamemnon), the ghost of Patrocles (*hinthial Patrucles*), *Vanth, Charu(n)* (Charon) and the two Ajaxes, Ajax the son of Oileus (*Aivas Vilatas*) and Ajax son of Telamon (*Aivas Tlamunus*), each of whom brings on another Trojan prisoner (*Truials*) (*CIE* 5256–5265) (fig. 35).

TLE 293–303. *ET* Vc 1.18, O. 40, 7.15, 7.18, 7.21, 7.23, 7.27, 7.28, 7.30, 7.33, 7.21, 1.26, 1.17. *CIE* 5247–5287. Buranelli, *La tomba François*.

55 Painted inscription on tablets held by a winged figure on the wall of the Tomb of the Shields in Tarquinia. Fourth century.

zilci vel[u]si hulchniesi larth velchas
vel[thur]s aprth[nal]c c[la]n sacniśa thui
[ecl]th śuthith acazr

'During the praetorship of Vel Hulchnie, Larth Velcha, son of Velthur and of
Aprthnai, having made offerings here in this tomb, made [the grave]'

> *TLE* 91. *ET* Ta 5.5. Staccioli, *Mistero* No. 11. M. Morandi. *ArchClass* 47 (1995)
> 282–287.

56 Inscription on the wall of a tomb in Tarquinia (now lost). Fourth or third
century.

vel aties velthurus lemniśa celati cesu
'Vel Aties, son of Velthur and of Lemni, lies in this cella'

> *TLE* 105. *ET* Ta 1.66 (*Lemnica*).

57 Inscription from a sarcophagus, perhaps from the Tomb of the Cardinal
in Tarquinia. Third century. Tarquinia, Museo Archeologico.

ravnthus felcial felces arnthal larthial vipenal śethres cuthnas puia
'[This is the grave] of Ravnthu Felci, daughter of Arnth Felce and of Larthi
Vipenai, wife of Sethre Cuthna'

> *TLE* 130 (cf. 103). *ET* Ta 1.197. *CIE* 5378. Staccioli, *Mistero* No. 16

58 Pillar from the Tomb of the Claudii in Cerveteri. Late fourth century.

laris avle larisal clenar sval cn śuthi cerichunce apac atic saniśva thui cesu
clavtiethurasi
'Laris (and) Avle, sons of Laris, (while) living made this tomb. Both father
and mother, deceased (?), lie here. For the family (?) of the Claudii'

śuthi and saniśva are written with the four-bar sigma, ⧓, typical of Cerveteri.

> *CIE* 6213. *ET* Cr 5.2. Pallottino, *StEtr* 37 (1969) 69. Cristofani, *Introduzione*,
> 131–133.

59 On the wall of a tomb in Tarquinia. Third century.

metli arnthi puia amce spitus larthal svalce avil LXIIII ci clenar acnanas arce
'Metli Arnthi was the wife of Larth Spitus; she lived for sixty-four years;
having had three sons, she made [the grave]'

> *TLE* 888. *ET* Ta 1.167. Staccioli, *Mistero* No. 14.

60 (*fig. 51*) Bronze model of a sheep's liver from the vicinity of Piacenza,
inscribed with the names of Etruscan gods. Hellenistic period. Piacenza, Museo
Civico.

There are twenty-one names of divinities, some of which can be identified:
tin = Jupiter; *uni* = Juno; *catha* = a solar divinity; *cel* = a mother goddess;
selvan = Silvanus; *fufluns* = Bacchus; *herc* (*Hercle*) = Hercules; *usil* = the sun;
tivr = the moon. Some are repeated (e.g. *tinś*, *fufluns*) three, four, or even five

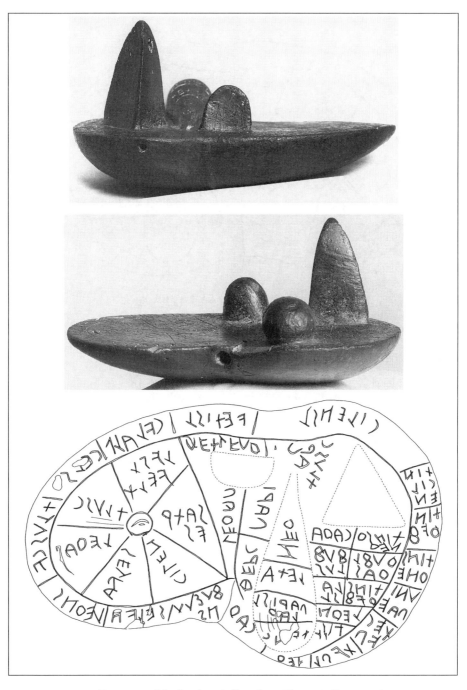

51 Bronze model of a sheep's liver from Piacenza (Source 60)

THE PIACENZA LIVER

a gall bladder
b caudate process
c papillary process

Border

1	Cilensl	9	Caθ
2	Tin Cilen	10	Fufluns
3	Tin Θvf	11	Selva
4	Tin Θne	12	Leθns
5	Uni Mae	13	Tluscv
6	Tecvm	14	Cels[.]
7	Leθn	15	Cvlalp
8	Eθ	16	Vetisl

Right lobe

In the grid pattern:

17	Tinsθ Neθ	21	Nc
18	Θuflθas	22	Lasl
19	Tins Θvf	23	Fuflns
20	Leθn	24	Caθa

Around the gall bladder:

25	Mar Tlusc	27	Herc
26	Mari		

On the gall bladder:

28	Θ	31	Marisl Laθ
29	N	32	Tv Θ
30	Leta		

Left lobe

Outside the wheel pattern:

33	Letham	34	Θetlumθ

In the wheel pattern:

35	Cilcen	38	Tlusc
36	Selva	39	Lvsl Vel
37	Leθms	40	Satres

times. They are native Etruscan gods, while Greek gods represented on mirrors belong to mythology, art, and literature.

TLE 719. *ET* Pa 4.2. Pfiffig, *Religio* 121–127. A. Maggiani, *StEtr* 50 (1984) 53–88. A. Morandi, *MEFRA* 100 (1980) 283–297; idem, *Nuovi lineamenti di lingua etrusca*, 196–206, No. 24. Van der Meer, *Bronze Liver*. G. Colonna, *StEtr* 59 (1993) 123 ff.

61 (*fig. 52*) Bronze base, probably for a bronze statuette representing Hercle, and dedicated to this divinity. Provenance: southern coastal city, or Orvieto. Hellenistic. Manchester Museum.

> *cae siprisni us[u] turce hercles clen cecha*
> *munis en ca elur [...] truta ala [...] alpnina luths inpa [...]*

'Cae Siprisni gave to Hercle on behalf of his son this (gift), the priest, in this place, dedicating it, the sacred gift (or, 'in the sacred place') ...'

J. MacIntosh Turfa and M. Pallottino, *Papers of the British School at Rome* 50 (1982) 183, 193–195, No. 72. M. Pallottino, *StEtr* 50 (1985) 609–611; G. Colonna, *StEtr* 55 (1987–88) 345. *ET* OA 3.9.

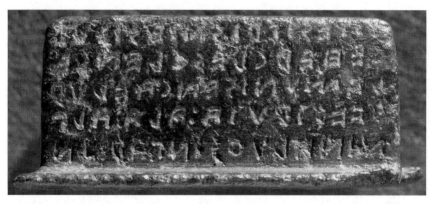

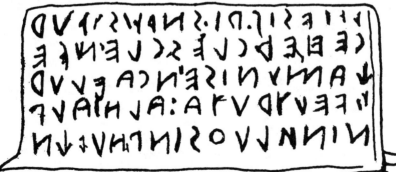

52 Bronze base dedicated to Hercle (Source 61)

62 Funerary urn from Monteriggioni, near Siena. Second century.

mi capra calisnaś larthal śepuś arnthalisla cursnialch
'I (am) the urn of Calisna Larth Sepus, (son) of Arnth and of Cursni'

TLE 428. *ET* Vt 1.77. Cristofani, *Introduzione*, 124–125. Staccioli, *Mistero*, 100, No. 17.

53 Hannibal inscription from Tarquinia (Source 63)

63 (*fig. 53*) Painted on the wall of a tomb at Tarquinia. Second century.

felsnas: la: lethes: svalce: avil: CVI: murce: capue: tleche: hanipaluscle:
'Felsnas Laris (son) of (Felsnas) Lethe, lived 106 years. (He) lived (?) at Capua. (He) was enrolled in (the army) of Hannibal'
or 'was wounded by those of Hannibal'

La is an abbreviation for Laris; *cf.* Latin *L* for *Lucius,* C for *Caius.*

TLE 890. *ET* Ta 1.107. Pfiffig, *Etruskische Sprache*, 226. M. Sordi, *StEtr* 56 (1991) 123–125. Cristofani, *Introduzione*, 141–142.

64 (*fig. 54*) Rectangular boundary stone from Perugia, with inscriptions on the front and the side. 149 cm ×54 cm × 24.5 cm. Second century. Perugia, Museo Archeologico.

[t]eurat tanna larezu [l] ame vachr lautn velthinaś eśtla afunaś sleleth caru
tezan fuśleri tesnś teiś raśneś ipa ama hen naper XII velthinathuraś araś
peraśc emulm lescul zuci enesci epl tularu
auleśi velthinaś arznal clenśi thii thil ścuna cenu eplc felic larthalś afuneś clen
thunchulthe falaś chiemfuśle velthina hintha cape municlet masu naper śran
czl thii falśti velthina hut naper penezś masu acnina clel afuna
velthina mlerzinia intemamer cnl velthina zia śatene tesne eca velthinathuraś
thaura helu tesner aśne cei teśnsteiś raśneś chimth śpel thuta ścuna afuna
mena hen naper ci cnl hare utuśe
velthina śatena zuci enesci ipa śpelanethi fulumchva śpelthi renethi eśtac
velthina acilune turune ścune zea zuci enesci athumicś afunaś penthna ama
velthina afuna thuruni ein zeriuna cla thil thunchulthl ich ca cecha zichuche

Preamble
(A)

'As mediator speaks Larth Rezus: the contract is made between the family Velthina (and) that of Afuna about the property according to Etruscan law; which are the twelve *naper* of the Velthina, exactly but [...] according to right.

[Stipulations:]

As to the boundaries of Aule Velthina, son of Arzna, he from his part gives up one *cenu*, and as to the property of Larth Afuna, son of Thunchulthe (?), it is divided in common. All the (real estate) property in the lower part of the site is divided into five *naper* and two *śran*; the six *naper* adjoining the five, these receives Afuna.

Velthina however the constructions made, the same Velthina will hold them by right. That funerary monument belonging to the Velthina according to Etruscan law Afuna (cedes) gives it up; according to this Etruscan law in all the crypt he gives it up and cedes it. The three *naper* there ... (*hare utuse*).'

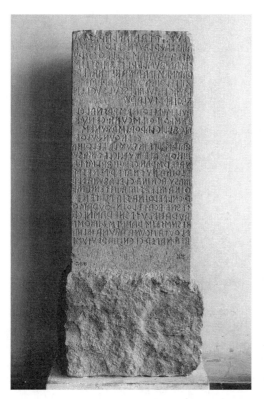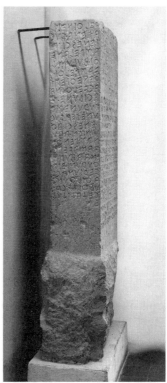

54 Boundary stone from Perugia (Source 64)

(B)

'Velthina rightly owns what around the tomb (is) immovable, which is in the
crypt and in the monument of stone. Velthina will do it, give it up and cede
it rightly. Of the noble Afuna (the ownership) is the monument (cippus).
Velthina and Afuna in agreement all this according to this final contract will
do this, as this agreement has been written down.'

(I have followed the reading of Roncalli, *Scrivere Etrusco*, 79. The translation,
adapted from Pfiffig, *Etruskische Sprache*, appeared in the Italian edition,
Lingua e cultura degli Etruschi (Rome, 1985) 166–169, pl. 7.) The agree-
ment was written down before a judge or witness (*[t]eurat*) named Larth Reza:
a contract (*vachr*) was made, or agreed to (*ama*), between the two families of
Aule Velthina and Larth Afuna concerning the partition, or the use of a family
tomb of the Velthina (*velthinathuras thaura*), and of the monument itself (side
B: *penthna*), according to Etruscan or public law (*raśneś*). The agreement is
written down (*zichuche*) as a valid contract. The word for boundary (*tularu*) is
well known in the area from a number of boundary stones from the Hellenistic
period referring to 'public boundaries' (*tular rasnal*) or 'city boundaries' (*tular
spural*): see Sources 27, 68. The names of the Velthina family and of Larth
Reza are well known in Perugia, while the family of the Afunas is common
in Chiusi. The interpretation of *naper* as a surface measurement, accepted by
Trombetti, Pallottino, and Battisti, is based on three glosses of Festus (160.7,
168–169 ed. Lindsay, Teubner 1913) and on *TLE* 203 and 381 (*ET* Vs 8.4, Vt
8.1). The division of the plot between the Afuna and Velthina families might
be as follows: Afuna owns six *naper*; Velthina owns five *naper*, plus the
funerary monument (*thaura*), plus two *śran*, which are equivalent to six *naper*.

TLE 570. *ET* Pe 8.4. *CIE* 4538. Pfiffig, *StEtr* 29 (1961) 111–154; *StEtr* 30 (1962)
355–57. Roncalli, *Scrivere etrusco* 74–89; *StEtr* 53 (1985) [1987] 161–170. (Reading
araś peraśc emulm lescal (lines 6–7), and *naper śran czl* (15), *Afuna Velthina mler
zinia* (17–18)). Beekes and van der Meer, *De Etrusken Spreken*, 69–72.

65 *(fig. 55)* Bronze inscribed tablet, the Tabula Cortonensis, found in 1992
in Cortona. 28.5 × 45.8 × 0.2 cm. Third or second century. Florence, Museo
Archeologico, Inv. 234.918. The inscription on both sides of the tablet may
record one or more contracts about land, including a vineyard (*vina*).

The bronze tablet, the size of a large piece of paper, was broken in antiquity
into eight pieces, one of which is now missing. The inscription was incised on
both sides directly on the bronze tablet after casting. It originally hung by its
handle, attached by a cord, in a public place, perhaps in an archive.

It contains forty lines (A = thirty-two lines, B = eight lines), and a total of
about two hundred words. Of the sixty or so different words it includes, other
than proper names (some are repeated, others may be enclitics), about half
are new. (See Glossary). Missing from the inscription are the signs for *ph* and
for *h* (*heta*). The backward *epsilon*, probably representing a different sound

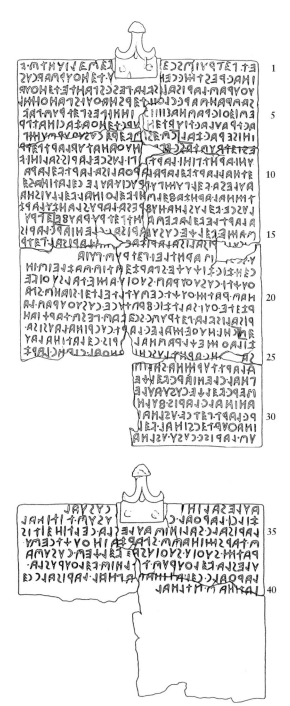

55 Bronze tablet from
Cortona (a) front (b) back
(Source 65)

from the normal *epsilon*, is unusual, but found in other inscriptions from Cortona. The paragraph sign, however, on lines 7, 8, 14, and 23, is unique.

Two hands can be recognized: one wrote A 1–26 and B 1–8, another A 27–32. It is not certain that the two sides A and B are related, but since some of the same names appear on both, Agostiniani and Nicosia publish them as one continuous text. Side A consists of six sections, separated either by starting at the beginning of the line, or marked by the paragraph sign. Each section contains a text; this is followed, in sections III, IV, and VI, by a list of names. Thirty-two men are mentioned by name; one woman, Arntlei Petrus, the wife (*puia*) of Petrus Scevas, is also listed. (The lack of a praenomen may be due to Roman influence.) Ten names of women appear as matronymics. On side B, section VII, the names are in the genitive, and thus incorporated in the text.

Side A, the longer text, opens with the name of a person, Petru Scevas, and the family of the Cusu, Cusuthur (a collective noun, ending in *thur*). There follows a list of fifteen people, all males, whose names follow the traditional pattern, with either two or three names, a combination of 1. praenomen, 2. gentilicial, 3. patronymic or matronymic, 4. cognomen. Five people are *eprus* (a new word), including two of the Cusu family (Petru Sceva and his wife, *Arntlei Petrus puia*). More text follows, naming Petru Sceva and the Cusu family and another long list of people.

<div align="center">

Side A

I.

et petruis sceves eliuntś vinac restmc cenu

'So [on the part of] Petrus Scevas the *eliun*, the vineyard and the *restm*
(*ratum*?) are *cenu*'

tenthur śar cusuthuraś larisalisvla pesc spante
'*tenthur* 10 of the Cusu family of Laris and a *pes* in the plain'

tenthur sa śran śarc
'*tenthur* four and *śran* ten'

thui spanthi mlesiethic rasna [...]
'here, in the plain and in the *mlesia*, people ...'

pes petrus pavac traulac tiur tenthurc [...]
'the *pes* of Petrus and the boy and the *traula*, a month *tenthur*'
(*tiur* = a month or measure? a thirty-day waiting period?)

II.

cś eśis vere cusuthurśum pes petrust-a scevaś
'of this *esi vere* [but] of the Cusu family the *pes* of Petru Scevas' [...]

</div>

The three lists of people in section III. IV and VI are each introduced by a brief text: *nuthanatur, epruś ame, cnl nuthe malec.*

<div align="center">

III.

nuthanatur (followed by a list of fifteen names):

</div>

lart petruni; arnt pini; lart v[i]pi lusce; laris salini vetnal; lart velara aulesa;
vel pumpu pruciu; aule celatina setmnal; arnza felśni velthinal; vel luisna
lusce; vel uslna nufresa; laru slanzu; larza lartle; vel aveś; arnt petru raufe

IV.

eprus ame velche cusu larisal cleniarc
'*eprus* they are, Velche Cusu son of Laris and his children'

laris cusu larisalisa larizac clan larisal petru scevas arntlei petrus puia
'Laris Cusu, son of Laris, and Lariza son of Laris, Petru Scevas, and Arntlei
the wife of Petru'

V.

cen zic zichuche
'This writing was written [by] ...'

sparzete thui
'in the spot here'

VI.

cnl nuthe malec
'[of] this one, let him *nuth* and see to it (guarantee)'

zilath mechl raśnal
'... magistrate of the people'

lart celatina a]pnal cleniarc
'Larth Celatina son of Apna and his children'

velche [... papal]śerc
'Velche and his grandchildren'

Side B, the shorter text, contains eight lines. It begins with a three-part name,
Aule Salini, son of Cusua (name, gentilicial name, and matronymic). It con-
tinues with a date, 'in the magistracy of Larth Cusus son of Titinei and of
Laris Salini son of Aule.'

Side B

VII.

aule salini cusual
'Aule Salini, son of Cusua' (matronymic)

zilci larthal cusuś titinal larisalc salinis aulesla celtnei tiss tarsminaśś
'in the magistracy of Larth Cusu (son) of Titinei (matronymic) and of Laris
Salini son of Aule (patronymic), in the plain of Lake Trasimeno'

The document may be a contract between the Cusu family, to which Petru
Scevas belongs, and fifteen people, perhaps a group of buyers to whom Petru
Scevas and others of the Cusu family are selling the property (including a
vineyard). A series of numerals, *zal* (two), *sa* (four), *sar* (ten), may relate to
measures of land *śran*, like the *naper* of the Perugia cippus. Some phrases are
readily understandable: *zilci*, 'in the magistracy of'. *cen zic zichuche*, 'this

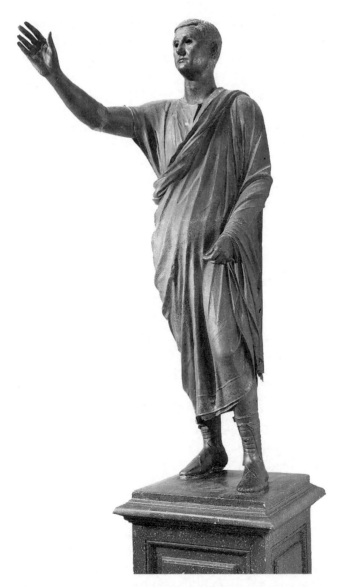

56 (a) Bronze statue of the Arringatore (Source 66)

56 (b) Drawing of inscription on hem of toga (Source 66)

document is written', emphasizes the importance of this written, recorded document.

L. Agostiniani, F. Nicosia, *Tabula Cortonensis*. C. de Simone, *AnnPisa* 53 (1998) [2000] has a different interpretation, and sees a religious content comparable to that of the Iguvine tablets.

66 (*fig. 56*) Inscription engraved on the life-size bronze statue called the 'Arringatore', 'the public speaker', offered as a public monument by his community. Early second century. The statue was found in Umbrian territory, perhaps at Perugia. Florence, Museo Archeologico.

auleśi . meteliś . ve[lus] . vesial . clenśi
cen . flereś . tece . sanśl . tenine . tuthineś . chisvlicś

'To (or from) Aule Meteli, the son of Vel and Vesi, this statue set up, as a
votive offering to Sans, Tenine (?) by deliberation (?) of the people'
('From Aulus Metellius, the son of Vel and Vesi, Tenine (?) set up this statue
as a votive offering to Sans, by deliberation of the people')

A connection of *tuthines* with the Umbrian word *tota* seems likely. *Tota* means 'the city', 'the community', 'the people'. The exact significance of the dative of agent here is uncertain: was Aule Meteli the one who dedicated the statue to the god *sanś*? Aule Meteli had evidently deserved to set up this statue as a civic honour. In this and in the following inscription note *ś*, typical of northern Etruria.

TLE 651. *ET* Pe 3.3. *CIE* 4196. T. Dohrn, *Der Arringatore* (Berlin, 1968). M. Pal-
lottino, with T. Dohrn, 'Nota sull'iscrizione dell'Arringatore', *Bollettino d'arte* 49
(1964) 115–116. G. Colonna, *StEtr* 56 (1991) 99–119.

67 (*fig. 57*) Sections of Etruscan text on the linen book torn to make bandages for the mummy of a woman, now in Zagreb, National Museum. 150–100 BC.

celi huthiś zathrumiś flerchva nethunsl śucri thezeri-c

'In the month of Cel, on the twenty-sixth [day] the offerings to Nethuns must
be made and immolated' (VIII.3)

cntnam thesan fler veiveś thezeri etnam aisna [...] ich huthiś zathrumiś

'And the same morning the offering to Veive must be immolated and
furthermore [...] the divine service as on the twenty-sixth (day)' (XI.14)

'In the month of Celi (September), on the twenty-sixth day the offerings to Nethuns must be made and immolated. And the same morning the offering to Veive must be immolated, and furthermore the divine service, as on the twenty-sixth day'

tinśi, tiurim, avils, 'day, month, year' (VIII.15)

TLE 1. *ET* LL. Pfiffig, *Etruskische Sprache*, 244–250. Roncalli, *Atti Firenze 1985*
(1989) III.1267–1270; *Scrivere etrusco*, 17–64.

68 Eight border markers with identical texts found in Tunisia between 1907

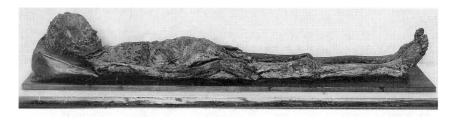

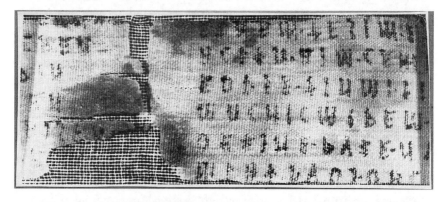

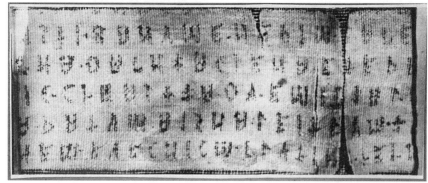

57 Zagreb mummy wrappings (Source 67)

and 1915, set up by Etruscan colonists (perhaps from Chiusi) to designate the territory of a clan, tribe, or village with the name *Dardanii*. Etruscan *termini* or boundaries were under the protection of Jupiter. The number 1000 indicates the size of the territory. The word *Dardanii*, 'Trojans', indicates Latin influence. Second or first century, perhaps 82 BC. Written in Latin characters:

M. UNATA. ZUTAŚ. TUL. DARDANIUM. TIN Φ

In Latin this would read:

Marcus Unata Zutas. Fines Dardanium. Iouis. 1000 passuum

'Marcus Unata Zutas. Boundaries of the Trojans. To Tin (Jupiter). 1000 paces'

An alternative translation (Rix, Wallace) reads 'Marcus Unata (was the one who) set up the cippus of the Dardani to Tin', taking *zutas* as a participial form of *zu-*, meaning 'set up, place'.

ET Af 8.1–8.8. J. Heurgon, *CRAI* 1969, 526–51. H. S. Versnel, *Bibliotheca Orientalis* 33 (1976) 107. O. Carruba, *Athenaeum* 54 (1976) 163–173.

GLOSSES

The following Etruscan glosses, that is Etruscan words with a trans-
lation in Greek or Latin, come from the *Lexicon* of Hesychius, the
Liber Glossarium, and a number of ancient authors: Varro, *De Lingua
Latina*, Verrius Flaccus, Strabo, Dioscorides (for the name of plants),
and others. The numbers are those of the *TLE*, where references will
be found.

801. *Aclus Tuscorum lingua Iunius mensis dicitur*
 The month of June is called *Aclus* in the language of the Etruscans.

802. ἀγαλήτορα παῖδα . Τυρρηνοί
 The Etruscans call a child *agaletora*.

803a. *quod aesar ... Etrusca lingua deus uocaretur*
 For in the language of the Etruscans a god was called *aesar*.

803b. τὸ λοιπὸν τὸ ὄνομα (αισαρ) θεὸν παρὰ τοῖς Τυρσηνοῖς νοεῖ
 For the rest, among the Etruscans the name *aesar* means god.

804. ἀϊσοί · θεοὶ ὑπὸ Τυρρηνῶν
 aisoi: gods among the Etruscans.

805. *Ampiles Tuscorum lingua Maius mensis dicitur*
 The month of May is called *Ampiles* in the language of the Etruscans.

806. ἄνδας · βορέας ὑπὸ Τυρρηνῶν
 andas: Boreas, the North Wind, among the Etruscans.

807. ἄνταρ · ἀετὸς ὑπὸ Τυρρηνῶν
 antar: eagle among the Etruscans.

808. *herba quae a Graecis dicitur chamaemelon: ... Tusci apianam*
 The plant which is called the *chamaemelon* (chamomile) by the Greeks,
 the Etruscans call *apiana*.

809. σέλινον ἄγριον · οἱ δὲ βατράκιον, ... οἱ δὲ ἱπποσέλινον; ... Ρωμαῖοι
ἄπιουμ ... Θοῦσκοι ἄπιουμ ρανίνουμ
Wild parsley is called by some *batrakion* ('frog plant', *ranunculum*),
by others *hipposelinon* ('horse celery'), by the Romans *apium*, by the
Etruscans *apium raninum* ('frog *apium*' – Ranunculus or apium family).

810. ἄρακος · ἱέραξ . Τυρρηνοί
arakos: the Etruscan word for hawk.

811a. οἳ καὶ τοὺς πιθήκους φασὶ παρὰ τοῖς Τυρρηνοῖς ἀρίμους καλεῖσθαι
They also say that monkeys among the Etruscans are called *arimoi*.

811b. *simiae ..., quas Etruscorum lingua arimos dicunt*
Monkeys ... which in the Etruscan language are called *arimi*.

811c. ἄριμος · πίθηκος
arimos: monkey

812. *arseuerse auerte ignem significat. Tuscorum enim lingua arse auerte,
uerse ignem constat appellari*
arseuerse means to turn away the fire. For in the Etruscan language
arse means 'turn away', *uerse* means 'fire.'

813. ἀταισόν · ἀναδενδράς . Τυρρηνοί
ataison: Etruscan word for the vine that grows on trees.

814. *atrium appellatum ab Atriatibus Tuscis*
atrium, so called from the Etruscan city of Atria.

815. αὔκήλως · ἕως ὑπὸ Τυρρηνῶν
aukelos: the dawn among the Etruscans.

816. *baltea ... Tuscum uocabulum*
baltea ... an Etruscan word.

817. βυρρός · κάνθαρος . Τυρρηνοί
burros: Etruscan word for dung-beetle (*kantharos*).

818. *Cabreas Tuscorum lingua Aprilis mensis dicitur*
The month of April is called *Cabreas* in the Etruscan language.

819a. ὅσα δὲ παρὰ Τυρρηνοῖς ... ἐτέλουν ... οἱ καλούμενοι πρὸς αὐτῶν
κάδμιλοι, ταῦτα ... ὑπηρέτουν τοῖς ἱερεῦσιν οἱ λεγόμενοι νῦν ὑπὸ
Ρωμαίων κάμιλοι
All the sacred things carried out among the Etruscans by those they
call the *kadmiloi* ... [they] assisted the priests, those whom the Romans
today call the *camilli*.

819b. *Tuscos Camillum appellare Mercurium, quo uocabulo significant prae-
ministrum deorum ... Romani quoque pueros et puellas nobiles et
inuestes camillos et camillas appellant flaminicarum et flaminum
praeministros*

The Etruscans call Mercury Camillus, the word they use to mean attendant of the gods ... The Romans, too, call unmarried ('sexually immature') boys and girls of good family *camillos* and *camillas*, the attendants of the *flaminicae* and the *flamines*.

820. κάπρα · αἴξ . Τυρρηνοί
kapra: Etruscan word for goat.

821. *falconis ... qui Tusca lingua capys dicitur ... Falco ..., cui pollices pedum curui fuerunt quem ad modum falcones aues habent, quos uiros Tusci capyas uocarunt*
... of the falcon ... which in the Etruscan language is called *capys* ... The falcon ... [For] Etruscans called *capys* men who had the thumbs of their feet curved, in the manner of falcon birds.

822. *cassidam autem a Tuscis nominatam. illi enim galeam cassim nominant, credo a capite*
But it is called *cassida* by the Etruscans. For they call the helmet *cassis*, I believe from the [Latin word for] head [*caput, capitis*].

823. ἀμάρακον · οἱ δὲ ἀνθεμίς, ... Ῥωμαῖοι σῶλις ὄκουλουμ, οἱ δὲ μιλλεφόλιουμ, Θοῦσκοι καυτάμ
amarakon: some call it *anthemis* (a medicinal plant) ... For the Romans it is the 'eye of the sun', for others the *millefolium* ('thousand-leaves'), for the Etruscans *kautam* (bachelor's button or Pyrethrum parthenion).

824. *Celius Tuscorum lingua September mensis dicitur*
The month of September is called *Celius* in the Etruscan language.

825. γεντιανή · ... Ῥωμαῖοι γεντιάνα, Θοῦσκοι κικένδα, οἱ δὲ κομιτιάλις
gentian: the Romans call it *gentiana*, the Etruscans *cicenda*, others *comitialis*.

826. *nomen herbae batrachii: a Graecis dicitur batrachion, Tusci corofis (cherifis, clorisis, cloroplis [= *χλωρόπιον ?]), Siculi selinon agrion, Romani apiurisu[m]*
The name of the plant *batracium* (*ranunculus*): by the Greeks it is called *batrachion*, by the Etruscans *corofis* (wild celery – Ranunculus or apium family), the Sicilians call it 'wild celery', the Romans *apiurisum*.

827. δάμνος · ἵππος . Τυρρηνοί
damnos: Etruscan word for horse.

828. δέα · δέα [= θεὰ ?] ὑπὸ Τυρρηνῶ[ν]
dea: Etruscan word for goddess.

829. δροῦνα · ἡ ἀρχή, ὑπὸ Τυρρηνῶν
drouna (drous): the Etruscan word for the beginning.

830. ὑοσκύαμος · οἱ δὲ Διὸς κύαμος, ... Ῥωμαῖοι ἰνσάνα, ... Θοῦσκοι
φαβουλώνιαμ·
hyoskyamos [*dioskyamos*] (henbane): some call this the 'bean of
Jupiter' ... the Romans, *insana*, ... the Etruscans *fabulonia* (*faba suilla*
'pork bean').

831. *a falado (falando), quod apud Etruscos significat coelum*
a falado (falando), which among the Etruscans means sky.

832. γάπος · ὄχημα . Τυρρηνοί
gapos: Etruscan for chariot.

833. χρυσάνθεμον ἢ χάλκας : ... Ῥωμαῖοι κάλθα, ... Θοῦσκοι γαρουλέον
chrysanthemum ['gold flower': marigold] 'bronze [flower]': the Romans
[call it] *caltha*, the Etruscans *garuleon*.

834. δρακοντία μικρά · οἱ δὲ ἄρον, ... Ῥωμαῖοι βῆτα λεπορῖνα Θοῦσκοι
γιγάρουμ
mikra (small) *drakontia*: some call it *aron* (*arum dioscoridis*), ... the
Romans, *beta leporina* [*beet*], the Etruscans, *gigarum*.

835. γνίς · γέρανος . Τυρρηνοί
gnis: Etruscan word for crane.

836. *[H]ermius Tuscorum lingua Augustus mensis dicitur*
The month of August is called *Hermius* in the Etruscan language.

837a. *quia ister Tusco uerbo ludio uocabatur, nomen histrionibus inditum*
Because *ister* was the Etruscan word for player, this name was given
to actors.

837b. *quia ludius apud eos [Tuscos] hister appellabatur, scaenico nomen*
histrionibus inditum est
Because a player was called *hister* among them [the Etruscans], an actor
was called with the name of *histrio*.

837c. *ludio Tusco verbo dicitur histrio*
A player (actor) is called *histrio*, with an Etruscan word.

838a. *Idus ab eo quod Tusci Itus, uel potius quod Sabini Idus dicunt.*
Idus, because the Etruscans call it *Itus*, or rather because the Sabines
say Idus.

838b. *Iduum porro nomen a Tuscis, apud quos is dies Itis uocatur, sumptum*
est. item autem interpretantur Iouis fiduciam ... Iouis fiduciam Tusco
nomine uocauerunt ... sunt qui aestiment Idus ab oue Iduli dictas, quam
hoc nomine uocant Tusci, et omnibus Idibus Ioui immolatur a flamine.
nobis illa ratio nominis uero propior aestimetur, ut Itus uocemus diem
qui diuidit mensem. iduare enim Etrusca lingua diuidere est.
The name of the Ides indeed is taken from the Etruscans, among whom
that day is called *Itis*. And they interpret [it as] the faith of Jupiter.

The faith of Jupiter they call with an Etruscan name ... There are some who think that the Ides are so called from the Idule sheep, which the Etruscans call by this name, and on all the Ides it is sacrificed to Jupiter by the *flamen*. But I think that the following reason for the name is closer to the truth, that we call *Itus* the day that divides the month. For *iduare* in the Etruscan language means 'to divide.'

839. Τυρρηνοὶ γὰρ ἰταλὸν τὸν ταῦρον ἐκάλεσαν
 For the Etruscans called the bull *italos*.

840. *laena vestimenti genus habitu duplicis. quidam appellatam existimant tusce, quidam graece; quam χλανίδα dicunt.*
 The *laena* was a kind of garment worn as a double covering. Some think the name was Etruscan, others that it was Greek; for the Greeks call it a *chlanida*. [From Greek *chlaina*].

841. *lanista, gladiator, id est carnifex, Tusca lingua appellatus, a laniando scilicet corpus.*
 The *lanista*, a gladiator, that is a *carnifex* (executioner), was so called in the Etruscan language, evidently from *laniare*, 'tearing apart the body'.

842. ἐρυθρόδανον ... Ῥωμαῖοι ῥούβια σάτιβα, θοῦσκοι λάππα μίνορ.
 erythrodanon [a red dye] ... the Romans call it cultivated madder (*rubia sativa*), the Etruscans *lappa minor* ('the smaller burr').

843. *lucumones, qui reges sunt lingua Tuscorum.*
 ... the lucumones, who are kings in the Etruscan language.

844. *mantisa additamentum dicitur lingua Tusca, quod ponderi adicitur, sed deterius ei quod sine ullo usu est*
 mantisa was the word for 'increase' in the Etruscan language, that is what was added to the weight, but in a bad sense, of that which is useless.

845. ἀναγαλλὶς ἡ φοινική · ... προφῆται αἷμα ὀφθαλμοῦ, ... Ῥωμαῖοι μάκια, οἱ δὲ ἀντούρα, οἱ δὲ τούρα, οἱ δὲ τουραδουπάγω, Θοῦσκοι μασύριπος
 The scarlet pimpernel (*anagallis*) ... prophets call it the 'blood of the eye', the Romans call it *macia*, some call it *antoura*, others *toura*, others *touradoupago*, the Etruscans *masuripos*.

846. θύμος · ... Ῥωμαῖοι θούμον, ... Θοῦσκοι μούτουκα
 thymos (thyme): the Romans call it *thymum*, ... the Etruscans *mutuka*.

847. ὁ Ὀδυσσεὺς παρὰ Τυρσηνοῖς Νάνος καλεῖται, δηλοῦντος τοῦ ὀνόματος τὸν πλανήτην
 Odysseus among the Etruscans is called Nanos, the name indicating the Wanderer.

848. *(nepos) ... Tuscis dicitur*
 nephew (grandson) ... he is called among the Etruscans.

849. σμῖλαξ τραχεῖα · ... Ῥωμαῖοι μεργίνα, ... Θοῦσκοι ῥαδία
 The prickly smilax or holm-oak ... the Romans call it *mergina*, the Etruscans *radia*.

850. λευκάκανθα · ... Ῥωμαῖοι γενικουλάτα κάρδους, Θοῦσκοι σπίνα ἄλβα
 The white thistle: ... the Romans call it the *geniculata* ('kneeling', or 'curved') thistle, the Etruscans, the *spina alba* (Latin, 'white thorn').

851a. *subulo dictus, quod ita dicunt tibicines Tusci: quodcirca radices eius in Etr[ur]ia, non Latio quaerundae*
 A *subulo* is so called, because that is what the Etruscans call flute players; since the origin of the flute is to be looked for in Etruria, not in Latium.

851b. *subulo tusce tibicen dicitur*
 In Etruscan a flute player is called a *subulo*.

852. ἄσαρον : οἱ δὲ νάρδος ἀγρία, προφῆται αἷμα Ἄρεως, ... Ῥωμαῖοι περπρέσσαμ, ... Θοῦσκοι σούκινουμ
 asaron: some call it it wild spikenard (valerian), the prophets call it the 'blood of Ares', the Romans *perpressa*, ... the Etruscan *sucinum*.

853. ἀναγαλλίς ἡ κυανῆ · ... οἱ δὲ αἰλοῦρου ὀφθαλμόν, ... Ῥωμαῖοι μεκιατούρα, οἱ δὲ ἀντοῦρα, Θοῦσκοι τάντουμ
 The blue pimpernel: some call it the 'eye of the cat', the Romans *meciatura*, others *antura*, the Etruscans *tantum*.

854. *Traneus Tuscorum lingua Iulius mensis dicitur*
 The month of July is called Traneus in the Etruscan language.

855. τύρσις γὰρ καὶ παρὰ Τυρρηνοῖς αἱ ἐντείχιοι καὶ στεγαναὶ οἰκήσεις ὀνομάζονται ὥσπερ παρ' Ἕλλησιν
 Tyrsis, 'tower': for among the Etruscans the fortified and covered buildings are called by the same name as among the Greeks.

856. *Velcitanus Tuscorum lingua Martius mensis dicitur*
 The month of March is called *Velcitanus* in the Etruscan language.

857. *agri modus ... plerumque centenum pedum in utraque parte, quod Graeci plethron appellant, Tusci (Osci) et Umbri uorsum*
 The measure of a field ... generally one hundred feet on each side, which the Greeks call a *plethron*, the Etruscans (Oscans) and the Umbrians call *uorsum*.

858. *Xosfer Tuscorum lingua October mensis dicitur*
 The month of October is called *Chosfer* in the Etruscan language.

MYTHOLOGICAL FIGURES

The following list of the major and some of the minor mythological figures whose names appear in Etruscan inscriptions includes both Greek divinities, heroes, and heroines, and purely Italic and Etruscan figures. Many are known from scenes represented on Etruscan gems, mirrors, and other monuments, and from votive inscriptions dedicating gifts to the gods. Some names recorded on the mirrors are otherwise unknown (e.g. Ucernei, Rathlth); some names which appear on the Piacenza Liver may be epithets of known divinities (e.g. Tluscv). For more information see the select bibliography at the end of this section, and in particular the *LIMC*.

Achlae (Acheloos) Horned river god, shown on a mirror struggling with Hercle. In Greek mythology, he was the son of Okeanos and Tethys. His bearded, horned head is often represented in Etruscan art from the sixth century on.

Achle, Achile (Achilles) The hero of the *Iliad* appears in scenes of death and violence, such as the ambush of Troilos (whose severed head he sometimes uses as a weapon), and the sacrifice of the Trojan prisoners in the François Tomb. On later mirrors, he sits quietly with other mythological figures in the Sacred Conversations (so called after the groups of saints standing together in Renaissance religious paintings). There he is often paired off with his mother, Thethis, or with Crisitha. De Simone lists thirty-seven occurrences of Achle (the most usual form) or related forms. He is a popular figure on gems: over a dozen of them bear his name, sometimes with that of Aivas.

Achmemrun (Agamemnon) His ghost appears in the Underworld, wearing bandages over the wounds from which he died, standing next to the ghost of Teriasa (Teiresias) in the Tomb of Orcus. He also appears in the François Tomb. In Homer, he was the leader of the Greek expedition in the Trojan War, who was murdered by his wife Klytemnestra and avenged by his son Orestes. His name appears on four mirrors (de Simone).

Achrum, Acharum (Acheron) The river of the Underworld. See Alcsti (Source 24). Formerly read as *Nathum*, Acharum appears as an Etruscan version of a Fury, shown on one mirror holding snakes as he watches Urusthe (Orestes) killing his mother Cluthumustha (Clytemnestra).

Achvizr, Achuvesr, Achuvizr, Achviztr A figure, sometimes male, sometimes female, associated with the circle of Turan, who was also represented in the company of Achle, Thethis, and Alpan. The name already occurs on seventh-century inscriptions (*TLE* 29, 939), together with the words *turannuve* (Turan), and *ithavus-* (Ethausva).

Aita, Eita (Hades) Appears enthroned together with Phersipnai (Persephone) as the couple ruling over the Underworld in the Tomba Golini I in Orvieto, in the Tomb of Orcus II in Tarquinia, and on a mirror from Orbetello, as well as (uninscribed) on the sarcophagus of Torre San Severo (Orvieto).

Aivas, Evas (Ajax) The two Ajaxes are shown in the François Tomb – Aivas Vilatas (Ajax son of Oileus), and Aivas Tlamunus (Telamonian Ajax) – leading the Trojan prisoners to Achilles. Aivas also appears on a number of scenes on mirrors. On a red-figure crater from Vulci, Ajax (son of Telamon), despondent at his failure to win the arms of Achilles, commits suicide by impaling himself on his sword. The suicide is also represented on a mirror in Boston, on which Menarva shows him the place where he must use his sword (his arm-pit). De Simone lists twenty-six occurrences of the name. The figure, and the name, appear on several gems.

Alchumena (Alcmena) Mother of Hercle by Zeus and of his twin brother Iphicles by Amphitryon, her husband: her name appears on two mirrors.

Alcstei, Alcsti (Alcestis) The heroine of Euripides' play, who died and went to the Underworld – Acheron – in place of her husband Atmite (Admetos). On a mirror in New York, she is reunited with him in marriage after she has been brought back by Hercle. A red-figure vase also showing the two together bears a rare narrative inscription referring to the story (Source 24).

Alichsantre, Alcsentre, Elchsntre, etc. (Paris Alexander) Frequently shown together with Elinei, and paired off with her in groups of young people, the so-called Sacred Conversations. The name appears eighteen times (Martelli, *Ceramica*).

Alpan, Alpanu, Alpnu A youthful female figure represented on several mirrors; she may stand for the Greek Harmonia, or the Roman Concordia. In votive inscriptions the word is often used, perhaps as the equivalent of the Greek *chairein*, Latin *libens*, 'willingly'.

Alpunia Female figure with stylus and tablets shown together with Umaele and the head of Urphe on a mirror in Chiusi.

Althaia (Althaia) In Greek myth, the mother of Meleager. The name appears on a mirror with the Judgement of Paris, in a grouping related to the Toilette of Helen or Malavisch. She holds a branch and stands in attendance, so the figure could correspond to the Greek Aithra, Theseus' mother and Helen's

attendant, shown in another mirror; her presence here could be due to a conflation of the Judgement of Paris with the theme of the Toilette of Helen. But her presence could also have been included on purpose.

Aminth A nude, winged figure of a child, looking much like Eros, has been identified with the god of love, Amor. The group of gods and heroes – Fufluns, Castur, Aratha (Ariadne), and Eiasun (Jason) – is involved in a scene difficult to interpret. The figure stands apart from the others on a little platform or base, and it may represent a statue of the god of love.

Amphiare See *Hamphiare*.

Amuce, Amuche, Amuke (Amykos) His name appears on a scarab and two mirrors. He was a barbarian king who challenged the Argonauts to a boxing match and was beaten by Polydeukes (Pollux).

Apulu, Aplu (Apollo) Son of Letun (Leto), brother of Aritimi (Artemis). The Greek god of prophecy, music, and youth, known by his Greek name, can be recognized in Etruscan art by his good looks and standard attributes, the laurel bough and laurel crown, cithara or lyre, and bow and arrow, as well as the necklace and bulla bracelet of an Etruscan youth. On a bronze statuette representing the god there appears a votive inscription dedicating it to his sister, Aritimi (Source 47). On mirrors he appears in scenes with either his sister or a nymph, as a spectator in such important scenes as the Adoption of Hercle, and in quiet conversation scenes. De Simone lists thirty-three occurrences of the name. (On the terracotta decoration of the temple of Veii he is clearly recognizable as he strives with Hercle for the Cerynean hind, and he also appears as a child in the arms of his mother Leto, who flees from the serpent Pytho).

Areatha (Ariadne) See *Fufluns*.

Aril On a mirror the figure of Atlas holding up the sky is labelled *Aril*, a name interpreted as the 'go-between'. On a gem Atlas, with Hercle and the tree of the Hesperides, is also called Aril.

Aritimi, Artumes (Artemis) Apollo's twin sister appears with her brother and other figures on mirrors; in one case *Artumes* is (mistakenly?) written above a male figure. Aritimi receives cult, as proven by votive offerings inscribed with her name.

Artile See *Cacu*.

Ataiun (Aktaion) The name of the young hunter, who was torn apart by his own hunting dogs because he saw Artemis naked, appears twice on inscribed red-figure vases and once on a gem.

Athrpa (Atropos) One of the Fates, according to Greek mythology. On a mirror in Berlin she appears as a beautiful nude figure, hammering the inexorable nail of Fate in place in the presence of other divinities (Source 41).

Atlenta, Atlnta (Atalanta) The athletic heroine, who in Greek mythology took part in the Calydonian boar hunt, is popular in Etruscan art. She appears on three inscribed mirrors, in the company of Meliacr (Meleager) and others,

as well as wrestling with Pele (Peleus). She wears an athletic costume: a cap or snood, and a perizoma, with or without a breast band. Her semi-nudity emphasizes her 'liminality', between male and female, and agrees with the later, related tradition of her representation on pornographic paintings. Her name appears once on a scarab, one of only three female names (with Elinei and Turan) to appear on gems.

Atmite (Admetos) Appears together with his wife Alcstei on mirrors and on red-figured vases. See *Alcstei*.

Atunis (Adonis) The beautiful lover of Turan (Aphrodite), whose youth is always emphasized – he appears sometimes as a very young boy – is shown in an amorous embrace with the older goddess. De Simone lists sixteen occurrences of the scene; van der Meer counts twenty-two.

Aturmuca (Andromache) An Amazon. Andromache is the most common name given to Herakles' opponent in Attic black-figure versions of the Amazonomachy in archaic Greek art (Neils 432). On a red-figure vase from Vulci the ghost of Andromache (*hinthi aturmuca* – not *hinthia turmuca*, the former reading) appears together with that of another Amazon, Pentasila (Penthesilea), both of them wearing bandages over the wounds from which they died.

Aulunthe Name of a satyr. Five are named on mirrors: the others are *Chelphun*, *Hathna*, *Sime*, and *Puanea*.

Cacu Young, Apollo-like singer or seer appearing on a mirror with the boy Artile as his attendant, reading a prophecy. The two are about to be ambushed by two soldiers, Caile and Avle Vipinas. The Etruscan rendering contrasts with the Roman myth of Hercules and half-human Cacus (Vergil, *Aeneid* 8.185–267).

Calaina (Galene, Doric Galana) The Etruscan name derives from that of one of the Greek Nereids ('calm, stillness of the sea'), with the transcription of η as *ai* coming into Etruscan from the Latin language, where it was frequent. On a mirror in New York Calaina appears as a companion or attendant at the toilette of Thethis.

Calanice (Kallinikos) Epithet of Hercle, 'beautifully victorious', occurring on a scarab and two mirrors.

Capne, Kapne (Capaneus) One of the Seven against Thebes. As he climbed the walls, boasting that not even Zeus could stop him, he was struck down by a thunderbolt. The fifth-century terracotta sculpture from Pyrgi shows this moment, as do a number of Hellenistic ash urns.

Caśntra (Cassandra) In Greek mythology a Trojan princess, daughter of Priam and Hecuba and a prophetess, was taken by Agamemnon as his slave and killed by Clytemnestra along with him. She appears in the François Tomb, and on three mirrors.

Castur (Kastor, Castor) One of the twin brothers of Helen and Clytemnestra in Greek mythology. Castur and Pultuce are known in Greek as the

Dioskouroi, 'children of Zeus' – an epithet translated in an Etruscan votive inscription as *tinas cliniiaras*, 'sons of Tina'. On Etruscan mirrors (eighteen occurrences of Castur), they appear in family units with their parents, Tuntle and Latva, in scenes of the presentation of the egg of Helen (Source 38). They also appear on their own, with attributes including shields, stars, Phrygian hats, and a kind of post or pediment known as the *dokana*. On mirrors of the Hellenistic period the Dioskouroi and Lasas are the most frequent representations. Castur also appears on gems, four times with his name inscribed.

Catha, Cavtha The Etruscan divinity Catha appears on the Zagreb mummy wrappings as *ati cath*, Catha the Mother. Identified with 'Celeritas solis filiae' (Martianus Capella), she is the daughter of a mother goddess, like Persephone (Proserpina). There is no inscribed representation of Catha or Cavtha. Cathesan (Cathe Sans), who appears on a mirror from Orbetello, seems to be the male Catha. (Or is it *ca Thesan*? TLE 340).

Catmite (Ganymede. Cf. English *catamite*) In Greek mythology Ganymede was the beautiful youth taken up to Mount Olympos by Zeus in the shape of an eagle, to be a cupbearer to the gods, as a male counterpart to Hebe. The Etruscan Catmite appears on a mirror as a naked youth, with a dog and a long torch, in the arms of an eagle. The Latin name Catamitus, which appears once (Plautus, *Men.* 144), derives by way of Etruscan from Greek *Gadymedes* (instead of *Ganymedes*).

Cel One of a number of mother goddesses (*ati Cel*), perhaps Mother Earth, like the Greek Ge. The name appears on the Piacenza Liver. Each of five bronze statuettes bears the votive inscription, *mi cels atial celthi*, 'I (belong) to Cel the mother, in the sanctuary of Cel'. (Colonna, correcting TLE 625). She is thus one of the Mother goddesses, along with Turan ati, Mater Matuta, etc.

Celsclan 'Son of Cel', a Giant, and so son of Ge, Mother Earth. He appears on a mirror, with rays (of light?) issuing from his head, pursued by the armed Laran in a scene from a gigantomachy.

Cerca (Circe) Cerca appears on several mirrors, together with Uthste (Odysseus) and Velparun (Elpenor) at the transformation of men to swine.

Chalchas (Calchas) The name is that of the Greek seer Calchas. A mirror shows the Etruscan figure, winged, reading entrails, his foot on a rocky outcrop as is proper for seers and prophets.

Chaluchasu The word, from the Greek *panchalkos*, 'wholly of bronze', is written on a mirror (kept in London) next to a beardless, nude youth fighting with the Dioskouroi in the presence of Turan and Menrva. Some have identified him as Talos, a kind of bronze robot on Crete who killed his victims by embracing them tightly against his heated body.

Charun, Charu (Charon) The name, which appears at least ten times (de Simone) translates the Greek Charon, the boatman of the Underworld. In

Etruria, however, there is little evidence of his connection with a boat, except in the Tomb of the Blue Demons, discovered at Tarquinia in 1985, where he ferries the dead to the Underworld. The Etruscan figure, whose attribute is the hammer, often appears together with Vanth, ready to guide the dead to the Underworld.

Chelphun Name of a Silenus or satyr on a mirror; perhaps related to Greek *chalepos*, 'harsh', 'mischievous', 'dangerous'. Other satyrs named on mirrors are *Aulunthe*, *Hathna*, *Sime*, and *Puanea*.

Cluthumustha, Clutmsta, Clutumita (Klytemestra, Clytemnestra) Daughter of Leda in Greek mythology, sister of Helen, and wife of Agamemnon, whom she kills on his return from Troy. She is in turn killed by her son Orestes. Her name appears seven times on Etruscan monuments (de Simone); on mirrors she is shown vainly appealing to Urusthe, or in sacred conversations.

Crisitha (Chryseis) The name of Agamemnon's slave in the *Iliad*, Chryseis, appears three times on mirrors with loving couples, twice paired off with Achle. For the suffix *-tha*, cf. Etruscan female names such as *Ramtha*.

Cruisie (Kroisos?) The name of a youth wrestling with a young woman, Talitha, in a scene in a palestra. It probably refers to Croesus, the hugely wealthy king of Lydia. The girl's name has been connected with the Greek word *talis*, 'marriageable girl'.

Culsans The Etruscan Janus, keeper of the gate (*cul alp*, on the Piacenza Liver).

Culsu The female equivalent of Culsans. This demon, dressed like Vanth, appears by the door on the sarcophagus of Hasti Afunei, from Chiusi. The cult of Culsu is recorded in the epitaph of Laris Pulenas. She is a divinity of doors and gates.

Easun, Eiasun, Heasun, Heiasun (Jason) Leader of the Argonauts, husband of Medea. The hero appears on the exergue of a mirror, slaying a dragon (Source 39). On an unpublished mirror he is embracing Turan, in a pose like that of Atunis, her lover. His name appears half a dozen times, once on a gem.

Ecapa (Hecuba, *Ekaba) Wife of Priam, king of Troy. Her name appears on two mirrors.

Ectur, Echtur (Hector, *Ektor) Trojan hero, son of Priam and Hecuba. His name appears on four mirrors.

Elchsntre, Alcsentre, etc. (Paris Alexander) See *Alichsantre*.

Elina, Elinai, Elinei (Helen) Frequently shown at her toilette, with Elchsntre and with Turan, nursing the baby Ermania, or even between her two husbands, Menle and Elchsntre. The name of Helen appears twenty-three times in de Simone. On gems she is mentioned once.

Enie (Enye) One of the Graiai, daughters of Phorkys, guardians of the Gorgons, described in Hesiod, *Theogony* 270–73. She appears on a mirror with Menarva and her sister Pemphetru, in a scene in which Pherse (Perseus),

on his way to behead Metus (Medusa), takes the sisters' single eye in order to force them to give him the information he needs.

Epiur, Epeur (Epiouros) A plump, winged boy shown on a mirror from Vulci, in Paris, on which Hercle presents him to Tinia in the presence of Turan and Thalna. On three other mirrors (one is uninscribed) he is either held by Hercle or is in his presence. It has been suggested that he is the son of Hercle, and some have identified him as Tages.

Ermania (Hermione) Daughter of Menelaos and Helen. On a mirror in Villa Giulia in Rome she appears as a baby, nursing at the breast of her mother, who is being watched by Paris Alexander and the goddess Turan.

Eris (Eris) Appears on two mirrors, once together with Thetis in a scene with Hercle and Menrva, another time with Thamu (Thama, Thamyris), the Thracian singer who challenged the Muses and was blinded. In Greek mythology, she is the personification or goddess of strife.

Erus (Eros) Appears on two mirrors and as a proper name on a Hellenistic urn lid. In Greek mythology, the god of love, son of Aphrodite, later the Roman Cupid.

Esplace (Asklepios) The god of healing is shown on a mirror bandaging the wounds of Prumathe, who is being unbound in the presence of Hercle and Menrva. Note the inversion of *c–p*, *Esplace* instead of **Esclape*.

Ethausva A female divinity, probably referred to as *eth* on the liver from Piacenza. Ethausva appears on a mirror with the birth of Menrva from the head of Tinia (*ES* 5.6), and may be related to the goddess of childbirth, Ilithiia.

Etule (Aitolos) On a mirror the Trojan horse (called Pecse) is being made by Sethlans (Hephaestus) and Etule; a tablet on the right reads *huins*. The Greek Epeios built the Trojan horse with the help of Athena (*Odyssey* 8.493): the Etruscans apparently used his brother's name, Aitolos.

Eurphia A nymph or a Muse shown on a mirror dancing in front of the youth Phaun.

Euturpa, Euterpe (Euterpe) In Greek mythology, the name of one of the Muses. In Etruria, where she appears on four mirrors, she seems to represent a personification of love or pleasure, like one of the Greek Charites.

Evan Minor divinity in the circle of Turan and Atunis, who appears on two mirrors, once as a young woman, another time as a young man.

Evtucle, [Ev]thucle (Eteokles, Eteocles) Appears on a mirror in the British Museum, and in the François Tomb together with his (uninscribed) twin brother *Pulnice* (Polyneikes). (The fight to the death of the two accursed sons of Oidipus at the conclusion of the siege of the Seven Against Thebes is one of the favourite motifs of Hellenistic cinerary urns).

Fufluns (Dionysos, Bacchus) The Etruscan name for the god of wine appears on the Piacenza Liver as that of a god who is worshipped. He is also represented on a number of mirrors, either as a baby taken from the thigh

of his father Tina, embracing his mother Semla, or with his wife Areatha (Ariadne). On one mirror he appears with a handsome larger female named Vesuna, accompanied by Svutaf and Hercle. A curious scene is one showing his conception, with Tina embracing Semla, who lifts her skirt in a gesture of anasyrmata (there are no inscriptions, but Tina is recognizable from his lightning bolt, and a satyr identifies the scene as related to Fufluns). De Simone lists six occurrences of Fufluns Pacha (Bacchus).

Hamphiare, Amphare (Amphiaraos) One of many seers represented in Etruscan art and inscriptions (Source 44). The Greek Amphiaraos fought as one of the Seven against Thebes, plunged with his chariot into a chasm made by Zeus' thunderbolt, and thereafter gave oracles. He appears in the François Tomb, where he is paired off with Sisyphos. (He was shown in both Greek and Etruscan art as being betrayed by Eriphyle, his wife, for the sake of a jewel, and on the Etruscan pedimental sculpture group at the temple at Talamone as foreseeing the tragic end of the expedition and looking out into the chasm.)

Hathna Name of a satyr. Five are named on mirrors: the others are *Aulunthe, Chelphun, Sime,* and *Puanea.*

Heiasun (Jason) See *Easun.*

Hercle, Hercele, Herecele, Herkle, Hrcle (Herakles, Hercules) One of the principal Etruscan deities. His name appears on the Piacenza Liver (Source 60, fig. 51), and he was worshipped; there was a sanctuary at Cerveteri where many inscribed votive gifts were found. On mirrors he is shown in a number of scenes together with Uni which have no precedent in Greek art. One Praenestine mirror shows the reconciliation with Juno brought about by Jupiter, while several Italic monuments show him nursing at the breast of Uni in a relationship which contrasts with the Greek Hera's hostility towards him (though it agrees with the etymology of his name, Herakles, 'glory of Hera'). He appears as a hero on the mirror with Prometheus unbound, with the eagle he has shot down crumpled on the ground at his feet. De Simone lists seventy-two occurrences for the name. On gems, Hercle is by far the most popular hero represented, often with his name inscribed – once with his epithet, Calanice.

Hipece (Hippokrene) Water-spouting lion's head on a mirror with Hercle at a fountain.

Huins The name of a square construction appearing in a scene of Sethlans and Etule working on the (bronze) horse Pecse. The word has been interpreted as an error for **Hlins* = Hellenes. The object might be a basin, or perhaps an oven, furnace or kiln.

Ilithiia (Eileithyia) Related to the Greek goddess of childbirth. A bronze statuette is dedicated to Ilithiia the mother: *mi flereś atis ilithiial,* 'I am the statue of Mother Eileithyia'.

Kanna The word appears on the garment being brought to Metaia (Medea) on a seventh-century bucchero vase (Source 5). See Glossary.

Laran (Ares, Mars?) Etruscan god of war who appears on a number of mirrors, often fully armed and bearded, but sometimes as a nude youth with helmet, sword, or spear. He is usually a spectator; once he pursues Celsclan in what looks like part of a gigantomachy.

Lasa The stem *las-* is connected with Lases in the hymn of the Arval Brothers, and with Lar, Lares (*s* becoming *r* (intervocallically). One of a number of nymphs associated with the circle of Turan. The name is found on the Piacenza Liver, on at least a dozen engraved mirrors, and on a gold ring. Mirrors of the later Hellenistic period often show (uninscribed) naked young women with alabastra, usually called Lasas, for whom Wiman has coined the term 'pseudo-Lasa'. Probably a generic term, the name is often used with an epithet: *lasa achununa, lasa racuneta, lasa sitmica, lasa thimrae, lasa vecuvia.* Lasa is usually represented as a beautiful young woman, nude, holding a sash or an alabastron and perfume dipper, attending the embraces of divine couples. Lasa Sitmica, however, is a male winged figure. On a mirror where Lasa is shown dressed and winged, holding a scroll with the names Lasa, Hamphiare, and Aias (Source 44), she seems to be taking the place of Vanth. Lasa Vecuvia is probably to be connected with the nymph Vegoia, whose prophecy circulated at the time of the civil wars in Rome.

Latva (Leda, Doric *Lada) Appears in a scene of the presentation of the egg of Helen, with Tuntle (Tyndareus), her husband, and other members of the family.

Leinth Appears on two mirrors, once as a young woman, standing beside Mean as she crowns Hercle, and once as a youth holding a baby, Maris Halna, in a scene with Menrva and Turan. The name may be related to the verb *lein*, 'to die'.

Letham, Lethns, Letha, Lethms, Leta This important Etruscan divinity was named five times on the Piacenza Liver (Source 60, fig. 51), and referred to several times on the Capua Tile. On the only mirror on which the name appears, the image is so damaged that we cannot even tell whether the god was shown as male or female. The location of its regions on the liver implies that its character was chthonian or infernal rather than celestial.

Letun (Leto) The name appears on two mirrors. See *Apulu*.

Lucumo Does not appear on inscriptions, but Roman historical tradition attributes his name (originally an Etruscan title) to Lucius Tarquinius Priscus.

Lunc, Lnche (Lynkeus, Lynceus) Appears on a scarab; on a mirror in the Louvre he is shown together with Urphe (Orpheus) at the side of a well.

Macstrna (Magister) The name appears on the François Tomb (Source 54) in the scene showing the freeing of Caile Vipinas (Caelius Vibenna) of Vulci by Macstrna. Mastarna was the Etruscan name of Servius Tullius, according to the bronze inscription from Lyons recording a speech of the Roman emperor Claudius.

Malavisch The name may be related to *malstria*, *malena*, 'mirror'. On a number of mirrors she appears in toilette scenes being dressed by her attendants; she may represent Elinei as a bride being prepared for her wedding, an extremely appropriate scene for a mirror and a gift for a bride. Such a scene showing her holding a mirror also allows the mirror maker to advertise his own wares.

Mariś One of a group of divinities, whose name is often used in conjunction with other names or epithets – *mariś menitla*, *mariś turans*, *mariś halna*, *mariś husrnana*, *mariś isminthians*. It is not easy to define him as a single figure or character; he appears as a bearded man, as a youth, and even as a group of babies tended by Menrva. The name appears twice on the Piacenza Liver, once on the lead tablet from Magliano.

Mean, Meanpe A female figure who appears on nine mirrors, she is present at the birth of Fufluns from the thigh of Tinia, at the wedding of Turan and Atunis, and crowns Calanice or Elchsntre with a wreath, as the Etruscan equivalent of Nike or Victoria. Meanpe on one mirror with Perseus in flight may refer to the 'Victory of Perseus'.

Meliacr (Meleager) The son of Althaia. According to the Greek myth he organized the Calydonian boar hunt, in which Atalanta was the first to wound the boar and won the prize. He appears on three mirrors, returning from the hunt, or in sacred conversations, together with Atlenta as a loving couple.

Memnum, Memrum (Memnon) The figure appears twice on mirrors. On a mirror in New York he is saved from Achle by his mother, Thesan (Eos).

Menarva, Menrva (Athena, Minerva) The goddess's Latin name comes from the Etruscan. She is one of the principal Etruscan and Italic divinities, whose name appears on numerous monuments, though not on the Piacenza Liver. Though she is armed and dressed in the Greek manner, with a peplos with overfold, and though she protects heroes like Hercle and Perse, her character is different from that of the Greek goddess of war, strategy, and wisdom. In Italy, Menrva has multiple functions: she attends scenes of love, healing, and birth, she confronts a monster, and she is also a kourotrophos or baby-sitter, looking after the Maris babies.

Menle (Menelaos) The Trojan war hero Menle (Menelaos) appears on a number of mirrors, often with his wife Elinei, as one of a group of beautiful young figures paired off as loving couples. De Simone lists sixteen instances of the name.

Metaia, Metua, Metvia (Medea) She appears with Taitle (Daidalos) on a seventh-century bucchero vase, in a scene with youths bringing a long folded garment (*kanna*) as she confronts an unnamed figure in a cauldron (Source 5). She is named on three mirrors, once with Heasun, once with Urste, referring to her magical, curative powers.

Metus (Medusa) The most famous of the Gorgons was beheaded by Perseus;

her head becomes the Gorgoneion, worn by Menrva on her aegis. She appears on an Etruscan mirror (Source 40).

Mlacuch A young woman abducted by Herecele on a mirror; the story, otherwise unknown, seems to constitute a purely Etruscan version of one of the exploits of Hercle.

Munthuch, Munthch, Munthu The name is probably related to *munth*, equivalent to Latin *mundus*, Greek *kosmos*, 'adornment' and 'order'. She appears as an attendant in adornment scenes on mirrors, once crowning Hercle, and once dancing like a maenad with a satyr named Chalphun.

Nestur (Nestor) In the François Tomb, the aged, wise hero of the *Iliad* and *Odyssey* is paired off with Phuinis (Phoinix).

Nethuns (Poseidon, Neptune) Umbrian god of springs and water, Nethuns was an important divinity in Etruscan religion. His name appears twice on the Piacenza Liver, once in conjunction with Tinia, and frequently on the Zagreb mummy bandages. On one mirror, he appears with Ucil (Usil) the sun god, and Thesan (Aurora). He is a different divinity from the Greek Poseidon, though he takes on his attributes, appearing with the trident, for example, on the Volterra mirror with Uni nursing Hercle (uninscribed) (Source 36, fig. 33).

Pacha (Bacchus) Epithet of Fufluns (Dionysos).

Palmithe (Palamedes) The name of this Greek hero, who was said to have invented the alphabet, occurs on two gems (as Talmithe), and four mirrors (twice as Talmithe). See *Urphe*.

Pantasila, Pentasila (Penthesilea) The name of the Amazon queen appears on five mirrors and a red-figure crater from Vulci, where she is represented as a *hinthial* or ghost, together with the Amazon *Aturmuca* (Andromache: formerly read *Turmuca*).

Patrucle (Patrokles, Patroclus) In the François Tomb (and elsewhere, uninscribed, in Etruscan art), the ghost or *hinthial* of Patrucle was present at Achle's sacrifice of the Trojan prisoners at his grave, a scene only briefly mentioned in the *Iliad* and never depicted in Greek art.

Pava Tarchies On a mirror in Tuscania the name identifies a young man dressed as a *haruspex*, standing in a ritual pose with one leg raised on a rock, studying the liver he holds in his left hand. Avle Tarchunus, (son of?) Tarchon, watches him. Also present are Rathlth, Ucernei, and Veltune (Voltumna?). Pallottino suggested that Pava Tarchies might correspond to Tages, the chief prophet of the Etruscans.

Pecse, Pakste (Pegasus) The name of the mythological horse, Pecse, was used on an Etruscan mirror for the Trojan horse being made by Sethlans (Hephaistos) and Etule. Pakste and Hercle appear together on another mirror.

Pele (Peleus) A popular figure on mirrors and gems, often with his name inscribed, he is shown pursuing Thethis, or wrestling with Atlenta. His name occurs seventeen times (de Simone).

Pemphetru One of the Graiai, daughters of Phorkys, guardians of the Gorgons, described in Hesiod's *Theogony*. She appears on a mirror with her sister Enie, Pherse, and Menarva.

Perse, Pherse Pictured with Menarva on a mirror in New York wearing Hades' wolf-head cap of invisibility, ready to steal the eye of two Graiai. On other mirrors he carries out his mission, beheading Metus (Medusa), fleeing from Purkus, or admiring the reflection of Metus' severed head in a pool of water. Menrva usually stands by protectively. The name occurs on nine mirrors, two gems, and a vase.

Phaun, Faun, Phamu (Faun) The name is that of the Greek Phaon, to whom Aphrodite gave eternal youth and beauty. Shown on three mirrors, twice as an Apollo-like youth playing the lyre.

Phersipnai, Phersipnei (Persephone, Proserpina) Daughter of Demeter, known as Kore in Greek mythology. In Etruscan art she appears as the consort of Aita (Hades), ruler of the Underworld, in the Tomba Golini I in Orvieto, and in the Tomba dell'Orco II in Tarquinia. The couple also appear (uninscribed) on the sarcophagus of Torre San Severo (Orvieto). She is labelled Prosepnai on a mirror.

Phersu In the Tomb of Augurs in Tarquinia the name of Phersu appears twice. A similar figure is also found (uninscribed) in the slightly later tombs of the Olympiads and of the Pulcinella – the latter so named from the figure of Phersu – the tomba del Gallo, and other monuments. He wears a mask with a long black beard, a pointed hat, a short chiton or shirt and in some cases a perizoma, and is involved in funeral games, singing, and dancing. The Latin word *persona* in its original meaning of 'mask' in the context of the theatre derives from the Etruscan adjective **phersuna*, 'related to Phersu'.

Phulsphna (Polyxena) On a mirror from Cerveteri in the British Museum she appears in a scene of Elinei (uninscribed) fleeing from Menle armed with a sword. Like Elinei, she is nude, with only some drapery around her lower legs. As in Greek art, Elinei (Helen) embraces the statue of Atena (the Greek Palladion) labelled *Cvera*. Thethis, Turan, and Aivas witness the scene.

Phuinis (Phoinix) Appears in the François Tomb as a pendant to Nestur. In the *Iliad*, Phoinix was the friend of Achilles' father Peleus, who had accompanied Achilles to Troy.

Preale Male figure, otherwise unknown, who appears on a mirror as a spectator at the birth of Menrva.

Prisis (Briseis) This war prisoner and companion of Achilles in the *Iliad* appears on a mirror along with Crisitha (Chryseis).

Priumne (Priamos) There are four occurrences of the name of the king of Troy, husband of Ecapa, father of Ectur, Casntra, and Elchsntre; he appears with them in conversation scenes. In Greek art he is shown with his wife Hecuba, with Paris, or with Cassandra.

Prucnaś Male figure, otherwise unknown, who appears on a mirror in the Metropolitan Museum being embraced by Zipunu.

Prumathe Prometheus unbound appears three times on Etruscan mirrors, each time with a different iconography. On a mirror in the Metropolitan Museum he is being taken down from the rock and attended by Menrva, Hercle, and Esplace. On another he is freed in the presence of Apollo, god of archery, while a third shows him held up by two young heroes, Castur and Calanice (i.e. Hercle).

Puanea Name of a satyr. Five are named on mirrors: the others are Aulunthe, Chelphun, Hathna, and Sime.

[Pul]nice, Pulunice, Phulnice (Polyneikes, Polyneices) Son of Oidipus, who appears in the François Tomb in fratricidal combat with his twin brother Evthucle (Eteokles), on four or five mirrors and two gems. See *Evtucle.*

Pulthisph Youth present, together with Snenath, at the embrace of Turan and Atunis. The name may refer to Thespios, an epithet of Apollo.

Pultuce, Pulutuce, Pulutuke, Pultuke (Polydeukes, Pollux) Pultuce and Castur (Castor), twin brothers of Helen and Clytemnestra, and sons of Tinia (Zeus), were known as the Dioskouroi in Greek mythology. In Etruscan religion they are worshipped as *tinas cliniiaras*: de Simone lists sixteen occurrences of Pultuce. They often appear on Etruscan mirrors; in the later, Hellenistic period, Dioskouroi and Lasas are the most frequent representations. See *Castur.*

Rath The name appears next to an Apollo-like figure holding a laurel branch on the mirror from Tuscania with Pava Tarchies carrying out *haruspicina* or reading of the entrails; also featured are Veltune, Aule son of Tarchon, and Ucernei. The genitive and locative endings of the word (*Rath-lth*) have been explained by Colonna as referring to the divinity, probably Apollo himself, as 'of the one in the sanctuary of Rath', that is Tarquinia.

Rathmtr (Rhadamanthys?) On a mirror in Boston (*c*.300) the inscription is incised next to the face of a draped, mature, bearded man leaning on a gnarled staff. He holds up his right hand, gesturing to the half-draped female figure before him, who turns back to look at him. This may be Rhadamanthys (De Puma). Rhadamanthys in Greek myth was the son of Zeus and Europa who went to Elysium and became judge of the dead. He would be another one of the many seers and prophets depicted in Etruscan art.

Rescial, Recial, Reschualc A young woman, like a Lasa, who appears on several mirrors. The name may be related to *sval*, 'live' (compare *lein*, 'die' perhaps related to *Leinth*). On a mirror from Talamone with Metvia holding out a patera to Heasun, she holds a bird (an iynx) and raises her skirt in an apotropaic gesture of anasyrmata.

Satre (Saturnus) The name (genitive, *satres*) appears on the Piacenza Liver, and probably on the Zagreb mummy wrappings (*satrs*). The Latin Saturnus (Saeturnus) may derive from the name of this Etruscan god.

Selvans (Silvanus) The Etruscan name of the god, which perhaps comes from the Latin, appears twice on the Piacenza Liver, once next to that of Fufluns, near Letham. He was worshipped: many votive offerings, in particular bronze statuettes, bear inscriptions with dedications to Selvans. He is referred to with a variety of epithets: *canzate, enizpeta, sanchuneta*. Most interesting is the dedication to Selvansl Tularias, 'Selvans of the Boundaries' (Source 50), since the principal function of Selvans seems to be the protection of boundaries. He does not appear in scenes of Greek mythology.

Semla (Semele) Mother of Fufluns Pachie (Dionysos, Bacchus), who appears on three mirrors together with her son in a loving embrace, or with Fufluns and Areatha (Ariadne). See *Fufluns*.

Sethlans (Hephaistos, Vulcanus) In spite of his Etruscan name, the god corresponds closely to the character of the Greek and Roman god of fire, the forge, and of craftsmen in general: his attributes are the hammer, tongs, and axe, and the pileus or workman's cap. His name appears for the first time on a seal, now lost. On Etruscan mirrors Sethlans appears as the divine craftsman. On one he is about to split Tina's head open to facilitate the birth of Menrva; on another he is freeing Uni from the throne in which she is imprisoned, with an assistant named Tretu; on still another he is building the Trojan horse (here apparently made of bronze, and named Pecse, or Pegasos), with an assistant named Etule. He appears with his attributes on coins of Populonia, a city with a flourishing metallurgical industry.

Sime The name of a satyr, a rendering of the Greek *Simos*, 'snub-nosed'. He appears on a mirror with Menrva and Thalna, and on another with Fufluns, Areatha, and Semla. Other satyrs named on mirrors are Aulunthe, Chelphun, Hathna, and Puanea.

Sispe, Sisphe (Sisyphus) Appears in the François Tomb and in the Tomb of Orcus (Source 53, fig. 49). (He has also been recognized on the sarcophagus of Laris Pulenas as an uninscribed naked kneeling figure with his hand on the rock that is his attribute.)

Snenath A young woman in the circle of Turan. One mirror shows *snenath tur(a)ns*; perhaps *snenath* means 'maidservant or companion': compare *acila* = *ancilla*, 'handmaiden', on a Praenestine mirror.

Svutaf A naked, winged boy with long hair pulled back in a pony-tail, attending the couple Fufluns–Vesuna on a mirror. He touches Vesuna's chin, and has been interpreted as the Greek Eros or Pothos, 'yearning' (Latin *suadeo*?).

Tages According to Etruscan mythology known through Greek and Latin sources, Tages, a prophetic child (a *puer senex*, 'child old man') sprang up from a freshly ploughed furrow at Tarquinia and gave out rules of divination and religion; these were then recorded and became the basis of the *Etrusca disciplina*. Though his name does not occur in inscriptions, he has been variously identified with the figures of Pava Tarchies or of the child Epiur.

Taitle (Daidalos, Daedalus) Appears with Metaia (Medea) on a seventh-century bucchero vase (Source 5), on two scarabs, and with his son, Vicare (Icaros), on a gold bulla in Baltimore.

Talitha See *Cruisie*.

Talmithe (Talamedes, Palamedes) See *Palmithe*.

Tarchunies Rumach, Cneve (Cnaeus Tarquinius of Rome) Appears on the historical painting in the François Tomb, being threatened by Marce Camitlnas (Source 54, fig. 50).

Tarchunus (*Tarchun*) Aule Tarchunus ('son of Tarchun') appears on a mirror from Tuscania wearing the pointed hat of a haruspex as he watches Pava Tarchies (Tages?) examining a liver for omens. According to one version of the Tages legend, Tarchon was the one who recorded Tages' prophetic song. See *Pava Tarchies, Rath, Ucernei, Veltune*.

Techrs (Teukros, Teucer) The figure of a mature, bearded man leaning on a gnarled stick and holding his hand on Paris' shoulder is so labelled on a mirror. It is similar to that of Rathmtr (Rhadamanthys?). In Greek myth, Teukros was the ancestor of the Trojan kings.

Telmun, Tlamun, Talmun, Tlamu (Telamon) Greek hero, one of the Argonauts, who helped Heracles against Troy. Father of Aivas Telmunus (Telamonian Ajax). There are at least ten instances of the name of the mythological figure (de Simone). The Etruscan city of Talamon, whose coins bear the legend *Tla*, was said to have been named after him.

Teriasals, Teriasa, gen. (Teiresias) The famous blind seer of Greek tragedy and mythology, who had known what it meant to be both man and woman, appears in Etruscan art as a ghost, *hinthial Teriasals*. In the François Tomb he stands by the ghost of [Ach]memrun. On a mirror where he is again labelled as a *hinthial*, he is represented as blind, with frontal face and female dress and features.

Thalna, Thalana, Talna A (usually) female divine figure from the circle of Turan, who corresponds to the Roman goddess Iuventas or the Greek Hebe. A popular figure on Etruscan mirrors, she attends scenes of love-making or of childbirth, often with Zipna, or with Mean, Thanr, or Ethausva. The figure can also be male, or androgynous. Cristofani lists sixteen examples of the name and variants, and there are others.

Thanachvil, Thancvil (Tanaquil). A theophoric name, 'gift of Thana'. The name has come down in Roman historical tradition as that of the Etruscan wife of Tarquinius Priscus, the Elder Tarquin.

Thanr Like Thalna, an Etruscan divinity present at scenes of divine births and babies on mirrors.

Thesan (Eos) Morning, Dawn, Aurora. She appears on a mirror in New York, rescuing her son Memnun from death at the hands of Achle. Elsewhere, she is shown carrying off one of her lovers, Tithonos or Kephalos. Unlike Eos in

Greek religion, Thesan is worshipped in Etruscan religion: the name appears on the Zagreb mummy wrappings, and on a bronze tablet from Pyrgi.

These (Theseus) Represented seated in the Underworld in the Tomb of Orcus. According to Greek myth he was the hero of Athens, who saved his city by killing the Minotaur of Crete with the help of Ariadne. Having abandoned her, he married her sister, Phaidra. He kidnapped Helen in her youth, then tried to run away with Persephone, but was imprisoned in Hades until he was freed by Heracles. The name also appears on several scarabs: there are at least four examples (de Simone).

Thethis, Thetis (Thetis) Sea divinity, mother of Achilles. On Etruscan mirrors she is shown at her toilette, or pursued by Pele. She also often appears in groups of heroes and heroines from Greek mythology, in 'sacred conversations'. De Simone lists seventeen instances of the name.

Thevru Mineś (Minotaur) The name appears by an image of the monster, shown on a mirror with Mine (Minos) and Ariatha (Ariadne). The figure of a bull-headed man, perhaps a Minotaur, appears in early Etruscan art; on a fourth-century vase in Paris he is shown as a baby in the arms of his mother Pasiphae.

Tina, Tinia, Tin (Zeus, Jove, or Jupiter) God of daylight and chief of the gods, who hurls the thunderbolts. Tina's name appears five times on the Piacenza Liver. The god, who is identified with the Greek and Roman king of gods and men, was worshipped in Etruscan religion, and appears often in Etruscan art. He is represented according to the classical Greek iconography of Zeus: on a mirror in Paris Tina appears in the pose of Pheidias' cult statue, enthroned, a mature figure, bearded, in heroic semi-nudity. He also appears as a youthful, unbearded male on six mirrors on which he is labelled. His most consistent attribute is the thunderbolt, usually in the shape of a stylized flower. The most popular scene is the birth of Athena-Menrva, a story taken from the Greek repertoire, but told with Etruscan touches: he is usually assisted by midwives. On a mirror Thanr bandages his aching head; on another Mean applies unguent from an alabastron. *Tinas cliniiaras* are the sons of Tina, the 'Dioskouroi' Castur and Pultuce.

Tiphanati Turan ati, shown with Atunis on one mirror. See *Cel*.

Tretu See *Sethlans*.

Truials (Trojan) The Trojan prisoners being sacrificed at the grave of Patrucle by Achle in the François Tomb, or brought up with their legs cut and bleeding to prevent their running away, are labelled Truia-ls, 'from (of) Troy'. On the Tragliatella oinochoe, *Truia* appears in the shell-shaped 'labyrinth' behind the horsemen.

Truile (Troilos) The youngest son of Priam, a beautiful Trojan prince represented (but not labelled) in the Tomb of the Bulls, where the armed (uninscribed) Achilles waits in ambush. His name appears on a mirror, and on a gem showing him alone, with shield and spear.

Tuchulcha A bestial, terrifying demon of death, with vulture's beak, donkey's ears, and writhing snakes. This terrible demon appears standing by the seated These in the Underworld in the Tomba dell'Orco II in Tarquinia. His head, like Charun's, has a hooked nose, wild hair, and flesh the colour of rotting meat. His image inspired the demon in Michelangelo's Last Judgement.

Tuntle (Tyndareos) Husband of *Latva* (Leda), and (human) father of Elinei (Helen). He and Latva are part of the assembled family to whom Elinei is presented as the egg of Zeus, her divine father, who impregnated Leda in the form of a swan.

Turan (Aphrodite, Venus) One of the most important of Etruscan divinities, she appears on many Etruscan mirrors, with her lover, Atunis, with other divinities such as Heasun (Jason) or, as in the *Iliad*, urging Elinei to reconcile with Paris Alexander. Once she appears with Atunis as Turan ati, 'Mother Turan', Venus Genetrix. She is named in inscriptions including four gems, and was worshipped, as shown by votive offerings from the sanctuary at Gravisca and elsewhere.

Turms̄ (Hermes, Mercury) Like the Greek Hermes, Turms is a young god, with winged sandals, travelling hat, and herald's staff. He accompanies other gods and heroes, conducts the goddesses to the Judgement of Paris, or delivers the egg of Helen to her parents, Latva and Tuntle (Leda and Tyndareus). On the mirror from Vulci on which he conducts the shade of Teiresias (*hinthial terasia*s) to Uthuze (Odysseus) he is called *turms aitas*, Hermes of Hades, or Hermes Psychopompos.

Turmuca See *Aturmuca*.

Turnu A mirror from Orvieto shows Apulu with a seated Eros, called Turnu – the child of Turan – playing with an iynx, while at the right Turan and Atunis embrace. The iynx, a magic love-bird, also appears with Mean, Rescial, and Thalna, and on Attic and South Italian red-figure vases.

Tusna (from Turnsna, *Turansna, 'of Turan'?) The name of the swan of Turan on a mirror with the embrace of Turan and a boyish Atunis.

Tute (Tydeus) The name occurs seven times, mostly on scarabs and on a mirror (de Simone). The hero, one of the Seven against Thebes, fought against his enemy Melanippos, asked for his head, and ate his brains. (The myth of the Seven was popular in Etruscan art: the fifth-century terracotta architectural relief from Pyrgi shows Tydeus eating the head of Melanippos, in the presence of a horrified Minerva who takes away the promised elixir of immortality).

Ucernei Female figure watching Pava Tarchies consulting a liver on a mirror from Tuscania; perhaps not a mythological name but that of the owner of the mirror, at whose wedding the omens are read.

Umaele Male figure tending the head of Urphe on a mirror; on another mirror, he appears to be reading a liver. The interpretation of his name, and his

identity, are controversial. Maggiani sees him as Apollo, with bow and quiver, and reads his name as an attribute of Apollo (*o Maloes umaele*). A relationship with the Greek *homilaos* 'discussant' might refer to Umaele's role as 'interpreter' of Urphe's prophecy.

Uni (Hera, Juno) The Roman queen of the gods, Iuno, is 'the goddess of youth' (*iuvenis*). Her name is related to that of the Etruscan Uni, with the *-i* ending of the feminine form. This goddess is much more important in Etruscan art and religion than her counterparts in the Greek and Roman pantheon. She appears in scenes of the Judgement of Paris, some of which are combined with the Toilette of the Bride. Her attributes often include a throne, and she wears a diadem and other jewellery. She appears in several scenes with Hercle, whom she nurses at her breast, or with whom she is being reconciled. On one mirror she is rescued by Sethlans and Tretu. On the Pyrgi tablet she is identified with Astarte.

Urphe (Orpheus) In Greek myth, he is one of the Argonauts, a famous singer, said to be the founder of Orphic religion. After his unsuccessful descent into the Underworld to bring back his wife Eurydice he was killed and dismembered by the women of Thrace; his severed head floated, still singing, to Lesbos. The Etruscans must have understood the myth of Orpheus' descent to the Underworld and the prophecies he sang, which were said to have been written down, within their own local tradition. They represented the consultation of the oracle of Urphe: on one of several mirrors his head appears on the ground surrounded by attentive listeners, including Umaele. On three mirrors, a seated figure (Talmithe, or Aluinea) holds a diptych on which he will record the prophecy: he brings his right hand with the stylus to his mouth in wonder and admiration. Urphe appears on gems as well as mirrors.

Urusthe, Urste (Orestes) In Greek mythology, the son of Agamemnon and Clytemnestra; he avenged his father's death by returning home and killing his mother, following Apollo's orders. In Etruscan art he is shown threatening Cluthumustha, who in at least one case uncovers her breast to ask for mercy. On another mirror he is purified by the sacrifice of a piglet at the sanctuary (*omphalos*) of Aplu, in the presence of Vanth and Metua (Medea) as Acherum, a Fury, stands by. The name appears at least six times (four of them on mirrors, de Simone).

Usil (Helios, Sol) God of the sun. His name, which appears on the lower surface of the Piacenza Liver, next to Tivs (Tiur), the moon, may be connected to the Sabine name of the sun, *ausel* (cf. also Latin *Aurelius?*). On two mirrors he appears with a halo, once with Nethuns, god of the sea and Thesan goddess of the dawn, another time with Uprium (Hyperion).

Utusthe, Uthste, Uthuze, Utuze, etc. (Odysseus, Ulysses) As in Greek art, scenes from the *Odyssey* were popular in Etruscan art from earliest times. The encounter with Cerca (Circe) is represented on several mirrors. Another

mirror shows him paired off with Ziumithe looking on at a scene of a man in a well. The Greek hero also appears on mirrors in 'sacred conversations' depicting heroes of the Trojan War. His attribute is the pointed pilos which identifies him as a traveller. De Simone lists sixteen occurrences of Uthste and related names; seven of these are on gems, on which the figure is popular.

Vanth A female demon of death, who accompanies the deceased to the Underworld, Vanth appears in several guises and a number of different costumes, nude and semi-nude. She often appears together with Charu[n], for example in the François Tomb, where her rainbow-coloured wings are outspread behind Achle and Patrucle. On sarcophagi, urns, and wall paintings, she is added to scenes of Greek mythology, often dressed like Artemis the huntress, or a Fury on South Italian vases, with short chiton, high boots, cross straps on naked breasts. On a vase painting from Orvieto she is dancing, naked, and looks like a Maenad, but holds a scroll on which her name, Vanth, is recorded. She is present at, but not involved in, death, and is sometimes given the role of a Greek Fury.

Vea Etruscan goddess who was worshipped, as shown by votive inscriptions from Gravisca, Volsinii (Orvieto, Santuario della Cannicella), and elsewhere. The name may perhaps be connected with the city of Veii. At Gravisca the cult is related to that of Demeter.

Vecu, Vecui, Vecuvia Name of a nymph, used as an epithet of Lasa on a mirror, probably related to that of the nymph Vegoia, whose prophecy concerning boundaries and slave revolts circulated in Roman times.

Veiove The name, which appears only on the Zagreb mummy wrappings, has been connected to the Veiovis of Roman religion, a chthonian divinity, as well as to Vetis (written in the genitive, Vetisl) on the marginal region of the Piacenza Liver.

Velparun (Elpenor) Appears on three mirrors as a ghost or *hinthial*, watching Uthste's encounter with Cerca in the *Odyssey*.

Veltune (Vertumnus, Voltumnus) Appears as an interested spectator, wearing boots, mantle, and bulla, and holding a spear, in the scene of Pava Tarchies and haruspicina.

Vesuna Appears on a mirror from the vicinity of Orvieto as a tall, majestic companion of Fufluns. The couple may represent Liber and Libera. The scene is flanked by a seated, youthful Hercle (Hrcle), and a winged boy labelled Svutaf. There may be an Umbrian influence present: an Italic goddess, Vesuna, is mentioned in the Tabulae Iguvinae, the bronze tablets from Gubbio (third or second centuries BC).

Vile, Vilae (Iolaos) The nephew and companion of Hercle on some of his exploits sometimes appears on the mirrors, either in the company of his uncle or alone, with Hercle's attributes. De Simone lists ten occurrences of the name.

Vipinas, Avle and *Caile* These two brothers, known from Latin sources as

Aulus and Caelius Vibenna and connected with Mastarna (Servius Tullius), seem to have been real historical characters. Evidently regarded as national heroes in Etruscan legend, they were represented in the François Tomb at Vulci and with Cacu on an engraved mirror. Their names also appear in a dedication (Sources 13, 45, fig. 42).

Zinthrepus See *Ziumuthe*.

Zipna, Zipanu, Zipa, Zipna, Zipnu, Zipunu, Sipna Etruscan minor female divinity connected with the circle of Turan. She appears on several mirrors, often with Thalna. On scenes of adornment she is usually the hairdresser. On a mirror with Turan, Atunis, and Tusna she is winged.

Ziumuthe, Zimuthe, Ziumithe, Zimite (Diomedes) In Homer's *Iliad* he appears as one of the major heroes of the Trojan War, a son of Tydeus, a companion of Odysseus. With the help of Athena he even fights against the gods Aphrodite and Ares. On Etruscan mirrors he often appears together with Odysseus. He is shown as an armed warrior, together with a graceful winged goddess named Zinthrepus, a deer, and another warrior, *Erus* (Greek *heros?*), whom she embraces with her right arm, as her wings spread out behind the two warriors. De Simone lists ten occurrences of the name on mirrors.

SELECT BIBLIOGRAPHY FOR DIVINITIES AND MYTHOLOGICAL FIGURES

Ambrosini, L. 'Sethlans con la ruota di Issione', *StEtr* 61 (1996) 181–203.

Bonfante, G. 'I nomi degli dèi romani ed etruschi', *RendLinc* 44 (1989) 3–5.

Bonfante, G. 'The Origin of Cannibalism in Dante', *EtrStud* 5 (1998) 3–6.

Bonfante, L. 'An Etruscan Mirror with "Spiky Garland" in the Getty Museum', *Getty Museum Journal* 8 (1980) 147–154.

Bonfante, L. 'Fufluns Pacha: The Etruscan Dionysos', in *Masks of Dionysos*, T. Carpenter, C. Faraone, eds. Oxford, 1993, 221–235.

Bonfante, L. 'The Judgment of Paris, the Toilette of Malavisch, and a Mirror in the Indiana University Art Museum', *StEtr* 45 (1977) 149–168.

Bonfante, L. *CSE USA 3*, New York, The Metropolitan Museum of Art. Rome, 1997.

Bonfante, L. 'Caligula the Etruscophile', *Liverpool Classical Monthly* 15 (1991) 50–53.

Buitron, D., and B. Cohen. *The Odyssey and Ancient Art*. Annandale-on-Hudson, NY, 1992.

Buranelli, F., ed. *La tomba François di Vulci*. Rome, 1987.

Buranelli, F. *The Etruscans. Legacy of a Lost Civilization from the Vatican Museums*. Memphis, TN, 1992.

Cataldi Dini, M. 'La tomba dei demoni azzurri', in M. A. Rizzo, ed., *Pittura etrusca al Museo di Villa Giulia* (Rome, 1989) 151–153.

Chiadini, G. 'Selvans', *StEtr* 61 (1995) [1996] 160–180.

Colonna G. 'Pyrgi', *StEtr* 56 (1991) 324, on the presence of Catha at Pyrgi.

Colonna, G. 'Culti del santuario di Portonaccio', *ScAnt* 1 (1987) 419–446.

Colonna, G. 'Il *dokanon*, il culto dei Dioscuri e gli aspetti ellenizzanti della religione dei morti nell'Etruria tardo-arcaica', in *Studi in onore di S. Stucchi*. Rome, 1996, 165–184.

Colonna, G. 'La dea etrusca Cel e i santuari del Trasimeno', *RivStorAnt* 6–7 (1976–77) 45–62.

Colonna, G. 'A proposito degli dèi del fegato di Piacenza', *StEtr* 59 (1994) 123–139.

Cristofani, M. 'Faone, la testa di Orfeo e l'immaginario femminile', *Prospettiva* 42 (1986) 2–12.

Cristofani, M. 'Il cosiddetto specchio di Tarchon: un recupero e una nuova lettura', *Prospettiva* 41 (1985) 4–20.

Cristofani, M. 'Le divinità', in *I bronzi degli Etruschi*. Novara, 1985, 277–287.

Cristofani, M. 'Sul processo di antropomorfizzazione nel panteon etrusco', in *Miscellanea etrusco-italica* I (1992) 9–21.

Cristofani, M., and M. Martelli. 'Fufluns Pachies. Sugli aspetti del culto di Bacco in Etruria', *StEtr* 46 (1978) 119–133.

De Puma, R. D. 'Greek Gods and Heroes', in N. T. de Grummond, *Guide* 89–100.

De Puma, R. D. 'The Greek Rhadamanthys?' *EtrStud* 5 (1998) 37–52.

de Grummond, N. T. *A Guide to Etruscan Mirrors*. Tallahassee, FL, 1982.

de Grummond, N. T., ed. *The Religion of the Etruscans*. Forthcoming.

de Grummond, N. T. 'Mirrors and Manteia: Themes of Prophecy on Etruscan and Praenestine Mirrors', *Aspetti e problemi della produzione degli specchi figurati etruschi*, A. Rallo, ed., Rome, 2000, 17–43.

de Simone, C. *Entlehnungen. Die griechischen Entlehnungen im Etruskischen* I–II. Wiesbaden, 1968–70.

Feruglio, A. E. 'Uno specchio della necropoli di Castel Viscardo, presso Orvieto, con Apollo, Turan e Atunis', *Scritti Pallottino*. Rome, 1997, 299–314.

Gantz, T. *Early Greek Myth*. Baltimore, MD, 1993, 1996.

Gaultier, F., and D. Briquel, eds. *Les Etrusques, les plus religieux des hommes*. Paris, 1997.

Gerhard, E., A. Klugmann, and G. Körte. *Etruskische Spiegel*. 5 vols. Berlin, 1840–1897.

Gran-Aymerich, J. 'Images et mythes sur les vases noirs d'Etrurie', in Massa-Pairault, ed., *Le mythe grec*. Rome, 1999.

Harari, M. 'Ipotesi sulle regole del montaggio narrativo nella pittura vascolare etrusca', in *Modi e funzioni del racconto mitico nella ceramica greca italiota ed etrusca dal VI al IV secolo a.C.* Salerno, 1995, 103–115.

Jannot, J.-R. 'Phersu, Phersuna, Persona. A propos du masque étrusque', in Thuillier, ed., *Spectacles sportifs et scéniques dans le monde étrusco-italique*. Collection de l'Ecole Française de Rome 172. Rome, 1993, 281–320.

Jannot, J.-R. 'Caru(n), Tuchulcha et les autres', *RömMitt* (1993) 59–82.

Jannot, J.-R. *Devins, Dieux et démons. Regards sur la religion de l'Etrurie antique*. Paris, 1998.

Krauskopf, I. *Heroen, Götter und Dämonen auf etruskischen Skarabäen*. Mannheim, 1995.

Krauskopf, I. *Der Thebanischen Sagenkreis und andere griechische Sagen*. Mainz, 1974.

Krauskopf, I. *Todesdämonen und Tötengötter im vorhellenistischen Etrurien*. Florence, 1987.

Krauskopf, I. various figures, in *LIMC*.

Malkin, I. *The Returns of Odysseus. Colonization and Ethnicity*. Berkeley, L. A., London, 1998.

Maggiani, A. 'Catha/Cautha', *RivStorAnt* 26 (1996) 249–279.

Maggiani, A. 'La divination oraculaire en Etrurie', *Caesarodunum*. Suppl. 56 (1986) 6–48.

Martelli, M., ed. *La ceramica degli Etruschi. La pittura vascolare*. Novara, 1987.

Martelli, M. 'Calanice', *StEtr* 54 (1986) 165–170.

Martelli, M. 'Sul nome etrusco di Alexandros', *StEtr* 60 (1994) 165–178.

Martino, P. *Il nome etrusco di Atlante*. Rome, 1987.

Massa-Pairault, F.-H., ed. *Le mythe grec dans l'Italie antique. Fonction et image*. Collection de l'Ecole Française de Rome 253. Rome, 1999.

Mastrocinque, A. 'Ricerche sulle religioni italiche', *StEtr* 61 (1996) 139ff.

Menichetti, M. *Archeologia del potere*. Milan, 1994.

Neils, J. 'The Euthymides Krater from Morgantina', *AJA* 99 (1995) 427–444.

Nicholls, R. V. *CSE* Great Britain, 2, Cambridge, 1993.

Pandolfini Angeletti, 'Proposta per il *Thesaurus Linguae Etruscae*. Volume II, Dizionario', *Scritti Pallottino*. Rome, 1997, 465–478.

Pasquali, G. 'Acheruns', *StEtr* 1 (1927) 291–301.

Pfiffig, A. *Religio etrusca*. Graz, 1975.

Rallo, A. *Lasa. Iconografia e esegesi*. Florence, 1974.

Rebuffat, D. *CSE* France 1.3. Musée du Louvre, 1997.

Richardson, E. H. 'The Gods Arrive', *Archaeological News* 5 (1976) 125–133.

Richardson, E. H. 'The Story of Ariadne in Italy', *Studies von Blanckenhagen*. Locust Valley, N.J., 1979, 189–195.

Roncalli, F. 'Laris Pulena and Sisyphus: Mortals, Heroes and Demons in the Etruscan Underworld', *EtrStud* 3 (1996) 45–64.

Simon, E. 'Il dio Marte nell'arte dell'Italia centrale', *StEtr* 46 (1978) 135–148.

Simon, E. 'Culsu, Culsans, Janus', *Atti Firenze 1985* (1989) 1271–1281.

Simon, E. *Die Götter der Römer*. Munich, 1990.

Simon, E. 'The Etruscan Pantheon', in de Grummond, ed., *The Religion of the Etruscans*. Forthcoming.

Small, J. P. *Cacu and Marsyas in Etrusco-Roman Legend*. Princeton, 1988.

Sowder, C. 'Etruscan Mythological figures', in de Grummond, *Guide*, 100–128.

Swaddling, J. *CSE* Great Britain, The British Museum. London, 2001.

ThLE.

Tirelli, M. 'La rappresentazione del sole nell'arte etrusca', *StEtr* 49 (1981) 41–50.

Torelli, M. ' "Etruria principes disciplinam doceto." Il mito normativo dello specchio di Tuscania.' *Studia Tarquiniensia*. Archeologia Perusina 9. Rome, 1988, 109–118.

Van der Meer, L. B. *Bronze Liver of Piacenza*. Amsterdam, 1987.

Van der Meer, L. B. *Interpretatio Etrusca. Greek Myths on Etruscan Mirrors*. Amsterdam, 1995.

Wood, R. E. 'The Myth of Tages', *Latomus* 39 (1980) 325 ff.

Zadoks-Josephus Jitta, A. N. 'Athena and Minerva: two identifications', *BABesch* 59 (1984) 69–72.

Zazoff, R. *Etruskische Skarabäen*. Mainz, 1968.

GLOSSARY

*Words preceded by an asterisk are forms not directly attested, but reconstructed from forms given by Greek and Roman authors. The order is that of the English alphabet. For further information see vocabulary lists in Pallottino, *Etruscans*; Pfiffig, Cristofani and *TLE* I. *Indice Lessicale*. Note that s and ś are often interchangeable, e.g. *sacnisa*, *sacniśa*. Only a few proper names are listed.

A

ac- (acnanasa) make, offer

acale (aclus) June

acazrce, acasce made

acil work, thing made

ais, eis god (aisar, eisar = gods)

aisine sacrifice (Umbrian *esono*)

aisiu, aisna, eisna divine, of the gods

al- give, offer (alpan)

alpan, alpnu gift, offering; gladly (Latin *libens*, Greek *chaire*)

alphaze offering

alumnathe loc., place [of congregation?]

alumnathuras group of *alumna* disciples (of Bacchus and Catha?): *thur*, coll.

am- to be

ampiles May

an (ana, ane, anc, ancn, ananc) he, she, this, that, rel. pronoun

apa father

apana related to the father, paternal

aper funerary sacrifice? (Latin *parentare*)

aprinthvale priest? (apa?)

ar-, er- to make, move

*arac falcon

*arim monkey

Arnth proper name (masc.)

ars- push away?

aska name of vase (Greek *askos*)

ateri parents, ancestors

aterś, aturs, atrs, atrus descendant, ancestor (ati)

athre building (Latin *atrium*?)

athumi nobility?

ati mother; ativu = dear mother

ati nacna grandmother

avil year

Avile, Avle, Aule Aulus

C

-c and (enclitic) (Latin -*que*)

ca, ta, cen, cn, eca, ek, tn; itun (emphatic) this (cehen, etc.)

Cae, Cai Caius, Gaius

calthi, celthi, clthi here, in this place (locative)

camthi name of magistracy

cana, kana, kanna gift (*agalma*), or image, work of art? (gloss: Hesychius II.1541, *chana*: *kosmesis* 'adornment')

canth-, canthce to be, can? acted as a camth(i)

cape, capi vase, container

capra urn, container

*capre April

*capu falcon (Greek *kapys*)

car-, cer- make, build

cecha ceremony (right, law): zilch cechaneri = title (*zilch iure dicundo*) (or: Latin *supra*, 'older', 'above')

cechase name of magistracy

cehen this one here

ceithurna ?

cel earth, land; celtinei, region

cela room (Latin *cella*)

celi September

celti, cel(tinei) on the land, locative (cel)

celu priestly title

cen- make, place; cenu, pass. with ablative of agent (Agostiniani)

cerichunce, cerchunce made (see car-, cer-)

cerine sacred place, building?

ces- to place, be placed, lie

cezp eight?

cezpalch eighty?

cezpz eight times?

ci three

cialch-, cealch- thirty

cilth people, nation

ciz three times

clan, clenar (plural) son

clanti, clanthi adoptive(?) son

clautiethurasi family of the Claudii

cletram basin, basket, cart for offerings (Umbrian *kletra*)

cleva offering

Clevsin- Chiusi

Cneve Cnaeus

crapsti name or epithet of divinity (Umbrian *Grabovius?*)

creal magistracy?

creice Greek

culichna, chulichna vase, 'little kylix' (Greek *kylix*)

culscva doors, gates

cupe cup (Greek *kúpe*?; Latin *cupa*)

cver gift, offering (Colonna = *alpan*)

cvil gift, offering; Thana-cvil, 'gift of Thana'

Ch

chim, chia pronoun

*Chosfer October (gloss)

chulichna see culichna

E

eca see ca

ei not

eleiva oil

eleivana of oil: aska eleivana (Greek *elaion*)

eliun of oil?

-em minus

enac, enach then, afterwards

enaś genitive of an/in

enesci ?

epl, pi, pul in, to, up to, until

eprus ? (noun)

ermius August

esis ?

eslz twice

espial ?

etera, eteri foreigner; client (*peregrinus, metoikos*)

eth, et thus, in this way (adverb)

etnam and, also, again, thus

F

*falatu (gloss, *falado*) sky

fan- to consecrate?

fanu verb, passive, with ablative of agent (Agostiniani)

farthan, farthn- generate

faśe, faśei bread? (Umbrian *farsiu*?)

favi grave, temple vault (Latin *fauissa*?)

fler offering, sacrifice

fler-, flerthrce to offer, sacrifice, satisfy

flerchva ceremony, sacrifice

flere divinity, god

fleres statue

fratuce ?

frontac interpreter of lightning; see **trutnuth** (Greek *bronte*?)

Fufluna, Pupluna Populonia (Latin *populus*? cf. Fufluns, 'city of Dionysos')

*fulum ? fulumchva = full of, provided with fulum

H

hanipaluscle for (or against?) Hannibal

hare ?

hath to be favourable (hathrthi = be favourable)

hec-, hech- put, place, add

hel, hels own, proper

heramaśva, herme, herma, hermeri, hermaier statue? (Greek *Hermes, herm*?)

Hercle Herakles, Hercules

*hermi- (gloss, Ermius) August

hermu Hermes?

hinth, hinthi, hinthia below

hinthial soul, ghost, of the Underworld (genitive of hinthi)

hiuls owl

hus-, husiur, husur (plural) children (Latin *liberi*)

husrnana epithet of Maris, 'The Youthful, Young'

huth six (four?)

huthz six times (four?)

huzrnatre, *husurnatra college of youths (Latin *iuuentus*)

I

ic, ich, ichnac as

ica this

ilu- verb of offering or prayer

in, inc, ininc it

ipa relative pronoun, which, where

ipe ipa whoever, whatever

*ister actor (gloss: Latin *histrio*)

ita this

*itu- (gloss: *itus* or *ituare*) to divide?

K

kana, kanna gift (see **cana**)

L

laive left

Larce proper name (masc.)

L(a)ris, Larth Lars, proper name (masc.)

larnas vase (Greek *larnax*)

Larthi, Larthia proper name (feminine)

lauch-, luc- to rule, be in charge

lauchum(e) king (Latin *lucumo*)

lauchumna 'belonging to a lucumo', of a palace

lautni 'of the family', freedman

lautnitha, lautnita freedwoman
lautun, lautn family, *gens*
*lechtum name of vase (Greek *lekythos*)
lechtumuza little lekythos (diminutive)
lein- to die?
Lepr(i)na epithet of Culsu
leu lion
luc- see lauch-
lucair to act as lauchum, lucumo, to rule; lucairce (to be *rex sacrorum*)
lup-, lupu to die
luth stone? temple?

M

-m, -um and
mach five
macstrev name of magistracy; macstrna, proper name (Latin *magister?*)
mal- to look, watch, guard, oversee
malena, malana, malstria mirror
Mamarce, Mamerce Mamercus (cf. Oscan Māmers, 'Mars')
man, mani the dead (Latin *Manes*)
manin- to offer to the Manes?
Marce Marcus
maru, marunu name of magistracy (Latin *maro?*; Umbrian *maron-*)
masan, masn name of month: December
mata vases
matam, matan above, before
math honey, honeyed wine (from IE language: Greek *methu*, English *mead*)
mech people, league, district
melicraticce honey and wine
men- make, offer (menache)
methlum district, people, nation, territory

methlumth, methlumt methlum, locative
mi, mini I, me
mlach, mlac beautiful
mlamna ?
mlesie ?
mlusna one who sacrifices, dedicates
mnathuras ?
mul-, to offer, dedicate as an ex-voto
mun-, muni underground place, tomb
mur- stay, reside (murce)
murs urn, sarcophagus
mutana, mutna sarcophagus
*mutuka thyme

N

nac how, as, because, since
namphe right
naper surface measure
nefts, nefs, nefis nephew, grandson (Latin *nepos*)
nene nurse, wet-nurse
neri water
nesna belonging to the dead?
nethsrac haruspicina
netsvis haruspex
nun-, nunth bring, involve
nuna offering?
nurph- nine?
nurphzi nine times?
nuth- ?
nuthanatur group who does nuth

P

pachathur Bacchante, maenad (Pacha)
pachie-, pachana Bacchic (Pacha)
pacusnasie Bacchic, Dionysiac (Pacha)
panalos ?

papa grandfather

papals, papacs of the grandfather: grandson

parnich magistracy or priesthood

Partuna proper name

patna name of vase (Greek *patane*, Latin *patina*?)

pava boy, youth

penthuna, penthna cippus, stone?

Perse Perseus

pes land? (pes spante)

pi for (enclitic); pen, pul, epl, prepositions

prinisera ?

pruch, pruchum jug (Greek *prochous*)

prumathś, prumts great-grandson

psl ?

puia wife

pul see **pi**

Pule, Pules proper name (masculine)

Pulena proper name

pulumchva stars?

Pupluna see **Fufluna**

purth, purthne, purtśvana name of magistrate or magistracy: dictator?

put-, puth- vase, pot, vessel, well? (Greek *potos*, Latin *puteus*, *puteal*?), diminutive putnza, putlimza

Ph

Phersu mask, masked person, actor (Latin *persona*)

Q

qutun, qutum name of vase (Greek *kothon*)

R

rach- prepare

Ramutha, Ramtha proper name (feminine)

ranvis ? (ranu = vase: Devoto)

rasna people; Etruscan, of Etruria (*Rasenna*)

ratum, ratm according to law, ritual (*rite*?)

Ravnthu proper name (feminine)

repinthi bend, incline?

restm, *rastum land (cultivated?)

ril at the age of ... (years) (Latin *natus*)

rumach Roman

ruthcva? ?

ruva brother

S/Ś

śa four (six?)

sac- carrying out a sacred act

sacni holy, consecrated, sacnicla (sacnicleri, accusative plural) = sanctuary

sacnisa consecrates?

sal- make, carry out: salt, salth

san- deceased?

sanisva bones?

śar ten

sarsnach tenth

sarsnau group of ten (decuria)

sath-, śat- put, establish, be put?

satu vase?

sc-, scu-, scune give, place, offer; or leave, dismiss

śealch forty

sec, sech daughter

sel- ?

semph seven?

semphalch seventy?

Sethra proper name (feminine)

Sethre proper name (masculine)

slica- ?

slichaches ?

snenath maid, companion, *ancilla* (feminine)

span-, spanti- dish; plain, fields

sparza ? (diminutive)

spur- city

spurana, spureni in the territory of (having to do with) the city

Spuria Spuria, proper name (feminine)

Spurie Spurius, proper name (masculine)

sran surface measure, two naper

sren ornament, figure, image

srencve decorated with figures?

sul liquid used in sacrifices (Pfiffig)

suntheruza little container?

*suplu flutist (Latin *subulo*)

śuth-, sut- to stay, place?

śuthi seat, tomb

śuthina having to do with the grave, sepulchral gift

suthiu is placed

suthiusve property?

suthivenas ?

sval- alive; to live

sve likewise

sveleri living creature?

T

ta, tal, tl, tei this

talitha girl

tamera name of magistracy

tarchianes ?

Tarchnalthi at Tarquinia (locative)

Tarchun Tarchon

Tarsminaś Trasimene (lake)

te- (tece) to place, put

teltei ?

ten-, tn-, -ta to act as magistrate

tenatha ?

tenthur ?

teras prodigy? (Greek *teras*?)

tes-, tesam- to care for

tesinth caretaker

teta grandmother

tev-, tv-, tva to show, see?

tevarath on-looker, judge at the games, umpire (tev)

tin- day: Tina, Tin, Tinia = Jupiter, Zeus, god of daylight

tiss lake

Tite Titus

tiu, tivr, tiur moon, month (tius, genitive?)

tleche ?

tmia place, sacred building, temple?

-tnam see etnam

*traneus month, July

traula ?

trin- to plead, supplicate

*triumpe triumph (Greek *thriambos*)

Truia Troy?

Truials Trojan

truth, trut libation, sacred action

trutnuth, trutnvt priest (*fulguriator*)

tul stone

tular, tularu boundaries (plural of *tul*)

tunur one at a time

tur- to give

tura incense

turza offering

tuś funerary niche

tusurthir married couples ('in the double urn'?)

tuthi, tuti- community, state (Umbrian *tota*?)

tuthin, tuthina- of the state, public

tva see tev

Th

tham-, them- to build, found (thamuce, themiase)

Thanachvil, Thancvil Tanaquil (Thana + cvil, 'gift of Thana')

thapna, thafna vase (for offerings?)

thar there

thaurch funerary

thaure, thaura tomb

Thefarie Tiberius

thesan morning, dawn

thevru bull (Latin *taurus*)

thez- to make an offering

thi pronoun, -*thi*, locative, suffix of offering, e.g. Unialthi

thina vase, crater (Latin *tina*, Greek *dinos*)

thra milk? (or thras = drank?)

thu one

thucte name of month (August?)

thui here, now

thuni at first

thunina the first

thunur one at a time

thunśna first

thunz once

-thur belonging to the group (suffix)

thutuithi in the middle of the people, (for) the state

U

ulpaia vase for wine (Greek *olpe*)

un, une (dative), **unu** (plural) you

urthan, urthanike to make, cause to be

us-, useti scoop, ladle, draw (water)

usil sun (Sabine *ausel*)

uslane at noon (usil)

ut- (utuse) carry out, perform, give

V

vacal, vacil, vacl libation?

val look, see

Varchti locative of Varch (vacal); varchti cerine = sacred place

Vel proper name (masculine)

Velathri Volterra

***velcitna (Velcitanus)** March

Velthur proper name (masculine)

Velzna- Volsinii

vere ?

vers- fire (or ladle?)

vertun vase

Vipiiennas Vibenna

vina vineyard

vinum, vinm wine (Latin *uinum*)

Z

zacinat ?

zal, zel-, esal- two

zamathi, zamth gold?

zar (śa) four

zathrum twenty

zavena vase

zelur two by two, two at a time (Latin *bini*)

zeri rite, legal action?

zic-, zich- to write, incise

zic, zich book, writing, document, inscription

zichu writer, scribe

zil- to rule, to hold office

zilach, zilath, zilc a magistrate (Latin *praetor*)

zinace made; zinaku = was made

ziva the dead, deceased

zuc- ?

SELECT BIBLIOGRAPHY FOR GLOSSARY

Agostiniani, L. '*Duenom duenas: kalos kala: mlach mlakas*', StEtr 49 (1981) 95–111.

Agostiniani, L. and F. Nicosia, *Tabula Cortonensis*. Rome, 2000.

Colonna, G. 'Nota di mitologia e di lessico etrusco: *turmuca, cvera, Esie*', *StEtr* 51 (1983) 143–170.

Colonna, G. 'Pyrgi', *StEtr* 56 (1989–90 [1991] 313–324 (on the presence of Catha at Pyrgi).

Cristofani, M. 'Lucumones, qui reges sunt lingua Tuscarum', *ArchClass* 43 (1991) 553–557.

de Simone, C. 'Etrusco *usil* = "sole"', *StEtr* 33 (1965) 537–543.

Durante, M. '*Masan*', *StEtr* 36 (1968) 67–69.

Hamp, E. P. 'Etrusco *phersu*', *Glotta* 53 (1965) 299–301.

Heurgon, J. '*Prumts, prumathś* et les arbres genéalogiques étrusques', in *Scritti in onore di G. Bonfante*. Brescia, 1976, 361–376.

Lejeune, M. 'Etrusque *avil(s)*. Essai lexical', *RPhil* 55 (1981) 15–19.

Martelli, M. 'Sul nome etrusco di Alexandros', *StEtr* 60 (1994) 165–178.

Morandi, A. 'Etrusco *ipa*', *Revue belge de philologie et d'histoire* 65 (1987) 87–96.

Olzscha, K. 'Das Aisera-Problem', *StEtr* 39 (1971) 93–105.

Olzscha, K. 'Etruskisch *lautn* und *etera*', *Glotta* 46 (1968) 212–227.

Pfiffig, A. J. 'Etruskisch *apa* Vater und Mame', *Beitrage Namenforschung* 6 (1971) 35–39.

Roncalli, F. 'Etrusco *cver, cvera* = greco *agalma*', *ParPass* 38 (1983) 288–300.

NAMES OF CITIES

Modern	Etruscan	Latin
Arezzo	Aret-(?)	Arrētium
Bologna	Felsina	Bonōnia
Bolsena (Orvieto?)	Velzna-	Volsiniī
Capua	Capua, Capeva	Capua
Cerveteri (Caere Vetus, 'ancient Caere')	Chaire, Chaisrie, Cisra	Caere, then Caere Vetus (Greek Agylla)
Cesena	Ceisna	Caesēna
Chiusi	Clevsin	Clusium, Camars
Cortona	Curtun	Cortōna
Fiesole	Vi(p)sul	Faesulae
Ischia	Inarime (?)	Pitecusa (Greek Pithekoussai)
Magliano	Hepa(?)	Heba
Mantova, Mantua	Manthva	Mantua
Marzabotto	Misa (?)	
Modena	Mutina	Mutina
Perugia	Per(u)sna	Perusia
(Poggio Buco)	Statna (?)	Statōnia
Populonia	Pupluna, Fufluna	Populōnia
Ravenna	Rav(e)na(?)	Rauenna
Rimini	Arimna	Ariminum
Roma	Ruma	Rōma
Siena	Saena(?), Sena	Saena
Sovana	Sveama-, Suana	Suana
Sutri	Suthri	Sutrium
Tarquinia	Tarch(u)na	Tarquiniī
Talamone	Tlamu	Telamōn
Todi	(tular)	Tuder

Tuscania	Tusc(a)na	Tuscāna
Veio, Veii	Veia	Veiī
Vetulonia	Vatluna, Vetluna	Vetulōnia
Viterbo?	Sur(i)na	Surriīna
Volterra	Velathri	Volaterrae
Vulci	Velch, Velc(a)l-	Vulcī

Sources: Pfiffig, *Einführung,* 92–93; Pallottino, 'Nomi etruschi di città', *Saggi di Antichità,* 710–726.

NAMES OF THE MONTHS

January	?
February	?
March	*Velcitanus (*velcitna)*
April	*Cabreas (*capre)*
May	*Ampiles or Amphiles*
June	*Aclus (acale)*
July	?
August	*Ermius*
September	*Caelius or Celius (celi)*
October	*Chosfer*
November	?
December	?

Note: The names of the months listed above are mostly known to us from glosses; no doubt they were used in ritual calendars. Forms ending in *-us* (e.g. *Velcitanus, Aclus*) have been Latinized. The month of *Masn*, or *Masan* (Pyrgi tablet, fig. 5; Zagreb mummy text, Source 67), has not yet been identified, nor has *Thucte*. Other words signifying dates include: *itus*, 'the Ides'; *tin*, 'day' (also the name of the god Tin or Tinia); *tiu*, *tiv* or *tiur-* 'moon' and also 'month' (also the name of the moon goddess). The text of the Zagreb mummy reads (VI): *eslem zathrumiś acale tinśin*, where *tinśin* means 'in the day' (*tin*), *acale* the month, and *eslem zathrumiś* is a numeral (18): 'the eighteenth day of June'.

COMPARATIVE WORD CHART

1. Family relationships

		Indo-European words		
Meaning	*Etruscan*	*Latin*	*Greek*	*Sanskrit*
father	apa	pater	patér	pitá
mother	ati	māter	máter, méter	mātá
son	clan	fīlius	hyiós	sunúḥ
daughter	sech	fīlia	thygátēr	duhitá
wife	puia	mulier, fēmina, uxor	gyné	gná
brother	ruva	frāter	(phrátér)	brátā

'Husband' does not appear in Etruscan texts, while 'wife', *puia*, does, because of the patriarchal nature of Etruscan society.

2. Religion and law

		Indo-European words		
Meaning	*Etruscan*	*Latin*	*Greek*	*Sanskrit*
Zeus, Jupiter	Tina, Tinia	Diēs (piter Iouis, Iu(ppiter)	Zeús patér	Dyaús pitá
king	lucumō	rēx, rēgis	—	rájā
god, divine	ais, eis, aisar (plural)	deus, deiuos	theós	deváḥ

3. Numerals

Indo-European words

Meaning	Etruscan	Latin	Greek	Sanskrit
1 one	thu	oinos, ūnus	oínē	é(kah)
2 two	zal	duo	dýo	dvắ
3 three	ci	trēs	treîs	tráyaḥ
4 four (or 6?)	śa	quattuor	téttares	càtvắraḥ
5 five	mach	quīnque	pénte	páñca
6 six (or 4?)	huth	sex	héx	ṣáṭ (sáṣ)
10 ten	śar	decem	déka	dáśa
20 twenty	zathrum	uīgintī	weíkosi	viṃśatíḥ
30 thirty	cialch	trīgintī	triắkonta	trimsát
50 fifty	muvalch	quinquāīgintī	pentḗkonta	pancāśát

Etruscan consistently differs in basic vocabulary from the other languages here chosen to exemplify the Indo-European family of languages. Etruscan is not a member of the family – probably the only language of ancient Italy in historical times that was not a member.

BIBLIOGRAPHY

I ARCHAEOLOGICAL INTRODUCTION

See also the notes to *Part one* for specialized works. The following are recommended for further reading.

Aigner-Foresti, L., ed. *Die Integration der Etrusker und das Weiterwirken etruskischen Kulturgutes im republikanischen und kaiserzeitlichen Rom.* Vienna, 1998.

Aigner-Foresti, L. *Tesi, ipotesi e considerazioni sull'origine degli Etruschi.* Vienna, 1974.

Aigner-Foresti, L. 'Etruria orientale, Umbria occidentale: un'area di confine', in *Assisi e gli Umbri nell'antichità.* Atti del Convegno Internazionale. Assisi, 1991, 11–27.

Aigner-Foresti, L. 'Federazioni e federalismo nell'Europa antica', Milan, 1994.

Aigner-Foresti, L. 'Gli Etruschi e la loro autocoscienza', in *Autocoscienza e rappresentazione dei popoli nell'antichità.* CISA 18. Milan, 1992, 93 ff.

Aigner-Foresti, L. 'L'origine di Roma e la Roma etrusca', in M. Sordi (ed.), *Roma dalle origini ad Azio.* Rome, 1994, 7 ff.

Aigner-Foresti, L. 'L'uomo Mecenate', *RivStorAnt* 26 (1996) 7 ff.

Aigner-Foresti, L. 'Movimenti etnici nella Roma dell' VIII secolo a.C.', in *Emigrazione e immigrazione nel mondo antico.* CISA 20. Milan, 1994, 3 ff.

Aspetti e problemi dell'Etruria interna. Atti dell'VIII Congresso di Studi Etruschi e Italici, Orvieto 1972. Florence, 1974.

Barker, G., and T. Rasmussen. *The Etruscans.* The Peoples of Europe. Oxford, 1998.

Bianchi Bandinelli, R., and A. Giuliano. *Etruschi e Italici prima del dominio di Roma.* Milan, 1973.

Boardman, J. *The Diffusion of Classical Art in Antiquity.* Princeton, 1994.

Boitani, F., Cataldi, M., Pasquinucci, M., Torelli, M., and F. Coarelli, ed. *Etruscan Cities.* Milan, 1974.

Bonfante, G. 'Religione e mitologia in Etruria', *StEtr* 54 (1986) 113.

Bonfante, L. *Etruscan Dress.* Baltimore, MD, 1975.

Bonfante L., ed. *Etruscan Life and Afterlife.* Detroit, MI, 1986.

Bonfante, L. *Etruscan Mirrors.* CSE, USA 3. New York, The Metropolitan Museum of Art. Rome, 1997.

Bonfante [Warren], L. 'Roman Triumphs and Etruscan Kings: The Changing Face of the Triumph', *JRS* 60 (1970) 49–66.

Bonfante, L. 'Etruscan Couples and their Aristocratic Society', in *Reflections of Women in Antiquity*, ed. H. Foley, New York, 1981, 323–343.

Bonfante, L. 'Il destino degli Etruschi', in A. Bongioanni, E. Comba, eds, *Libertà o necessità? L'idea del destino nelle culture umane*. Ananke, Turin, 1998, 53–65.

Bonfante, L. 'Roman Dress. Etruscan Derivations and a Glossary', *ANRW* I. 4 (1973) 584–614.

Brendel, O. J. *Etruscan Art*. With bibliographical essay by F. R. S. Ridgway. New Haven, 1995. Originally published, Harmondsworth, 1978.

Briquel, D. *Chrétiens et haruspices*. Paris, 1997.

Briquel, D. *Les Étrusques, peuple de la différence*. Paris, 1993.

Bruni, S. 'Prima di Demarato. Nuovi dati sulla presenza di ceramiche greche e di tipo greco a Tarquinia durante la prima età orientalizzante', *La presenza etrusca nella Campania meridionale. Atti delle giornate di studio, Salerno–Pontecagnano 1990*. Florence, 1994, 310–313.

Buranelli, F., ed. *The Etruscans. Legacy of a Lost Civilization from the Vatican Museums*. With an introduction and translation by N. T. de Grummond. Memphis, TN, 1992.

Camporeale, G. 'La mitologia figurata nella cultura etrusca arcaica', *AttiFirenze 1985*, 905–924.

Carandini, A. *La nascita di Roma: dèi, lari, eroi e uomini all'alba di una civiltà*. Turin, 1997.

Colonna, G. 'Ceramisti e donne padrone di bottega nell'Etruria arcaica', in *Indogermanica et Italica. Festschrift für Helmut Rix*. Innsbruck, 1993, 61–68.

Colonna, G. 'La produzione artigianale', in Momigliano-Schiavoni, 1988, 291–316.

Colonna, G. 'Quali Etruschi a Roma', in *Gli Etruschi a Roma. Incontro di Studio in Onore di Massimo Pallottino*. Rome, 1981, 159–172.

Colonna, G., ed. *Santuari d'Etruria*. Arezzo, Milan, 1985.

Cornell, T. *The Beginnings of Rome: Italy and Rome from the Bronze Age to the Punic Wars (c. 1000–264 B.C.)*. London, New York, 1995.

Cornell, T. 'The Tyranny of the Evidence: A Discussion of the Possible Uses of Literacy in Etruria and Latium in the Archaic Age', in *Literacy in the Roman World. JRA* Suppl. 3, Ann Arbor, MI, 1991, 7–33.

Corpus delle urne etrusche di età ellenistica 1. *Urne volterrane* 1. *I complessi tombali*. M. Cristofani, M. Martelli, E. Fiumi, A. Maggiani, A. Talocchini. Florence, 1975.

Cristofani, M., ed. *Etruria e Lazio arcaico*. Rome, 1987.

Cristofani, M., ed. *Gli Etruschi. Una nuova immagine*. Florence, 1987.

Cristofani, M. *I bronzi degli Etruschi*. Novara, 1985.

Cristofani, M., ed. *La Grande Roma dei Tarquinii*. Exhibition Catalogue, Rome, 1990.

Cristofani, M. *The Etruscans*. London, 1979.

Cristofani, M. 'Nuovi spunti sul tema della talassocrazia etrusca', *Xenia* 7–8 (1984) 3–20.

de Grummond, N. T. *A Guide to Etruscan Mirrors*. Tallahassee, FL, 1982.

Dennis, G. *The Cities and Cemeteries of Etruria*. 3rd ed. London, 1883.

Edlund, I. E. M. *The Gods and the Place*. Stockholm, 1987.

Enking, R. 'P. Vergilius Maro Vates Etruscus', *RömMitt* 66 (1959) 65–96.

Etrusca disciplina – Culti stranieri in Etruria. AnnFaina. Relazioni dei convegni del 1987 e del 1988. Orvieto/Rome, 1998.

Fraschetti, A. 'Le sepolture rituali del Foro Boario', in *Délit religieux* (1981) 51–115.

Gaultier, F., and D. Briquel, eds. *Les Étrusques, les plus religieux des hommes. État de la recherche sur la religion étrusque.* Actes du colloque international XII. Rencontres de l'École du Louvre. Paris, 1997.

Hall, J., ed. *Etruscan Italy. Etruscan Influences on the Civilization of Italy from Antiquity to the Modern Era.* Provo, Utah, Brigham Young University Museum of Art, 1996. Distributed by Indiana University Press.

Harris, W. V. *Rome in Etruria and Umbria.* Oxford, 1971.

Harris, W. V. *Ancient Literacy.* Cambridge, MA., 1989.

Haynes, S. *Etruscan Bronzes.* London, 1985.

Haynes, S. *Etruscan Civilization. A Cultural History.* Los Angeles, London, 2000.

Heres, H., and M. Kunze. *Die Welt der Etrusker. Internationales Kolloquium, Oktober, 1988.* Akademie-Verlag, Berlin, 1990.

Heurgon, J. *La vie quotidienne chez les Étrusques.* Paris, 1961. Translation, *The Daily Life of the Etruscans.* New York, 1964.

Higgins, R. *Greek and Roman Jewellery.* 2nd edn. London, 1980.

Jannot, J.-R. *Devins, dieux et démons. Regards sur la religion de l'Étrurie antique.* Paris, 1998.

Macnamara, E. *The Etruscans.* London, Cambridge, MA., 1990.

Markussen, E. P. *Painted Tombs in Etruria. A Catalogue.* Rome, 1993.

Martelli, M., ed. *La ceramica degli Etruschi. La pittura vascolare.* Novara, 1987.

McBain, B. *Prodigy and Expiation: A Study in Religion and Politics in Republican Rome.* Brussels, 1982.

Mele, A. *Il commercio greco arcaico: prexis ed emporie.* Cahiers du Centre Jean Bérard 4. Naples, 1979.

Menichetti, M. *Archeologia del potere. Re, immagini e miti a Roma e in Etruria in età arcaica.* Milan, 1994.

Menichetti, M. 'Le aristocrazie tirrene: aspetti iconografici', in Momigliano, Schiavoni, *Storia di Roma*, 1988, 75–124.

Momigliano, A., and A. Schiavoni *Storia di Roma 1. Roma in Italia.* Einaudi, Turin, 1988.

Müller, K. O., and W. Deecke. *Die Etrusker.* Revised by A. J. Pfiffig. Graz, 1965. Originally published Stuttgart, 1877.

Ogilvie, R. M. *A Commentary on Livy, Books 1–5.* Oxford, 1965.

Pairault Massa, F. -H. *Iconologia e politica nell'Italia antica. Roma, Lazio, Etruria dal VII al I secolo a.C.* Milan, 1992.

Pairault Massa, F. -H. [Massa-Pairault]. *La cité des Étrusques* CNRS, Paris, 1996.

Pallottino, M. *The Etruscans.* Revised and enlarged by D. Ridgway. Harmondsworth, 1978.

Pallottino, M. *A History of Earliest Italy.* Jerome Lectures 17. Ann Arbor, 1991. Translation of *Storia della Prima Italia.* Milan, 1984.

Pallottino, M. *Origini e storia primitiva di Roma.* Milan, 1993.

Pallottino, M., ed. *Les Étrusques et l'Europe.* Paris, 1992. Berlin, 1993.

Pellegrini, G. B. 'Metodologia nell'esplorazione della toponomastica etrusca', *Atti Firenze 1985.* Florence (1989) vol. 3, 1591 ff.

Pfiffig, A. J. 'P. Vergilius Maro – vates etruscus', *ÖstArchInst* 58 (1988) Beiblatt, 177–194.

Prayon, F. *Frühetruskische Grab- und Hausarchitektur.* Heidelberg, 1975.

Principi etruschi tra Mediterraneo ed Europa. Catalogue of Exhibition, Bologna, Museo Civico, 2000.

Rallo, A., ed. *Le donne in Etruria.* Studia Archaeologica 52. Rome, 1989.

Rasenna. Storia e civiltà degli Etruschi. Milan, 1986.

Rasmussen, T. see Barker.

Rebuffat, D. *CSE* France 1.3. Musée du Louvre, 1997.

Ridgway, D. 'The Etruscans.' *CAH* 4 (1988) 623–675.

Ridgway, D. *The First Western Greeks.* Cambridge, 1992.

Ridgway, D. 'Phoenicians and Greeks in the West: A View from Pithekoussai', in G. R. Tsetskhladze and F. de Angelis, eds. *The Archaeology of Greek Colonization. Essays Dedicated to Sir John Boardman.* Oxford, 1994, 35–46.

Ridgway, D., and F. R. S. Ridgway, eds. *IBR.*

Rykwert, J. *The Idea of a Town. The Anthropology of Urban Form in Rome, Italy and the Ancient World.* MIT, Cambridge, MA, and London, 1988. Originally published, Princeton, 1976.

Rykwert, J. *The Dancing Column. On Order in Architecture.* MIT, Cambridge, MA, London, 1996.

Skutsch, F. 'Etrusker', *RE* 2 (1907) cols 770–806.

Small, J. P. 'A Conference on Etruscan Vases', *JRA* 11 (1998) 408–412.

Small, J. P. 'New Views on Greek Artifacts Found in Etruria', *JRA* 8 (1995) 317–319.

Small, J. P. 'Scholars, Etruscans, and Attic Painted Vases', *JRA* 7 (1994) 35–39.

Small, J. P. 'The Tragliatella Oinochoe', *RömMitt* 93 (1986) 63–96.

Sordi, M. *Il mito troiano e l'eredità etrusca di Roma.* Milan, 1989.

Sordi, M. 'La centralità dell'Etruria nella politica di Mecenate', *RivStorAnt* 25 (1995) 149 ff.

Spivey, N. *Etruscan Art.* World of Art. London. New York, 1997.

Sprenger, M., G. Bartoloni, M., and L. Hirmer. *The Etruscans.* New York, 1983. Originally published as *Die Etrusker.* Munich, 1977.

Steingräber, S. *Città e necropoli dell'Etruria.* Rome, 1983.

Steingräber, S. *Etruscan Painting.* Catalogue Raisonné of Etruscan Painting. Johnson reprint, New York, 1986.

Stoddart, S., and J. Whitley. 'The Social Context of Literacy in Archaic Greece and Etruria', *Antiquity* 62 (1988) 761–772.

Szilágyi, J. G. *Ceramica etrusco-corinzia figurata.* Parte I. 630–580 a.C. Rome, 1992.

Thuillier, J. P. *Les jeux athlétiques dans la civilisation étrusque.* Rome, 1985.

Thuillier, J. P., ed. *Spectacles sportifs et scéniques dans le monde étrusco-italique.* Collection de l'École Française de Rome 172. Rome, 1993.

Torelli, M., ed. *Gli Etruschi.* Catalogue of Exhibition, Palazzo Grassi. Venice, 2000.

Torelli, M. *Il rango, il rito e l'immagine. Alle origini della rappresentazione storica romana.* Milan, 1997.

Torelli, M. in *Rasenna* (1986) 'La storia', 15–76; 'La religione', 159–237.

Torelli, M. *La storia degli Etruschi.* Bari, 1984. Reprinted, Rome, Bari, 1998.

Torelli, M. 'Delitto religioso. Qualche indizio sulla situazione in Etruria', in *Délit religieux* (1981) 1–7.

Torelli, M. 'History, Land and People', in *EtrLife*, 47–65.

Tsetskhladze, G. R., and F. de Angelis, eds. *The Archaeology of Greek Colonization. Essays Presented to Sir John Boardman*. Oxford, 1994.

Vacano, O.-W. von. *The Etruscans in the Ancient World*. Bloomington, Indiana, 1960.

Van der Meer, L. B. *Interpretatio Etrusca. Greek Myths on Etruscan Mirrors*. Gieben, Amsterdam, 1995.

Van der Meer, L. B. *The Bronze Liver of Piacenza. Analysis of a Polytheistic Structure*. Amsterdam, 1987.

Van der Meer, L. B. 'Dilemmas and Antithetical Deities on Etruscan Mirrors', *BABesch* 65 (1990) 73–79.

Van der Meer, L. B. 'Religion ombrienne et religion étrusque: Influences réciproques', in Gaultier, Briquel. *Actes Paris 1992*, 223–231.

II LANGUAGE – GRAMMAR, EPIGRAPHY

See also the notes to *Part two*.

Agostiniani, L., and F. Nicosia. *Tabula Cortonensis*. Rome, 2000.

Agostiniani, L. *Fonologia etrusca, fonetica toscana: il problema del sostrato*. Atti della giornata di studio organizzata dal gruppo archeologico Colligiano, Colle di Val d'Elsa 1982. Florence, 1986.

Agostiniani, L. *L'Umbria nel quadro linguistico dell'Italia mediana*. Incontro di Studio, Gubbio 1988. Naples, 1990.

Agostiniani, L. *Le 'iscrizioni parlanti' dell'Italia antica*. Florence, 1982.

Agostiniani, L. *Lessico etrusco cronologico e topografico dei materiali del Thesaurus Linguae Latinae*. Florence, 1988.

Agostiniani, L. 'Contributi', in F. Buranelli, *La raccolta Giacinto Guglielmi, Parte I. La ceramica*. Rome, 1977, 180–182, 383.

Agostiniani, L. 'Contribution à l'étude de l'épigraphie et de la linguistique étrusques', *Actes des sessions de linguistique et de littérature de l'école normale supérieure. LALIES*. Paris, 1992, 37–64.

Agostiniani, L. 'Duenom duenas: kalos kala: mlach mlakas', *StEtr* 49 (1981) 95–111.

Agostiniani, L. 'Il genere grammaticale etrusco', *Studi linguistici per i 50 anni del Circolo Linguistico Fiorentino e i Secondi Mille Dibattiti*. Florence, 1995 9ff.

Agostiniani, L. 'La sequenza eiminipicapi e la negazione in etrusco', *AGI* 49 (1984) 85.

Agostiniani, L. 'Sull'etrusco della stele di Lemno e su alcuni aspetti del consonantismo etrusco', *AGI* 71 (1986) 25–39.

Agostiniani, L. 'The Language', in M. Torelli, ed., *The Etruscans*. Venice, 2000, 485–499.

Bagnasco Gianni, G. *Oggetti iscritti di epoca orientalizzante in Etruria*. Biblioteca di Studi Etruschi 30, Florence, 1996.

Bagnasco Gianni, G. 'L'acquisizione della scrittura in Etruria: materiali a confronto per la ricostruzione del quadro storico e culturale', in G. Bagnasco Gianni, F. Cordano, eds., *Scritture mediterranee tra il IX e il VII secolo a.C.* Atti del Seminario, Università degli Studi di Milano. Istituto di Storia Antica, 1998 (Milan, 1999).

Bagnasco Gianni, G. 'Imprestiti greci nell'Etruria del VII secolo a.C.: osservazioni

archeologiche sui nomi dei vasi'. A. Aloni, L. de Finis, eds, *Dall'Indo a Thule: i Greci, i Romani, gli altri*. Trento, 1996, 307–317.

Battisti, C. 'Aspirazione etrusca e gorgia toscana', *StEtr* 4 (1931) 249–254.

Beekes, R. S. P. 'The position of Etruscan', *Indogermanica et Italica. Festschrift für Helmut Rix*. Innsbruck, 1993, 46–60.

Beekes, R. S. P., and L. B. Van der Meer. *De Etrusken Spreken*. Muiderberg, 1991.

Benelli, E. *Le iscrizioni bilingui etrusco-latine*. Florence, 1994.

Beschi, L. 'ATITAS', *ParPass* 51 (1996) 132–136.

Biondi, L. '*Aska eleivana*', *ParPass* 48 (1993) 57–64.

Biondi, L. 'Kothon nell'Italia medio-tirrenica', *Annali della Facoltà di Lettere e Filosofia dell'Università degli Studi di Milano* 50 (1997) 3–31.

Biondi, L. 'Presunti grecismi del lessico vascolare etrusco', *ParPass* 47 (1992) 62–71.

Bizzarri, M. 'La necropoli di Crocifisso del Tufo a Orvieto', *StEtr* 30 (1962) 1–151, especially 136–151, Appendix I, Le iscrizioni funerarie.

Blakeway, A. 'Demaratus', *JRS* 25 (1935) 129–148.

Bloch, R. 'Étrusques et Romains', in *L'Écriture et la psychologie des peuples*. Centre international, XXII^e semaine de synthèse. Paris, 1963, 182ff.

Bonfante, G. 'Arezzo e gli Etruschi', in *Atti e Memorie dell'Accademia Petrarca di Lettere, Arti e Scienze di Arezzo* n.s. 41 (1973–75) [1977] 378–382.

Bonfante, G. 'Il suono *f* in Europa è di origine etrusca?' *StEtr* 51 (1983) [1985] 161–166.

Bonfante, G. 'L'opposizione *k:ch (k:X)* in etrusco', *StEtr* 62 (1998) 273.

Bonfante, G. 'Language and alphabet', in *Out of Etruria* (1981) 111–134.

Bonfante, G. 'L'iscrizione su una fuseruola a Genova', *StEtr* 22 (1952–53) 427.

Bonfante, G. 'La pronuncia della *z* in etrusco', *StEtr* 36 (1968) 57–64; 'Ancora la *z* etrusca', *StEtr* 37 (1969) 499–500.

Bonfante, G. 'Problemi delle glosse etrusche', in X *Convegno di Studi Etruschi e Italici, Grosseto 1975. Atti*. Florence, 1977, 84.

Bonfante, G. 'Sull'origine delle rune', *RendLinc* 40 (1985) 145–146.

Bonfante, G. 'The origin of the Latin name-system', *Mélanges Marouzeau* (Paris 1948) 43–59. Reprinted in *Scritti Scelti* II 391–406.

Bonfante, G., and L. Bonfante. *Lingua e cultura degli Etruschi*. Rome. 1985. *Limba si cultura Etruscilor*. Bucharest, 1995. Revised translations of *The Etruscan language. An Introduction*, 1983.

Bonfante, G., and L. Bonfante. '"Deciphering" Etruscan', in Y. Duhoux, ed., *Problems in Decipherment*. Bibliothèque des Cahiers de l'Institut de Linguistique de Louvain 49. Louvain-la-Neuve, 1989, 189–216.

Bonfante, L. *Etruscan*, in *Reading the Past*, J. Hooker, ed., The British Museum Press, London, 1990; Berkeley and Los Angeles, 1990. French translation, in *La Naissance des écritures. Du cunéiforme à l'alphabet*. Editions du Seuil, Paris, 1994, 404–482.

Bonfante, L., ed. *Out of Etruria*. BAR International series 103, 1981.

Bonfante [Warren], L. 'Roman Triumphs and Etruscan Kings: The Latin Word *Triumphus*', *Studies in Honor of J. A. Kerns. Ianua Linguistica*, Mouton, 1970, 108–120 = *Out of Etruria*. 103 (1981) 93–110.

Bonfante, L. 'Appendix. Vocabulary', in Bonfante, *Etruscan Dress*, 101–104.

Bonfante, L. 'Inscriptions', in de Grummond, *Guide*, 69–78.

Bonfante, L. 'Un bronzetto votivo da Bolsena (?)', *MiscPallottino. ArchClass* 43 (1991) 835–44.

Bonfante, L. in *REE*, with note by M. Cristofani, *StEtr* 59 (1994) 269–271, No. 26, pls 47–48.

Bonfante, L., and R. Wallace. 'An Etruscan pyxis named *suntheruza*', *StEtr* 64 (2001), 201–212.

Brandenstein, W. 'Die Tyrrhenische stele von Lemnos', *Mitteilungen der Altorientalischen Gesellschaft* 7. Leipzig, 1934, 1–51.

Brandenstein, W. *RE* 7 (1948), 1913 ff. s.v. Tyrrhener.

Breyer, G. *Etruskisches Sprachgut im Lateinischen unter Ausschluss des spezifisch onomastischen Bereiches.* Orientalia Lovaniensia Analecta 53. Leuven, 1993.

Breyer, G. 'Historische Aspekte der Entlehnung etruskischen Wortgutes im Lateinischen', *StEtr* 61 (1997) 255–262.

Briquel, D. 'Perspectives actuelles sur la langue étrusque', *Ktema* 10 (1985) 111–125.

Buonamici, G. *Epigrafia etrusca.* Florence, 1932.

Caffarello, N. *Avviamento allo studio della lingua etrusca.* Florence, 1975.

Camporeale, G. 'Sull'alfabeto di alcune iscrizioni etrusche arcaiche', *ParPass* 112 (1967) 227–35.

Chadwick, J. *The Decipherment of Linear B.* Cambridge, 1958, 34, 48, 50.

Colonna, G. 'Appendice I. I dadi "di Tuscania"', *StEtr* 46 (1978) 115.

Colonna, G. 'Etruria e Lazio nell'età dei Tarquinii', in M. Cristofani, ed., *Etruria e Lazio Arcaico.* Rome, 1987, 55–66.

Colonna, G. 'Firme arcaiche di artefici nell'Italia centrale', *RömMitt* 82 (1975) 181–192.

Colonna, G. 'Il fegato di Piacenza e la tarda etruscità cispadana', in *Culture figurative e materiali tra Emilia e Marche. Studi in Memoria di Mario Zuffa.* Rimini, 1984, 171–180.

Colonna, G. 'La dea etrusca Cel e il santuario del Trasimeno', *Rivista di Storia Antica* 6–7 (1976–77) 45–62.

Colonna, G. 'La piú antica iscrizione di Bologna', *Studi e documenti di archeologia* 2 (1986) 57–66.

Colonna, G. 'Le iscrizioni votive etrusche', in *Anathema.* Atti del Convegno Nazionale. *ScAnt* 3–4 (1989–1990) [1991] 197–216.

Colonna, G. 'Nome gentilizio e società', *StEtr* 45 (1977) 175–192.

Colonna, G. 'Nomi etruschi di vasi', *ArchClass* 25–6 (1973–4) 132–150; and *Prospettiva* 53–56 (1989) 30–32.

Colonna, G. 'Scriba cum rege sedens', in *Mélanges Heurgon.* Rome, 1976, 187–195.

Colonna, G. 'L'écriture dans l'Italie centrale à l'époque archaïque', in *Revue de la société des anciens élèves et amis de la section des sciences religieuses de l'Ecole Pratique des Hautes Etudes* (Paris 1988) 12–31.

Colonna, G. 'Un'iscrizione di Talamone e l'opposizione presente/passato del verbo etrusco', *ParPass* 202 (1982) 5–11.

Cornell, T. J. '*Principes* of Tarquinia'. Review of *Elogia Tarquiniensia*, by M. Torelli, *JRS* (1978) 167–173.

Corpus Inscriptionum Etruscarum (CIE).

Cristofani, M. *CIE* II, 1, 4. Florence, 1970, with addenda and corrigenda, *StEtr* 44 (1976) 187–99. Reviewed by L. Bonfante, *JRS* 66 (1976) 243–244. For other reviews, see M. Cristofani, *IBR* 408, n. 3.

Cristofani, M. *Due testi dell'Italia preromana.* Quaderni di Archeologia Etrusco-Italica 25. CNR. Rome, 1996.

Cristofani, M., ed. *Gli Etruschi. Una nuova immagine*. Florence, 1984.

Cristofani, M. *Saggi di storia etrusca arcaica*. Archaeologica 70. Rome, 1987.

Cristofani, M. *Introduzione allo studio dell'etrusco*. Revised edn, Florence, 1991. Originally published 1973. Reviewed by G. Bonfante, *AGI* 61 (1976) 268–77; A. J. Pfiffig, *Gnomon* 47 (1975) 418–420.

Cristofani, M. *Tabula Capuana. Un calendario festivo di età arcaica*. Biblioteca di Studi Etruschi 29. Florence, 1995.

Cristofani, M. 'Antroponimia e contesti sociali di pertinenza', in *Saggi di storia etrusca arcaica*. Rome, 1987, 107–125.

Cristofani, M. 'Celeritas Solis Filiae', *Kotinos, Festschrift E. Simon*. Mainz, 1992, 347–349.

Cristofani, M. 'Il "dono" nell'Etruria arcaica', *ParPass* 30 (1975) 132–152.

Cristofani, M. 'La formazione della scrittura', in *Saggi di storia etrusca arcaica*. Archaeologica 70. Rome, 1987, 25–37. Originally in Atti del Convegno, *La scrittura in Etruria*, Orvieto, 1985.

Cristofani, M. 'L'alfabeto etrusco', *Popoli e Civiltà* 6 (1978) 403–428.

Cristofani M. 'Le divinità', in *I bronzi degli Etruschi*. Novara, 1985, 277–287.

Cristofani, M. 'Note di epigrafia etrusca', *StEtr* 47 (1979) 157–161.

Cristofani, M. 'Rapporto sulla diffusione della scrittura nell'Italia antica', *Scrittura e Civiltà* 2 (1978) 5–33.

Cristofani, M. 'Recent advances in Etruscan epigraphy and language', in *IBR* 373–412.

Cristofani, M. 'Società e istituzioni nell'Italia preromana', *Popoli e civiltà* 7 (1978) 53–112, esp. 67–99.

Cristofani, M. 'Sul morfema etrusco *-als*', *AGI* 56 (1971) 38–42.

Cristofani, M. 'Sul processo di antropomorfizzazione nel panteon etrusco', in *Miscellanea etrusco-italica* I (1992) 9–21.

Cristofani, M. 'Sull'origine e la diffusione dell'alfabeto etrusco', in *ANRW* I, 2. Berlin and New York, 1972, 466–489.

Cristofani, M., and M. Martelli. 'Fufluns Pachies. Sugli aspetti del culto di Bacco in Etruria', *StEtr* 46 (1978) 119–133.

Cristofani, M., and M. Martelli. *L'oro degli Etruschi*. Novara, 1983.

Cristofani, M., and K. M. Phillips. 'Poggio Civitate: Etruscan letters and chronological observations', *StEtr* 39 (1971) 409–430.

D'Aversa, A. *La lingua degli Etruschi*. Brescia, 1979.

de Grummond, N. T. 'For the Mother and for the Daughter', in *Studies in Honor of Sara Immerwahr*. Forthcoming.

de Grummond, N. T. 'An Etruscan Mirror in Tokyo', in A. Rallo (ed.), *Aspetti e problemi della produzione degli specchi etruschi*. Rome, 2000, 47–52.

de Simone, C. *Die griechischen Entlehnungen im Etruskischen*. Wiesbaden, 2 vols. 1968–70.

de Simone, C. *I Tirreni a Lemnos. Evidenza linguistica e tradizione storica*. Florence, 1996. Reviewed by Rex Wallace, *AJA* 102 (1998) 460–461; L. Beschi, *ParPass* 51 (1996) 132–136.

de Simone, C. 'I morfemi etruschi *-ce (-ke)* e *-che*', *StEtr* 38 (1970) 115–139.

de Simone, C. 'I Tirreni a Lemnos: l'alfabeto', *StEtr* 60 (1995) 145–163.

de Simone, C. 'Il problema storico-linguistico', *Magna Grecia, Etruschi, Fenici*. Atti 33^{mo} Convegno di Studi sulla Magna Grecia, Taranto 1993. Napoli, 1996, 89–121.

de Simone, C. 'Per la storia degli imprestiti greci in etrusco', *ANRW* I 2 (1972) 490-521.

de Simone, C. 'Zur altetruskischen Inschrift aus Rom', *Glotta* 46 (1968) 207ff. See also M. Pallottino, *StEtr* 33 (1965) 501–507; E. Gjerstad, *Early Rome* IV. Lund, 1966, 124.

Devine, A. M. 'Etruscan language studies and the aspirates', *StEtr* 42 (1974) 123–151.

Devoto, G. *Storia della lingua di Roma*, second edition, with introduction and bibliography by A. L. Prosdocimi. Bologna, 1983.

Devoto, G. 'Il latino di Roma', *Popoli e civiltà* 6 (1978) 469–485, esp. 480–1, 'La comunità culturale etrusco-laziale', and 485, notes 57–62.

Die Göttin von Pyrgi. Akten des Kolloquiums zum Thema. Archäologische, linguistische und religionsgeschichtliche Aspekte. Tübingen, 1979. Florence, 1981. With contributions by M. Pallottino, G. Colonna, F. Prayon, M. Cristofani, C. de Simone, H. Rix, A. Tovar, R. Bloch, I. Krauskopf, O.-W. von Vacano.

Dumézil, G. *Archaic Roman Religion*. Chicago, 1970. 'Appendix. Archaic Etruscan Religion', 623–696.

Durante, M. 'Una sopravvivenza etrusca in latino', *StEtr* 41 (1973) 193–200.

Ernout, A. 'Les éléments étrusques du vocabulaire latin', *BSL* 30 (1930) 82ff.

Fiesel, E. *Namen des griechischen Mythos im Etruskischen*. Göttingen, 1928.

Fiesel, E. *Etruskische*. Berlin, 1931.

Forni, G. 'Le tribù romane nelle bilingui etrusco-latine e greco-latine', *Studi Betti* (1961) 195–207, esp. 203.

Garbini, G. 'Lingua etrusca e aritmetica', *ParPass* 20 (1975) 345–355.

Gaultier, F., and D. Briquel. 'Réexamen d'une inscription des collections du Musée du Louvre: Un Mézence à Caeré au VII^e siècle av. J.-C.', *CRAI* (1989) 99–115.

Gaultier, F., and D. Briquel. 'L'iscrizione arcaica di Lucio Mezenzio', in *Miscellanea Ceretana* I. Quaderni del Centro di Studio per l'Archeologia etrusco-italica 17, Rome, 1989, 41–49.

Geissendörfer, D. *Der Ursprung der Gorgia Toscana*. Neustadt/Aisch, 1964.

Gelb, I. J. *A Study of Writing*. Chicago and London, 1952; 2nd edn, 1963.

Giannecchini, G. ' "Destra" e "sinistra" e lo strumentale in etrusco', *StEtr* 62 (1998) 281–310.

Gill, D. W. J. '*Metru menece*. An Etruscan painted inscription on a mid-5th-century B.C. red-figure cup from Populonia', *Antiquity* 61 (1987) 82–87.

Guarducci, M. *Epigrafia Greca, I*. Rome, 1967.

Hermeneus 45 (1973–74). Special issue on the Etruscans.

Heurgon, J. 'A propos de l'inscription tyrrhénienne de Lemnos', in *Atti Firenze 1985*, 93–102.

Heurgon, J. 'La coupe d'Aulus Vibenna', in *Mélanges J. Carcopino*. Paris, 1966, 515–528.

Heurgon, J. 'Note sur la lettre L dans les inscriptions étrusques', in *Studi Banti*. Rome, 1965, 177–189.

Heurgon, J. 'Recherches sur la fibule d'or inscrite de Chiusi: la plus ancienne mention épigraphique du nom des Étrusques', *MEFRA* 83 (1971) 9–28.

Heurgon, J. 'The date of Vegoia's prophecy', *JRS* 49 (1959) 41–45.

Heurgon, J. 'The Inscriptions of Pyrgi', *JRS* 56 (1966) 1–14.

Hodos, T. 'The asp's poison: women and literacy in Iron Age Italy', in R. Whitehouse

(ed.), *Gender and Italian Archaeology. Challenging the Stereotypes*. Accordia Specialist Studies on Italy 7. London, 1998, 197–208.

Hoenigswald, H. review of A. J. Pfiffig, *Ein opfergelübde an die etruskische Minerva*. *AJA* 75 (1971) 227–228.

Hooker, J. T. *The Coming of the Greeks*. Claremont, 1999.

Jeffery, L. H. *The Local Scripts of Archaic Greece*. Oxford, 1961.

Johnston, A. W. *Trademarks on Greek Vases*. Warminster, 1979.

Kaimio, J. 'The Ousting of Etruscan by Latin in Etruria', *Acta Instituti Romani Finlandiae V*. Rome, 1972, 85–245.

Keyser, P. 'The Origin of the Latin Numerals 1 to 1000', *AJA* 92 (1988) 529–546.

L'etrusco arcaico. Atti del colloquio, Firenze, 1974. Florence, 1976.

La naissance de Rome. Paris, Petit Palais, 1977. Exhibition Catalogue.

Lambrechts, R. *Essai sur les magistratures des républiques étrusques*. Inst. Hist. Belge de Rome 7. Brussels, 1959.

Lambrechts, R. *Les inscriptions avec le mot tular et les bornages étrusques*. Florence, 1970. Review by J. Heurgon, *Latomus* 31 (1972) 570–573.

Lambrechts, R. '*CII*, SI 254. Nunc ubi sit comperi', in *Études Étrusco-Italiques*. Louvain, 1963, 101–109.

Le lamine di Pyrgi. Tavola rotonda internazionale, Roma 1968. Accademia Nazionale dei Lincei, Quaderno No. 147. Rome, 1970.

Le ricerche epigrafiche e linguistiche sull'etrusco. Atti del Colloquio, Firenze 1969. Florence, 1973.

Lejeune, M. 'Notes de linguistique italique, XIII: sur les adaptations de l'alphabet étrusque aux langues indo-européennes d'Italie', *REL* 35 (1957) 88–105.

Lejeune, M. 'Note sur les vases de terre cuite avec inscriptions étrusques du Musée du Louvre', *StEtr* 26 (1958) 86–101.

Lejeune, M. 'I numerali etruschi', *REL* 59 (1981) 69 ff.

Lejeune, M. 'La notation de F dans l'Italie ancienne. Notes de linguistique italique, XXI', *REL* 44 (1966) [1967] 141–181.

Lejeune, M. 'Le jeu des abécédaires dans la transmission de l'alphabet', *Atti Firenze 1985* (1989) 1285–1291.

Lejeune, M. 'Rencontres de l'alphabet grec avec les langues barbares au cours du Ier millénaire av. J.-C.', in *Forme di contatto e processi di trasformazione nelle società antiche*. Pisa, Rome, 1983, 731–752.

Les écrivains et l'etrusca disciplina de Claude à Trajan. Caesarodunum. Suppl. No. 64 (1995). CNRS 126/4, Université de Tours, Bulletin de l'Institut d'Etudes Latines et du Centre de Recherches A. Piganiol.

Liber Linteus Zagrebiensis. Vjesnik Arheoloskog Muzeja u Zagrebu. Zagreb, 1986. With chapters by M. Pallottino, A. J. Pfiffig, H. Rix, and others.

Lindsay, W. M. *Sexti Pompei Festi de verborum significatu quae supersunt, cum Pauli epitome*. Leipzig, 1913.

Maggiani, A., ed. *Vasi attici figurati con dediche a divinità etrusche*. Suppl. *RdA* Rome, 1997.

Maggiani, A. 'Alfabeti etruschi di età ellenistica', *AnnFaina* 4 (1990) 177–217.

Maggiani, A. 'Appunti sulle magistrature etrusche', *StEtr* 62 (1998) 95–138.

Maniet, A. 'Les correspondances lexicales de l'osque et du latin. Problème de méthode', in *Études Étrusco-Italiques*. Louvain, 1963, 131–143.

Marchesini, S. *Studi onomastici e sociolinguistici sull'Etruria arcaica: il caso di Caere.* Florence, 1997. Reviewed by D. Ridgway, F. R. Serra Ridgway, *JRA* 12 (1999) 448–450.

Martelli, M., ed. *Tyrrhenoi Philotechnoi.* Atti della giornata di studio, Viterbo 1990. Terra Italia 3. Collana di studi archeologici sull'Italia antica. GEI, 1994.

Mazzarino, S. 'Sociologia del mondo etrusco e problemi della tarda etruscità', *Historia* 6 (1957) 63–97, 98–112.

Mingazzini, P. 'Sul fenomeno dell'aspirazione in alcune parole latine ed etrusche', *StEtr* 24 (1955/56) 343–349.

Morandi, A. *Epigrafia di Bolsena etrusca.* Rome, 1990.

Morandi, A. *Epigrafia italica.* Rome, 1982.

Morandi, A. *Nuovi elementi di lingua etrusca.* Rome, 1991.

Negri, M., ed. *Alfabeti. Preistoria e storia del linguaggio scritto.* Atlante della comunicazione dell'uomo. Atlanti del pensiero. Colognola ai Colli (VR), 2000. With chapters on Greek by F. Cordano, on Etruscan by G. Bagnasco Gianni, on runes by R. Gendre. Good illustrations.

Nicosia, F., and L. Agostiniani. *Tabula Cortonensis.* See Agostiniani.

Nielsen, M. 'Common Tombs for Women in Etruria: Buried Matriarchies?', in P. Setälä, L. Savanen, eds, *Female Networks and the Public Sphere in Roman Society.* Rome, 1999, 65–115.

Olzscha, K. *Interpretation der Agramer Mumienbinde.* Leipzig, 1939.

Olzscha, K. 'Einige etruskische Formen auf *-cva* und *-chva*', in *Gedenkschrift W. Brandenstein.* Innsbruck, 1968, 191–196.

Pallottino, M. *Elementi di lingua etrusca.* Florence, 1936.

Pallottino, M. *Testimonia Linguae Etruscae (TLE).* 2nd edn, Florence, 1968.

Pallottino. *The Etruscans.* Harmondsworth and Bloomington, 1975. Part 3, 'The Etruscan Language', 187–234.

Pallottino, M. with the collaboration of G. Colonna, L. V. Borrelli and G. Garbini, 'Scavi nel santuario etrusco di Pyrgi', *ArchClass* 16 (1964) 49–117.

Pallottino, M. *Saggi di Antichità.* Rome, 1979.

Pallottino, M. 'I documenti scritti e la lingua', in *Rasenna.* Milan 1986, 309–367.

Pallottino, M. 'Lo sviluppo socio-istituzionale di Roma arcaica. Alla luce di nuovi documenti epigrafici', *Studi Romani* 27 (1979) 11–12.

Pallottino, M. 'Nota preliminare sulla iscrizione del kantharos di bucchero del Metropolitan Museum di New York', *StEtr* 34 (1966) 403–406.

Pallottino, M. 'Nota sui documenti epigrafici rinvenuti nel santuario', *Pyrgi. Scavi 1959–1967. NotSc 1970. Supplemento* (1973) 730ff.

Pallottino, M. 'Rivista di epigrafia etrusca: Roma', *StEtr* 33 (1965) 505–507.

Pandolfini, M., and A. Prosdocimi, *Alfabetari e insegnamento della scrittura in Etruria e nell'Italia antica.* Florence, 1990.

Pasquali, G. 'Acheruns, Acheruntis', *StEtr* 1 (1927) 291–301.

Peruzzi, E. *Mycenaeans in Early Latium.* Rome, 1980, 'Appendix I. Mycenaeans and Etruscans', 137–149.

Peruzzi, E. 'Romolo e le lettere greche', *Origini di Roma*, II. Bologna, 1973, 9–53.

Peruzzi, E. *Aspetti culturali del Lazio primitivo.* Florence, 1978.

Pfiffig, A. J. *Die etruskische Sprache.* Graz, 1969. Reviewed by C. Battisti, *Atene e Roma* n.s. 16 (1971) 103–112; C. de Simone, *Kratylos* 14 (1969) 91–100; G. Bonfante,

AGI 56 (1971) 167–172; R. Pfister, *Gnomon* 44 (1972) 18–25; H. Rix, *GöttGelAnz* 277 (1975) 117–143.

Pfiffig, A. J. *Einführung in die Etruskologie – Probleme, Methoden, Ergebnisse*. Darmstadt, 1972.

Pfiffig, A. J. *Gesammelte Schriften zur Sprache und Geschichte der Etrusker*. Vienna, 1995.

Pfiffig, A. J. 'Hannibal in einer etruskischen Grabinschrift in Tarquinia', in *Gesammelte Schriften* (1995) 239–245. Originally published in *StEtr* 35 (1967) 659–663.

Pfiffig, A. J. 'Stellung und Funktion der allomorphen Suffixe *-s(i)* und *-l(a/e)* im etruskischen Kasussystem', *Gesammelte Schriften* (1995) 439–459.

Pfiffig, A. J. 'Zur Förderung nach moderner Sprachbetrachtung in der Etruskologie', *Die Sprache* 18 (1972) 163–187.

Pieri, S. *Toponomastica della Toscana meridionale*. Siena, 1969. Revised by G. Bonfante.

Pisani, V. *Le lingue dell'Italia antica oltre il latino*. 2nd edn. Turin, 1964.

Poupé, J. 'Les aryballes de bucchero', in *Études Étrusco-Italiques*. Louvain, 1963, 227–260.

Powell, B. *Homer and the Origin of the Greek Alphabet*. Cambridge, 1991.

Prosdocimi, A. L. see Pandolfini.

Prosdocimi, A. L. '*Vetusia* di Praeneste: etrusco o latino?', *StEtr* 47 (1979) 379–385.

Ridgway, D., and Ridgway, F. R. S. *IBR*, Part Four, 'Aspects of the Etruscans', 239–412.

Rivista di Epigrafia Etrusca, (*REE*) ongoing survey of inscriptions and readings, published in *Studi Etruschi*.

Rix, H., *Das etruskische Cognomen*. Wiesbaden, 1963.

Rix, H. *Etruskische Texte, editio minor. I, Einleitung, Konkordanz, Indices. II, Texte*. Tübingen, 1991. *ET*.

Rix, H. *Rätisch und Etruskisch*. Innsbruck, 1998.

Rix, H. in *Neue Pauly*, s.v.

Rix, H. 'Einige morphosyntaktische Übereinstimmungen zwischen Etruskisch und Lemnisch: die Datierungsformel', in *Gedenkschrift W. Brandenstein*. Innsbruck, 1968, 213–222.

Rix, H. 'Etrusco *un, une, unu*, "*te, tibi, vos*" e le preghiere dei rituali paralleli nel *liber linteus*', *ArchClass* 43 (1991) 665–691.

Rix, H. 'Etruskische Personennamen', in E. Eichler, G. Hilty, H. Löffler, H. Steger, L. Zgusta, eds, *Namenforschung. Ein internationales Handbuch zur Onomastik*, 719–724. Berlin/New York, 1995.

Rix, H. 'L'apporto dell'onomastica personale alla conoscenza della storia sociale', in M. Martelli and M. Cristofani, *Carattere dell'ellenismo nelle urne etrusche*, Florence, 1977, 64–73.

Rix, H. 'La scrittura e la lingua', in M. Cristofani, ed., *Gli Etruschi. Una nuova immagine*. Florence, 1984, 210–238.

Rix, H. 'Zum Ursprung des römisch-mittelitalischen Gentilnamenssystems', in *ANRW* I, 2. Berlin and New York, 1972, 700–758.

Robb, K. 'Poetic sources of the Greek alphabet: Rhythm and abecedarium from Phoenician to Greek', in E. Havelock and J. P. Hershbell, eds, *Communication Arts in the Ancient World*. New York, 1978, 23–36.

Rohlfs, G. *Studi e ricerche su lingue e dialetti d'Italia*. Manuali di Filologia e Storia. Florence, 1972, esp. 51–52.

Roncalli, F. *Scrivere Etrusco*. Milan, 1985.

Roncalli, F. 'Etrusco *cver, cvera* = greco *agalma*', *ParPass* 38 (1983) 111.

Roncalli, F. '*Carbasinis uoluminibus implicati libri*. Osservazioni sul *liber linteus* di Zagabria', *JdI* 95 (1980) 227–264.

Roncalli, F. 'La pietra come "instrumentum scriptorium" e il cippo di Perugia', *Ann-Faina* 4 (1990) 11–20.

Santoro, C. 'Per un contributo alla lingua ed all'epigrafia etrusca (su dieci epigrafi etrusche inedite e su due poco note)', in *Studi Pisani*, 1992, 469–500.

Santoro, P., ed. *Civiltà arcaica dei Sabini nella valle del Tevere, 3. Rilettura critica della necropoli di Poggio Sommavilla*. Consiglio Nazionale delle Ricerche, Centro di Studio per l'Archeologia Etrusco-Italica. Rome, 1977.

Sassatelli, G. 'Graffiti alfabetici e contrassegni nel villanoviano bolognese', in *Emilia preromana* IX-X (1981–82 [1984]) 147ff.

Sassatelli, G. 'Nuovi dati epigrafici da Marzabotto e il ruolo delle comunità locali nella "fondazione" della città', *Misc. Pallottino. ArchClass* 43 (1991) 693–715.

Sassatelli, G. 'Il principe e la pratica della scrittura', in *Principi etruschi*, Bologna, 2000, 307–326.

Schmitz, P. C. 'The Phoenician Text from the Etruscan sanctuary at Pyrgi', *JAOS* 115 (1995) 559–575.

Schrimer, B. 'I verbi *muluvanice* e *turuce*. Prolegomena per una determinazione di semantica ed impiego', *ParPass* 48 (1993) 38–56.

Schumacher, S. 'Sprachliche Gemeinsamkeiten zwischen Rätisch und Etruskisch', *Der Schlern* 72 (1998) 90–114.

Sordi, M. 'L'idea di crisi e di rinnovamento nella concezione romano-etrusca della storia', *ANRW* I, 2 (197) 781–793.

Staccioli, R. A. *Il 'mistero' della lingua etrusca*. Rome, 1977.

Steinbauer, D. *Neues Handbuch des Etruskischen*. St Katharinen, 1999.

Stibbe, C. M., G. Colonna, C. de Simone, and H. S. Versnel, with an introduction by M. Pallottino. *Lapis Satricanus. Archaeological, epigraphical, linguistic and historical aspects of the new inscription from Satricum*. 's-Gravenhage, 1980.

Stopponi, S. 'Iscrizioni etrusche su ceramiche attiche', *AnnFaina* 4 (1990) 81–112.

Tagliamonte, G. 'Iscrizioni etrusche su strigili', in Thuillier, ed. (1993) 97–120.

Thesaurus Linguae Etruscae. I. Indice Lessicale. Edited by M. Pallottino, with M. Pandolfini Angeletti, C. de Simone, M. Cristofani and A. Morandi. Rome, 1978. *Thesaurus Linguae Etruscae, I. Indice Lessicale, ordinamento inverso dei lemmi*, edited by L. Fasani, M. Pallottino, M. Pandolfini Angeletti. Rome, 1985; I *Supplemento*, edited by M. Pallottino, M. Pandolfini Angeletti. Rome, 1984; II *Supplemento*, edited by M. Pallottino, M. Pandolfini Angeletti. Rome, 1991; III *Supplemento*, edited by M. Pandolfini Angeletti. Rome, 1998.

Torelli, M. *Elogia Tarquiniensia*. Florence, 1975. Reviewed by J. Heurgon, *StEtr* 46 (1978) 617–623; T. J. Cornell, *JRS* 68(1978) 167–173.

Torelli, M. 'Glosse etrusche: qualche problema di trasmissione', in *Mélanges Heurgon*. Rome, 1976, 1001–1008.

Torelli, M. 'Scavi di Gravisca', *ParPass* 26 (1971) 55ff. 'Il santuario greco di Gravisca', *ParPass* 32 (1977) 398–458; *ParPass* 37 (1982) 304–325.

Turcan, R. 'Encore la prophétie de Végoia', *Mélanges Heurgon*. Rome, 1976, 1009–1019.

Van der Meer, L. B. *The Bronze Liver of Piacenza. Analysis of a Polytheistic Structure*. Amsterdam, 1987.

Van der Meer, L. B. '*Iecur Placentinum* and the Orientation of the Etruscan Haruspex', *BABesch* 54 (1979) 49–64.

Ventris, M. 'Introducing the Minoan Language', *AJA* 44 (1940) 501–520. See Chadwick.

Wachter, R. *Non-Attic Greek Vase Inscriptions*. Archaeologia 717. Rome, 1997.

Wallace, R. 'The Etruscan Gentilicia *kuritianas* and *kurtinas*', *Beiträge zur Namenforschung* 25 (1990) 145–148.

Wallace, R. 'On the transcription of sibilants in Etruscan: a new proposal', *Glotta* 79 (1991) 77–83.

Wallace, R. in REE, *StEtr* 59 (1994) 271–273, No. 27, pl. 49.

Wallace, R. see L. Bonfante.

Watmough, M. M. T. *Studies in the Etruscan Loanwords in Latin*. Biblioteca di Studi Etruschi 33. Florence, 1997.

Weinstock, S. 'Martianus Capella and the Cosmic System of the Etruscans', *JRS* 36 (1946) 101–129.

Woodard, R. D. *Greek Writing from Knossos to Homer. A Linguistic Interpretation of the Origin of the Greek Alphabet and the Continuity of Ancient Greek Literacy*. New York, Oxford, 1997.

Wylin, K. *Il verbo etrusco. Ricerca morfosintattica delle forme usate in funzione verbale*. Studia Philologica 20. Rome, 2000.

Wylin, K. 'Modes, Tenses and Aspects: A Preliminary Attempt to Establish a Morphology of Etruscan Verbs', *RBPhil* 75 (1997) 5–36.

ON THE 'TYRRENIAN CIPPUS' AT DELPHI

Amandry, P. 'Trépieds de Delphe et du Péloponnèse', *BCH* III (1987) 79–131, especially 124–126.

Colonna, G. 'Apollon, les Étrusques et Lipara', *Atti Firenze 1985*, I, 361ff.

Colonna, G. *MEFRA* 96 (1984) 564ff.

Colonna, G. 'Doni di Etruschi e di altri barbari occidentali nei santuari panellenici', in A. Mastrocinque, ed., *I grandi santuari della Grecia e l'Occidente*. Trento, 1993, 43–67.

Cristofani, C. *Civiltà degli Etruschi* (1985) 256, No. 9.20.

Cristofani, C. 'Nuovi spunti salla talassocrazia etrusca', *Xenia* 8 (1984) 12–20.

Pallottino, M. 'Proposte, miraggi, perplessità nella ricostruzione della storia etrusca', *StEtr* 53 (1985) 3–16, especially 7–14.

Steuernagel, D. *Menschenopfer und Mord am Altar*. Wiesbaden, 1998, 151.

Vatin, C. 'Etruschi a Delfi', *AnnFaina* 2 (1985) 173–181, figs 1–9.

Vatin, C. *Monuments votifs de Delphes*. Archaeologica 100. Rome, 1991, 256–259.

WORKS ASSUMING AN IE BASE FOR THE ETRUSCAN LANGUAGE

Battaglini, S. *Le lamine di Pyrgi e le origini etrusche*. Rome, 1991.

Favini, L. *Interpretazioni etrusche*. Florence, 1989.

Pittau, M. *Testi etruschi tradotti e commentati, con vocabolario.* Rome, 1990.

Magini, L. *La parola degli Etruschi. Saggio.* Rome, 1987.

Morandi, A. *Le ascendenze indoeuropee nella lingua etrusca*, I–III. Rome, 1984–1985.

Woudhuizen, F. C. *Linguistica Tyrrhenica. A Compendium of Recent Results in Etruscan Linguistics.* Amsterdam, 1992.

Woudhuizen, F. C. *Linguistica Tyrrhenica* I, II. Amsterdam, 1992, 1998.

Woudhuizen, F. C. *The Language of the Sea Peoples.* Amsterdam, 1992, 164–187.

Woudhuizen, F. C. 'Etruscan Numerals in Indo-European Perspective', *Talanta* 20–21 (1988–89) 109–124.

Zavaroni, A. *I documenti etruschi.* Padova, 1996.

INDEX TO SOURCES

CONCORDANCE

TLE	ET	TLE	ET
1	LL	91	Ta 5.5
2	TC	93	Ta 1.81
3	Cm 2.33	94	Ta 1.82
10	Cm 2.39	95	Ta 7.87
13	Cm 2.46	98	Ta 1.169
22	Cm 2.50	99	Ta 1.170
24	La 2.4	100	Ta 5.6
28	Fa 2.1	102	Ta 7.84
29	Fa 0.4	105	Ta 1.66
34	Ve 3.5	115	Ta 1.28
35	Ve 3.11	116	Ta 1.200
39	Ve 3.21	119	Ta 1.89
43	Ve 3.28	122	Ta 1.50, 1.51
45	Ve 3.34	123	Tc 1.52
49	Ve 9.1	126	Ta 1.9
51	Cr 5.3	128	Ta 1.15
54	Cr 2.13, 2.14	129	Ta 1.14
55	Cr 9.1	130	Ta 1.197
56	Cr 0.1	131	Ta 1.17
57	Cr 3.11	135	Ta 1.182
63	Cr 2.18, 2.19	136	Ta 1.183
64	Cr 2.20	149	Ta 3.6
74	Cr 7.1	156	Ta 3.2
84	Ta 5.2	158	AT 1.192
87	Ta 7.59	165	AT 1.171
88	Ta 7.67	169	AT 1.105
90	Ta 5.4	171	AT 1.108

TLE	ET	TLE	ET
172	AT 1.107	606	Pe 1.211
173	AT 1.109	625	Co 4.5
174	AT 1.100	630	Co 1.3
176	AT 1.125	632	Co 8.2
203	Vs 8.4	640	Co 3.4
219	Vs 4.74	644	Co 4.6, 4.7
232	Vs 1.178	651	Pe 3.3
242	Vs 1.4	652	Co 3.6
256	Vs 3.4	653	Co 3.7
276	AH 1.47	663	Ar 3.2
278	Fa 6.3	675	Fs 8.2
282	AH 3.4	681	Fs 7.2
293–303	Vc 1.17, 1.18,	682	Fs 7.1
	0.40, 7.15, 7.18,	696	Um 3.2
	etc.	697	Um 1.7
320	Vc 1.91	719	Pa 4.2
321	Vc 1.92	734	AS 4.1
324	Vc 1.93	736	Vs 3.7
328	Vc 3.10	737	OB 3.2
334	Vc 7.38	752	AH 3.3
340	AV S.6	760	Cr 3.17
359	AV 4.1	761	OA 2.2
363	Vn 1.1	762	Fa 2.3
368	Po S.1	764	OB 2.3
370	Po 6.1	769	Cr 3.18
381	Vt 8.1	773	OA 3.8
386	Vt 1.154	801–58	Glosses
397	Vt 3.3	868	Cr 3.20
399	Vt S.2	873–876	Cr 4.2–5
407	Vt 1.85	877	Cr 4.8
419	AS 1.314	878	Cr 4.10
420	AS 1.311	880	Ta 1.153
428	Vt 1.77	882	Ta 1.159
429	Vt 3.1	885	Ta 7.81
472	Cl 1.320	887	Ta 1.164
505	Cl 3.5	888	Ta 1.167
523	Cl 1.957	889	Ta 1.168
553	AS 1.472	890	Ta 1.107
559	Ta 3.9	930	Ar 1.3
566	Pe 5.1	939	Cr 0.4
570	Pe 8.4	940	Cr 3.4–3.8
605	Pe 1.313		

INDEX

For Etruscan mythological figures, see also pp. 192–211.